MATISSE
— AND —
PICASSO

The Story of Their
Rivalry and Friendship

JACK FLAM

Icon Edition
Westview Press
A MEMBER OF THE PERSEUS BOOKS GROUP

All Matisse illustrations © 2003 Succession H. Matisse, Paris / Artists Rights Society (ARS), New York
All Picasso illustrations © 2003 Estate of Pablo Picasso / Artists Rights Society (ARS), New York
Copyright © 2003 by Jack Flam

The Library of Congress has cataloged the hardcover edition as follows:
Flam, Jack D.
 Matisse and Picasso : the story of their rivalry and friendship /
Jack Flam.—Icon ed.
 p. cm.
 Includes index.
 ISBN 0-8133-6581-3 (hardcover : alk. paper)
 1. Matisse, Henri, 1869–1954—Friends and associates. 2. Picasso, Pablo, 1881–1973—Friends and associates. 3. Artists—France—Biography.
I. Title
ISBN 0-8133-9046-X (paperback)
 N6853.M33 F529 2003
 759.4—dc21

 2002154120

Westview Press is a member of the Perseus Books Group.
Find us on the World Wide Web at http://www.westviewpress.com

Westview Press books are available at special discounts for bulk purchases in the U.S. by corporations, institutions, and other organizations. For more information, please contact the Special Markets Department at the Perseus Books Group, 11 Cambridge Center, Cambridge, MA 02142, or call (800) 255–1514 or (617) 252–5298, or e-mail j.mccrary@perseusbooks.com.

Text design by Brent Wilcox
Set in 10.5-point Sabon by the Perseus Books Group

First paperback printing, March 2004

1 2 3 4 5 6 7 8 9 10—05 04

CONTENTS

PREFACE

This book takes a fresh look at the relationship between Henri Matisse and Pablo Picasso, two artists who dominated the art of the twentieth century. It is different from other books on the subject in that it deals with their rivalry and friendship as a continuous story, from the time they first moved into each other's orbit in 1905 until they died. It explores the various ways that Matisse and Picasso inspired and challenged each other, and shows how their responses to each other's work often had a determining effect on the directions their art took. As will be seen, the work of each would have been less rich without the constant presence of the other to provoke him and to pressure him toward fresh paths.

I also pay a good deal of attention to the ways their personal affairs affected their art and their interactions with each other. I want to give the reader a sense of these two extraordinary individuals as men as well as artists, and to situate their art in the context of their lives. I am aware that this is a potentially dangerous area, especially with regard to men like Matisse and Picasso, whose work defied the stable codes and narrative subjects of traditional art and was meant to be open and ambiguous, even at times intentionally inconclusive and contradictory. This aesthetic makes their art particularly resistant to the kind of interpretive paraphrase that is often necessary to relate a work of art to an artist's life and makes the whole enterprise somewhat risky. But I believe it is a risk worth taking, because the common practice of discussing their works as if they had set out to solve abstract sets of formal or art-historical problems distorts the art at least as much by draining away some of its reason for being.

In modern painting, there are fewer conventionally agreed-on meanings than in traditional art. As a result, the latent or private content of a work often becomes part of its public or manifest content. This situ-

ation is especially true of Picasso, because so much of his work is clearly autobiographical. In fact, the private meanings in his works have been so much written about that they have become part of their public meaning. With Matisse, the situation is different. His subjects tend to be more neutral than Picasso's, and his art is structurally so much more open that—simply in pictorial terms—specific readings are more difficult to discuss. And because Matisse was uneasy about the possibility of his work revealing more about himself than he wanted to make known, he actively resisted interpretation. Actually, it seems he wanted to have it both ways. On the one hand, he told the poet André Verdet that he believed a work of art was "the emanation, the projection of self. My drawings and my canvases are pieces of myself. Their totality constitutes Henri Matisse." But at the same time, he also insisted that his art had virtually nothing to do with the events of his life, as if the "self" he was speaking of existed on a higher plane than the mere man. This dichotomy I am willing to grant, for his view of art was a transcendent one. But as will become apparent in the following pages, Matisse's work, though not autobiographical in the same way as Picasso's, is more directly related to the events in his life than one might suppose.

Crucially, both Matisse and Picasso were primarily painters of women, and the erotic plays an important part in the work of both artists. With Picasso, the role that specific women played in his art is taken for granted, and the division into periods that is commonly used in the discussion of his work is often coordinated with the main woman in his life. It is a cliché, but like many clichés it holds a good deal of truth. Those women did affect his art in distinct ways, both as subjects and in terms of style, and he seems to have used them as catalysts for change.

Among other things, they spurred Picasso to reflect on himself. A vast range of lived experience is encompassed by his art—from his romantic, youthful pictures of poverty and sexual longing to the harrowing pictures of old age and death that he painted during his last years. During three-quarters of a century, Picasso's art reflected many aspects of his personal life and referred to much of the disquiet of the world around him. He had enormous natural gifts and a temperament that prodded him to try virtually anything, no matter how outrageous. He would stick pieces of newspaper or oilcloth in his pictures; he would make sculptures out of spoons or scraps of wood; he would get his friend Julio González to weld together pots and colanders and scrap iron and call it sculpture. In the 1920s, madly enamored of a beautiful and very young

woman—a woman whose very existence he would keep secret for many years—he would paint her nude body with all the orifices in full display, and with her anus more prominent than her vagina. The relative abstraction of the rendering allowed people to pretend not to notice, but there it was—almost an open declaration of his sexual preferences. No wonder the Surrealists loved him so. André Breton illustrated the first part of "Surrealism and Painting" entirely with Picasso's works, and the Surrealists considered him one of their most important acquisitions, after a fashion; although Picasso stayed close to the group for years, he never became a card-carrying member of the movement. He was not by nature a joiner. It would take an organization as large and lethal as the Communist Party to get him to become one.

Compared with the direct, narrative character of so much of Picasso's art, Matisse's painting and the language we feel we must use to describe it are relatively esoteric—despite the simplicity of his imagery. The subjects of Matisse's paintings are often neutral, but the way they are painted often raises them to the realm of the metaphysical. This engagement with the metaphysical rather than the social is, by the way, one of the things Picasso took away from his early acquaintance with Matisse; and as we shall see, it had no small bearing on Picasso's Cubism. But given the intense visuality of Matisse's painting, and the difficulties involved in describing it, it is not surprising to find that during most of their lifetimes, in comparisons between the two, Matisse was bound to suffer. Whereas Picasso seemed deeply engaged with the contemporary world and with history in the making, Matisse seemed to ignore the political and social issues in the world around him.

With Matisse, little differentiation has been made between his private and public selves, and as a result his art is held to have had no direct relation to his private life. But a number of women played important roles in relation to Matisse's art. As with the main women in Picasso's life, each of Matisse's women affected his style as well as his imagery. During the years between 1925 and 1940 in particular, part of the artistic rivalry between Matisse and Picasso was acted out as a kind of duel that revolved around the depictions of some of these women.

RATHER THAN BEING ORGANIZED in terms of periods of stylistic development, this book is organized in terms of the artists' responses to three aspects of life that we to some degree all share. The first has to do

with establishing one's identity and making the most of one's abilities and limitations. For an artist, this study of self always involves the overriding question, Am I really capable of being a great artist? The second has to do with how one relates emotionally to the people around one—one's family, one's sexual partners, the handful of people whom in the course of a lifetime one really loves. For an artist, the overriding question here is, Am I capable of overcoming my own self-absorption and really loving someone else? The third has to do with whether, in the face of physical decline, it will be possible to continue to act effectively in the world, and with what sort of courage one will finally face extinction. The overriding question here is, Can I continue to work and grow and wring meaning from the confrontation with my own death?

Although this book does not set out to follow a specific theoretical model, my thinking about how artists deal with the various phases of their careers has benefited from the useful discussion of "Poetic Crossing" that Harold Bloom develops in the coda to his study of Wallace Stevens's poetry. Simply stated, Bloom posits three "Crossings," each of which involves an artist's dilemma in "confronting death, or the death of love, or the death of the creative gift, but in just the reverse order." These three crossings correspond to phases that are especially germane to the careers of both Matisse and Picasso. Although they were a dozen years apart in age, they seem to have passed through them at around the same time—partly as the result of global historical events, including two world wars, and partly because of an odd congruence of personal circumstances.

Each artist played an important role in how the other defined himself in relation to these three crossings. For example, between 1906 and 1918, Matisse produced some of his greatest works. But his sense of "election" as a great artist was to some degree called into question—and in a way deferred—by Picasso's achievement. During the 1920s and 1930s, the strategy each man brought to the subject of love was profoundly affected by his awareness of the way the other was treating it. And during the last decades of Picasso's life, his awareness of Matisse's achievement seems to have provoked him to measure himself against the past masters, as if to allay doubts about the lasting value of his work.

———✦———

THE MORE ONE LOOKS at the works of these two exceptional artists together, the more engaging, and mysterious, they become. When their

works are studied together, a kind of synergetic effect is created, and indeed the work of one makes the other's work look stronger—as if each artist is in some way more complete when his works are considered along with those of the other. This relationship is something both men seem to have understood. Throughout their lives, from the first time they met, each recognized that the other would somehow be the main presence that he would have to reckon with. For a half century, they spurred each other on to do things that might not have been possible without the other, like top-level athletes who set the pace for each other. "All things considered," Picasso remarked, "there is only Matisse." Matisse, for his part, said, "Only one person has the right to criticize me, that is Picasso." And more than once, both of them were reported to have said something to this effect: "We must talk to each other as much as we can. When one of us dies, there will be some things that the other will never be able to talk of with anyone else."

1

BEFORE MATISSE
AND PICASSO

As an artist, a man has no home in Europe save in Paris.
— FRIEDRICH NIETZSCHE, *ECCE HOMO*

On the fourteenth day of April 1900, the Paris World's Fair opened to an excited public. The fairgrounds covered some 547 acres, making it the largest ever in Europe. Two of the most popular exhibitions, at the Château d'Eau and the Hall of Illusions, involved spectacular displays of electricity. There were also elaborate presentations of colonial cultures, most notably from Africa and the South Seas, and a panorama that re-created part of the Trans-Siberian Railway. The various nations had their pavilions along the quai d'Orsay on the left bank of the Seine, and a bridge named for Alexander III of Russia was built to join the pavilions on the Left Bank with those on the Right Bank, which included two newly built "palaces" for art, the Grand Palais and the Petit Palais, just off the Champs-Elysées.

At that fair, a talented eighteen-year-old Spanish artist named Pablo Ruiz exhibited a painting called *Last Moments*, an accomplished narrative in an academic realist style, which portrayed a dying girl surrounded by a priest, a nun, and her family. Ruiz had never been to Paris, but before the year was out he planned to go there to see his painting in the company of his close friend Carles Casagemas, with whom he shared a studio in Barcelona. In Paris, as Vicente Huidobro would later write, "You are at the door of the century. You have the key to the door in your hands."

Just a few months earlier, while the stone and cast-iron Grand Palais was being built, a thirty-year-old artist named Henri Matisse had been

hired to paint garlands for the scenery on the Trans-Siberian Railway exposition. The work was backbreaking and tedious, and after a few weeks he took ill and was fired. He, too, had submitted a painting to the fine arts section, but it was refused. Matisse at the time was married and had two children. His six-year-old daughter Marguerite had been born to another woman five years before Matisse married his wife, Amélie, who generously adopted and lovingly cared for her. Their son Jean was just a year old. By the time the World's Fair closed at the end of the year, the Matisses had a second son, Pierre. Dirt poor, they were supported partly by Matisse's father and partly by the hats that Amélie Matisse made and sold.

Whereas Ruiz was considered one of the most talented artists in Barcelona, the gifts of his friend Casagemas were of a decidedly limited nature. But in Paris, this distinction didn't count for much, and neither man made much of an impression. Ruiz and his friend did, however, meet some interesting women, and Casagemas fell madly in love with Germaine Gargallo (née Florentin), who though born in Montmartre was part Spanish and spoke the language. She liked Casagemas well enough, but although they slept in the same bed, it was with a good deal of frustration, as the poor man's sexual potency was even weaker than his artistic talent. When he and Ruiz returned to Barcelona, they still shared a studio. Casagemas was writing frenzied love letters to Germaine and drinking so much that Ruiz was glad to see him leave for Paris the following February.

But when Casagemas saw Germaine, she explained to him that they had no future together. Casagemas decided to return to Spain and invited his small circle of mostly Spanish friends to a farewell dinner at a local restaurant. There, after everyone had drunk a good deal of wine, he pulled out a revolver, aimed it at Germaine, and fired. He missed. Then he put the revolver to his temple and blew his brains out.

The sudden death of Casagemas deeply affected Ruiz, who by the middle of the year had begun to sign his work with the name of his mother rather than his father: Pablo Picasso. During the next year or so, Picasso painted several pictures that touched on the death of Casagemas, including a large pseudo-religious painting called *Evocation*, in which Casagemas is represented with his arms stretched out in a Christ-like gesture, ascending to Heaven on a white horse. There he is greeted by a trio of prostitutes dressed only in colored stockings—mocking both the Christian Trinity and the pagan Three Graces. This

is when Picasso began to paint primarily in melancholic, deep blue tonalities. His paintings often depicted human suffering in a tender, even sentimental way, although they sometimes had a very sharp edge.

Many of Picasso's paintings from this period are autobiographical in that they record the ongoing discovery of the world by a talented and alert young man who is especially sensitive to themes dealing with sex, friendship, and poverty. Later, when he became the most famous artist alive, this autobiographical aspect of his work would come under microscopic scrutiny, and a number of his works would be revealed to have quite specifically private meanings. In some cases, such as *La Vie* of 1903 (Fig. 1.1), the public and private meanings have become so intertwined that it is virtually impossible to separate them.

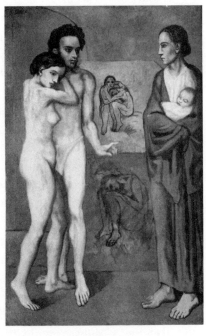

FIGURE 1.1 Picasso, *La Vie*, 1903. 197 x 127.3 cm.

In *La Vie* the young man at the left resembles Casagemas, and the woman next to him bears the likeness of Germaine, the woman for whom he committed suicide. A number of studies for the painting have survived, and in these—as well as in the first sketches on the canvas itself—Picasso represented *himself* as the nude young man, standing in what is clearly an artist's studio, and the space where the woman and child appear was occupied instead by an elderly bearded man. Picasso seems to have associated Casagemas's sexual impotence with his friend's failure as an artist, and in the original conception for the painting he appears to have been wrestling with his sense of guilt, not only in relation to the dead Casagemas—Picasso was Germaine's lover both before and after Casagemas's suicide—but also in relation to his own father. Don Jose Ruiz, also an unsuccessful artist, is evoked by the person of the bearded old man. The drama of guilt and redemption that seems to underlie this painting is thus suggested both publicly, in the clear allusions to Adam and Eve and to the Madonna and Child, and privately, in relation to the traumatic instances represented by Casagemas's suicide and Don Jose's "death" as an artist.

Another level of biographical meaning is suggested by x-rays of the painting, which reveal that it was painted atop *Last Moments* of 1899, the deathbed scene Picasso had exhibited at the Spanish Pavilion at the 1900 World's Fair. Although it has been said that Picasso overpainted the earlier large picture simply because he could not afford canvas at this time, it seems more likely that painting over *Last Moments* had important personal significance for him. That painting, done in an academic narrative style, was meant to commemorate the death of Picasso's sister María de la Concepción—called Conchita—in 1895. At the time of Conchita's illness, the thirteen-year-old Picasso swore that if she were to live, he would give up painting forever. So even though her death was a terrible emotional blow to him, it also gave him permission to continue as a painter. Picasso was deeply superstitious, and this sanction must have produced an enormous feeling of guilt. Painting over *Last Moments* seems to have been part of a complex act of obliteration and conciliation, in which he attempted to exorcise his lingering sense of guilt by conflating on a single canvas his feelings of responsibility for the deaths of Conchita and Casagemas. Even at this early stage, painting was a form of magic to him.

In 1903, Picasso's overpainting *La Vie* on top of *Last Moments* was also a way of disavowing his earlier anecdotal, academic style of painting. His later contempt for *La Vie*, which he characterized as "awful," reflected not only a rejection of its sentimentality but also his continued uneasiness with the charged and ambivalent feelings involved in its creation.

MATISSE'S EARLY CAREER FOLLOWED a very different trajectory. Less obviously gifted and certainly less precocious than Picasso, he had first studied law and then spent years as an art student. He remained at the academic École des Beaux-Arts for six years, then studied in a series of private studios where he drew from the live model with dogged persistence. In the years immediately following the 1900 World's Fair, he struggled with poverty, with a financial scandal that almost landed his in-laws in jail (they were unwittingly implicated in their employer's fraudulent financial scheme), and with a good deal of public indifference toward his work. During that time, he worked his way through the different modes of vision employed in nineteenth-century avant-garde painting, starting with the Impressionists and then moving on to

Seurat, van Gogh, Gauguin, and especially Cézanne, who was to remain the greatest and longest-lasting source of inspiration to him. As early as 1899, Matisse made great sacrifices in order to buy a small but powerful Cézanne, *Three Bathers*, and he was the first of the younger avant-garde artists to absorb the radically new kind of pictorial thought that Cézanne's painting embodied. Cézanne was, as Matisse said, "a sort of god of painting."

DURING THE FIRST YEARS OF THE CENTURY, the paths of Matisse and Picasso crossed several times, though the two men apparently never met. They both showed at Berthe Weill's gallery early in 1902, and their works were hung together for the first time in a group exhibition at Weill's that June. Both also showed at the gallery of Ambroise Vollard, who was Cézanne's dealer and from whom Matisse had bought his *Three Bathers*. Picasso participated in a two-person exhibition at Vollard's in 1901, and Matisse had his first one-man show there in 1904. Both artists had small followings during those years, but until 1905 neither attracted a great deal of attention, and neither could count on loyal or influential collectors for support.

In 1905 this situation began to change. That February, Picasso participated in a three-person show at the Galeries Serrusier on the boulevard Haussmann, for which the influential critic Charles Morice wrote the catalogue essay. A few months later, Picasso's new friend, the poet Guillaume Apollinaire, published two deeply appreciative review-essays about his work. Referring to the pervasive melancholy associated with Picasso's Blue Period works, Apollinaire noted that although "It has been said of Picasso that his work bears witness to a precocious disenchantment," the opposite was true: "Everything enchants him, and his incontestable talent seems to me to be at the service of a fantasy that justly blends the delightful with the horrible, the abject with the refined."

That same spring, when Matisse exhibited the Neo-Impressionistic *Luxe, calme et volupté* at the Salon des Indépendants, he was singled out by the critic Louis Vauxcelles as "the leader of a school." For the summer, Matisse went to Collioure on the Mediterranean coast near the Spanish border, where he was joined by his younger colleague André Derain (who was barely a year older than Picasso). There Matisse began to paint more freely and with brighter colors than he had

before. Mixing an emotional intensity inspired by van Gogh with the abstract sense of space that he so admired in Cézanne, he began to formulate the bold kind of chromatic near-abstraction that would be associated with the first avant-garde movement of the new century: Fauvism. (The French word *fauve* means "wild beast.")

In those first Fauve paintings, Matisse often worked in an all-over manner in which the specific textures and densities of things were subsumed by the network of painted marks on the surface of the canvas. He developed a way of working that uncannily re-created the uncertainties, ambiguities—and surprises—inherent in perception itself. This openness would become an enduring characteristic of his work. Unlike Picasso's paintings, which were often painted from imagination and were clearly focused on the component parts of his subjects, Matisse's paintings were painted directly from nature and incorporated the same

FIGURE 1.2

Matisse, *Woman in a Japanese Robe Beside the Sea*, 1905. 35 x 29 cm.

kind of dispersal and fluctuating sense of attention that we sense in our experience of the world. In a painting such as *Woman in a Japanese Robe Beside the Sea* (Fig. 1.2), the diverse parts of the subject matter are both unified and transformed by the way the picture is painted. The woman's body and the landscape are differentiated not through contour but largely through color and, especially, by the way the rhythms of the brushstrokes vary as they describe various kinds of things. As a result, we understand the interactions between the woman and the landscape to be reciprocal. Her inner energy radiates into the surrounding landscape at the same time that the surrounding landscape feeds energy back into her. The contrasts between varied kinds of brush marks and colors create metaphorical interactions between different orders of things—as in the striking way that the swirling forms on the woman's Japanese robe are painted so as to suggest a displaced embodiment of the water that surrounds her. This kind of dynamic interaction between different parts of the picture had been suggested to Matisse by the fluidity of the space in Cézanne's late paint-

ings, and by the way that Cézanne was able to make it seem as if the objects he painted could exist within more than one realm—and even inhabit more than one space—at the same time.

When Matisse first exhibited such paintings, at the 1905 Salon d'Automne, they were met with hilarity, shock, and disbelief. In Vauxcelles's famous review, where the word *fauve* was first used, it was employed in two very different ways. The first time, Vauxcelles used it to characterize the anticipated reaction of the philistines and academics, who would presumably pounce on Matisse's paintings like wild beasts. Vauxcelles wrote that Matisse was courageous, "because what he is showing—and moreover he knows it—will have the fate of a Christian virgin thrown to the wild beasts *(fauves)* in the amphitheatre." Later in the same review, Vauxcelles used the word in the opposite way, to characterize the effect created by the paintings of Matisse and his colleagues. Writing about two rather traditional pieces of sculpture by Albert Marque, Vauxcelles noted that they were surprising to come upon "in the midst of an orgy of pure colors: Donatello among the fauves."

It was at this Salon that an odd family of American expatriates decided to buy one of the most original paintings that Matisse had created—a portrait of his wife that was even more outrageous than his nearly indecipherable paintings of figures in landscapes.

2

Two Encounters

Matisse was far older than Picasso, and a serious and cautious man. He never saw eye-to-eye with the younger painter. As different as the North Pole is from the South Pole, he would say, when talking about the two of them.

—FERNANDE OLIVIER

The Stein family later gave different accounts of it, but they agreed they had trouble deciding whether to buy the picture, a roughly painted, brightly colored portrait of a woman wearing an absurdly large hat (Fig. 2.1). They were intrigued but put off by its sheer, aggressive ugliness. "It was . . . a thing brilliant and powerful," Leo, who probably first saw it, later recalled, "but the nastiest smear of paint I had ever seen." Gertrude—as was her habit—later claimed to have discovered the picture on her own, but at the time it was her brother Leo who had the better and more adventurous eye. She was a quick study, though, and in the end they decided to buy it precisely because they found it so disturbing. Its very ugliness made it paradoxically appear to be an important artistic statement.

In the fall of 1905, Gertrude, an aspiring but as yet unpublished writer, who described the picture as "very strange in its colour and in its anatomy," must have been especially struck by the way the richness of the formal language was able to make a rather banal subject seem fresh and new, and by the original way the painting depicted the image of a woman. It was at once something more than a portrait of a specific woman, and yet it was also a portrait, and a raw one at that—very different from the sweet and often sentimental depictions of "femininity" that characterized women's portraits at the time. This was a notion that Gertrude was struggling with in her own writing, and it struck a chord.

Although the painting seemed to be all on the surface, it also laid bare the woman's inner state of mind—and it did so not by a dramatic facial expression or elaborate gestures but because of the way it was painted.

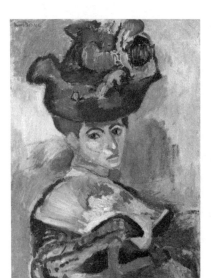

FIGURE 2.1
Matisse, *The Woman with the Hat*, 1905. 80.6 x 59.7 cm.

The woman is posed conventionally, seated in an armchair, her head exactly in the center of the canvas. But the viewer is immediately unsettled by the degree to which her face is overwhelmed by everything around it—the fan she holds, the bright orange belt she wears, and especially her enormous and extravagantly decorated hat. And when we finally do focus on her face, we are struck by how determined and yet how vulnerable and sad she looks. She seems to peer out from behind an elaborate network of physical and psychological shields, her masklike face concealing more than it reveals. It is the radical rendering that evokes these contradictions, the dissonance of the colors and the rough way the paint is laid down.

The psychological ambiguity of the picture is intensified by an equally strong sense of physical uncertainty. The rhythmic brushstrokes suggest an overall sense of fragmentation, as if the image we are looking at is on the verge of physical disintegration; or paradoxically, as if we see it in the process of coming into existence. The fluidity of the rendering and the way the forms are set against large areas of blank canvas owe a good deal to Cézanne. So does the subject, which recalls Cézanne's portraits of his wife, of which Leo and Gertrude already owned a first-rate example. But *The Woman with the Hat* took the expressive distortions of Cézanne considerably further, and its raw aggressiveness was a far cry from Cézanne's austere, almost classical humanism.

In studying this picture by Henri Matisse, an artist at the time unknown to them, the Steins sensed that something new was happening to the art of painting, and to human character. A new and undiscovered territory was opening up—a vast terrain in the Land of the Ugly, in which traditional aesthetic values seemed to be reversed, and in which ugliness seemed to be replacing beauty as the most essential element in art. Or maybe it was that from within the depths of this apparent ugliness, a ter-

rible new beauty was being born. Was that what Matisse was suggesting in *The Woman with the Hat*? Was it possible that the picture the Steins watched crowds come to laugh at, and that critics were deriding as depraved, would within a few years come to be seen as beautiful? Would pictures such as this one, which critics were calling "barbarous and naive" and which were held to reflect a "sick imagination"—would such pictures, which were scorned as the worst things Matisse had painted, come to be considered some of his very best? It seemed that the very nature of aesthetic judgment was changing, and that the idea of looking at the world in a radically new way was much more important than the traditional notion of beauty as a criterion of excellence.

When Matisse exhibited *The Woman with the Hat*, the Salon d'Automne was a newly founded annual exhibition of progressive art, initiated only a couple of years before as a complement to the well-established Salon des Indépendants, which took place in the spring and had no jury. The new autumn Salon was juried, which in principle ensured a greater control of quality. It also featured retrospective exhibitions by major modern masters—in 1905 the works of Ingres and Manet were shown. But the significant event of that autumn Salon turned out to be the paintings by Matisse and his colleagues. People came to laugh and jeer at them, and they became the target of outraged moralists, who called the artists "Incoherents" and "Invertebrates." The wild way a picture like *The Woman with the Hat* was painted seemed more appropriate to savages than to civilized people. Serious, right-minded people associated it with anarchy and the breakdown of social values.

At the time, Matisse, a thoughtful and impecunious thirty-five-year-old father of three children, was as horrified by the public's reaction as the public was by his painting. To add insult to injury, a group of conservative artists sent him a woman hideously "painted with chrome oxide green stripes from forehead to chin," as if to say, here was a model appropriate for his kind of painting. After his first visit to the Salon d'Automne, Matisse decided not to return, and he urged his wife, the subject of the controversial portrait, to stay away completely.

Matisse was therefore somewhat surprised, just a week before the show closed, to hear that an offer had been made for the painting, for which, after a brief negotiation, the Steins paid the respectable asking price of 500 francs. It was through this purchase that Matisse came to know the family of American expatriates who would be his first major patrons: Leo, his sister Gertrude, their brother Michael, and his wife Sarah. Leo was a collector and amateur painter who had studied Re-

naissance art with Bernard Berenson in Florence and was passionate about the art of Cézanne. He had settled in Paris in 1903, at the rue de Fleurus on the Left Bank, and Gertrude had joined him there shortly afterward. Michael, the eldest of the three, had stayed in San Francisco to run the family's cable car company. But he, too, came to realize that he had no taste for commerce and followed his siblings to Paris, where he and his wife found an apartment on the nearby rue Madame.

The sale of this painting was an important event for Matisse. It not only brought him an infusion of much-needed cash but also reinforced his confidence in what he was doing and provided an entrée into another corner of Parisian society. Soon Matisse and his wife were invited to Leo and Gertrude's Saturday night salon, where *The Woman with the Hat* held pride of place on their studio wall. Gertrude especially liked Amélie Matisse, a clear-featured, dark-haired woman from the south of France, whom she admired for her practical, matter-of-fact manner and simple strength. In a rush of energy, as if inspired by the hideously painted woman the conservative artists had sent him, Matisse created a second, even more intensely colored portrait of his wife—this time with a bright green stripe running down the center of her face. That painting, in which Amélie Matisse looks as tough as nails and ready to take on the world, was immediately purchased by Michael and Sarah Stein and hung at their apartment on the rue Madame.

The Steins discovered that the man who had produced those wild paintings did not quite look the part of a revolutionary or a madman—or even an artist. Quite the opposite. They found Matisse to be a reflective, medium-size man with a well-trimmed reddish beard and wire spectacles. Although he radiated a strong sense of energy, which suggested inner turmoil, it was held in check by an outward manner of great reserve. The persona he presented to the world was carefully composed. He dressed neatly and spoke with a measure, gravity, and lucidity that reflected his early training as a lawyer. "The professor," his friends called him, affectionately, but with an edge of irony. Though he moved slowly and with deliberation, his blue eyes were quick and alert, penetrating, full of curiosity. But as he stared out through his gold-rimmed spectacles, he seemed always to be holding something back, as if the thick lenses that shielded his myopic eyes were a visible reminder of the psychological distance from which he observed the world around him, as if he were looking out at the world from behind a mask.

—∞—

ACCORDING TO BOTH GERTRUDE AND LEO, they discovered Picasso shortly after the purchase of *The Woman with the Hat*. But a good deal of evidence suggests that they misremembered the sequence of events and that Leo had bought a painting by Picasso, and had even met him, through the writer Henri-Pierre Roché, in spring 1905. Leo saw the Picasso painting, which had an oddly poetic subject and was rendered with exquisite skill, in Clovis Sagot's gallery in Montmartre and found it compelling, perhaps because of its odd affinities with Renaissance art. It showed a family of traveling performers seated together with their infant child and a monkey (Fig. 2.2). In it the father, dressed as a harlequin, leans toward his wife and gently watches the child that squirms on her lap, while the monkey—apparently part of their circus act, but also clearly a member of the family—watches with intense curiosity and concern.

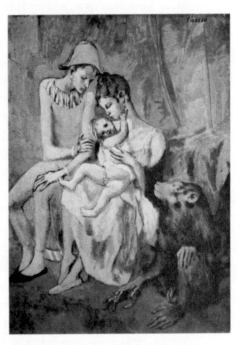

FIGURE 2.2
Picasso, *The Acrobat's Family with a Monkey*, 1905. 104 x 75 cm.

The Acrobat's Family with a Monkey delicately balances a number of opposing thoughts and feelings. It is at once lyrically tender, almost sentimental, and yet full of wicked irony. The soft colors and delicate rendering create a mood of deep sympathy and compassion, which is reinforced by the way the monkey is made part of the human family: The animal's sympathetic attention, like that of the parents, is concentrated on the robust child who occupies the center of the picture and around whom everything in it revolves. In a surprising touch, we are positioned at the eye level of the monkey, so we see the scene as if through its eyes. Our gaze is led up to the child's face by the mother's hand; and along this same axis, the lines of sight of the father and the monkey meet—the father's glancing down and the ape's staring up. In addition to the subtle psychological interactions this picture depicts, it is fraught with ironic historical references. The overall composition and the child's pose evoke the theme of the infant Christ in the arms of the Madonna—a reading reinforced by the

elaborate contrapposto of his body and the broad sweeping arcs of the rendering, which recall High Renaissance representations of that theme by Leonardo da Vinci and Raphael. This reference in turn suggests a parallel with representations of the Holy Family and St. John the Baptist, who is frequently dressed in an animal skin.

Leo Stein was intrigued by this mixture of tenderness and mockery, by the way a clearly profane scene was charged with sacred overtones that would have been openly blasphemous had they not been depicted with such subtlety, human warmth, and technical mastery. "The ape looked at the child so lovingly," Leo remembered, "that Sagot was sure this scene was derived from life." Leo correctly believed otherwise, and when Picasso later told him that the monkey was pure invention, Leo saw it as "proof that he was more talented as a painter than as a naturalist."

It wasn't until after the purchase of *The Woman with the Hat* that Leo took his sister to see more Picassos. At first Gertrude didn't like what she saw. In fact, she so hated the "monkey-like feet" in Leo's second Picasso purchase, *Girl with a Basket of Flowers*, that she threw down her knife and fork and refused to eat when he told her he had bought it. Leo himself seems to have been pulled in opposing directions: Whereas the Matisse painting seemed to be on the cutting edge of modernity, the Picassos he was interested in, from the Blue and Rose Periods, were comparatively provincial and still employed the language and sensibility of late-nineteenth-century Symbolism. If Leo later misremembered the sequence of his first purchases of paintings by Matisse and Picasso, it might well have been because he was still uncertain about the direction his collecting was going to take.

Eventually Gertrude came around, and late that year the Steins made their way across Paris to the odd little building on the Butte Montmartre where the twenty-four-year-old Picasso had his studio. The ramshackle building at 13 rue Ravignan was known as the Bateau-Lavoir, named for its resemblance to a dilapidated Seine laundry barge. From the entrance on the rue Ravignan, the building seemed to be a wide, low, single-story shack with a number of angular skylights perched on the roof. But what appeared to be the ground floor from outside was actually the top floor, since the structure was built on a steep hill and extended down to the street behind in a sprawling warren of irregularly shaped rooms inhabited mostly by artists and writers.

To reach Picasso's studio, the Steins had to make their way up and down a rickety wooden staircase into a mazelike space full of intersecting corridors. The walls were damp, the dark hallways stank of mildew and cat, and a single fountain in the stairwell provided the only source of water for the whole building. The building's many skylights, which made it unbearably hot in the summer, also invited the cold of winter, so that a bowl of soup or coffee left overnight would be frozen in the morning. Picasso's studio was at the end of a long corridor on either the top or the ground floor, depending on whether the visitor counted from the street out back or from the rue Ravignan.

The studio was a medium-size room with dingy walls and massive exposed beams. Apart from an iron stove, it was sparsely furnished: a wooden paint box, a small round table in a vaguely Second-Empire style that had obviously been picked up at a junk shop, a couple of chairs, and a sagging sofa that served as a bed. At the far end of the room was a small alcove with a mattress, which intimate friends referred to as "the maid's bedroom." There was no gas or electricity in the building, and a small oil lamp stood on the table. Picasso preferred to paint at night, and he used the lamplight to work by or to show his canvases to visitors such as the Steins. At times when he could not afford oil for the lamp, he painted with a candle in his left hand, squatting over his canvas. Although the room had little furniture, it looked quite full. The artist seemed never to have thrown anything away, and the floor was littered with paints, brushes, rags, an array of jars and bottles, and a vast assortment of junk.

The Steins could hardly have imagined a place more different from their comfortable, tastefully furnished apartment, full of Renaissance furniture, Chinese sculptures, and Japanese prints—or, for that matter, from Matisse's modest but brightly lit and orderly apartment on the quai Saint-Michel, overlooking the river and Notre-Dame. There, "every chair, every material or object showed a personal touch and most careful selection." In Matisse's immaculate studio, there was "a place for everything and everything in its place," as Leo remarked, "both within his head and without."

Picasso, by contrast, seemed to revel in a calculated disorder—both around him and within him. Even physically, he was the opposite of Matisse: short, with a compact but virile body, given to quick movements, dressed in workman's clothes. Though not especially handsome in any ordinary sense, he was striking to look at—and to be looked at by. His large dark eyes had a riveting, magnetic stare—they fixed you

with their unnaturally large pupils, which were always dilated as if he were staring not quite at you but into you, or through you, or beyond you. "When Picasso had looked at a drawing or a print," Leo recalled, "I was surprised that anything was left on the paper, so absorbing was his gaze." He had enormous presence and what the Steins understood to be a Spanish way of interacting with the world. His regard was bold, aggressive, sexual—a striking example of what the Spanish call *mirada fuerte*, or "strong gazing." In Andalusia, where Picasso grew up, it has been said that the eye "is akin to a sexual organ . . . looking too intently at a woman is akin to ocular rape."

If the Steins were surprised to find that Picasso was smaller than they had expected, it was in some measure because the woman he was with, a full-hipped, heavy-lidded beauty, was nearly a head taller than he— "a large, placid woman, with a beautiful complexion and great almond eyes, sleepily sensual. . . . She was remarkably idle, and she . . . would lie in bed watching Picasso do whatever housework was done." This was Fernande Olivier, whom Picasso's friends called "La Belle Fernande." She had only recently moved in with him, but he had been in love with her for more than a year, from the time the previous summer when he first saw her returning to the building from the small square in front of it and playfully tried to block her way. Picasso was so smitten that shortly after their first meeting he had done a drawing of her, which he used as the center of a mock-serious altar fashioned as a kind of ex-voto of his cult of devotion to her, in which the portrait was mounted in a frame covered with blue cloth taken from one of her chemises and set up between two bright blue vases filled with artificial flowers.

The two appear to have had a brief affair at this time, and not long afterward he did a watercolor of himself watching her sleep. It was then that the predominant tonality of his pictures shifted from blue to dull pink, the beginning of the so-called Rose Period, and that his subject matter shifted from the crippled and the abject poor to amorous couples and traveling performers, as in the picture the Steins had just acquired. Fernande had at first resisted getting involved with him. She had not found him particularly attractive, despite his remarkable eyes and his rather dainty hands and feet, and he was too poor, too inarticulate, too Spanish. She worked as an artist's model and had endured many difficult times with men, starting with the middle-aged man who had raped her when she was only seventeen and who, after having been forced to marry her, submitted her to repeated brutality and sexual

degradations. On leaving that monstrous relationship, she had been caught up in one unhappy love affair after another. She wanted to do better, but eventually circumstances and Picasso's persistent ardor had worn her down.

<center>⸺⋇⸺</center>

PICASSO AND GERTRUDE STEIN felt an immediate bond. In part it was a kind of chemical, almost sexual attraction. She appealed to him as a woman who had a powerful physical presence but who at the same time was de-eroticized by her masculine bearing and her homosexuality. It was therefore possible for Picasso to consider her as intensely feminine and at the same time paradoxically possessed of what to him were the masculine virtues of independence, intelligence, and artistic ambition—qualities that were in direct opposition to the more traditional femininity of Fernande, whom Stein herself characterized as being concerned with little else than perfume and hats. Whereas Matisse appeared eminently respectable and resembled a doctor—or, even worse, a college professor, such as those she had vainly attempted to study medicine with back at Johns Hopkins—Gertrude found in Picasso a true bohemian, like the acrobats and actors he hung around with and depicted in his works. He was a kind of rebel who lived on the fringes of society and who seemed to make his own laws.

Picasso, moreover, was surrounded by interesting types, in contrast to Matisse whose daily life was centered on his family. Picasso lived in a veritable artists colony. The poets Max Jacob and André Salmon lived at the Bateau-Lavoir, and during the five years Picasso resided there, its inhabitants included such notables as the composers Edgar Varèse and Erik Satie; the painters Kees Van Dongen, André Derain, Maurice Vlaminck, Georges Braque, Juan Gris, and Amadeo Modigliani; the mathematician Maurice Princet, one of the early theorists of fourth-dimensional geometry; and writers such as Pierre MacOrlan and Maurice Raynal. Unlike Matisse, who was essentially a loner, Picasso was firmly entrenched within a milieu: first one of fellow Spaniards, then of French artists and writers, later of prominent artists and public figures in all fields. He was like a magnet that drew people to him, whereas Matisse, for all his surface sociability, never fully participated in a group.

The friendship between Picasso and Gertrude was no doubt given further impetus by their outsider status within French society.

Gertrude's French was only marginally better than his, and she spoke it with a manner and accent that were in their own way as awkward and abominable as his own. Although he would spend the rest of his life in France, Picasso never mastered the language, and during those early years he was especially self-conscious about how bad his French was. When the Steins brought Matisse and Picasso together for the first time, Picasso was intensely aware of how much more articulate the older painter was. Matisse "had an astonishing lucidity of mind," Fernande Olivier remembered, "precise, concise and intelligent," and he was masterful in his ability to "argue, assert and endeavor to persuade." On the occasion of a Manet and Redon exhibition at the Durand-Ruel gallery, Matisse, who was friendly with Redon, told Leo that he thought Redon was even better than Manet, and that he had said so to Picasso, who had agreed with him. When Leo Stein later expressed his astonishment about this to Picasso, he replied with exasperation, "Of course I agreed with him. Matisse talks and talks. I can't talk, so I just said *oui oui oui*. But it's damned nonsense all the same."

In fact, Picasso had a complex relationship to language generally. He was born in Malaga, but his family moved to Corunna (Le Coruña), on the northwestern coast of Spain, when he was only nine. In Corunna, his Andalusian accent would have been quite conspicuous, and the local people used the Galician dialect as well as Castilian. Four years later, his family moved to Barcelona, where Catalan was widely spoken, especially in the *catalaniste* circles he frequented. Two years after that, Picasso went to study in Castilian-speaking Madrid, and it was not until the summer of 1898, when he went to the mountain village of Horta de Ebro with his friend Manuel Pallarès, that he became comfortable speaking in Catalan.

When he first visited Paris in October 1900, Picasso's French was virtually nonexistent, and his circle of friends included primarily Spaniards. When he returned to Paris the following year, his French was still so poor that he and his new friend, the poet Max Jacob, had to communicate largely with gestures. Throughout his life, Picasso continued to speak French with a marked Spanish accent and to employ an idiosyncratic form of spelling, no matter which language he was writing. Some idea of how his speech, and his views about women, appeared to the French can be had from reading Guillaume Apollinaire's novel *La Femme assise*, in which the madly jealous Picasso-like painter Pablo Canouris implores his mistress, "*Elbirre, écoute-moi oubbre-moi jé te aime, jé te adore et si tu né m'obéis pas, jé té touerrai avec mon*

rébolber" (Elbira, listen to me, obben the door, I lova you, I adora you and eef you do not obey me, I will sheeoot you wif my rebolber). Earlier in the book, Canouris remarks, *"Pour aboir braiment une femme, il faut l'aboire enlébée, l'enfermer à clef et l'occouper tout lé temps"* (To breally hab a woman, you have to kidnab her, lock her ub and take care ob her all de time).

During most of his formative years, Picasso used language as an outsider. Thus, even before he arrived in Paris, he was already a "vertical invader"—a maverick who was able to occupy a place at the center through the sheer magnetism of his personality. (In Montmartre, his French artist and writer friends came to be known as members of *la bande à Picasso*. In the Spanish manner, he made himself the center of a *tertulia*, or circle of cronies.) Picasso's sense of dislocation and his fluid relationship to language must have given him an extremely strong sense of the arbitrariness of all systems of communication, including visual ones, and was no doubt a contributing factor to his extraordinary freedom from self-censorship—in his speech, his actions, and his art.

THE STEINS' INTEREST IN PICASSO complicated Matisse's relationship with them. Although Matisse was twelve years older than Picasso and better established, he had little time to savor his newfound patronage before paintings by his young rival began to appear on the walls next to his own. This was the beginning of a pattern that would persist well into the future: Each time Matisse seemed on the verge of carrying the day, Picasso would somehow arrive on the scene and sour the situation, sometimes giving it a distinctly bitter edge (and at each turn, Picasso would greatly profit from what he in turn was able to take from Matisse). In a typical gesture, shortly after Picasso met the Steins, he underscored his feeling of sympathy for Gertrude—and got one up on Matisse—by asking her to sit for a portrait. This was a turning point in the relationship between the Steins and Picasso and in the relationship between Picasso and Matisse.

AT THE TIME THEY WERE TAKEN up by the Steins, Matisse and Picasso had not yet met, and they had only a passing acquaintance with each other's work. Though their paintings had sometimes been handled

by the same dealers, there was no particular reason for either to have paid much attention to the other's works before the Steins started to collect them. Picasso's work was not well known, and for all its poetical verve and precocious technique, it was considerably less advanced than that of Matisse and would not have impressed him much. Matisse's paintings were better known, since the older artist had been exhibiting at the progressive Salons for the past few years, and his work was regularly mentioned in newspaper reviews. But Picasso, who refused to exhibit at the Salons, evidently did not go out of his way to see the Salons, either. In any event, most of the works that Matisse had previously exhibited were still lifes and landscapes—neither of which would have held much interest for Picasso.

Picasso's first significant exposure to Matisse's work seems to have been at the same 1905 Salon d'Automne where Matisse was discovered by the Steins—and where by coincidence Picasso's Catalan friend Ramon Pichot, who painted with a colorful palette, had a picture hanging in the same room as paintings by Matisse. These were the works in which Matisse was beginning to come into his first real maturity and to assert his originality—the brightly colored and freely brushed works that would be called Fauve. Matisse showed eight oil paintings at that Salon, mostly landscapes and figures in landscapes. All were boldly painted, but Picasso's attention would naturally have been drawn to *The Woman with the Hat*. His own painting at the time was centered on the human figure, and it was in *The Woman with the Hat*, with its emphasis on the portrait, that Matisse's audaciousness was most readily apparent. After all, if an artist colors a tree bright red, or moves a house or an outcropping of rocks a couple of yards, few will take him to task for it. But if he moves someone's nose a couple of centimeters, or colors it vivid green, there will be hell to pay. This was a lesson Matisse learned at the 1905 Salon d'Automne, where it was *The Woman with the Hat* rather than his figures in landscapes that set people's teeth on edge, and which was prominently reproduced in the popular weekly *L'Illustration*. Gertrude Stein was not far off the mark when she wrote, "if you do not solve your painting problem in painting human beings you do not solve it at all." In advanced French painting at the beginning of the century, the ultimate painting problem would focus on ways in which the human figure could be represented in a subjective, sometimes nearly abstract way and still have its human content be convincing.

The Woman with the Hat must have been like a slap in the face to Picasso. All his life he had been something of a boy wonder, and by the

fall of 1905 he was getting enough notice to reinforce his convictions about the rarity and importance of his own talent. So far as he could tell, there was no real competition around. But seeing Matisse's work brought him up short; it made clear that whatever virtues his own Symbolist-inspired work might have, it was distinctly provincial-looking and more than a bit old-fashioned. The Manet and Cézanne paintings that he saw at that same Salon d'Automne would have driven home the point even more. Matisse had been struggling for the past several years with the enormous implications of Cézanne's late paintings—such as their fragmentation, lack of finish, and overtly metaphysical ambition. Picasso had seen Cézanne's paintings at Vollard's gallery as early as 1901, but he had first been attracted to the violent—and often misogynistic—imagery of Cézanne's early work, as is evident in Picasso's drawing of a man strangling a woman, which appears to be based on Cézanne's *The Strangled Woman*. Picasso had only recently begun to look seriously at Cézanne's formal innovations, and he still had found no way to make meaningful use of them in his own work. Though he had a number of friends among French writers, his artistic milieu was based in the villagelike atmosphere of Montmartre and was still primarily Spanish.

When Picasso's paintings began to appear at the rue de Fleurus, Matisse could not have found them especially threatening from an artistic viewpoint. The Steins' expressed fondness for the young Spaniard, however, and the hold he seemed to have on Gertrude's loyalty during the winter he began to work on her portrait were another matter. These developments put Matisse in an awkward position. He was older and better-established than Picasso, and he was on his home turf. For a thirty-six-year-old artist to acknowledge that he was engaged in open competition with a twenty-five-year-old upstart would be demeaning—especially since Picasso's bohemian nonchalance seemed so unworldly. Yet as Matisse must have understood, Picasso began immediately to occupy as much terrain as he could, effectively ingratiating himself with the Steins. He had proposed doing the portrait of Gertrude right after his first dinner with them, and it turned into an arduous project for which she would sit some ninety times. A few months later, while he was still working on the large oil portrait of Gertrude, Picasso used his fluent technical facility to good advantage by doing a small, frontal portrait of Leo, his face lyrically rapt in a flattering mix of critical appraisal and aesthetic reverie. Around the same time, in order to please the Steins of the rue Madame, Picasso also did a handsome profile por-

trait of Michael and Sarah's son Allan. In this way Picasso was shrewdly able to accommodate virtually the whole family while still reserving pride of place for Gertrude, whose portrait was the largest, and done in oil on canvas rather than in gouache on cardboard as were the other two. In later life, Picasso was famous for his skill in playing people off against each other; clearly this was a gift that he had from the beginning.

Matisse, moreover, was not an artist to whom things came easily, and casual commissions such as the portraits of Leo and Allan Stein would have been virtually impossible for him to take on. He did not have the same fluency with the brush that Picasso had, and everything he worked on was a struggle. "All his pictures," as Leo noticed, "were to give him a lot of trouble. . . . He worked endlessly on his pictures, and wouldn't let them go till they were finished." To a large degree, this was because Matisse thought with his brush, and in a sense discovered his pictures in the act of painting them. Picasso, by contrast, always had a strong narrative gift, and his brush generally followed his preconceived idea of what the picture would look like.

It would be difficult to think of two gifted men whose temperaments and strengths were more different. It was only natural that from the moment the Steins first began to collect their work, the two artists would see themselves as rivals.

A NEW ARENA

*Matisse and Picasso then being introduced to
each other by Gertrude Stein and her brother
became friends but they were enemies.*

— GERTRUDE STEIN

Picasso took Gertrude Stein's appearance in his life as a kind of sign, and he put enormous effort into the portrait he asked her to sit for (Fig. 3.1). Although his usual practice was to work from memory and imagination rather than directly from the model, he insisted that Stein sit for the portrait, and starting in late 1905 she dutifully took the omnibus across Paris and trekked up the Butte Montmartre several times a week to accommodate him. Stein later described the first sitting: "Picasso sat very tight on his chair and very close to his canvas and on a very small palette which was of uniform brown grey colour, mixed some more brown grey and the painting began."

In the initial stages of the Stein portrait, Picasso was trying to come to grips with the unlikely combination of Cézanne and Ingres, both of whose work he had recently seen at the autumn Salon. Stein's powerful presence is reminiscent of Ingres's famous portrait of Louis-François Bertin, whom Manet had wittily dubbed "the Buddha of the bourgeoisie," but her pose echoes that in the portrait of Mme Cézanne that she and Leo owned, with the position of the hands reversed. The modeling is finely chiseled, as in Cézanne's most sculptural manner; at the time, Cézanne's more fluid late style was more difficult for Picasso to absorb.

During the course of the sittings, Fernande Olivier would sometimes

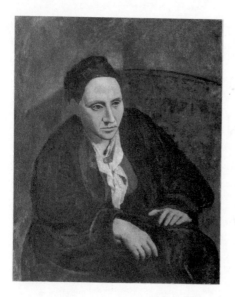

read to artist and model from La Fontaine's *Fables,* but they also talked at length. At the time the portrait was being painted, Gertrude was working on a story about a black girl named Melanctha Herbert, which would appear in her book *Three Lives.* That story would have been of particular interest to Picasso, because it was so typically American, and its subject would be even more so later in the year, when he became interested in African art. It was also especially important to Stein, who had started it as *Q.E.D.,* an autobiographical account of an unhappy love affair, which she then rewrote, transposed into a black setting. At a time when "Negro" and "African" were virtually interchangeable cultural concepts, Stein was already involved in a kind of cross-cultural masking.

PICASSO WAS WORKING ON Gertrude's portrait at the time he and Matisse first met. Accounts differ as to exactly when and where their first encounter took place, but it was probably in March 1906, either at the Steins' apartment or at a gallery where Matisse was having an exhibition. Soon after, Matisse went to Picasso's studio, along with Gertrude and Leo. The Steins were not conventional people by any standards, especially European ones, and Gertrude was the least conventional of all. Under her habitual "sort of kimono made of brown corduroy," similar to her attire in Picasso's portrait, Gertrude often dispensed with wearing a corset, allowing her abundant flesh to swell and ripple. The family as a whole made little distinction between country and city dress and often wore sandals right in the heart of Paris. Marguerite Matisse later remembered accompanying her father on his first visit to the Bateau-Lavoir. Recalling the event through the eyes of the twelve-year-old girl she then was, she said nothing of what she saw in Picasso's studio, but she did remember his dog, a Saint Bernard, and especially her excruciating embarrassment as she and her father made

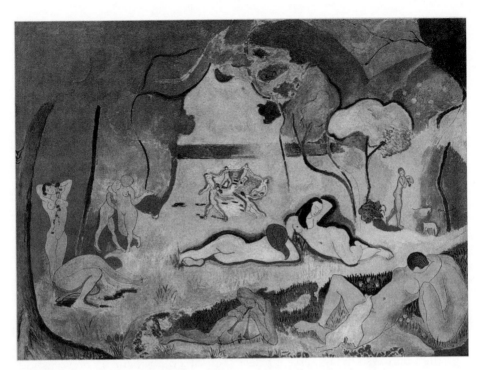

FIGURE 3.2 Matisse, *Le Bonheur de vivre*, 1905–1906. 174 x 238.1 cm

their way on foot across Paris with their new American friends: "On the Avenue de l'Opéra, people watched our group go by with consternation. The Steins were conspicuously got up, especially her, stout, massive, rather mannish. She wore thick corduroy dresses that were not at all fashionable. And they all wore sandals with leather straps, barefoot like Nazarenes or like the Duncan family."

When the two men met, Matisse's career was beginning to take off. On March 19, 1906, his second one-man show opened at the Galerie Druet, where he exhibited fifty-five paintings, along with a number of sculptures, watercolors, drawings, and lithographs. The paintings ranged in date from 1897 to the current year, so the exhibition served as a retrospective that gave a clear idea of his development. The very next day was the opening of the Salon des Indépendants, where Matisse showed a single painting, *Le Bonheur de vivre* (Fig. 3.2), which was the largest—and most daring—canvas he had ever done. Matisse was acutely aware of the importance of this work, and in sending the solitary canvas to the 1906 Salon at the same time that he had a one-man show in a private gallery, he no doubt meant to lay full claim to being the "leader of a school." This gesture of establishing himself as the

most important of the progressive painters was not lost on Picasso—nor was the shocking originality of *Le Bonheur de vivre* and the recent works shown at Druet's, especially the radically simplified drawings and lithographs of female nudes. By comparison, Picasso's portrait of Gertrude Stein was somewhat timid.

Le Bonheur de vivre throbs with nervous energy, clashing colors, and pulsing arabesques. Ablaze with bright reds, yellows, and violets, it is also intensely "mixed" in style, making it a major early example of a new aesthetic of stylistic dissonance. Throughout the picture, there are surprising differences in paint application and abrupt changes in the manner of rendering, even in adjoining passages. This stylistic dissonance is made even more emphatic by the painting's intense—almost madcap—eclecticism. The obvious sources range from allusions to prehistoric cave painting to the compositional structures of Ingres and Cézanne, as well as the sinuous arabesques of contemporaneous Art Nouveau decoration. The ring of dancers alone recalls artists as diverse as Mantegna, Ingres, Goya, and Agostino Carracci—not to mention Greek vase painting, medieval tapestries, works by Antonio Polliauolo, and early Renaissance book illumination. The aggressive eclecticism of *Le Bonheur de vivre* would have been especially provocative to Picasso, whose own paintings so frequently alluded to earlier art, often in an ambiguous or ironical way.

Although the subject of *Le Bonheur de vivre* places it squarely within a tradition of pastoral painting that dates to the Renaissance, the picture mixes diverse aspects of that tradition in such unusual ways that it seems at once to be not only a summation and synthesis of the whole of Western painting but also a sustained attack on it. This is especially evident in the way the painting largely deconstructs its nominally pastoral subject matter—a garden of earthly delights—with the fluid and violently primitivistic effect of the way it is rendered. In doing so, Matisse transforms the traditional pastoral into a reverie about the origins of desire—a notion very much in keeping with the literary source for the painting, Stéphane Mallarmé's erotic reverie "L'Après-midi d'un faune." As in the Mallarmé poem, Matisse's imagery is dreamlike, the figures are mostly self-absorbed and self-contained, and the picture as a whole exudes an oddly detached sensuality.

The two reclining nudes at the center evoke the two nymphs in the Mallarmé poem, which he refers to as a "fantasy of your fabulous desires." The clashes between their complementary colors typify the tensions and contrasts that run through the entire painting and are emblematic of its narcissistic eroticism. The figure on the right with the

raised arm is based on ancient representations of Ariadne and is a traditional symbol of *Luxuria*, or lust. This image, which can be characterized as the "Dream-of-Desire" woman, would become an especially important motif in Matisse's work. As we shall see, he would repeat it almost obsessively throughout most of his life—and it would later be picked up from him by Picasso as a means of both homage and attack.

Because of its large size, *Le Bonheur de vivre* drives home a point that was less obvious in Matisse's smaller works—that he was now using color in an important new way, as an equivalent for the sensation of light rather than as a description of it. *The Woman with the Hat* had unexpectedly shocked people, but with *Le Bonheur de vivre* Matisse seems to have set out purposely to create a shocking effect. That Matisse meant his painting to be a kind of manifesto was not lost on the critics. Charles Morice, who had written the catalogue essay for Picasso's exhibition at the Galeries Serrusier the previous winter, expressed strong reservations about *Le Bonheur de vivre*, but nonetheless referred to it as the "question" of the Salon. The crowds found the painting hilarious and strange, Morice reported, although he found it "excessively schematized and theoretical." Even Leo Stein, who bought the picture, was puzzled when he first saw it. He returned to the Salon numerous times to study it and only after a week of intense scrutiny did he decide to acquire it, declaring it to be "the most important painting done in our time." Shortly after the Salon closed, the painting went straight to the rue de Fleurus, where it was hung high in Gertrude and Leo's studio—in the same room as a recently acquired large Picasso, the 1906 *Boy Leading a Horse*.

Leo's high opinion of *Le Bonheur de vivre* must have vexed Picasso, who had to concede that it was bolder and more "advanced" than anything he was working on, and that it used color in a way that was quite beyond his gifts as a colorist. The sensation Matisse's painting created made it all the more difficult for Picasso to bring the portrait of Gertrude to a satisfactory conclusion. Clearly, he had wanted to make an impression with it, directly competing with *The Woman with the Hat*. But the unexpected boldness of *Le Bonheur de vivre* changed the terms of the encounter. Not long after Picasso saw Matisse's new painting, he expunged the face in the portrait and told Gertrude, "I can't see you any longer when I look." When he left to spend the summer in Gosol, a Catalonian hill town north of Barcelona, the portrait was left unfinished.

IF THE RELATIONSHIP BETWEEN Matisse and Picasso would later become something like a game of chess, at this phase it was more like a boxing match—but one in which each combatant wanted to give the impression that he wasn't really engaged in a fight. Although there was already a keen sense of competition between them, both men found it convenient to play down that competitiveness and to emphasize their collegiality before the Steins. That May, when Leo wrote to Matisse to tell him that Ambroise Vollard had bought twenty-seven paintings from Picasso's studio and had paid a fairly good price (2,000 francs), thus enabling Picasso to feel at ease for the next few months, Leo assumed that Matisse (who had sold 2,200 francs' worth of pictures to Vollard only a couple of weeks earlier) would be pleased by Picasso's success. And very likely Matisse was, since he still saw Picasso as if he were a somewhat troublesome but gifted and charming younger brother.

While in Gosol, Picasso thought about how he could respond to Matisse's latest move, and how he could better infuse his paintings with

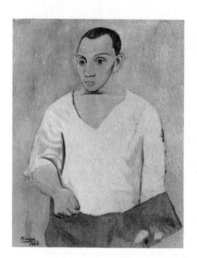

FIGURE 3.3
Picasso, *Self-Portrait with a Palette,* 1906. 92 x 73 cm.

the sense of gravity he had come to admire so deeply in Cézanne. He began to exaggerate the sculptural and archaic manner he had initiated in the spring, inspired partly by his experiences with medieval Catalan art and with the rustic people in Gosol, and partly by the ancient Iberian sculptures from Osuna he had seen at the Louvre that spring. Over the course of the summer, the forms in Picasso's paintings became more austere, more stonelike, more sculptural. Some of the anecdotal quality of his earlier work remained, but his paintings became more ambiguous and less overtly narrative. It was at Gosol that he did the severe *Self-Portrait with a Palette* (Fig. 3.3), in which color is not so much reduced as refused. The only note of lively color is that on his palette, as if to imply a process that is the opposite of Matisse's: that of mixing bright colors such as reds down into buffs and grays.

In this painting, Picasso looks older than he is, as if he wants to present himself as wiser and more reserved. His shorn head gives him an ascetic, monklike look, which is exaggerated by the emphasis on the bony area of the clavicle and by the closed and somewhat passive image

he presents. Although he holds a palette, he is not depicted at work; his right hand is tucked mutely into his waistband, and he seems to represent himself in the act of judging rather than painting. He is not looking at himself in a mirror or at the viewer, but off into space, as if trying to see himself in the third person—from a position outside himself. He represents himself with the modesty of a workman. The palette that serves as an emblem of his calling is held with so little sense of drama or creative pretension that it might almost be a plasterer's trowel.

Picasso's sober self-portrait makes a striking contrast with the one Matisse did that same summer (Fig. 3.4). When the two paintings are hung side by side, the energy projected by the Matisse painting is far stronger than that of the Picasso. Matisse's face fills a large part of the picture space, and he stares out at the viewer with unflinching intensity, his defiance tinged by a hint of defensiveness. (A sheet of studies he did for this painting shows how hard he worked to create this effect.) He is not wearing his eyeglasses, and his boat-neck striped sailor shirt—the same kind of shirt Picasso frequently wore in later years—falls partly off his shoulder, giving him an insouciant, almost jaunty air. There is something both romantic and appraising about the evenness of his gaze and about the firmness

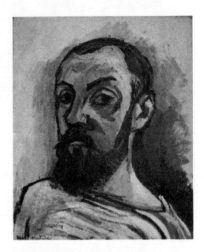

FIGURE 3.4 Matisse, *Self-Portrait,* 1906. 55 x 46 cm.

with which his head occupies the rectangle of the canvas and fills the solid space behind it, carved out as if with a chisel. The painting is at once Matisse's most painterly and most sculptural self-portrait, modeled in a coloristic way that recalls the most dynamic aspects of Cézanne's mature style. The layering of the forms and brushstrokes reveals so much of the process of its making that the creative act of painting captures almost as much of our attention as the face it represents.

The sheer energy of the Matisse self-portrait, which Picasso saw shortly after he had finished the portrait of Gertrude Stein, undoubtedly presented the younger artist with a major challenge; Michael and Sarah Stein purchased the painting and hung it in their apartment on the rue Madame, where Picasso would see it every time he came to dinner.

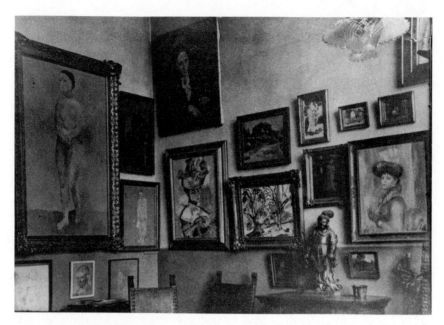

FIGURE 3.5 Studio of Leo and Gertrude Stein, c. 1906

PICASSO'S RESOLUTION OF THE Gertrude Stein portrait has come to symbolize an enduring theme of modern art—that of the artist backed to the wall by his need to find a new way to describe reality and discovering the solution within himself. When Picasso returned to Paris in August, he boldly repainted the face, working from memory, without his model, as if to emphasize his willfulness and his independence from the world of mere appearances. Gertrude was pleased by the portrait, which Picasso with uncharacteristic generosity offered as a gift. She brought it back to the rue de Fleurus and, in what can only be seen as a defiant gesture, hung it—still unframed—right above Matisse's *Woman with the Hat* (see Fig. 3.5). A number of her friends were shocked by the severity of the face and said it did not look like her. "Never mind," Picasso rejoined, "in the end she will manage to look just like it." And so she did: Over the years, the portrait came to define her artistic personality as well as her outward appearance.

Picasso's portrait of Stein embodies two very different styles: the Cézanne-like handling of the drapery and background, and the rougher, more archaic-looking modeling of the face and hands. This painting marks an important stage in Picasso's evolution, for in it he begins to make expressive use of stylistic conflict within a single work—and to do so in a very different way from Matisse. The "archaic" style in which

Stein's face is rendered, in contrast to the elegantly graceful rendering of her dress, suggests the "primitive" and unconventional aspects of her forceful personality, and the ways her personality transcended the conventions of dress and decorum within which she was superficially contained. The disjunction between styles, which echoes—though still only faintly—the dissonant use of styles in Matisse's *Le Bonheur de vivre*, plays an important role in the meaning of the picture, for it suggests a division or tension within Stein herself—between the placid and composed nature of her exterior, as expressed in her clothing, and the willful tension in her hands and face. The masklike face conceals as much as it reveals. Or more accurately, it is meant to make us aware that it both conceals and reveals, and that what is mysterious and unknowable about this person is more powerfully present than what is evident and knowable. Our sense of the dichotomy between her inner and outer selves suggests that Picasso is not so much defining his subject for us as sharing his puzzlement about her.

In its matter-of-fact sobriety and its monochromatic heaviness, the Picasso portrait of Stein more closely parallels Gertrude's writing ambitions than any of the Matisses the Steins owned. For Gertrude herself, it must have represented a more realized version of the qualities she had initially liked in *The Woman with the Hat*, in which the face was also masklike and concealed more than it revealed, but in which the woman's vulnerability was emphasized. In Picasso's painting, the mask has been transformed into an image of determination and power that was much more in keeping with Gertrude's idea of herself and of what she wanted her own art to project. By placing what is so clearly meant to be understood as a painted mask over his naturalistic portrait, Picasso was creating a parallel to "the linguistic mask Stein was simultaneously devising for herself." This was especially true of her fictional Melanctha; Stein had rewritten her story for black characters in a way that anticipated Picasso's use of African masks in such works as *Les Demoiselles d'Avignon* (see Fig. 3.8). Stein's masklike countenance emphasizes the tension "between impersonality and individuality, between conventional representation and likeness," that both she and Picasso would explore throughout their careers.

———

IN THE FALL OF 1906, both Matisse and Picasso became very much preoccupied with primitive-looking imagery, though in different ways.

During the summer in Collioure, Matisse had alternated between Cézanne-like modeling and a flat, decorative, almost childlike style, as in the two versions of *The Young Sailor*. When he returned to Paris that fall, he was so uncertain about some of the works he had just done that he half-jokingly disavowed them, remarking to friends that his more primitivistic canvases had been created by the local postman.

The 1906 Salon d'Automne included a memorial exhibition for Gauguin, in which a substantial number of his primitivist wood-carvings and ceramic sculptures were shown along with his paintings. Both Matisse and Picasso were already interested in Gauguin, and after their summer experiences, the Gauguin exhibition was all the more provocative—especially since it was accompanied by a substantial selection of paintings by Cézanne, which provided the impulse for another kind of expressive distortion. In the wake of these exhibitions, Picasso was inspired to do a number of wood carvings, and Matisse, who had been creating sculptures in modeled clay, carved his only sculpture in wood. They were not, of course, alone in their enthusiasm for carving. Derain, one of the first French artists to become enthusiastic about Primitive art, also began to carve in wood and stone.

The story of how Matisse introduced Picasso to African sculpture has become famous. Since the previous spring, Matisse had been fascinated by the African objects he saw almost daily in the window of a curio shop on the rue de Rennes. He remembered being astonished by the sculptural language they employed, which he thought was similar to that in Egyptian art. "Compared to European sculpture," he said, "which always took its point of departure from musculature and started from the description of the object, these Negro statues were made in terms of their material, according to invented planes and proportions." One day he entered the shop and for fifty francs bought a small Congolese carving of a seated man with his hands raised to his mouth. He then went to Gertrude Stein's apartment: "I showed her the statue, then Picasso came by, and we chatted. That was when Picasso became aware of African sculpture."

Whereas Matisse remembered his main interest at the time as being in the imaginative reinvention of the planes and proportions of the human body, Picasso later remembered being struck by the demonic and magical qualities of African sculpture—although his initial response seems to have been closer to Matisse's. In the piece that Matisse showed Picasso, the "fetishistic" qualities of African art were not immediately apparent. Since we know that Picasso's "revelation" about African art came in the

spring of 1907, rather than in the fall of 1906, there were in fact two distinct phases in his appreciation of it—the first similar to Matisse's, the second altogether more original and violent. The first is reflected in paintings such as *Two Nudes* (Fig. 3.6), done in the fall of 1906, which emphasizes the massive structural qualities and compressed proportions of African sculpture, as well as a generally "primitive" subject. The blocky figures in this painting also evoke a fairly clear image of an undressed Gertrude Stein. The association of an Africanizing theme with Gertrude Stein, who had been working on her story about Melanctha, is not surprising, nor is the enigmatic doubling of the figure here, which suggests not only a split identity but also a lesbian relationship—a theme that fascinated Picasso, and one he had treated in a number of erotic drawings a few years earlier.

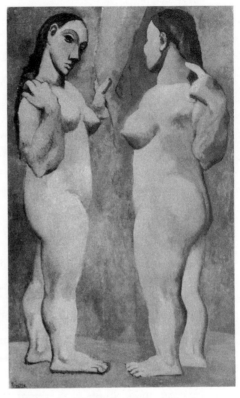

FIGURE 3.6 Picasso, *Two Nudes,* 1906. 151.3 x 93 cm.

In *Two Nudes*, the position of the two women in front of the partially open curtain is especially evocative. The gestures they make, the one clearly pulling back the vulvalike fold of the curtain, the other pointing to what is within that fold, are at once gestures of revelation and of hiding. They appear to be pointing to some kind of inner mystery, but their very physical presence blocks that mystery from our view.

The second phase of Picasso's response to Primitive art came the following spring when he visited the ethnographic museum at the Trocadéro, an experience he later described in powerful language. In contrast to the Post-Impressionists, who had looked outside the European tradition to Japanese art, Picasso—who did not care for Japanese prints—affirmed his love for "fetishes" and for African art. "For us it was the Negroes," he later told André Malraux. "Their forms had no more influence on me than they had on Matisse. Or on Derain. But for them the masks were just like any other kinds of sculpture. When Ma-

tisse showed me his first Negro head, he spoke to me about Eyptian art." Picasso then described in detail the second stage of his encounter with African art:

> When I went to the Trocadéro it was disgusting. The flea market. The smell. I was all alone. I wanted to get away. But I didn't leave. I stayed. I stayed. I understood something very important: something was happening to me, right?
>
> The masks weren't like other kinds of sculpture. Not at all. They were magical things. And why weren't the Egyptian or the Chaldean pieces? We hadn't realized it. Those were primitive [archaic], not magical things. The Negroes' sculptures were intercessors, I've known the French word ever since. Against everything; against unknown, threatening spirits. I kept looking at the fetishes. I understood: I too am against everything. I too think that everything is unknown, is the enemy! Everything! . . . I understood what the purpose of the sculpture was for the Negroes. Why sculpt like that and not some other way? . . . But all the fetishes were used for the same thing. They were weapons. To help people stop being dominated by spirits, to become independent. Tools. If we give form to the spirits, we become independent of them. The spirits, the unconscious (which wasn't yet much spoken of then), emotion, it's the same thing. I understood why I was a painter. All alone in that awful museum, with the masks, the redskin dolls, the dusty mannequins. *Les Demoiselles d'Avignon* must have come to me that day, but not at all because of the forms: but because it was my first canvas of exorcism—yes, absolutely!

—

IN ADDITION TO PICASSO'S SPRING 1907 visit to the Trocadéro and his exposure to African sculpture the previous fall when Matisse showed him the piece at Gertrude Stein's, another factor precipitated his renewed and transformed interest in such art. That catalyst was Matisse's *Blue Nude* (Fig. 3.7).

Blue Nude was shown at the 1907 Salon des Indépendants, and like *Le Bonheur de vivre* the year before, it was the only painting Matisse sent to the exhibition. The image of the woman in *Blue Nude* is based on the reclining Dream-of-Desire woman with the raised arm at the center of *Le Bonheur de vivre*, and as if to emphasize this continuity, Matisse titled it simply *Tableau No. III*, placing it within what he saw

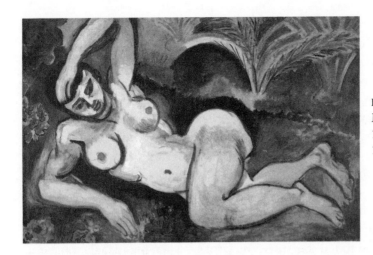

FIGURE 3.7
Matisse, *Blue Nude*,
1907. 92.1 x
140.4 cm.

as a sequence of imagined pastoral images. But this painting, even more than *Le Bonheur*, was a direct attack on the tradition to which it belonged. Although it nominally depicts a favorite academic subject, it is among other things a violent reaction to academic nudes—and in its roughness and coarseness, it is also a reaction against Ingres, whose *Grande Odalisque* had been shown along with Manet's *Olympia* at the Louvre the previous year. Even more important, with its Cézanne-like blue tonality and its willed awkwardness, *Blue Nude* is both an homage and a powerful response to Cézanne, who had died the previous November.

But the most striking feature of *Blue Nude* is its aggressive ugliness and the way that ugliness is employed to stand for primal authenticity. This notion is reinforced by the vigorous paint application, the rough modeling, and the abrupt transitions—similar to those that both Matisse and Picasso admired in African sculpture. The upper and lower parts of the woman's torso are turned so extremely in relation to each other that they appear to belong to different figures. The upper part of the body is seen as if from eye level, full front; the lower part as if she were turned on her belly and seen from above. What unifies the image, in addition to the continuous rhymes between the curves of the woman's body and the landscape around her, is the way the forms of her body literally radiate into the surrounding landscape. The figure in *Blue Nude* is seen from neither a single viewpoint nor a fixed place, and she imparts a greater symbolic charge to the space around her than any of Matisse's previous figures. It is as if the rootlike form of the woman, at once contained by and bursting from the confines of the earth, has caused the forms around her to burgeon into existence. The woman is

symbolic of the primitive intensity and violence of the land Matisse sensed when he visited the Algerian oasis at Biskra the previous spring, and is a convincing metaphor for dynamic growth—a kind of modern African Venus.

The rough handling of the paint and the uningratiating ugliness of the figure, coupled with its masculine head and shoulders (reminiscent of the sexual ambiguity of Cézanne's *Bathers* and Michelangelo's Medici tomb figures), made a deep impression on Gertrude and Leo Stein, who bought the painting. Gertrude enjoyed the shock effect it had on their visitors and recalled with relish how the five-year-old son of their concierge had jumped into her arms when he first saw it and "cried out in rapture, oh là là what a beautiful body of a woman." Gertrude liked to tell this story, she wrote, "when the casual stranger in the aggressive way of the casual stranger said, looking at this picture, and what is that supposed to represent."

Blue Nude posed an important challenge to Picasso. During the previous few months, he had been working with archaic and primitive forms as a way of trying to reconcile Ingres's linearity with Cézanne's monumental solidity. The aggressive handling of form in *Blue Nude* almost mocked that endeavor, and in any case made it seem quite beside the point. The aspect of Cézanne's work that Picasso best understood then was the extraordinary plasticity of Cézanne's middle period. Matisse, on the other hand, was already experimenting with Cézannesque fragmentation of form and a conception of pictorial space in which things are conceived not so much as solid entities but as abstract forces. This was the most radical aspect of Cézanne's late style and the one that would have the most profound effect on later twentieth-century painting. But it was grasped by relatively few artists at this time—Matisse foremost among them. Like Cézanne's late paintings, *Blue Nude* is rendered in a fluidly transparent way, yet the forms seem solidly modeled. This paradoxical combination gives the picture space a strong sense of unity and also a great feeling of tension. *Blue Nude*, with its combination of extreme distortion, fluid pictorial space, and strong plasticity, pointed the way toward a new synthesis: between Cézanne and African sculpture.

Blue Nude also was an extremely powerful response to the gender ambiguity apparent in so many of Picasso's figures during the previous few months—inspired in part by his friendship with Gertrude Stein—and that had been a key aspect of the Stein portrait and of paintings such as *Two Nudes*. In *Blue Nude*, Matisse seemed to be outdoing Pi-

casso on his own territory. And since, despite its subtle use of color, the painting was not especially coloristic, its chromatic restraint seemed to be challenging Picasso in the area of his greatest strength. But it was precisely this reduction of color that afforded Picasso a way to move into the world of its innovations. Once he had seen *Blue Nude,* the idea of competing directly with Matisse in terms of the style of *Le Bonheur de vivre* no longer seemed interesting or relevant, either to his rivalry with Matisse or to his sense of his own artistic destiny.

If, as Picasso said, *Les Demoiselles d'Avignon* resulted from his encounter with African sculpture at the Trocadéro, that was possible because Matisse's *Blue Nude* had shown how the insights provided by African sculpture could be combined with the innovations of Cézanne. And *Blue Nude* did so, moreover, in a domain where Picasso was temperamentally better suited than Matisse to pursue this new concept to its limits. In commenting on Matisse's paintings in 1907, the critic Michel Puy noted that "Their harmonies no longer sing, they roar; they don't caress you, they jump at your throat." At a time when sheer aggressiveness was being so highly valued in the new art, Picasso was incited to plumb the considerable violence within his own temperament.

DURING THE SPRING OF 1907, Picasso was in a state of great agitation, working on the painting he had conceived as a response to Matisse. That painting, which Picasso's friends first called "The Philosophical Brothel" and which eventually was entitled *Les Demoiselles d'Avignon* (Fig. 3.8), is not only one of the great milestones of modern painting but one of the most remarkably violent pictures of the twentieth century.

Picasso started *Les Demoiselles d'Avignon* as one of a series of brothel scenes, in which its most notable predecessor was *The Harem,* painted during the summer of 1906 as a response to Ingres's *Turkish Bath. The Harem* features a prominent male figure in the form of a eunuch sitting next to a specifically Spanish still life composed of sausage, bread, and an amusingly phallic *porrón* of wine. In *Les Demoiselles d'Avignon,* by contrast, the distant and exotic harem is transposed into a contemporary brothel, and the only oriental echo that remains is the slice of melon, which is as sharp and menacing as the blade of a scimitar.

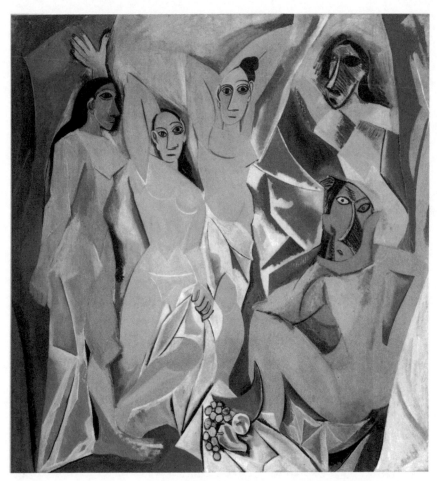

FIGURE 3.8 Picasso, *Les Demoiselles d'Avignon,* 1907. 243.9 x 233.7 cm.

As evidenced in the numerous early studies Picasso did for *Les Demoiselles d'Avignon,* he originally meant to include two male figures. In a crayon drawing rendered in a lyrically Cézannesque fashion, the setting is relatively friendly: A plate of melon slices rests on the table, and a pitcher filled with flowers is placed in the foreground. A man holding a book (usually identified as "a medical student") is seen entering from the left; a second male figure (called "the sailor") is seated at the table among the five prostitutes, holding what is apparently a skull. This skull, which appears in a number of other studies, marks the brothel as a place fraught with danger—in the form of disease and violence and in the hazards of sex itself.

In its early stages, the large painting was rendered in the suave linear style that is evident in the second and third figures from the left; these are

sometimes referred to as the "Iberian" women, because they recall the archaic, simplified look of figures that were inspired by Picasso's interest in early Iberian sculpture. The other three figures were probably repainted in June 1907, after Picasso had studied the African sculptures in the Trocadéro museum. These women are sometimes referred to as the "African" figures, and they are much more aggressively rendered than the others: The paint is literally slashed onto the canvas. It is understandable why Picasso later remembered this as his first canvas of "exorcism."

But exorcism of what? At the time, Picasso and Fernande were having difficulties and in fact separated for several months later that year. Fernande's first instinct amid such tension was to punish her lover by sleeping with someone else; given Picasso's wild jealousy, this would have caused him great pain. But it should be kept in mind that the need for exorcism went far deeper than the surface events of Picasso's life at the time and was related to his profoundly fraught and complicated feelings about women generally. Raised by a doting mother in a household full of doting women—numerous aunts and a succession of maids—his attitudes toward women alternated between misogyny and tenderness, an "insatiable need for their love and attention" and a "sometimes heartless manipulation of them." Picasso himself would later characterize women as "goddesses and doormats." And his ambivalence toward women informs virtually every aspect of this painting, from its nominal subject to its conflict between styles. In this painting he compounds and attempts to exorcize a number of deep-seated fears that he associated with women and with sex—fear of being too completely possessed by love, of venereal disease, of castration, and of death.

———

IN THE FINAL PAINTING, the male figures have been eliminated, and the subject has been changed in drastic fashion. The viewer is put clearly in the position of a client in a brothel, for whom the women are displaying themselves and among whom he will eventually be urged to make a choice. The direct inclusion of the viewer within the psychological framework of the painting, and the surprising aggressiveness of the women, clearly recall Manet's *Olympia*, which Picasso had seen at the 1905 Salon d'Automne and then again at the beginning of 1907, when it was hung next to Ingres's *Grande Odalisque*. In *Les Demoiselles*, the skull and book that were in the study have been eliminated, but the sense of danger clearly persists in the bladelike melon included

in the still life at the bottom of the painting—which, given its cramped, cavelike space, suggests an overriding metaphor of a *vagina dentata* (an image that would reemerge in Picasso's fiercely toothed women of the 1920s and 1930s). How unlike Matisse's renderings of plant forms are the objects in this still life! Whereas *Le Bonheur de vivre* is almost purely vegetal in nature—even the figures are held in the sway of the undulating arabesques—*Les Demoiselles d'Avignon* seethes with animal energy. But at the same time, there is also something dehumanized about Picasso's figures. This is in part because of the violent way in which they are rendered, and in part because of the way the forms around them are fractured, almost like shattered glass. The very structure of the painting is full of angular menace.

<center>⎯⎯⎯⎯⎯</center>

ALTHOUGH *LES DEMOISELLES D'AVIGNON* initiates a general shift away from narrative subjects in Picasso's painting during his Cubist years, strong elements of narrative still remain in it. Taken literally, the viewer is placed in the position of a customer in a brothel, being offered the choice of one of these five women—who represent varied attitudes toward the viewer, ranging from enticement to indifference to frightening aggressiveness. Two of the women appear to be returning from encounters with other clients and seem hardly to notice us: The woman on the left raises a curtain with her left hand as she enters the room, stately as an Egyptian goddess; the scarified African woman at the upper right is also just coming into the room, and her raised arms also push back a curtain (in a gesture reminiscent of *Two Nudes*). The two figures with the so-called Iberian faces offer themselves to us in an elegantly detached, professional way (their faces are also rather Matissian, and the one with the raised arms directly echoes the pose of one of the main figures in *Le Bonheur de vivre*). The face of the woman seated at the lower right, by contrast, is a grotesque mask, set on a twisted neck, that glares back at us with monstrous intensity. Her pose recalls similar squatting figures in Cézanne's Bather paintings—and specifically in the *Three Bathers* that Matisse owned. It is not entirely clear whether this figure is supposed to be seated on a cushion or on a bidet, but there is a strong suggestion of the latter. In any case, she demonstrates Picasso's compulsion to parody as well as pay homage to the masters who meant most to him. Giving this Cézannesque woman the most grotesque face in the painting and placing her on what can be taken for a bidet was a

way for Picasso to thumb his nose at both Cézanne and Matisse—or in any case, at Matisse's conception of Cézanne. Typically, in absorbing the work of a strong predecessor, Picasso has not only willfully "misread" it but also actively attacked it.

The "unresolved" stylistic differences within the painting play a crucial role in its subject. The painting presents us not only with a range of styles but also with a range of female assertiveness, running from the coolly passive to the heatedly aggressive. These contrasts are especially appropriate to the overt subject of the painting: facing a choice which entails a range of experiences that could run from simply buying and "consuming" the chosen woman to being threatened, perhaps even destroyed, by her—as suggested by the grotesquely masked woman at the lower right, who resists our gaze and our domination and who, by pointing to a deep sense of threat, upsets both our social expectations of the subject and our stylistic expectations about the way it is represented. If *Les Demoiselles d'Avignon* remains to some degree "unfinished" or "unresolved," it is not only because it combines polar opposites within Picasso's private mythology—virgin and whore, noble savage and menacing cannibal. It is also unresolved because its very structure implies a kind of artistic and cultural impasse: Which woman to choose, which culture to choose, which style to choose? Even, in a sense, which Africa to choose?

Matisse's version of African art was related to the benevolent image of the French African colonies, such as the Ivory Coast, where the Africans were supposed to embody a surviving instance of the noble savage. This precivilized state of humanity symbolized childlike innocence and spiritual reverence, and its naturalness and authenticity were set in refreshing contrast to the decadent West. But Africa also presented directly opposite connotations, as the continent of human sacrifice, witchcraft, and repellent, mysterious rites and practices. Africa, like primitivism itself, was conceived as being both attractive and repellent, beautiful and grotesque. In *Les Demoiselles d'Avignon*, Picasso plays these tensions against each other in a powerful and moving way.

※

LES DEMOISELLES D'AVIGNON is also a ferocious critique of Matisse's *Le Bonheur de vivre*, which for the past year Picasso had seen every time he visited Leo and Gertrude Stein's apartment. Although by 1907 the rough and overtly primitivistic style of Matisse's *Blue Nude*

was more immediately provocative and inspiring to him than the flat and brightly colored *Bonheur de vivre*, the ambitious subject matter and sheer size of *Le Bonheur de vivre* offered the most visible target for Picasso's competitive spirit. In *Les Demoiselles*, Picasso seems quite literally to deconstruct *Le Bonheur*, in almost every way possible: *Le Bonheur* is curvilinear, exuberant, and brightly colored; *Les Demoiselles* is angular, harsh, and monochromatic. Matisse's large picture presents a rather innocent erotic reverie in a bucolic setting and is a celebration of life's pleasures; Picasso's even larger picture is a violent depiction of the harsh realities of a modern urban brothel and suggests a confrontation with sexual trauma and death. Matisse's painting had in a way thumbed its nose at the grand tradition; Picasso's picture in effect declares that tradition—and Matisse's painting—to be irrelevant, even frivolous. The critics had accused Matisse of having gone too far; Picasso implies that he had not gone far enough.

A conversation Picasso had at the rue de Fleurus with the American artist and critic Walter Pach in the fall of 1907 casts interesting light on Picasso's feelings about *Le Bonheur de vivre*.

"Does that interest you?" Picasso asked Pach as they were standing before the painting.

Pach, who at the time didn't much like Matisse's work, responded that it did, but in an odd way: "It interests me like a blow between the eyes," he said. "I don't understand what he is thinking."

"Neither do I," Picasso replied. "If he wants to make a woman, let him make a woman. If he wants to make a design, let him make a design. This is between the two."

This criticism of Matisse's picture goes straight to its principal weakness. And now that Picasso had painted *Les Demoiselles d'Avignon*, he could speak freely about how much its highly stylized artificiality annoyed him. Now it was he who could claim the greater authenticity of feeling and the greater sense of being "modern." He had good reason to believe that he was at last getting the upper hand.

IN ITS MIXTURE OF STYLES and degrees of finish, in its aggressive handling of the paint and abstract fragmentation of the figures and the picture space, *Les Demoiselles d'Avignon* quite literally created a revolution in European painting. Because of its fractured planes, it is sometimes referred to as the first Cubist painting, a historical reading that is

frequently contested—despite the fact that the painting is found at the beginning of virtually all histories of Cubism. The confusion is perhaps because the painting defies categories—and was meant to do so. It was conceived of as a self-consciously monstrous painting—so much so that Picasso himself didn't quite know what to do with it. It remained in his studio, unexhibited, for nearly ten years, and for much of that time he was probably not even sure whether it was finished.

Because *Les Demoiselles d'Avignon* was painted in direct competition with Matisse, against the large and elaborate format of *Le Bonheur de vivre* and in response to the "savagery" of *Blue Nude*, it is no mere coincidence that the style Picasso developed at this time was deemed anti-Matissian. It was marked by a severe reduction of color and a strict avoidance of the organic curves and comforting sensuality that were associated with the older painter. In *Les Demoiselles*, Picasso set out to stake his claim to radical originality and preeminence within the avant-garde. While at work on *Les Demoiselles* and for several months afterward, Picasso created an extraordinarily violent series of Africanized nudes, in which the paint is also dashed onto the canvas, and in which an urgent need for exorcism is strongly felt.

Within the context of this first phase of the two artists' rivalry, Picasso's new paintings constituted a remarkable counterattack. Although some of his supporters were put off by what they saw as the outrageous violence of his new work, he could no longer be regarded simply as the talented young Spaniard who was bringing up the rear guard behind Matisse. When the Russian collector Sergei Shchukin (who was introduced to Picasso by Matisse) first saw *Les Demoiselles*, he lamented, "What a loss for French art!" But shortly afterward, he was collecting Picasso as avidly as he was Matisse.

Nowhere was this shift in taste more apparent than in the response of Leo and Gertrude Stein. Although they had been impressed by the aggressive ugliness and radical Cézannesque tone of *Blue Nude*, it turned out to be the last Matisse they would purchase. That fall, they bought Picasso's extremely violent *Nude with Drapery*, which directly quoted (and seemed to parody) the pose in *Blue Nude*—but translated into a standing figure. With barbed wit, Picasso referred to this painting as *"mon nu couché"* (my reclining nude), as if to emphasize its connection with the now overshadowed Matisse. In a gesture that must have rubbed salt into Matisse's wound, the Steins also bought a sketchbook of related drawings from Picasso, some of which Leo had mounted on canvas and framed.

4

NIGHT AND DAY

*You've got to be able to picture side by side everything
Matisse and I were doing at that time. No one has
ever looked at Matisse's painting more carefully than I;
and no one has looked at mine more carefully than he.*

— PABLO PICASSO

Picasso decided not to show *Les Demoiselles d'Avignon* publicly be-
cause he was not sure it was finished, and it was forcing him to re-
think his whole notion of what a painting was. He was reconsidering
what constituted a finished picture, what the function of representation
was, and where its limits lay. For the first time, he was directly engaged
with the way the arbitrariness of representation could serve as an ex-
pressive, even philosophical, element in painting.

He did, however, show *Les Demoiselles* to people in his studio, and
even his friends were taken aback by it. Some considered it a sign of
madness. Derain is supposed to have told Daniel-Henry Kahnweiler,
soon to become Picasso's main dealer, that he was afraid Picasso
would one day be found hanging behind his picture. Kahnweiler, who
saw the picture in the early fall of 1907, felt it was a "failure," an un-
finished and unrealized attempt at something that Picasso had been
unable to fully execute.

Another among Picasso's close band of friends, André Salmon, re-
membered that some of Picasso's painter colleagues were "now giving
him a wide berth.... Picasso, somewhat deserted, found his true self in
the company of the African soothsayers ... and painted several formi-
dable grimacing nudes, worthy objects of execration."

Guillaume Apollinaire was silent about the picture, at least in pub-
lic. But in a notebook entry written just after Picasso had begun the

painting, he observed that Picasso's new work contained a "wonderful language that no literature can express, for our words are made in advance. Alas!" When Apollinaire took Georges Braque to see it, the latter told Picasso, "With your painting, it's as if you wanted us to eat tow or drink kerosene," like a fire-spitter in a fairground. Within a few months, though, Braque himself would be trying to spit fire, and not long afterward he began his own response to *Les Demoiselles*—his *Large Nude*, which was based on a combination of Picasso's figures and Matisse's *Blue Nude*.

Leo and Gertrude Stein had seen *Les Demoiselles* in its early stages that spring, but they were unprepared for the reworked version they saw in October, along with a number of other paintings that were in the studio, including the recently begun *Three Women*, which they would eventually acquire. Gertrude, who thought of her writing as related in form to Picasso's endeavor, nonetheless had difficulty with the new version, which she described (through the eyes of Alice Toklas) as "an enormous picture, a strange picture of light and dark colours, that is all I can say, of a group, an enormous group and next to it another in a sort of red brown, of three women, square and posturing, all of it rather frightening." Leo, who would never follow Picasso far into Cubism, felt that *Les Demoiselles* was a "horrible mess." He felt similarly about *Three Women*, and evidently burst out laughing when he came to see it along with Matisse, exclaiming, "but that's the fourth dimension!" Matisse, who did not see *Les Demoiselles* and *Three Women* until the fall, is also said to have laughed—although this seems highly unlikely. According to Fernande Olivier, Matisse swore to "get" Picasso, an accusation that has been repeated countless times but never been proved. It is more likely that Picasso, sensing Matisse's antagonism, imagined his rival reacting just as he would have. In fact, it was Picasso who at the time was out to "get" Matisse. His band of friends, led by Apollinaire, roamed around Montmartre scrawling graffiti on the walls that echoed government warnings about alcohol: *Matisse induces madness! Matisse has done more harm than war! Matisse is more dangerous than alcohol!*

Whatever Matisse did or didn't say, he was clearly shaken by the picture, which was a direct assault on his whole sense of values—and on the position of leadership that he had worked so hard to attain. He had at least three good reasons to be unsettled by *Les Demoiselles*: It was a very radical interpretation of Cézanne; it took the inventive aspects of African art so much further than he himself was willing to go; and it was so violent. In painting *Le Bonheur de vivre* and *Blue Nude*, Ma-

tisse was near his limit in the domain of aggressive ugliness. Beyond a certain point, his natural reserve and his deep inner disquiet would not let him go. The kinds of feelings Picasso was exploring in *Les Demoiselles* frightened Matisse. He felt them in himself, but his way of dealing with them was to try to sublimate them—to feed off the energy they generated but not to risk giving them free rein. For the first time, Matisse had to acknowledge that Picasso was much less inhibited than he was—that he was up against an adversary who didn't mind acting like a criminal or an outlaw.

Furthermore, the picture touched a deep nerve in people. This, too, was not lost on Matisse, who knew from experience that the public's negative reactions to new art were often directly related to the potency of the truth the art contained. No one knew better than Matisse that the most serious painting of a given moment would necessarily be at odds with the conscious ideas of the public. And no one who saw *Les Demoiselles* was indifferent to it. After initial reactions of horror at its ugliness, a number of artists were inspired to try to imitate it, though somewhat tamely. As Picasso told Gertrude Stein, the person who creates a thing "is forced to make it ugly" by the very intensity of the struggle to create and because he doesn't yet know what he is going to create, whereas "those who follow can make of this thing a beautiful thing because they know what they are doing, the thing having already been invented."

PICASSO NOT ONLY HAD INVENTED a radically original pictorial structure, but also had connected with a deep fault line within the culture as a whole—one that mixed sexuality, violence, and misogyny in a way that seemed to anticipate the intense struggle between the sexes and the explosive physical violence of the century that was to follow. As Baudelaire had noted in his celebrated essay "The Painter of Modern Life," the prostitute was "a perfect image of savagery" in the midst of modern society because she had the "kind of beauty which comes to her from sin." According to Baudelaire, it was within the "foggy chaos" of the brothel that a certain kind of deep truth could be realized. That was where, "bathed in golden light, undreamed of by indigent chastity, gruesome nymphs and living dolls, whose childlike eyes have sinister flashes, move and contort themselves."

LES DEMOISELLES D'AVIGNON is a nighttime painting, literally set in night town and addressing the dark underbelly of civilization itself— a kind of *malheur de vivre*. It sets the idea of order, implied by its almost classical geometric structure, against the explosive, fragmentary qualities of the dark energies it addresses. And if it has achieved legendary status as an icon of "modernity," and even as being symptomatic of the extreme violence and disruption of the coming century, it is because Picasso was able to use his own psychological tensions as a lightning rod for a deep historical and cultural malaise. Picasso had already conceived in nascent form one of his most important ideas: that the things of the world could be endlessly recombined and reinvented. Related to this was his perception that pictorial disharmony and the destruction of the human image would best capture the spirit of the new century. Matisse would never become reconciled to the idea of radically linking destruction with creation and violence with modernity.

James Joyce, another master of the night, nicely described the situation: "If we are to paint the twilight of the human personality we must darken the landscape. . . . but the hidden or subconscious world is the most exciting and the modern writer is far more interested in the potential than the actual—in the unexplored and hallucinatory, even, than in the well-trodden romantic or classical world."

PICASSO WORKED BY NIGHT, Matisse by day. This pattern, which each man maintained throughout most of his life, reflects essential aspects of their being. Picasso reveled in the darkness he sensed within himself, and he was fascinated by the abyss. Matisse, who was also constantly tormented by anxiety, sought light as an antidote to the darkness within himself and had a horror of the abyss.

Their diurnal and nocturnal habits had a practical basis, too. A painter who works perceptually and who is a colorist needs natural light, whereas one who works from imagination and thinks primarily in terms of line and tone can work more easily by artificial light, and might find the surrounding darkness more conducive to his thought. The Faustian dimension of Picasso's undertaking has been understood as closely related to his nocturnal habits, his "habit of shutting himself up in his studio for hours and hours on end (the hours of the night)."

These two ways of working also implied a focus on different aspects of experience. Matisse, working during the day, constantly confronted

the visible world and struggled to wrest meaning from the bland and often banal appearances of everyday things. He lacked imagination in the literary sense, and his visual imagination needed the stimulation of real things. Picasso, by contrast, worked almost entirely from imagination and memory—and not infrequently from photographs. (In fact, though neither artist spoke much about it, both relied rather heavily on photographs at this time, as a source for motifs and as a way of setting up norms that could be used as points of departure for their innovative reinventions of the world.) Picasso had an extraordinary graphic imagination and was able to create compelling visual narratives. He always had an enormous gift as an illustrator, a talent Matisse lacked almost entirely.

Matisse cultivated a sense of clarity and wanted his art to have a calming effect. The bright colors and the decorative motifs were part of a strategy for distancing his art from his inner turmoil. Simply in terms of color, there is a strong sense of daylight in Matisse's painting in the years before World War I, whereas Picasso's muted, near-monochromatic works appear lit almost by candlelight. This is a predisposition Picasso had from his earliest work. During the time he worked at the Bateau-Lavoir, Picasso would often show his paintings to visitors by candlelight. When they first got to know Picasso, both Salmon and Apollinaire were impressed by how the flickering light enhanced the mystical quality of his pictures. "In order to show us the numerous canvases that were stacked here and there, or hung high on the wall," Salmon remembered, "Picasso lit a candle which he held at arm's length in front of each picture. . . . Without saying a word, Picasso followed the curve of our emotion, the movement of the acrid pleasure that Apollinaire and I shared."

The experience of seeing Picasso's paintings in such light understandably led Apollinaire to emphasize their deep sense of mystery and their "heavy somber lights, like those of grottoes." This is an element that would persist in Picasso's work as a profound part of his aesthetic. His Cubist paintings also create a tremulous, flickering effect, so that even when seen in full light they have some of the mysterious fluctuating quality produced by candlelight. (This contrast between the two artists lasted to the end of their lives. Matisse's Chapel of the Rosary in Vence, consecrated in 1951, is literally awash in sunlight. In 1952, Picasso started the paintings for his Chapel of Peace in Vallouris, of which he said, "There's not much light in this chapel, and I don't want it lit. Let the visitors take a candle and walk round the walls as if they

were in prehistoric caves, picking out the figures, with the light flickering over my paintings, just a tiny candle flame.")

⸻

PICASSO ADDRESSED THEMES of sexuality and sexual violence more directly, more fully, and more compulsively than any other important modern artist—perhaps more than any other artist in history. From his earliest years he had painted a number of erotic pictures. Many of them have a tough, cynical edge that comes from the milieu of brothels and the world of chance sexual encounters, as in his drawing of a fat client being fellated by a prostitute. But many are quite tender, such as the pictures of couples making love, or the lovely watercolor of a woman standing in front of a bidet full of water stained by menstrual blood—a virtually taboo subject, for which there are few if any precedents. Several of his early erotic works also have a strong sense of curiosity, an almost adolescent fascination with the look and functions of the intimate parts of the female body. The most arresting feature of these works is their specificity of detail, the loving care given to the precise form of a woman's vagina, or the exact weight and curve of her thigh. If there is a Faustian element in his work, there is also a strong element of the Don Juan, the man driven by a hunger to experience every woman possible. An insatiable thirst for love, one might say, but also an insatiable desire to see, to experience, to decipher the mystery of Woman. So strong were Picasso's hunger and need that Max Jacob said he thought Picasso would rather be Don Juan than a great artist. An exaggeration, surely, but one that points to a deep truth. And Don Juanism is itself a complex notion—and was especially so in the twentieth century, when spirituality became increasingly confused and even conflated with profane love, and when sex became a mode of quasi-religious worship. In such a context, even Don Juan could be seen not as the "profaner of love, but the hero of profane love."

⸻

IN THIS REGARD THERE ARE many direct parallels between Picasso and Guillaume Apollinaire, a man known for his gargantuan appetites—for food as well as for sex—and who was a voracious womanizer, sadomasochist, and devotee of flagellation. Apollinaire, arguably the best poet of his generation, also became an influential art critic, and he played

an important role in the fortunes of both Picasso and Matisse. In fact, his relative evaluations of the two artists—and his partiality for Picasso—affected the ways in which their reputations were eventually built.

Like Picasso, Apollinaire was an outsider. Born in Rome a year earlier than Picasso, he was the bastard son of Angélique Kostrowitsky, a Polish adventurer who liked to call herself a countess. Until 1901 he went by the name Wilhelm Apollinares de Kostrowitzky, which he gallicized when he began to write regularly for literary and artistic reviews. Apollinaire had a deep love for Picasso, and when they first met he haunted Picasso's studio, stopping by almost daily. Although Apollinaire at five feet, five inches was not much taller than Picasso (five feet, two inches), his bulk and his large, pear-shaped head made him seem so, and in contemporary accounts he is described as projecting an enormous sense of physical presence.

The two men saw themselves as uniquely gifted and having a unique affinity. This is apparent in Apollinaire's first essays on Picasso, written as reviews of his 1905 exhibition at the Galeries Serrusier. Although the exhibition ran for only a couple of weeks, it was reviewed twice by Apollinaire, whom Picasso had met just a few weeks before the show opened. In the first essay, Apollinaire asserted that Picasso's "incontestable talent appears to be in the service of a fantasy which nicely mixes the delicious and the horrible, the abject and the delicate." Such paradoxical opposites, as between naturalism and mysticism, and sinfulness and piety, run through Apollinaire's brief article—reflecting traits that Apollinaire appreciated in Picasso's work and that were also characteristic of his own writing.

Picasso and Apollinaire shared similar artistic ambitions and sometimes directly inspired each other's work. In particular, Picasso would serve as the model for the artist called L'Oiseau de Benin, the main character in *Le Poète assassiné*. In that book, as in much of his prose fiction, Apollinaire moves up and back from a tone of high seriousness to one of violent satire—a change of voice and mood that has much in common with Picasso's violent stylistic disjunctions. Parts of the book are directly autobiographical. Croniamantal, the poet in the title, is obviously a stand-in for Apollinaire, and the description of his first visit to the painter's studio in Montmartre reflects Apollinaire's first visit to the Bateau-Lavoir—and his first encounter with Picasso's painting—at the beginning of 1905.

In his second article about Picasso, Apollinaire waxes lyrical about the man as well as the work and compares the artist's eyes to "flowers

that always want to contemplate the sun." In *Le Poète assassiné*, Apollinaire would write in similar terms about himself: "I am Croniamantal, the greatest of living poets. I have often looked God directly in the face. I have withstood the divine force that tempered my human eyes. I have lived in eternity."

———

WITH MATISSE, APOLLINAIRE'S relationship was very different. Eleven years separated them in age, and although Matisse's early work was pictorially engaging, it had no literary interest—and Apollinaire's early taste in art was basically literary. The relationship was complicated by the fact that Apollinaire had been introduced to Matisse by the poet and philosopher Mécislas Golberg, who had a great influence on the development of avant-garde thought in the early twentieth century and whose ideas were later appropriated by Apollinaire without due credit. In 1907, Golberg arranged for Apollinaire to interview Matisse in order to write an article for his publication, *Cahiers de Mécislas Golberg*, but Apollinaire apparently was somewhat reluctant to go ahead with the project, very likely because of his friendship with Picasso at a time when the rivalry between the two artists was becoming especially heated. Golberg, terminally ill with tuberculosis, urged Apollinaire on, but the article was not finished until just before Golberg's death and was published instead in another journal. Although Apollinaire's article is supportive, it lacks fire. It consists mostly of quotes from his interview with Matisse, and Apollinaire's voice remains detached. The article does have one oblique reference, however, to Matisse's rivalry with Picasso: "I have never avoided the influence of others," Matisse told Apollinaire. "I would have considered this cowardice and a lack of sincerity toward myself. I believe that the personality of the artist develops and asserts itself through the struggles it has to go through when pitted against other personalities. If the fight is fatal and the personality succumbs, it is a matter of destiny."

In subsequent years, Apollinaire frequently cast Matisse in a subsidiary role in relation to Picasso, whom he constantly promoted as being at the center of what was most original and vital in modern painting. During the early years of Cubist painting, Apollinaire often exaggerated the opposition between the two painters, incorrectly attributing the origin of the word "Cubism" to a pejorative reference Matisse made about Picasso. Apollinaire also was not above discussing

Matisse in a mocking tone, contrasting his ponderousness with Picasso's freewheeling originality: "The erudite Henri Matisse paints with gravity and solemnity, as if hundreds of Russians and Berliners were watching him." But he also supported Matisse against philistine critics and liked to say that he was Matisse's most consistent defender. Matisse, who disapproved of Apollinaire's personal comportment, was reluctantly forced to acknowledge this support. When he showed his *Dance* and *Music* panels in the fall of 1910, Apollinaire was the only critic to defend them, prompting Matisse to write to a friend: "I have only one defender but as he inspires disgust in me I would have better liked an enemy. I'm speaking of Apollinaire."

PICASSO AND APOLLINAIRE SHARED a deep interest in sexual activity that breaks social norms—the kinds of violent, sadistic sexual imagery that would appear in Picasso's art until the end of his life. Picasso was especially fond of Apollinaire's pornographic novel *Les Onze Mille Verges* (The Eleven Thousand Rods), first published in 1907. (The title contains multiple puns: a *verge* is both a birch rod used for caning and slang for a man's penis; it also sounds similar to *vierge*, or virgin.) Its main character, Mony Vibescu, is given over to a frenzy of violent sexual acts, such as whipping and torture, and is especially devoted to anal intercourse. The book is a hectic sequence of various kinds of couplings and beatings, full of scatological references and outrageous puns. Apollinaire inscribed a copy of it to Picasso, with a racy seven-line poem whose first letters form an acrostic for Picasso's name. The poem summarizes Vibescu's prodigious sexual abilities ("At any time his prick was ready for action") and in the last line concludes with the ironic gibe "O Pablo be able some day to do better." Picasso (who later insisted that his mistresses prepare themselves for him by reading the marquis de Sade) is said to have regarded this book as Apollinaire's masterpiece, and some of its themes would be directly echoed in *Desire Caught by the Tail*, a short play Picasso wrote in 1941.

Apollinaire's other erotic masterwork, *Exploits of a Young Don Juan*, is set in a large country house and told in the first person by thirteen-year-old Roger, who in the course of the book makes love to two of his sisters and to his aunt, as well as to a number of servants. The tone of this book is very different from that of the violent and scatological *Onze Mille Verges*. Here the story is recounted within the framework of an

adolescent boy's sexual awakening, and the descriptions lovingly evoke the thrill of first discovering sex, as when Roger's fourteen-year-old sister Berthe falls and exposes her private parts to his avid gaze: "I saw the place where the lower part of her stomach met her thighs, an odd rise, a plump triangular mound on which I could see a few blond hairs. Almost at the place where her thighs came together, this mound was parted by a large cleft about an inch wide with two lips spread apart on each side of it. . . . her slit, which at the time was about three inches long, had opened up; and during this time I was able to see the red flesh of the interior."

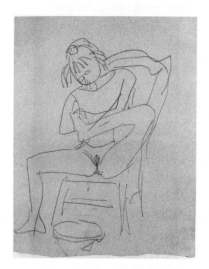

FIGURE 4.1
Picasso, *Drawing of Raymonde*, 1907. 22 x 17 cm.

The blend of matter-of-fact curiosity and adolescent lustfulness calls to mind certain of Picasso's early erotic works—especially his drawing of Raymonde, the attractive thirteen-year-old girl that he and Fernande adopted in spring 1907 (Fig. 4.1). In this drawing, Raymonde sits with her legs spread, exposing her genitals in a way that—as in Apollinaire's description of Berthe—mixes innocence and provocation. Fernande, aware of Picasso's attraction to Raymonde, made him leave the room when the girl was trying on underwear—an incident that curiously echoes the futile attempts of Roger's family to contain his burgeoning sexuality. Apollinaire's book is an odd mixture of down-to-earth sensuality and outrageous irony, contradictory qualities that would appear in many of Picasso's later works.

DESPITE THE UNDERLYING TENSIONS between them, Matisse and Picasso remained cordial at this time, and toward the end of 1907 they decided to exchange pictures. The trade took place at a dinner in Picasso's studio, where *Les Demoiselles d'Avignon* and an early stage of *Three Women* were leaning against the wall. A core group of Picasso's cronies—Apollinaire, Jacob, and Salmon—attended to witness the exchange, along with artists such as Vlaminck and Braque, who were still associated with Fauvism. Picasso was tense and silent throughout the

evening. Matisse was uncomfortable and behaved rather stiffly. Salmon saw Matisse as being "susceptible only to a kind of filtered sensuality, removed from life as we knew it and . . . impervious not to humor as such but to light-hearted humor." Picasso's friends interpreted Matisse's stiffness as haughtiness, and it provoked them to make him the butt of clubhouse humor after he left.

Despite the discomfort of the evening, and despite Gertrude Stein's later assertion that each artist had selected one of the other's weakest pictures in order to demean him—which she probably based on studio gossip—they in fact made typically interesting and unexpected choices. Picasso took Matisse's *Portrait of Marguerite*, a flat, childlike image of his thirteen-year-old daughter, in which her name is printed awkwardly at the upper left, in imitation of the printing in children's paintings. As Picasso later pointed out, he selected this picture because of the way Matisse had captured the direct, primitive quality of his children's drawings, and because he considered it a "key picture." Picasso at this time was trying to control his extraordinary facility of hand, and he was greatly impressed by the straightforward simplicity of Matisse's image. Matisse's choice is also revealing. He took a Picasso still life, *Pitcher, Bowl, and Lemon,* done around the same time as *Les Demoiselles d'Avignon,* in which the composition of roughly rendered and boldly drawn objects is based on striking visual rhymes, such as that between a lemon and the lemon-shaped opening of the bowl next to it. Here, as in *Les Demoiselles,* Matisse must have been struck by the way Picasso departed from verisimilitude in a manner the opposite of his own. Whereas the distortions in Matisse's pictures seemed to be produced by the inner force of objects expanding outward, in Picasso's recent paintings the distortions seemed to come from outside the objects, from vectors of force that were imposed on them rather than determined by them. This is typical of the difference between Matisse's organic way of creating a picture and Picasso's more constructional manner of composition.

IF THE EXCHANGE OF PICTURES did produce some bad feelings, it was for reasons that had little to do with the choices made. Shortly afterward, the rumor spread that Picasso's friends were throwing toy darts at the Matisse picture. According to André Salmon, they had indeed done so, using toy arrows tipped with suction cups so as to avoid

damaging it: "'A hit! One in the eye for Marguerite!' 'Another hit on the cheek!' We enjoyed ourselves immensely." Although this activity may have been imaginary, and in any case cannot have continued for long, since the picture bears no trace of it, the aggressiveness with which the rumor was spread made a lasting impression on both men; Picasso later even expressed regret. It was around this time that Picasso's friends, knowing how sensitive Matisse was to public criticism, started their graffiti campaign.

PICASSO'S FRIENDS HAD MORE reason to tease Matisse early the following year, when he started a school that was attended mostly by foreigners. (This also became a source of some merriment in the French press.) The idea for the school seems to have come from Sarah Stein and a young German artist named Hans Purrmann, who thought it would be beneficial to have Matisse give them critiques. Leo Stein, who continued to nourish hopes of being able to paint, was among the early students.

Matisse's new status as the head of a school, in addition to being generally recognized as the unofficial *chef d'école* of the avant-garde, rubbed Gertrude Stein the wrong way. She began to call him *"cher maître"* (dear master), sometimes abbreviated to "C.M.," and their relationship then cooled considerably. By Stein's own account, Matisse's irritation with her closeness to Picasso was an important factor. At one point, when Matisse intimated that Gertrude seemed to have lost interest in his work, she told him, "there is nothing within you that fights itself and hitherto you have had the instinct to produce antagonism in others which stimulated you to attack. But now they follow." She was, as she said, put off by his "brutal egotism," which she saw expressed in the tenacity with which he held to his view of experience, "the dogged persistence of the thing that for the time he knows." But in fact, she seems to have been put off as much by what she deemed his know-it-all manner, which was so like Leo's, and his seigneurial self-confidence, which was so like her father's. By the time Matisse started his school, Alice Toklas had come into her life, and Gertrude was becoming increasingly impatient with men who set themselves up as authority figures. For all of Picasso's machismo and egotism, he was anything but an authority figure, and he was mercifully free of the desire to lecture or to explain.

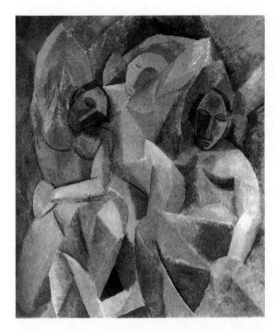

ALTHOUGH *LES DEMOISELLES D'AVIGNON* was the most unnerv-
ing painting Picasso had done, *Three Women* (Fig. 4.2) was more di-
rectly challenging to Matisse. As he would have realized, *Les Demoi-
selles* and related smaller works broke the mold of traditional painting
but did not create a solid foundation for something new; they were as
much the explosive end of something as the beginning of something
else. Like Fauve painting, they contained a violence that could not be
long sustained. The early version of *Three Women* that Matisse saw in
Picasso's studio was another matter. It was a highly structured picture
that clearly encroached on territory Matisse had thought was his. The
subject and style of the painting, three figures set in a landscape, ren-
dered in a carefully modulated, planar fashion, obviously owed much
to Cézanne; and in its early stages, when the painting contained a good
deal of blank canvas and free brushwork, it was especially informed by
the dynamic openness of Cézanne's late style. The underlying subject of
the painting was also one that Matisse had been working with for the
past few years: It was an image in which process—the coming-into-being
of things—was emphasized over stability. With its outward-spiraling
composition of three figures that seem to emerge from the bowels of the
earth right before our eyes, *Three Women* was a more resonant evoca-
tion of primal beginnings than had been Matisse's renderings of such
subjects, as in *Le Bonheur de vivre* or *Le Luxe*—and also a challenging
appropriation of imagery from African art.

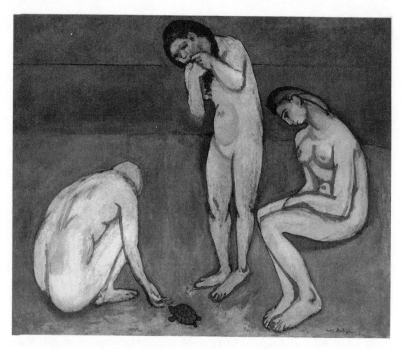

FIGURE 4.3 Matisse, *Bathers with a Turtle*, 1908. 179.1 x 220.3 cm.

Three Women further contained a bold imbrication of the figures within their background—a motif Matisse had employed in his Fauve paintings, such as *Woman in a Japanese Robe Beside the Sea* (Fig. 1.2). But whereas Matisse's merging of figure and ground, with the difficult legibility that it entailed, was based on a profusion of optical sensations, Picasso was developing a more obviously symbolic language. This approach also was something Matisse himself had been involved with for much of the past year, especially in his ambiguous but highly evocative treatment of mythological themes. Picasso's *Three Women* seemed to combine references to a standard mythological theme, such as the Three Graces, with a more generalized "birth of the world" imagery that went to the heart of the primitivism that had haunted both artists—along with their colleagues, such as Derain, Vlaminck, and Braque—for the past year or so.

In response to *Three Women*, Matisse painted *Bathers with a Turtle* (Fig. 4.3), a composition also with three figures, depicted in crouching, sitting, and standing poses, on a canvas exactly the same size. The poses of the figures, like those in *Three Women,* suggest an uncoiling that evokes a progressive transformation of states of being, an evolution of consciousness. But in this painting, Matisse has refused the pla-

nar modulation of Picasso's style—and of late Cézanne—and instead employs flat, simple forms. *Bathers with a Turtle* insists on clarity, in opposition to Picasso's increasing fragmentation. Its sober color and austerely simplified composition also mark a clear departure from the bright hues and flamboyant brushwork that had characterized so many of Matisse's paintings over the previous three years. The summer before he painted it, Matisse had gone to Italy, where he studied early Renaissance frescoes. The clear legibility, emotional gravity, and simple color harmony of *Bathers with a Turtle* reflect his deep admiration for the paintings of Giotto.

Bathers with a Turtle is one of Matisse's most disturbing paintings. The figures are not traditional "bathers" but rather seem more like primeval creatures set in some indefinite place at the very ends of the earth. The roughness of the rendering and the primordial visage of the central figure reinforce the sense of a primitive or primeval state of being—which is intensified by the presence of the turtle. Itself a primordial creature, the turtle seems to symbolize sexuality and the earth, as it does in primitive cultures, where it is associated with life force, fecundity, and transformation. The intensity with which the three figures attend to the turtle, coupled with the energetic and somewhat atypical liveliness of the turtle itself, focuses our attention on the contrast between the outward calm of the subject and the ferocity of its inner tensions.

Although the painting does contain some narrative, it is hard to make sense of what is happening. The figures are acutely isolated from one another, and it is impossible to determine what the woman in the center is doing. Her hands are raised to her mouth (in a position similar to the Congolese figure Matisse had bought and shown to Picasso), but what does the gesture mean? Is she eating, whistling, moaning, or silently grasping herself in a fit of agitation? Why does her face have such a strongly simian look? What is the significance of the third "eye" that is visible just above her ear (perhaps the result of incomplete repainting when Matisse repositioned the figure)? And what, for that matter, is the significance of the turtle? (Around this time, Picasso kept a turtle in his studio. Was Matisse making some sort of reference to it?) For the viewer studying this enigmatic painting, such questions multiply. A number of underlying mythological themes have been suggested to explain the picture's mysterious subject, but it is difficult to make a completely convincing case for any of them. Although it evokes a mythic modality, the painting refuses to connect specifically with any

text, leaving part of the work of creating "meaning" to the viewer and reasserting the independence of painting from literature—one of the essential tenets of modern painting generally.

Picasso had started *Three Women* well before Matisse began *Bathers with a Turtle*, but he continued to work on it long after Matisse had finished his painting. The final version of *Three Women* is less overtly Cézanne-like, in that the distinct rendering of the forms seems to resist the nondefinition and spatial ambiguity associated with Cézanne. *Three Women* also suggests evolving states of being, though in a way very different from Matisse's painting. The color is subdued and earthen, the forms are conceived sculpturally, almost like a bas-relief, and the precise parts of the women's bodies are difficult to read; similar forms are repeated throughout the canvas, and they are read as describing different things largely because of their relative positions. Here, more overtly than in *Bathers with a Turtle*, the subject is that of the female figures rising out of the earth as a symbol of becoming. Indeed, the figures are, in effect, the earth. The modulated planarity of this painting and the unification of the various parts of the subject into a single painterly substance, without differentiations between the colors and textures of things, are important steps toward Cubism.

Matisse finished *Bathers with a Turtle* in time for the Salon des Indépendants, but decided not to show it there. For the first time in six years, he sent nothing at all to the Salon. His competition with Picasso seems to have been an important factor in this decision. Since Picasso never showed at the Salons, it was impossible for Matisse to engage him directly in that arena. And by the spring of 1908, Derain and Braque were already under Picasso's spell and had moved, as Gertrude Stein put it, from being Matisseites to Picassoites—so much so that it was as if Picasso himself was present when Derain and Braque, "completely influenced by his recent work, showed theirs." It would have been a waste of energy for Matisse to compete with the second-stringers when his real adversary was hidden from view. Besides, Karl Osthaus was interested in acquiring the painting for his Folkwang Museum in Essen, and Matisse was probably wary about risking a sale to a major collector by exposing the picture to adverse criticism in the press. Leo and Gertrude Stein also expressed interest in buying *Bathers with a Turtle*, but then said they could not take it because it was too large for the space they had available. Thus it must have been doubly galling to Matisse when they purchased *Three Women* (whose title

Gertrude would echo in her first published book, *Three Lives*)—which was exactly the same size as *Bathers with a Turtle*. Since the Steins had witnessed the evolution of both paintings, this episode made it quite clear where their preferences lay.

STATED SIMPLY, ONE COULD SAY that Picasso was moving toward fragmentation and Matisse was moving toward simplicity. But during the rest of 1908, Matisse was still involved with his form of Cézannism, and he must have been perplexed to see the kind of fragmentation he had pioneered first being pushed further by Picasso and then being taken up by others. This new Cézannism unleashed a powerful force in French painting, the main thrust of which endorsed angularity and geometry rather than the qualities Matisse most appreciated in Cézanne's composition, which he later characterized as "the force, the song of the arabesque working together with color." The artists involved in this new Cézannism were trying to redefine the aesthetics of painting, so it is not surprising that Derain and Braque also took on themes related to the Three Graces—which symbolized beauty in the classical world—and set out to make them as "ugly" as possible, as a way of emphasizing the degree to which they were quite literally reinventing beauty. The strategy worked: The American writer Gelett Burgess associated their paintings with "a new world, a universe of ugliness."

DURING THE NEXT YEAR OR SO, Picasso embraced the ideal of an anonymous kind of painting that would have a special claim to truth through its overriding geometry and the supposedly "objective" pictorial language it employed. This austere extension of Cézannian painting was in striking contrast to the expressionistic subjectivity that Matisse held dear. As Picasso began to occupy the territory of Cézanne, Matisse seemed to be moving closer to the legacy of van Gogh and Gauguin, as it was then conceived, and he found himself pushed to find a new and different way of dealing with the fluidity and dynamism that meant so much to him in Cézanne's paintings.

This Matisse did by turning even more intensely toward the decorative. During most of 1908, while Picasso worked toward sculptural

fragmentation and radical reinvention of the figure, Matisse continued to work with flat forms and to explore the inherent ambiguities of the pictorial field—especially the ways in which it was possible to give the sensation of limitless space and to have what was traditionally considered the background become to some degree even more important than the figures it contained. Since childhood he had loved textiles, and he had an acute understanding of the possible symbolic uses for decorative patterns—as in van Gogh's portraits of Madame Roulin as "La Berceuse," in which the floral patterning that surrounds the woman becomes a metaphor for her vitality and fertility. Matisse's use of decorative patterning also provided him with another way of holding emotion at arm's length while maintaining its intensity. It allowed him to create a pictorial space that was sufficiently open and imaginative to incorporate a wide range of contrasting visual rhythms, which he would eventually use to evoke different kinds of perceptual sensations. Such a fluid and open space enabled him to invest everyday subjects with a powerful sense of spirituality.

FOR THE 1908 SALON D'AUTOMNE, Matisse planned a kind of apotheosis, a substantial exhibition that would put him in the ranks of the modern masters who had been given retrospectives there in recent years—including Ingres, Manet, Gauguin, and Cézanne. It would, in essence, consolidate his position as the leader of the Parisian avant-garde. But it was to this Salon that Braque sent some of the landscapes he had done the previous summer at L'Estaque (where Cézanne had also painted). Matisse was a member of the jury, and he was annoyed by the Picasso-like geometry and monochromatic, earthen color of those landscapes—one of which he had recently seen at Picasso's studio. When Braque's paintings were presented to the jury, Matisse reportedly muttered, "Always the cubes, the little cubes," and he used his influence to have three of them rejected. In a huff, Braque withdrew all his paintings and showed them instead at Kahnweiler's gallery. (This incident was the basis for a number of writers mistakenly attributing the origins of the word "Cubism" to Matisse.) Apollinaire rallied to Braque's defense, writing that Braque was "evolving within and outside himself a universal pictorial renaissance," and that each of his works "becomes a new universe with its own laws." In using such language, Apollinaire was only giving new emphasis to what had al-

ready become something of an avant-garde truism, but his extreme statement of the case was a response to the extreme form the paintings themselves had taken.

Given Matisse's sympathy to avant-garde painting generally, and to Cézannist painting in particular, we may wonder why he reacted so adversely to these 1908 landscapes, which Braque considered as homages to Cézanne. There seem to have been three main reasons. First, Braque's paintings were a reaction not only against Impressionism and photographic naturalism but also against the Fauve ideals of personal expression and individuality that were so essential to Matisse's undertaking. Further, they obviously had been created under the influence of Picasso's recent work. And finally, Matisse was put off by what he perceived as the aggressive and purposeful misreading of Cézanne that Braque's canvases embodied. For years, Matisse had felt he had a privileged understanding of Cézanne, and Braque's paintings flew in the face of it—not least by the way he had translated Cézanne's approach into a kind of geometrical formula. Although Matisse believed he understood Cézanne better than anyone else, his use of Cézannian elements remained discreet and respectful; for Matisse, it was important to try not to "misread" Cézanne, but rather to continue on the path elaborated by the older artist, much as he imagined Cézanne might have done. The battle that was underway, and that would be continued during the next several years, was over the question of how Cézanne, and by extension modern painting, would be understood.

As the centerpiece of his Salon d'Automne exhibition, Matisse sent *Harmony in Red* (Fig. 4.4), which had been commissioned by Sergei Shchukin for the dining room of his Moscow mansion. This large painting was as much the opposite of what Picasso and Braque were doing as could be imagined—flat, brightly colored, decorative. It was also a daringly different way of approaching the kind of cosmogonic imagery that Matisse had treated in *Bathers with a Turtle* at the beginning of the year. Instead of some mythic and primeval setting, this world-coming-into-being image is nominally placed in the banal setting of a dining room while the table is being prepared for dessert. It brings the idea of the potentially transcendent experience to the most mundane activities.

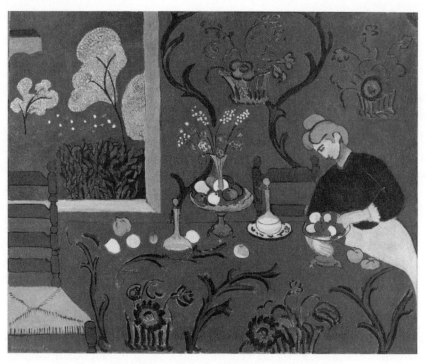

FIGURE 4.4 Matisse, *Harmony in Red*, 1908. 180 x 220 cm.

The image seems to exist somewhere between the imagined and the real, in a symbolic space where the visible merges and interacts with the invisible. Color replaces natural light, the picture space is intensely flattened, and objects are perceived independently of fleeting optical effects. What is depicted is seen neither from a single point of view nor as happening at a specific moment in time. The purposeful ambiguity of the painting is especially evident in the way the window view functions as a picture within the picture. The view that it offers (which may be a painting) evokes early spring, complete with blossoming fruit trees and flowers bursting into bloom. Against these relatively realistic floral motifs are played the dynamic floral patterns within the room, the arabesques that sprawl across the table and up the wall, and out of which both real and decorative fruit and flowers grow. The dynamic forces within the red room thus become a symbolic translation of the forces that underlie the predominantly green spring landscape outside. Within this context, the woman clearly embodies a life-affirming female principle—fructification, fertility. Energy flows from her hand to the fruit and sets in motion the forces of growing things. In *Harmony in Red*, what is happening in the room has been transformed into a

graphic, signlike image of what is happening outside: The world is coming back to life, and the arabesques are understood to embody the dynamism of nature and to function as abstracted symbols of growth and energy. Matisse has transformed a genre scene into a meditation on time and becoming.

Harmony in Red is an excellent example of the way Matisse was able to translate a perceptual image into a symbolic ensemble. This is very much the process that he discusses in his essay "Notes of a Painter," which he published at the end of December 1908 and which made him not only the leading practitioner but also the leading spokesman for the new painting. "Underlying this succession of moments which constitutes the superficial existence of beings and things," he wrote, "and which is constantly modifying and transforming them, one can search for a truer, more essential character, which the artist will seize so as to give to reality a more lasting interpretation." The essay was soon translated into German, and it had a considerable effect on subsequent thinking about modern painting. In it, Matisse defends the subjectivity of his art and sets forth the notion of art as a form of self-expression: "I am unable to distinguish between the feeling I have about life and my way of translating it."

In this essay, Matisse also made a remark that would dog him for the rest of his life. "What I dream of," he wrote, with his Russian businessman patrons Ivan Morosov and Sergei Shchukin in mind, "is an art of balance, of purity and serenity, devoid of troubling or depressing subject matter, an art that could be for every mental worker, for the businessman as well as the man of letters, for example, a soothing, calming influence on the mind, something like a good armchair that provides relaxation from fatigue." On the basis of this unfortunate simile, he would become for many quite simply "the painter of the good armchair," charming but superficial. And this analysis, of course, cast him precisely in the opposite role from the obviously disturbing Picasso. Day and night.

5

REDEFINING
REALITY

*Matisse—color. Picasso—form. The two
great pointers toward one great goal.*

— WASSILY KANDINSKY

Sergei Shchukin's support was important to both artists. He had been buying from Matisse since 1906, and when Gertrude and Leo Stein stopped acquiring Matisse's work, Shchukin became his main patron. After Matisse introduced Picasso to Shchukin, the Russian also became one of Picasso's most passionate collectors. The two artists played complementary roles in Shchukin's emotional life. Shchukin regarded Matisse as a kind of soul mate, whose work provided spiritual nourishment and consolation through a series of personal tragedies, including the death of Shchukin's wife and the suicides of two of his sons and a brother. Matisse's paintings provided Shchukin with a sense of solace and renewal. At the same time, Shchukin considered Picasso's paintings to partake of another, darker kind of spirituality—he said they reminded him of cathedrals—that gave him comfort of another type.

Shchukin's patronage provided an important source of income for both painters, and by fall 1909 both were able to move to better quarters. That year's commission for the large *Dance* and *Music* paintings not only gave Matisse increased financial security, but also put him in need of more space, so he moved to a large house in Issy-les-Moulineaux, a suburb southwest of Paris. There he had a custom-built studio constructed, along with substantial gardens that supplied flowers for his still lifes. About the same time, Picasso moved from the Bateau-

Lavoir to a large, bourgeois apartment on the boulevard de Clichy. The apartment had electricity and heat, and meals were served by a maid in a white apron. For a while, Picasso and Fernande were "at home" on Sunday afternoons, reciprocating for the rounds of visits they made to the Matisses, who received on Fridays, and to the Steins' rue de Fleurus salons on Saturday evenings. But Picasso chafed at being caught up in such conventional behavior, and after a few months the Sunday receptions petered out.

Things were also changing between Leo and Gertrude, who had once been considered the happiest couple in Paris. They were no longer a couple and no longer very happy. Alice Toklas, who would be Gertrude's lifelong companion, had arrived on the scene in September 1907 and moved into the apartment a year later. When Gertrude had first come to Paris, Leo was generally believed to be the family genius. But after years of trying unsuccessfully to paint and to write, he had become increasingly opinionated and boorish—and resentful of Gertrude's growing self-confidence. Gertrude was enthusiastic about Cubism, but Leo believed that both her writing and Cubism were "hogwash." Though he had largely directed their early collecting, Gertrude was now buying the pictures. It was she who bought one of Picasso's radically geometric and fragmented Horta landscapes shortly after he returned from the Spanish hill town at the end of the summer of 1909, and it was she who would continue to purchase works by him up until the war. By 1910, Leo and Gertrude had divided their collection, with Leo taking the Matisses and Gertrude the Picassos. This split reflected more general thinking. The sense that the works of Matisse and Picasso were aesthetically incompatible was becoming widespread by then. That December, in a review of a Picasso exhibition at Vollard's gallery, Salmon wrote: "There are lovers of art capable of admiring both Picasso and Matisse. These are happy folks whom we must pity." This polarization, which reflected a deep-seated division between supposedly rational and instinctive approaches to art, would keep recurring throughout the two men's careers—even after it had become fashionable to admire them both.

DURING THIS TIME, Matisse and Picasso forged a good deal of the vocabulary of modern painting. They were among a steadily growing group of French painters who took it for granted that art did not have

to imitate nature but should transmit the feelings of the artist—in Mallarmé's famous phrase, "To paint not the thing, but the effect it produces." Matisse and Picasso, along with Braque, were clearly emerging as the artists within that group who had the most original vision.

Their basic goals were in many ways similar. Both men had a deep and evident concern with the autonomy of the picture as distinct from what the picture represented, and both aspired to emphasize the psychic rather than the physical reality of the world around them. But by 1909 each had staked out different territory, and their very real differences were further exaggerated by artists and critics who conveniently saw them as representing two completely opposed, predefined schools of thought. Matisse continued to be associated with the spontaneity of Fauvism long after Fauvism ceased to exist; Picasso was identified with the new horizons offered by Cubism, considered a more intellectual kind of painting. When the word "Cubism" was first used, in a review of the 1909 Salon des Indépendants by Charles Morice, he summed up the main issue of the day as a polarity between excessive, even aimless subjectivity and the excessively rigid use of theory and formula. In succeeding years, Matisse and Picasso would come to stand for these opposing positions.

BY 1909, PICASSO WAS involved in a partnership with Braque that ultimately led to the creation of Cubism. They worked so closely together for the next five years that Braque described them as being like two mountain climbers tied together. (Picasso, with typical machismo, referred to Braque as "my wife.") During much of this time, they showed each other virtually everything they did, and when possible they saw each other daily. (Throughout his life, Picasso needed companionship in order to act effectively—unlike Matisse, who was the consummate loner. Braque said he and Picasso could discuss things that they could talk about with no one else. Years later, Matisse and Picasso would say almost the same thing about each other.) Their collaboration pushed both Picasso and Braque toward a degree of abstraction they might never have achieved working alone. The sense of an underlying grid in their paintings became steadily stronger, and the increasingly arbitrary, signlike relations between their forms came to have almost linguistic overtones. This was at the same time that Ferdinand de Saussure was developing his course in general linguistics at the University of

Geneva, which would revolutionize the study of semiotics by treating language as a sign system and emphasizing the arbitrariness of the relationship between signs and what they signified.

As Picasso placed greater emphasis on form, his subject matter became narrower, and the emotionally charged themes of his earlier works gave way to more neutral subjects, such as still lifes, landscapes, and single figures—all rendered in an increasingly abstract way. In turn, the form of his paintings became the most important part of their "subject matter." Picasso's collaboration with Braque was related to the idea that "an anonymous art" could better express universal truths. They sought a kind of communal artistic expression in their work at this time, what Picasso later called "a kind of laboratory research from which every pretension or individual vanity was excluded." For this undertaking, Picasso's practice of working from memory and imagination was a great help, since it allowed him to avoid the incidental visual effects that might otherwise have distracted him from his goal. He became more interested in the distinctive qualities of the forms he was using and was fascinated by the ways in which he could create visual puns that high-

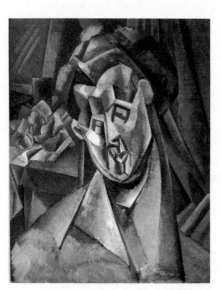

lighted the metaphorical qualities of different systems of representation. In *Woman with a Fan* of 1909, for example, he emphasizes forms that evoke folding or pleating, which are carried out throughout the painting. In *Still life with Liquor Bottle* of 1909, virtually the whole picture is rendered in crystalline, faceted planes, making the cut-glass liquor bottle, the least fragmented object in the painting, exemplify the style of the painting as a whole.

Picasso was also intensely interested in how the illusion of sculptural form could be inscribed on the flat plane of the picture. His concerns are nicely summed up in *Woman with Pears* (Fig. 5.1), a portrait of Fernande painted during the summer of 1909, in which he

FIGURE 5.1
Picasso, *Woman with Pears*, 1909. 92 x 73.1 cm.

pushes the fracturing of the woman's body to an extreme. As in most of his paintings done at this time, an implied diagonal grid seems to determine the fault lines along which the forms are fractured, so that we are

constantly aware of a strong underlying schema. We are not, of course, expected to believe that this is what Fernande really looks like, or to see the representation of her as an expressive distortion of a perceptual phenomenon. In fact, a word such as "distortion," which was used in relation to Matisse's paintings of this period, hardly applies here. Rather, following the lead of African sculpture, Picasso quite literally reinvents the forms of the face. He creates a new entity, based on his knowledge of its underlying structure, which conforms more to what he knows about the head than to what he sees when he looks at it. The reduced color and sharp angularity of such works posited a radically new idea about the very nature of humanity. Their geometry and inorganic look led to the idea that the people represented in them are somehow dehumanized.

During this first phase of his Cubism, Picasso had no particular interest in Matisse's work, but Matisse was paying careful attention to what Picasso and Braque were doing. Cubism, which was frequently characterized as an entirely new kind of painting, marked a more obvious break with the past than anything Matisse was involved in, and it soon was being discussed and imitated throughout Europe. Matisse's decorative manner, on the other hand, was associated with a kind of feminine superficiality, what Salmon—quoting Picasso, some believed—described as being like a dressmaker's "taste for chiffon." (Years later, it was still rumored that Picasso had referred to Matisse as a maker of bright ties, or as a "perfumed handkerchief.")

AT THIS TIME MATISSE also was experimenting with different ways of using the metaphorical arbitrariness inherent in various modes of pictorial representation, but in a very different way. He did not use an implied grid, and although he sometimes fractured his forms, he did so in order to energize the individual objects he was painting rather than to submit them to a sense of an outside organizational system. Perhaps because he painted directly from nature, he was unwilling to make such a clear break with mimesis. Although in 1909 he spoke of creating a signlike "linear script" in his paintings, Matisse's signs were conceived in a general way rather than in a specifically semiotic sense. They often stand not for tangible things but for visual sensations, and the ensembles of his forms are meant to create ambiences within which various kinds of signs can cohabit and interact. One of the most striking characteristics of his work at this time is the way it is able to suggest solid-

ity of form while maintaining a remarkable transparency in the paint surface, creating unity through the tension between opposing perceptions. Matisse often mixes different orders of signification in ways that are not always stylistically consistent but that nonetheless have their own internal cogency. In *Algerian Woman* (Fig. 5.2), he combines a generalized linear rendering of the figure with a surprisingly illusionistic one. The staccato brushstrokes may draw our attention to the abstract qualities of the painted marks, but they also vividly evoke the varying degrees of transparency in the woman's robe. Matisse mixes his visual languages even further by emphasizing the tendril-like spiraling form on the rug behind the woman, which we read as a graphic sign for her inner vitality. This amalgamation of different realms of perception and experience is one of the crucial qualities of his art. He did not work systematically, since the perceptual elements he was trying to balance quite literally defied being systematized. As a result, the variety of his work done directly from the model at this time is astonishing.

FIGURE 5.2
Matisse, *Algerian Woman*, 1909. 81 x 65 cm.

Matisse's lack of a consistent approach to painting puzzled and irritated people, especially since it was seen in contrast to Picasso's apparent single-mindedness. In February 1910, when Matisse's retrospective exhibition opened at the Bernheim-Jeune gallery, he may have anticipated the virulent criticism he received in the popular press, which deemed his works a form of charlatanism. More bitter to him were the severe doubts expressed by people generally sympathetic to avant-garde painting. A number of writers criticized his apparent lack of stylistic coherency and accused him of substituting new gimmicks for solid structure. "Henri Matisse contradicts himself at every stage," Salmon wrote. "He is the most incoherent of modern artists."

THE EFFECT THAT SUCH CRITICISM had on Matisse was exacerbated by the stress of the secret affair he was carrying on with one of his

FIGURE 5.3 Matisse, *Sculpture and Persian Vase,* 1908.
60.5 x 73.5 cm.

students, a thirty-year-old Russian woman named Olga Merson. It is generally believed that the women in Matisse's life, unlike those in Picasso's, had little effect on his work. But that was not the case, as we shall see, although Matisse was much more discreet than Picasso, who openly used his lovers as the inspiration for extended series of works. Early on in his affair with Olga, Matisse revived the Dream-of-Desire woman in a new context. Back in 1907, when he had painted *Blue Nude,* he had also created a sculptural version of the figure, *Reclining Nude I.* He now began to incorporate that sculpture into his still lifes, as in *Sculpture and Persian Vase* (Fig. 5.3), an exuberantly sensual picture organized around the dialogue between the curves of the woman's body and those of the vase. The spout of the vase, which echoes the sweeping curves of her raised arm and thigh, also penetrates her body as if it were a large phallus, and the flowers, in a typically Matissian metaphor, are the offspring of the union of these highly animated inanimate objects.

Equally striking and unusual is *Nymph and Satyr* (Fig. 5.4), one of two paintings on the theme that Matisse did in late 1908 and early 1909. *Nymph and Satyr,* which represents a large-handed satyr lunging toward a sleeping nymph, is rendered in a very agitated way, and the theme is charged with an overt sexual violence that is unusual for Ma-

FIGURE 5.4
Matisse, *Nymph and
Satyr,* 1908–1909.
89 x 117 cm.

tisse—it is a theme that would later be associated with Picasso. The
light-skinned reddish-blonde woman in the painting is also an unusual
type for Matisse and is almost certainly meant to evoke Olga. This
painting had a particular appeal to Shchukin, who was deeply moved
by its raw and primal qualities. At the time Matisse became involved
with Olga, the Russian collector was his main patron, and Olga's pres-
ence probably inspired Matisse to work in a somewhat heavier "Russ-
ian" manner—as in the use of large areas of bright red in *Harmony in
Red* and in *Dance* and *Music.* Some of the boldness in these works cer-
tainly drew on their affair, with Olga as a lover who was a painter and
as a woman who came from the country where many of Matisse's best
paintings were headed.

BETWEEN 1910 AND 1912, the subjects represented in Picasso's
paintings became increasingly disembodied. This process can be nicely
seen in *Girl with a Mandolin (Fanny Tellier)* of 1910 (Fig. 5.5), in which
the forms on the left side are more sculptural and the woman's body
more clearly separated from the background than on the right side.
Whereas the left side continues the sculptural mode of 1909, the right
side anticipates the more abstract style that Picasso would develop over
the next two years. He worked on this painting for a long time, and, as
with *Les Demoiselles d'Avignon,* he initially considered it to be unfin-
ished. But unlike with *Les Demoiselles,* he signed it a few years later, as
if to acknowledge his alertness to the force that conflicting styles could
produce. This is one of a series of works, starting with the *Portrait of*

Gertrude Stein, in which notions of stylistic consistency and finish are redefined—and in which the different kinds of rendering constitute an important part of the painting's meaning.

The apotheosis in transparency and fragmentation of form was achieved in a series of paintings that Picasso and Braque began during the summer of 1911 and continued into the next spring. One of Picasso's most haunting works of the period is *"Ma Jolie"* (Fig. 5.6), painted in the fall of 1911, which brings him to the edge of abstraction. Although Picasso described the picture as a "A woman in an armchair with a zither and sheet music with ma jolie written on it," the woman is barely visible, and the identification of the musical instrument is far from unequivocal. Whatever legibility the forms have is provided by brief passages of more recognizable representations, such as those that denote the woman's breast, the collar of her dress, and the fringed chair arm at the extreme right. Later, Picasso described this process of providing the bare minimum of legible form in his Cubist paintings as a system of adding what he called "attributes." He said he used the concept almost as a writer might use an adjective to qualify the subject. "But the verb and the subject are the whole painting, really," he noted. "The attributes were the few points of reference designed to bring one back to visual reality, recognizable to anyone. And they were put in, also, to hide the pure painting behind them." Such paintings, he explained, at first looked as if they "were about to go up in smoke." But, he added, "When I paint smoke, I want you to be able to drive a nail into it. So I added the attributes—a suggestion of eyes, the wave in the hair, an ear lobe, the clasped hands." As in a difficult philosophical text, he added, the artist had to mix familiar elements into the unfamiliar invention in order to retain viewers' interest and draw them into the picture. And then "their mind thrusts forward into the unknown and they begin to recognize what they didn't know before and they increase their powers of understanding."

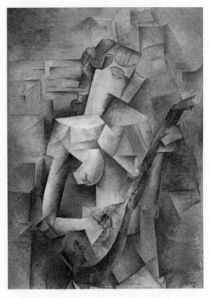

FIGURE 5.5 Picasso, *Girl with a Mandolin (Fanny Tellier),* 1910. 100.3 x 73.6 cm.

In *"Ma Jolie,"* which is an extreme case, the most concrete information about the woman comes largely through the two words "MA JOLIE,"

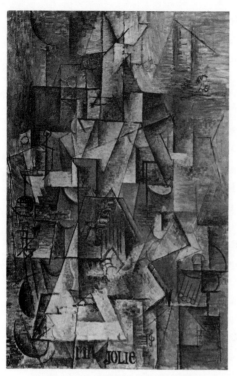

FIGURE 5.6
Picasso, *"Ma Jolie" (Woman with a Zither or Guitar)*, 1911. 100 x 65.4 cm.

which refer to the refrain from a popular song. That she is pretty, that she is beloved by the artist (as implied by the possessive form), indeed that she is even a woman at all, we must take on faith, since we cannot clearly see the woman in the painting. It is commonly said that a picture is worth a thousand words. But in this picture two words reveal more than the entire image. The stylistic conundrum of *"Ma Jolie"* poses a number of questions about the arbitrariness of representational signs, and about which kinds of signs should be given priority in pictures. In its hesitation at the limits of abstraction, the painting casts doubt on the whole enterprise of visual representation.

Paintings like this provoked talk of what Apollinaire called "new measures of space which, in the language of the modern studios, are designated by the term *fourth dimension.*" The idea that Cubist painting employed a new kind of spatial geometry, such as that proposed by Maurice Boucher's *Essai sur le hyperspace* (1903) or by Maurice Princet, who lived in the Bateau-Lavoir, caught the imagination of many people interested in painting at the time. These ideas were generally associated with the quasi-scientific objectivity of the Cubist style and its engagement with searching out underlying truths. Matisse was also interested in such ideas and had read Boucher's book quite early. Matisse's concept of the fourth dimension was expressed in neither mystical nor mathematical terms, but in what Max Weber, who studied with Matisse, referred to as "the consciousness of a great and overwhelming sense of space-magnitude in all directions at one time," which could be suggested by imagery existing in the "three known measurements." The intuition of such a space evoked "the immensity of all things," a notion very similar to what Matisse would later refer to as "cosmic" space.

Both Matisse and Picasso, it should be said, were wary of mystical theories and avoided speaking publicly about the fourth dimension, though in different ways their work provided excellent examples of the ideas then associated with it. One of their common goals at this time was to create a kind of painting that could evoke the sacred through objects in the everyday world. To do this, they emphasized the way the objects they depicted retained at least some of their physical identity but were also transformed into something else. Transparent or translucent effects played an important role in both their endeavors. Such effects provided a means of suggesting the paradoxical way in which their subjects were both material and nonmaterial. Transparency emphasized the metaphysical quality of their vision by indicating that forms could be depicted without being fixed in a specific place.

PICASSO CHARACTERIZED THE ARBITRARINESS of representation in his Cubist paintings as resulting from his desire for "a greater plasticity." Rendering an object as a square or a cube, he said, was not a negation, for "reality was no longer in the object. Reality was in the painting. When the Cubist painter said to himself, 'I will paint a bowl,' he set out to do it with the full realization that a bowl in painting has nothing to do with a bowl in real life." Matisse, too, was making a distinction between real things and painted things, and fully understood that the two could not be confused. But for Matisse, a painting should evoke the essence of the things it was representing, rather than substitute a completely new and different reality for them. In contrast to Picasso's monochromatic, geometric, and difficult-to-read pictures, Matisse's paintings were brightly colored, based on organic rhythms, and clearly legible. For all their expressive distortions, they did not have to be "read" in terms of some special language or code.

Matisse, however, was acutely aware of the radical transparency and dematerialization of form in Cubist painting, and he was eager to learn more about it. According to one eyewitness, as early as 1909 or 1910, Matisse had said while standing before one of Picasso's canvases, "That's Cubism . . . I mean by that an immense step toward pure technique. We'll all come to it." A year or so later, Matisse visited Braque and Picasso at the latter's studio on the boulevard de Clichy specifically to see how their work might help him find solutions to his pictorial problems. When they showed him a painting and asked if he could tell

what it represented, he replied that he couldn't. According to Christian Zervos, Picasso then "went to fetch a mustache and applied it to the picture, at which point Matisse began to make out a pair of eyes, a tie, etc." Picasso explained that since they wanted to get away from nature, they thought the sudden addition of a well-defined object would be enough to allow the whole picture to be read by analogy. But Matisse, Zervos said, "would not be convinced and replied that the colors and the canvas should be sufficient for the painter to create his structures without the help of any external object."

DURING THE SUMMER OF 1911, while Picasso and Braque were deeply involved with the monochromatic, fragmentary, relieflike space that marked the height of Analytic Cubism, Matisse was working on a series of large decorative panels representing his studio and his family. For the previous few years, many of his paintings had been composed of flat, highly patterned planes with clear contrasts of color and texture, which sometimes looked as if they could have been fabricated with pieces of cloth or paper. He was also working on a much larger scale than Picasso and Braque. Most of their paintings were small easel pictures; his were mural-like in size and decorative conception. Inspired by Islamic art and by Russian icons (neither one of which interested Picasso), Matisse's paintings became at times ferociously decorative, as in *The Painter's Family* of 1911, in which a variety of almost ecstatic decorative patterning pervades the image.

A number of his paintings from this period also seem to reflect the inner tumult of his personal life. *The Painter's Family*, for example, is the first picture in which he represented his entire family together, and he does so with such detachment that it is almost as if he were taking leave of them. The placid calm of the nominal subject—his wife sewing, his two sons playing checkers, his daughter standing with a book in her hands—is belied by the very violence of the decorative motifs. The whole room seems to be shaking with nervous energy, and the checkerboard at which the two boys are seated seems to be splitting apart as if under the stress of an earthquake. On the mantelpiece in front of the blank mirror, where Matisse's reflection would appear if he were literally painting this group portrait from life, is a representation of his sculpture *The Serf*, a bearded male figure who clearly serves as a surrogate self-portrait; its presence makes the family complete by including

the artist, and ironically refers to Matisse's sense of enslavement by family life.

During the summer of 1911, Olga Merson stayed for a while with the Matisses in Collioure, and it was then that Matisse painted his remarkable portrait of her (Fig. 5.7). In this portrait, the ghostlike aura around the figure, the scumbling and scraping of the paint in the face area, and especially the bold, saberlike strokes that accentuate the main arcing movements of her body give the picture an intensely dynamic quality that is set in direct contrast to the woman's static, nearly symmetrical pose. Although she is seated, there is no chair beneath her, so she seems to hover before us in an abstracted, empty space—as much a hallucinatory vision as a real person. In its abstractness and its emphasis on structure, this painting tacitly acknowledges Picasso's Cubist figure paintings and offers an alternative by positing a rather different idea of dematerialized space. Around the same time, Olga painted a portrait of Matisse, which she boldly exhibited at the 1911 Salon d'Automne, where it caught the attention of Apollinaire, who gave it a brief mention in his Salon review.

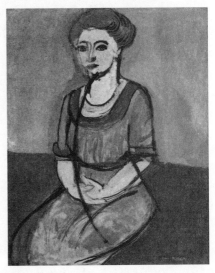

FIGURE 5.7
Matisse, *Portrait of Olga Merson,* 1911. 100 x 80.6 cm.

That summer, Matisse also did the superb *Interior with Eggplants* (Fig. 5.8), which contains a still life with three eggplants (a Chinese symbol of happiness) and a plaster cast of the *Flayed Man,* a symbol of human suffering that Cézanne had represented in still lifes. In *Interior with Eggplants,* the decorative abundance all but overwhelms the human element represented by the sculpture, setting human suffering (and happiness) as small incidents within the larger sense of the cosmos evoked by the intensely ornamented room. This painting marks the culmination of Matisse's intensive decoration, and in its own way is as much a probing of limits as Picasso's most nearly abstract Cubist paintings. It is an extremely hyperbolic painting, and the key to its hyperbole—its vehicle, and its most extravagant excess—is seen in the floral pattern that covers, unites, and fairly overwhelms the areas that are supposed to denote the wall and floor. The effect of this floral pattern,

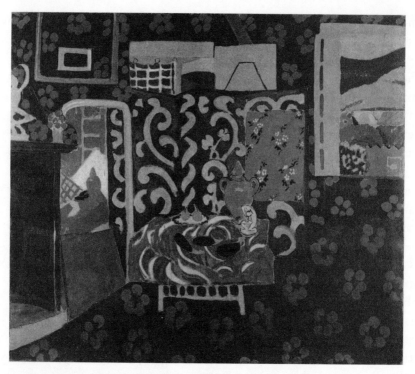

FIGURE 5.8 Matisse, *Interior with Eggplants*, 1911. 212 x 246 cm.

devoid of foreshortening, is altogether abstract. It emphasizes—indeed insists on—the reduction of everything to surface, to the most irreducible and basic physicality of painting.

The suggestion of another, "higher" dimension of space and time was even stronger when the painting was surrounded by its original painted false frame, since lost, which contained a continuation of the floral motifs that appear inside the picture space, rendered in reversed colors and values, dark violet on light. The painted border not only further flattened the image by extending the floral motifs out to an unequivocally flat plane but also added another collagelike aspect to it—which echoed the disruptive effect of the various highly patterned rectangles contained within the encompassing rectangle of the canvas. Matisse put a painted frame on at least one other painting during 1911, the subsequently destroyed *Large Nude*, which represented a fair-haired woman in a vivid embodiment of the Dream-of-Desire pose that he had come to associate with Olga Merson. (Was that why *Large Nude* was destroyed?)

Sarah Stein, who purchased *Interior with Eggplants*, told Matisse that she thought it marked "a real step forward" in his path. In fact, it

marked the end of this period of hyperbolic decoration. But a year later, this painting would help open the way for a step forward by Picasso.

<center>—∞—</center>

THE RISE OF CUBISM PRODUCED a shift in how the history of recent French painting was perceived. The Cubists were seen as the heirs to Cézanne, and by spring 1912 Gleizes and Metzinger's book *Du "Cubism"* triumphantly proclaimed this to be so. Cézanne, they asserted, had taught painters "how to dominate universal dynamism" and had revealed "the modifications that supposedly inanimate objects impose on one another." Those who understood Cézanne, they claimed, were close to Cubism, for "at present Cubism is painting itself."

The increasingly accepted assertion that Cubism embodied the essence of modern painting vexed Matisse. Until about 1909, he had seemed to represent the cutting edge of avant-garde painting in Europe. But when he visited Russia in the fall of 1911, he was already seen as old hat compared with Picasso and the Cubists, who were exerting great influence on the development of Russian avant-garde painting. "In the final analysis," one Russian critic wrote, drawing yet another comparison between them, "Matisse is a *cravate*, a colored necktie, in the words of Pablo Picasso, his opposite. He is beautiful but not profound. . . . The most original and talented artists . . . have not continued to follow him." By 1911, Cubism seemed to be everywhere and inescapable. That fall Apollinaire published a short, ironic article noting that when Matisse returned to Collioure for the summer, he had been chagrined to find the sign for KUB, a popular brand of bouillon, painted on a building across the way. This reminder of Cubism, according to Apollinaire, had spoiled Matisse's vacation.

Only a few years earlier, the Paris art world had been divided between what Gertrude Stein called the Matisseites and the Picassoites. Now Matisse was in such full retreat that it sometimes seemed he was the only remaining Matisseite.

Years later, Matisse admitted that "the period of Cubism's triumph was a difficult watershed" that had caused him great anguish: "I was entrenched in my own pursuits: experimentation, liberalization, color, problems of color-as-energy, of color-as-light. Of course, Cubism interested me, but it did not speak to my deeply sensory nature, to my great love of line, of the arabesque, those bearers of life. . . . For me to turn toward Cubism would have been to go counter to my artistic ideas."

But a few years later he *would* turn toward Cubism, in a decisive and original way.

THE LIVES OF MATISSE AND PICASSO are full of curious coincidences. They often made sharp changes in style around the same time, and important transitions in their personal lives frequently happened in tandem as well. During the winter of 1911–1912, both were separated from women they had loved and whose presence had affected their work for the previous several years.

In the fall of 1911, around the time he painted *"Ma Jolie,"* Picasso was involved in a painful and drawn-out breakup with Fernande Olivier. They had spent much of the previous summer apart, and in the fall Picasso had become infatuated with Eva Gouel, who at the time was living with the painter Louis Marcoussis. The fullest single account of what happened came, interestingly enough, from Matisse, who heard it from one of his models who was part of Picasso's Montmartre crowd. Matisse in turn told the story to Michael Stein, who passed it on in a letter to Gertrude.

The final straw came when Fernande began a passionate affair with a twenty-two-year-old Italian painter named Ubaldo Oppi, who had come to Paris with the Futurists. Fernande then made the colossal mistake of using her friend Eva Gouel as a confidante, and one day asked her to deliver a letter to Oppi. Eva, eager to have Picasso to herself, gave it instead to Picasso: "So P. confronted F. And they split. P. went to K[ahnweiler] got money, cleared all his things out of Ravignan, discharged the maid, locked up the other place and decamped to Céret with the friend." Picasso tried to shrug off the incident by sardonically characterizing it in a letter to Braque as "Fernande has run off with a futurist." In fact, although Picasso later cultivated the image of a man constantly breaking women's hearts in a cool and unfeeling way, he was intensely jealous and possessive. This was especially true with regard to Fernande, whom he had initially kept sequestered almost like a woman in a harem, and whose capricious flirtations and real or imagined infidelities deeply wounded him.

Around the same time, Olga Merson's psychological equilibrium had become so precarious that she sought medical treatment. Then, while Matisse was in Russia that fall, she made it clear to Amélie Matisse that she was having an affair with her husband. Matisse was now forced to

choose between the two women, and after a great deal of anguished soul-searching, he decided to try to save his marriage by giving up Olga. To make the break all the more complete, he left Paris for a while with Amélie, originally planning to go to Marseilles but eventually going even farther away, to Morocco.

Some sense of Matisse's state of mind at this time is indicated by a comment he made years later to Picasso's mistress Françoise Gilot. One of the first paintings Matisse did in Morocco was the intense and splendidly luminous *Basket of Oranges*, which Picasso acquired in 1942 and displayed prominently in his studio. When Gilot asked Matisse about the circumstances in which that painting had been made, he told her he had been so depressed when he painted it that he was seriously contemplating suicide. The reason he gave for his suicidal mood was that he was desperately poor. But by 1912, of course, Matisse was quite well off. He used the clichéd starving-artist story to hide the real reason for his despair.

WHEN MATISSE RETURNED FROM Morocco that spring, he was full of turbulent emotions, and he created some of his most memorable and original works. Among them is a painting of a bowl of goldfish set next to his *Reclining Nude I* sculpture, which he had first begun to use in still lifes at the beginning of his involvement with Olga Merson. If *Sculpture and Persian Vase* conveyed a strong sensual exuberance, the 1912 still lifes that incorporate the Dream-of-Desire sculpture, such as *Goldfish and Sculpture* (Fig. 5.9), are charged with nostalgic reverie. In *Goldfish and Sculpture,* we are constantly aware of the contrast between containment and openness, and between different ways of viewing. The bright red goldfish are surrogates for the artist himself, gazing at the world through his thick eyeglasses. Confined within the miniaturized pond of their bowl, the goldfish restlessly contemplate the reclining nude even as we contemplate their contemplation of her. The artificial world the goldfish inhabit is compared to the patently artificial arrangement of objects on the tabletop, so that the themes of artifice and displacement operate on several different levels. On this tabletop, nature is miniaturized and transformed into proxies: the bowl for the pond, the flowers for foliage, the sculpture for a real woman. In this fluidly brushed painting, the liquid greens, blues, and ochers flow across the surface as if the whole painting were perceived through

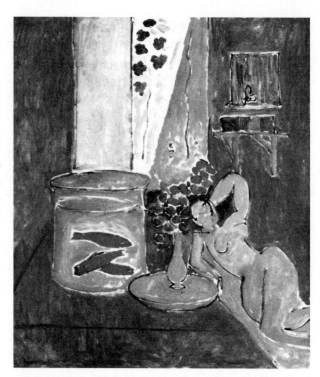

FIGURE 5.9
Matisse, *Goldfish
and Sculpture,* 1912.
116.8 x 100.6 cm.

water. The floating effect is heightened by the incongruous way the sculpture floats free of the line that suggests the front edge of the table, enhancing the nostalgic and dreamlike mood of the painting and suggesting that the subject has been transposed to another plane of consciousness. By presenting the image of the woman via the artificial device of the anonymous sculpture, Matisse sublimates his desire and gives himself permission to conjure the impermissible presence. If, as Salmon said, Matisse was "susceptible only to a kind of filtered sensuality," this did not mean that he was removed from life but rather that he engaged life, and love, on his own very private terms.

A similarly apparition-like effect is evoked in *Nasturtiums with "Dance" (II)* (Fig. 5.10), in which Matisse incorporates an image of the first version of his 1909 *Dance.* The multiple rendering of the dancers creates a powerful sense of process, duration, and becoming—in which time as well as space is expanded. Movement is made synonymous with creation, as evidenced by the convergence of the figures over the open mouth of the large vase, from which both the flowers and the dancers seem to emerge. The depiction of movement through multiple renderings reflects Matisse's study of Italian Futurist painting, which had recently

been exhibited in Paris at the Bernheim-Jeune gallery, where he himself showed, with a catalogue that contained a bombastic manifesto: "The Simultaneousness of States of Mind in the Work of Art: That is the Intoxicating Aim of our Art." These words must have resonated with Matisse, for this was what he had been aiming at for years, though by different means. If this painting combines imagery of creation with a "symbolism of loss," as indicated by the empty chair, it clearly reflects Matisse's deep sense of personal loss at the time he painted it.

The most strikingly autobiographical of the paintings Matisse did after he returned from Morocco is *Conversation* (Fig. 5.11), which he had probably started at the beginning of his affair with Olga Merson but did not finish until that distressing summer of 1912. *Conversation* represents Matisse and his wife confronting each other with unnerving intensity—he dressed in striped pajamas, she wearing a black-and-green bathrobe. He stands stock-still, his

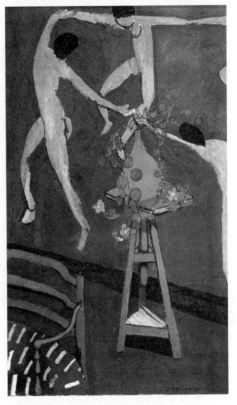

FIGURE 5.10
Matisse, *Nasturtiums with "Dance" (II)*, 1912. 190.5 x 114 cm.

hands in his pockets, upright, rigid, frozen, as if incapable of speech or action. Across from him, larger than life, she returns his blank stare with the dignity and aplomb of a queen. Neither is about to budge: Each is enveloped by the dense silence of the blue room, and each exudes stubbornness and will. As if to emphasize the tension between them, outside the window the world is springing back to life, the grass and trees a vivid green, the red flowers bursting like flames from their beds. Within the encompassing blue of the room, the only indication of any communication is subtly embedded in the almost electrical connection between the woman's black sleeve and the black arabesques of the window grillwork, which seems to suggest movement or articulation: speech.

As we look more closely at the image, we are startled to see that the window grillwork spells out a word—as if in indirect recognition of

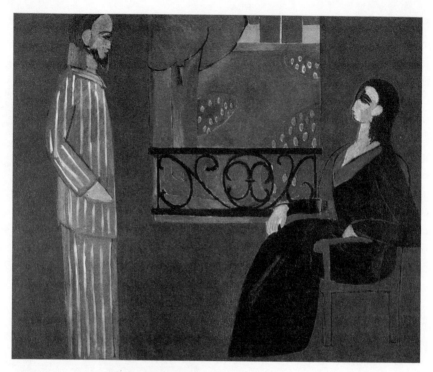

FIGURE 5.11 Matisse, *Conversation*, 1912. 177 x 217 cm.

the typography that Picasso had been using in his painting for the past year or so. That word is "NON"—a symmetrical word that asserts its negation in both directions, and that fixes its limits at the plane of the window, where private life stops and the garden bursts into bloom. As we behold this family drama, the NON becomes emblematic of the space and substance of the room and, by extension, of the married couple contained within its engulfing blueness. The shock produced by this extraordinary image of isolation is intensified when we realize that this is the first of Matisse's paintings in which two people actually face each other.

This is one of Matisse's most psychologically raw and revealing paintings, and it was never exhibited in Paris. The only time it was publicly shown before being sent to Shchukin in Russia was at the second Post-Impressionist Exhibition in London in the fall of 1912. There even so acute an observer as Roger Fry followed the clichés that had been circulating about Matisse—and Matisse's own remarks in "Notes of a Painter"—rather than the evidence before his eyes. Fry asserted that in Matisse's *Conversation* "there is no dramatic tension. This commonplace event is seen with epic generalisation. It becomes placid, monu-

mental, and sedate . . . and in the end one is inclined to agree with Matisse that the mood his art inspires is of security and repose."

<center>⸺∞⸺</center>

DESPITE THE WAY that Picasso's reputation had surpassed Matisse's during the rise of Cubism, the two artists were widely considered the leaders of the avant-garde, in some measure precisely because they were so different. In his essay about the 1912 Post-Impressionist Exhibition, Fry characterized Matisse as singularly aloof and "withdrawn from the immediate issues and passions of life," whereas Picasso's art was imbued with the "concentrated passion, the almost tragic intensity of his mood." As if in recognition that they had indeed achieved their "election" as important artists, Fry stated that Matisse and Picasso together now occupied a position similar to that of Cézanne at the time of the first Post-Impressionist Exhibition in 1910. "No sharper contrast can be imagined than exists between these two men," Fry wrote, noting that it was "one of the hopeful signs of the present movement that it allows of such striking diversity."

6

CROSSINGS

*One day, having met Max Jacob on one of the boulevards,
I said to him: "If I weren't doing what I'm doing, I would
like to paint like Picasso." "Well, that's odd!" said Max.
"Do you know Picasso said the same thing about you?"*

— HENRI MATISSE

At the end of August 1913, Matisse and Picasso sent similar post-cards to Gertrude Stein, who was in Spain. Like diplomatic communiqués, both messages were short. "We ride on horseback with Matisse in the forest of Clamart," Picasso informed her. "Picasso is a horseman," Matisse wrote. "We go riding together. This amazes a lot of people." That Gertrude would be among the amazed certainly pleased Matisse. After a period of cool relations, Matisse and Picasso were now seeing each other again, and this created a stir among the avant-garde. Rather than being regarded as incompatibly opposed rivals, Matisse and Picasso were coming to be seen as the twin leaders of the new art. They were also beginning to feed off each other's work more directly than they had for the past five years and at times were even crossing over directly into each other's territory. Picasso was drawn to the flat planes and abrupt transitions in Matisse's decorative compositions, and Matisse became increasingly involved with Cubist fragmentation.

This rapprochement did not preclude their remaining wary of each other. In the fall of 1913, when the Japanese painter Riichiro Kawashima asked Picasso whether he liked Matisse, Picasso's eyes widened. "Well, Matisse paints beautiful and elegant pictures," he replied. "He is understanding," he added, but refused to say more. Years later, when Kawashima asked Matisse what he thought of Pi-

casso, Matisse hesitated for a moment before saying, "He is capricious and unpredictable. But he understands things."

PICASSO'S RENEWED INTEREST IN Matisse's work seems to have been initiated partly by Braque, who visited Matisse in Collioure during the summer of 1911, while he was working on *Interior with Eggplants*, which Picasso later saw at Sarah and Michael Stein's. Picasso's sharp eye picked up on the way different visual textures were played off against each other in Matisse's large paintings, almost as if they had been laid down in overlapping sheets—so different from his own work, which was built up of small repetitive units without any differentiation between the textures or local colors of the objects represented. Picasso astutely realized that Matisse, whose recent work had seemed quite irrelevant to him, might be pointing the way toward a new aesthetic.

Picasso had good reason to want to move beyond the limited vocabulary of Analytic Cubism at this time. He was becoming impatient with the constraints imposed by the hermetic language he had been working in, which forced him to omit so much of his experience of the world. Such a move also offered the possibility of increasing the scale of his pictures. Ever since Shchukin had commissioned the *Dance* and *Music* panels from Matisse, Picasso had been eager to do a large decorative ensemble. Aside from the question of artistic ambition, he noticed that the large Matisse commissions temporarily cut into his own sales to Shchukin. In 1909 he had taken on a decorative commission from the American collector Hamilton Easter Field, which placed him in direct competition with the large-scale paintings Matisse was doing for Shchukin. Although Picasso struggled with the project for years, he was never able to bring it to a satisfactory conclusion. Because the Cubist style was based on small, highly nuanced brushstrokes, repetitive forms, and severely reduced color, it could not easily be adapted to mural-scale painting.

In the spring of 1912, Picasso began to make greater differentiations between the visual textures in his paintings. A few months later, Braque introduced cut-paper elements into some of his drawings, which are generally acknowledged to be the first *papiers collés*. Picasso followed suit almost immediately, but he elaborated the new technique of collage in a more dynamic and suggestive way. Whereas Braque pasted areas of

wood-graining into his compositions and then painted or drew over them to integrate them into the surrounding space, Picasso allowed the disparate elements he pasted into his pictures to retain their original identity, creating an effect of dissonance rather than harmony. This stylistic dissonance was accompanied by a broadening of his subject matter to include fragments of the detritus of industrial culture. The tension between the handmade and the mechanically produced trompe-l'oeil elements in his work is part of his continued refusal to imitate, but it is also the result of his espousing the ready-made to express new, and specifically modern, social and psychological realities. Picasso's transgression of the boundaries separating the work of art from its surroundings and his expansive exploration of elements taken from popular culture—features of his work that were to have such a profound effect on the course of twentieth-century art—date from this time.

Collage resonated with Picasso's polyglot mentality, as can be seen in one of the first works he did in the medium, *Guitar, Sheet Music, and Glass* (Fig. 6.1). Against a ground of real wallpaper, Picasso sets a real newspaper clipping, a piece of sheet music, a charcoal drawing of a "Cubist" wine glass, and four pieces of cut paper that evoke rather than directly represent a guitar. These pieces of pasted-down paper initiate a radical new system of representation, in which objects are suggested by abstract signs that minimally intervene in a planar field. Whereas Analytic Cubism employed modeled forms that existed in relation to an atmospheric ambience, this new planar mode had a disembodied quality similar to that in Matisse's recent works. But the evocation of objects in Picasso's work is much more elliptical and abstract, and in a sense it is often word-oriented: We do not so much *see* the gui-

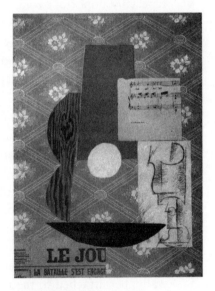

FIGURE 6.1
Picasso, *Guitar, Sheet Music, and Glass*, 1912. 47.9 x 36.5 cm.

tar in this picture as sense that it is being *named*. That process of verbal evocation gives the collage a distinctively linguistic aspect.

Guitar, Sheet Music, and Glass brings together a striking and clearly defined series of different languages: the Latin alphabet and the French language; the language of musical signs; the language of hermetic Cu-

bism; the decorative language of floral design set within a grid; the trompe-l'oeil language of the faux-bois wood texture. Each of these languages is set within a delimited area of the picture space, against which is placed the overriding synthetic language of the undelimited signs that evoke the intangible guitar. It was this especially condensed and arbitrary evocation of the guitar that contained what at the time was the newest of Picasso's sign systems: the intensely planar, discontinuous, and intangible pictorial language that would come to be called Synthetic Cubism. In contrast to earlier Cubist painting, with its sense of breaking down or analyzing form, this new phase emphasizes the notion of combination or synthesis of the forms in the picture. (In linguistics, synthesis denotes the use of inflections rather than the order and function of words to express syntactic relations; the discrete elements within collages can be seen as a series of pictorial inflections that to some degree replace the proper spatial order of things within the picture.)

The newspaper clipping in *Guitar, Sheet Music, and Glass* plays an especially important role, functioning in a way similar to the caption-like words in *"Ma Jolie."* "LA BATAILLE S'EST ENGAGÉ[E]," the headline declares in bold capital letters, referring to the Balkan War that was then raging (outside the picture, of course). But by using only part of the headline (which in its entirety told the reader that "LA BATAILLE S'EST ENGAGÉE FURIEUSE sur les Lignes de Tchataldja"), Picasso also comments on what is happening *inside* the picture. That "battle" is the one between the different styles and sign systems that make up the collage. These are set against each other in a fashion that emphasizes their conflicting claims to validity, in what constitutes a critical appraisal of the possibilities of pictorial representation in late 1912. On a more personal level, the battle extends beyond Picasso's friendly competition with Braque to his more troubled one with Matisse—who is alluded to by the decorative wallpaper. That piece of wallpaper makes direct reference to the rectangle of flowered ocher wallpaper attached to the right side of the screen in *Interior with Eggplants*, which is depicted so flatly and so disjunctively that it produces a remarkably collagelike effect.

BECAUSE BOTH MATISSE AND PICASSO had been away from Paris a good deal during the past year and a half, they had had little opportunity to see each other before the summer of 1913, when they

began to meet regularly again and to visit each other's studios. Matisse had recently returned from his second trip to Morocco, and Picasso had come back to Paris after a very difficult spring. His father had died, after a debilitating illness, on May 13. At that same time, Eva, his new mistress, discovered she was seriously ill, with what was first diagnosed as some sort of pulmonary congestion, perhaps even tuberculosis, but was most likely cancer. Compounding Picasso's feelings of gloom, and no doubt awakening his deep superstition, his beloved dog Frika also fell ill and had to be put down. While painting that spring in Céret, near the Spanish border, Picasso was less closely in touch with Braque, who was at Sorgues. Although Braque had promised to stop by and visit, he failed to do so. After more than four years of working so closely together, they no longer felt "impelled to follow and respond to every move the other made." In June, concerned about Eva's health, Picasso returned to Paris to seek medical advice from Gertrude Stein and Alice Toklas; he may also have sought out the notoriously hypochondriacal Matisse about the matter.

But shortly after Picasso and Eva returned to Paris, it was he who fell ill, with typhoid fever. Matisse, whose empathy was always awakened by illness, came to see him, bringing flowers and oranges. Picasso did not care much for flowers (he sometimes placed them "in waterless containers, remarking that they would soon die in any case") but he took the oranges as a welcome symbolic gesture. (In Apollinaire's essay for the first Matisse-Picasso show a few years later, he would compare Matisse's art to an orange.) Years later, Picasso would buy Matisse's 1912 *Basket of Oranges*, and when Matisse adopted the habit of sending him oranges as a New Year's gift, Picasso would leave them in a bowl on the mantelpiece, where he would point them out to visitors: "Look at Matisse's oranges."

Matisse was much the better horseman, and Picasso normally wanted to outdo everybody in whatever he did, especially in the presence of a woman. Thus, for Picasso to agree to take Eva horseback riding with Matisse was a telling gesture on his part, and indicates his desire to regain a sense of solidarity with the older painter. Given Picasso's love of gossip, he must have been curious for details about the relationship between Matisse and Olga Merson, for he would have known about the liaison from the Steins. But Matisse, ever on his guard, would certainly not have been inclined to discuss his private affairs with Picasso, or to inquire about his. The affair with Olga Merson must have lingered in Picasso's mind as another instance of his friend's

unfathomable reserve. Years later, when Matisse was living with Lydia Delectorskaya, Picasso would complain about Matisse's persistent refusal to give any information about his private life.

THE RENEWAL OF THEIR FRIENDSHIP was most obviously beneficial to Matisse, who had come to be seen as a has-been by a number of avant-garde artists and writers. His being taken up by Picasso gave him a

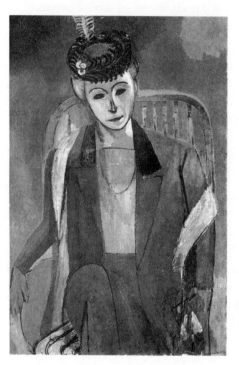

FIGURE 6.2
Matisse, *Portrait of Mme Matisse*,
1913. 145 x 97 cm.

new credibility in their eyes, in part simply because Picasso was paying so much attention to him, but also because he was beginning to reconsider his contact with Cubism. Matisse's Moroccan works, which were exhibited at the Bernheim-Jeune Gallery in April 1913, had already indicated that he was looking carefully at Cubist painting. And when he showed the striking *Portrait of Mme Matisse* (Fig. 6.2) as his only entry at the 1913 Salon d'Automne, the Cubist critical establishment—probably with Picasso's encouragement—got behind him. The usually antagonistic André Salmon wrote that this was a painting "that can satisfy those whom he satisfies least often . . . it sums up the most beautiful qualities of this artist who is so dangerous a master." Salmon noted that Matisse had always had difficulties with the human face: "Here again, his woman in blue is covered by a wooden mask smeared with chalk and is once again a figure in a nightmare, quite a harmonious nightmare."

More significant was Apollinaire's unreserved enthusiasm for the painting, which he wrote about twice. In his first review he called it a masterpiece, "the most voluptuous painting that has been done in a long time," and emphasized Matisse's position as an artist apart from the major trends of his era. In another article published the very next

day, Apollinaire declared that along with *The Woman with the Hat*, the portrait was "the best thing Matisse has done." Apollinaire asserted that "never has so much life been given to color," and went so far as to say that the painting inaugurated "a new era in Matisse's art, and perhaps even in contemporary art, from which voluptuousness had almost entirely disappeared."

Apollinaire notwithstanding, thoughts of voluptuousness and rich color are hardly the first qualities that come to mind when one looks at the painting. The woman is ghostlike, and so are her surroundings. The unusually specific rendering of her jacket and charming hat serve to emphasize the contrast between the sedate way she is dressed and the intense emotion expressed by the tragic mask of her face. Salmon was closer to the mark when he compared the face with a mask, for its symmetry and simplifications recall West African chalk-faced masks, which represent spirits or ghosts. (Picasso owned a very fine example.) Matisse had worked on this portrait for several months—his wife sat nearly a hundred times for it—and Picasso saw its evolution on his visits to Matisse's studio. It had begun as a fairly realistic depiction of Amélie Matisse, in which she had looked quite lovely, and she is known to have wept when this likeness was painted over. This kind of divergence from literal representation was not uncommon in Matisse's portraits, so Amélie's sadness probably was not due solely to her fondness for the first rendition. Knowing her husband's unwavering artistic honesty, she no doubt knew as soon as she saw herself virtually annihilated and reconstituted as a kind of tragic ghost that there was no hope for their marriage.

———

Despite his reintegration into the avant-garde, Matisse had reason to be disquieted. The portrait of his wife, in which the paint is violently scratched and scraped as well as brushed, and in which the forms are jarringly discordant, was one of the most difficult paintings he had ever done, and one of the driest in color. With its eradication of the nominal subject, its masklike face, and its mannequin-like articulation of the arms, it contained Matisse's clearest acknowledgment of Cubist painting. Yet here was Apollinaire, praising its supposedly rich color and voluptuousness. Matisse could not have failed to perceive that at the very moment he was beginning to move toward Cubism, Apollinaire was complimenting his painting for virtues that had little to do with ei-

ther the picture's appearance or Cubism. Apollinaire, whose book *The Cubist Painters* had just been published, seemed to be more concerned about defending Picasso's position than with advancing Matisse's.

Although Matisse's portrait owes an obvious debt to Picasso's Cubism, the affinity is with Picasso's Cubism of a year or two earlier rather than Picasso's most recent works—which in fact were becoming rather Matissian. This moment of intersection is especially interesting because the two artists seem not only to be acknowledging their mutual debts and respect, but also to be reasserting their own personalities on each other's terrain. In the *Portrait of Mme Matisse*, for example, the forms are not so much pulverized as expressively distorted—and thus they resist Picasso at the same time they acknowledge him. The painting is also as Cézannian as it is Cubist, and its reference to African masks is extremely aggressive. Picasso's recent paintings had generally cast aside the issue of depicting recognizable or expressive human faces. And if the rendition of a recognizable face had become more or less an impossibility in Cubist painting, that was all the more reason Matisse wanted to forge such a bold image of his wife's face. Henceforth, the two artists would typically borrow from each other in this fashion. They would not simply borrow directly. Rather, each would discover aspects of himself in the other, and therefore of the other in himself. "There is no question that we each benefited from the other," Matisse later said. "I think that, ultimately, there was a reciprocal interpenetration between our different paths."

ALTHOUGH THIS EPISODE IN their friendship is often regarded in terms of how Matisse, through Picasso's helping hand, could be reintegrated into the avant-garde, Picasso had his own deep reasons for wanting to renew his contact with Matisse at this time. He had always thought of Matisse as a kind of father figure, so it was natural to turn to him after his own artist-father died. Eva's illness made him feel unusually vulnerable. And there was also a good deal of artistic self-interest involved. He had seen in Matisse's recent work something he could make use of, and at that time an alliance with the older artist would serve as a counterweight to the strong association that had been established between Picasso and Braque. Their longtime partnership had reinforced Picasso's feeling that he was much the better artist, and in addition to seeking a greater challenge, he was probably eager to see an

end to the constant pairing of his name with Braque's, and of the partial loss of identity that alignment entailed. This embrace of Matisse at a time when Braque was becoming less useful to him as a source of inspiration echoes the way Picasso felt impelled to shed the woman in his life at times of artistic change.

Matisse's portrait of his wife provoked a direct response from Picasso. In the fall of 1913, Picasso settled into his new studio on the rue Schoelcher—a curious choice for a superstitious man with an ailing mistress, for it overlooked the Montparnasse cemetery. There he began work on a painting of Eva, *Woman in an Armchair* (Fig. 6.3). Picasso had been making mostly collages and collagelike paintings at this time, but his response to Matisse prompted a radically different vocabulary from that in any of his other Cubist paintings. The anatomical elements here are more clearly fleshlike, and the woman's geometrically defined body is set within a sur-

FIGURE 6.3
Picasso, *Woman in an Armchair* (Eva), 1913. 148 x 99 cm.

prisingly realistic armchair, complete with cast shadows and a glimpse of decorated fabric. If Matisse's portrait of his wife was to some degree dematerialized by his acknowledgment of Picasso's Cubism, the greater physicality and more specific setting in Picasso's representation of Eva is a clear bow in Matisse's direction.

Picasso very much wanted to convey Eva's vivid physical presence in *Woman in an Armchair*. He later recalled Apollinaire saying that when he looked at the woman in this painting, he wanted to lift her silk underskirt. To which Picasso had replied: "You can see very well that she's a real woman; that she's really got what she's hiding." While looking at the painting with Braque, Picasso had asked: "Is it a woman or a picture? Do her armpits smell?"

In its own way, *Woman in an Armchair* is as relentless a depiction of Eva as Matisse's painting is of Amélie. We see the woman not only partially undressed but almost as if partially dissected, alternating between

outer and inner views of her body, though not in a consistent way. Her masklike triangular face and long wavy tresses float above her body as if detached from it. Her breasts seem to be virtually nailed onto her tubular torso, and that slim torso is contained within yet another, broader representation of her torso, hips, and legs—as if her body has been split open, like a carcass in a butcher's shop, to reveal another body inside it. The unsettling representation of her meaty ribs situates them both within and outside the bounds of her body, and even the intricate folds of her silk underskirt suggest her intestines as well as an undergarment.

The surprising fleshiness of this painting seems to have been provoked by Eva's illness, and the painting is a moving testimony to Picasso's awareness of the simultaneous attraction and feebleness of her flesh. To hide his distress about Eva's illness, Picasso would "shock people by saying that he should have left Eva with Marcoussis and landed *him* with her doctor's bills," but the depth and complexity of his love for her come through strongly in this painting. It has been suggested that the nailed-on breasts connote a mastectomy, and "even that the painting was in the nature of an ex-voto." In a way, the painting anticipates the surgery that Picasso and Eva knew would soon be necessary, and that she in fact underwent the following spring. Picasso believed in the magical and apotropaic qualities of painting—"if we give form to the spirits, we become independent of them"—and he may have hoped to effect his own kind of surgical cure through the magic of his art; perhaps, in a way, he aimed to compensate for his inability to prevent the death of his sister Conchita almost twenty years earlier. But he would be no more successful this time than he had been then.

ON MARCH 2, 1914, an important auction featuring works by Matisse and Picasso was held at the Hôtel Drouot in Paris. The collection belonged to an association called La Peau de l'Ours (The Bear's Skin, named for a fable by La Fontaine), which had been founded in 1904 by André Level for the express purpose of buying modern art, holding it for ten years, and then selling it for a substantial profit. The association's annual budget was fixed at 2,750 francs a year, and with that money the group acquired 145 works, including ten paintings by Matisse and a dozen paintings and drawings by Picasso. Although the purpose of La Peau de l'Ours was primarily speculative, the investors be-

lieved their undertaking could further the cause of modern art by establishing a sound financial value for it. In the interest of fairness, they agreed that each living artist would receive 20 percent of the profit from the resale of his work. (Not until 1920 would this resale principle, known as the *droit de suite*, be incorporated into French law.) The auction was preceded by a carefully orchestrated publicity campaign that turned the event into "a forum for the aesthetic, political, and economic estimation" of the works in the collection.

The sale brought in a total of 116,545 francs, on an investment of 27,500 francs over a ten-year period, irrefutably establishing the desirability and financial value of early-twentieth-century art. (This was equivalent to more than 400,000 dollars in 2002 dollars.) The highest prices were paid for the paintings by Matisse and especially Picasso, whose 1905 *Family of Saltimbanques* sold for 12,650 francs. (Level had acquired it directly from the artist for 1,000 francs at the beginning of 1908, a time when Picasso was especially short of cash.) Picasso carefully recorded his earnings from the overall *droit de suite*, down to the last centime, as 3,978.85 francs (which constituted nearly 20 percent of his entire income in 1914). Matisse's share from the sale was approximately 2,000 francs.

The Peau de l'Ours sale established the two artists' preeminence in the marketplace on the eve of World War I and established a model for the integration of modern art into the mainstream of the French economy that would help to make both men rich during the following decade.

THE ARTISTIC DIALOGUE BETWEEN Matisse and Picasso became quite active and varied during the next few years. One of the Matisse paintings most obviously affected by the vocabulary of Analytic Cubism was his 1914 *Portrait of Mlle Yvonne Landsberg* (Fig. 6.4), which Matisse undertook as a commissioned portrait, but with the understanding that he would have free rein in how he painted it and that the Landsberg family would not be obliged to buy it. In this painting, the monochromatic austerity of the color, the repetitive organization of the forms, and even the setting of the figure within the rectangle of the canvas clearly refer to Picasso's Cubist works of 1910–1912, such as *Girl with a Mandolin* (see Fig. 5.5) or *"Ma Jolie"* (Fig. 5.6). But even as Matisse accepts Cubist conventions, he also resists and "corrects" them, as if to offer Picasso a lesson about what his Cubist paintings might have lacked. In

place of the overriding angularity of Cubist paintings, Matisse's picture is full of expanding curves, scratched into the surface with alarming rawness, which not only dematerialize the forms of the woman but draw her inner energy out to the space around her.

FIGURE 6.4
Matisse, *Portrait of Mlle Yvonne Landsberg*, 1914. 147.3 x 97.5 cm.

For all its abstractness, *Portrait of Mlle Yvonne Landsberg* is also meant to convey the quintessence of its specific subject, whereas Cubist paintings had to a large degree effaced their subjects' identities. Like the 1913 portrait of Matisse's wife, this painting was done directly from the model and required many sittings. And like that earlier portrait, it began naturalistically and then was progressively abstracted until the woman seems to exist in another time and space. Yvonne Landsberg's brother, who accompanied her to the sittings, was struck by how the less the painting came to resemble her physically, the better it conveyed her personality. It was not until the last sitting that Matisse scratched the radiating lines into the paint surface with the handle of his brush, largely deconstructing the mass of the figure he had worked so hard to build up. Although Matisse obviously took his inspiration from Cubist and Futurist works, he turned them very much to his own ends, transforming the woman, with her radiating plantlike tendrils, into a Matissian flower-woman. This painting uses a Cubist-Futurist point of departure to bring together several of the artistic, intellectual, and spiritual concerns that Matisse associated with Cubism and that he had not been able to express quite so clearly with his usual vocabulary. The association of the young woman with a flowering plant, and the sense of the unfolding of a life at its beginning, full of possibilities, are clearly felt in this mysterious and compelling image—which the Landsbergs, after some hesitation, decided was not sufficiently portraitlike and declined to buy.

THE NEW BOLDNESS AND FREEDOM in the handling of form that Matisse derived from Picasso's Cubism are expressed in a number of

works he created around this time, most notably in the deep blue *View of Notre Dame* of 1914, whose linear structure echoes the scaffolding of Picasso's 1912–1913 collages, and in the brooding, nearly abstract *French Window at Collioure* of 1914, one of Matisse's most somber paintings, dominated as it is by a large black rectangle that evokes a vision into a night of utter darkness.

Picasso, on the other hand, was particularly drawn to the monochromatic blue backgrounds in several of Matisse's paintings at this time, and some of his works reflect this interest. His *Green Still Life* of 1914 is a direct response to Matisse's *Blue Window* of 1913, another work he would have seen in Matisse's studio. In *Green Still Life*, Picasso (who had already had his Blue Period) has adopted the idea of having the background of the painting keyed to a single, richly brushed, and densely saturated color. His attitude toward objects has also changed. For the past several years, the objects he depicted had been subsumed by the structures of his paintings. Now, following Matisse, he gives new emphasis to the specific character of the individual objects. As in Matisse's paintings, they become actors, as it were, in the pictorial drama of the picture, which is enlivened by the energetic linear movements that connect them to each other.

Portrait of a Young Woman (Fig. 6.5), which is believed to represent Eva, seems to be another response to Matisse's 1913 portrait of his wife. The woman is set within the canvas in a way that recalls the Matisse painting, and like Amélie Matisse, she sports a rather fanciful hat. The ground color is again an overall vivid green, and Picasso playfully sets a variety of visual textures against it. Most striking are the collagelike fragments of floral patterning that (like the floral patterning in Matisse's paintings) are not pasted in but are painted to resemble collage—a witty

FIGURE 6.5
Picasso, *Portrait of a Young Woman*, 1914. 130 x 97 cm.

reversal of the intentions that had led to collage in the first place, and not without an edge of self-mockery. Played against these planar forms is a kind of Neo-Impressionistic stippling, which Picasso employs to enhance the parodistic quality of the picture as a whole. He also plays two differ-

ent conceptions of the head against each other—one a black, planar, backward-B shape that is reminiscent of the form he had been using to

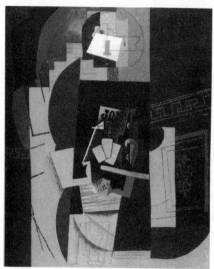

FIGURE 6.6
Picasso, *Card Player*, 1913. 108 x 89.5 cm

depict guitars and heads in his collages; the other a kind of masklike stippled trapezoid in greens and whites, which appears to function somewhere between a veil and a face. At the same time, the dispersal of the forms over the surface of the canvas is so thorough that the woman's body is difficult to locate, and the geometric tilt of the trompe-l'oeil moldings offer considerable resistance to the Matissian notion of the integrity of the object.

This new vocabulary, in which Picasso mixes Matisse-based decorative elements with the fractured planes of Synthetic Cubism, also exerted a reciprocal influence on Matisse. Picasso's *Card Player* of 1913 (Fig. 6.6), with its abbreviated decorative motifs and its paradoxically luminous use of black, seems to have been one of the sources of inspiration for Matisse's great *Goldfish and Palette* of 1914 (Fig. 6.7). The fracturing of the subject in *Card Player*, which is so pervasive that the presence of the figure is barely separable from the table in front of it, appears to have intrigued Matisse. The dramatic lighting, the way the decorative molding is separated and laterally skewed, and the way the face is transformed into a kind of architectural structure all have their counterparts in Matisse's painting.

———

THE GREATER SOBRIETY THAT characterized many of both artists' wartime paintings is abundantly evident in *Goldfish and Palette*, one of the first works Matisse did after the war broke out. This painting began as a clear self-portrait (Matisse included a sketch of it in a letter he sent to a friend, the painter Charles Camoin) and gradually evolved into a more abstract representation. But even in the finished painting, Matisse includes more than just his palette, for the right side of the picture contains clear indications of his legs, his left arm, and an abstract version of his upper body and head, translated into architectonic forms clearly rem-

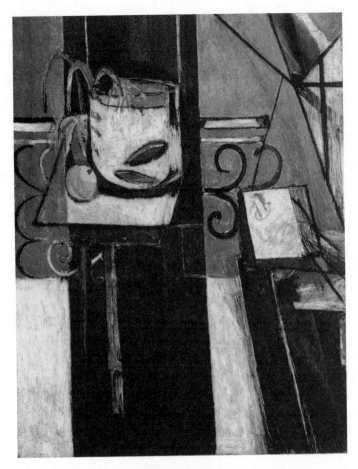

FIGURE 6.7 Matisse, *Goldfish and Palette*, 1914.
146.5 x 112.4 cm.

iniscent of Picasso. The presence of the artist's body within the painting
is a crucial part of its dialogue with Picasso, and of its meaning; in fact,
Artist and Goldfish would be a more appropriate title for the painting,
since so much of the artist is represented. The ambiguous and difficult-
to-read body of the artist reflects Matisse's desire to push close to Pi-
casso's combination of representation mixed with near-illegibility. It also
provides the basis for the central drama of the painting, which is the ten-
sion between internal and external versions of what we see before us.

In Matisse's previous paintings, the integral quality of the body and
face had been of paramount importance. In this painting, Picasso's Cu-
bism has affected not only the abstraction, the planarity, and the frag-
mentation of the window grillwork but also the dispersion of the forms
of the figure into an architectural scaffolding that makes it almost un-

readable—as had been the figures in so many of Picasso's recent works. In *Goldfish and Palette,* Matisse builds on the way Picasso was flattening and fracturing the planes in pictures such as *Card Player*—in effect, reworking Picasso's versions of ideas that Picasso had himself based on Matisse's earlier works.

This painting is one of Matisse's most resonant and somber works and one of his most introspective. In it we see him quite literally as he "sees" himself, in his mind's eye, in the act of painting. The nominal subject of the goldfish is more clearly focused in his eyes than is his own troubled being, which is composed of a complexly skewed network of lines and angles, violently intersecting and overlapping planes, and roughly scraped and scumbled aftershocks and afterthoughts. The image as a whole—not only its subject but also its tensely worked surface and provisional placement of forms—is like a projection of Matisse's inner state of being laid down coterminously over a description of the external world. The conflation of such dual realities draws on psychological aspects of Picasso's previous work as well as on formal properties that Matisse adapted from the paintings of both Picasso and Gris, especially the vertical banding and the intensely fractured representation. One of Matisse's strongest innovations in this picture is a practice he would build on many times in his career and that Picasso would also pursue: the evocation of light through the color black.

The sheer force of this painting, which so well caught the dark mood of the beginning of the war, made a deep impression on everyone who saw it. Years later, when André Breton negotiated its resale to Jacques Doucet (along with *Les Demoiselles d'Avignon*), he wrote, "I believe Matisse's *genius* is here, where everywhere else there is only his talent, which is immense. . . . I am persuaded that nowhere else has Matisse put so much of himself as in this picture."

PICASSO WAS DEEPLY IMPRESSED by Matisse's *Goldfish and Palette,* and its emotional force and resonant use of black seem to have influenced his 1915 *Harlequin* (Fig. 6.8), one of his most austere and moving paintings, and one in which his previous preoccupation with multiple identities assumes a new importance.

In his early work, Picasso had frequently represented harlequins, who often served as surrogate self-portraits. But he had painted none after 1909, when his subject matter became more abstract. In the fall of

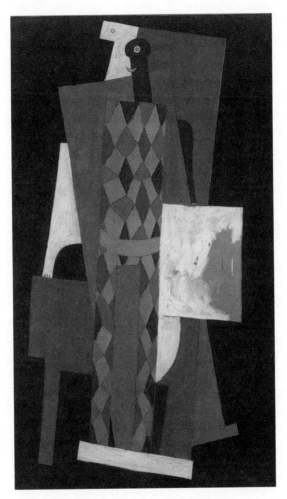

FIGURE 6.8 Picasso, *Harlequin*, 1915.
183.5 x 105.1 cm.

1915 he returned to the harlequin theme, at a time when he had begun
to work in two widely divergent modes: At the same time that he was
working on abstract and planar Cubist works, he was also doing a se-
ries of pencil portraits of his friends and acquaintances that were metic-
ulously rendered in a style reminiscent of Ingres's drawings.

The 1915 *Harlequin*, with its somber colors and its odd mixture of
the deadly serious and the bitterly comical, reflects Picasso's dark state
of mind at this difficult time in his life. Eva's health had become much
worse. By the fall of 1915 she was hospitalized and clearly was about
to die. A letter Picasso wrote to Gertrude Stein on December 9, just five
days before Eva's death, describes his situation: "My life is hell. Eva is

still ill and gets worse every day, and now she's been in a nursing home for a month already. . . . I hardly work any more at all. I run back and forth to the nursing home and I spend half my time in the Métro. I haven't had the heart to write to you."

In the course of its execution, *Harlequin* seems to have undergone an important transformation. In a series of related watercolors, Picasso depicted a dancing couple, but as the painting evolved, the two figures were conflated into a single haunting and mysterious being. If *Harlequin* builds on Picasso's experiences with collage, it does so on a larger scale, with a broader formal vocabulary and a richer sense of surface texture. The figure is set within the somber darkness of the black background, against which are played the planes of the brown table and the boldly abstracted forms of the harlequin himself. Especially striking is the way Picasso pulls the image of the harlequin apart, as if combining two different personages within a single figure. The white forms of the hand that touches the table, and the squarish white area that contains the harlequin's right eye, are quite literally detached from the main area of his body. The black side of the schematically rendered head is articulated in the most minimal way, with a small circle for the eye and a simplified rictus for the mouth.

Harlequin is one of Picasso's first clear images of a divided personality, of two figures conflated into one, as if to suggest two different psychological realities within the same person—not entirely at odds with each other but not quite in harmony, either. This evocation of multiple identities is given an added dimension by the rendering of the white rectangle next to the harlequin's body, which is only partly painted. This can be interpreted either as a palette, or—because of the ghostly image of a head in profile, formed by the unpainted part of the rectangle—perhaps as an unfinished canvas. (This profile remains hauntingly present once it has been noticed, and Picasso almost certainly intended it.) Because this rectangle is rendered in a painterly way, it also suggests—quite independently of how we may read it as the representation of a *thing*—the *process* of painting itself. Or, perhaps more to the point, it is a reminder of the impossibility of completeness, either in painting or in life. This enigmatic rectangle, which stands for the ambiguities of "painting" itself, is the most disquieting part of this disquieting picture—and also one of the most suggestive, in the way that it anticipates the range of representational languages Picasso would make use of in the years to come.

It is understandable that when Matisse saw *Harlequin* at Rosenberg's gallery, he told the dealer his goldfish had led to it, for in this

painting Picasso has picked up on precisely those aspects that Matisse had taken from *him*, such as the conflation of the figure with its surroundings, the suggestion of different psychological viewpoints, the fractured planarity, and most especially the situating of the picture in a space that lies somewhere between the thought and the seen, the internal and the external. In *Harlequin*, Picasso responds with his own version of multiple realities, along with the strong sense of process and the strikingly original use of black as an element to evoke both light and darkness that he took as lessons from Matisse's painting.

Picasso was especially proud of the recently finished *Harlequin*, which he mentioned at the end of his December 9 letter to Gertrude Stein: "I've done a picture of a harlequin, however, that I think in my opinion and in the opinion of several other people is the best I've ever done. Mr. Rosenberg has it. You will see it when you get back to Paris. In the end, my life is very full, and as always I don't stop working."

Among the "several other people" who had said the painting was Picasso's best was none other than Matisse, who had seen it at Rosenberg's gallery in late November. Rosenberg reported this to Picasso in some detail.

The master of "the Goldfish" was, like me, somewhat taken aback. Your "Harlequin" is such a revolution within your work that even those who were used to your previous compositions are a bit thrown off by it. I put the "Harlequin" next to your "Green Still Life," and you cannot imagine to what degree the latter picture, while completely retaining its magnificent painterly qualities, seemed relatively small in conception, a little "constructive game" treated with tact and sensibility. In the "Harlequin" Matisse found that the means were in accord with the action, that they were equal to it, while in the still life there were only *means*, very fine in quality but without an object. Finally, he expressed the opinion that it was "his goldfish" that had led you to the harlequin. To sum up, though surprised, he couldn't conceal that your picture was very fine and that he had to admire it. In my opinion, this work of yours is going to influence his next picture.

SHORTLY AFTER THE WAR STARTED, most of the younger French artists had left for military service. Apollinaire, who was eager to obtain French citizenship, went into the army almost immediately, as did

Braque, Derain, and Léger. Matisse, who was then forty-four, tried to enlist but was rejected because of his age. Picasso, as a Spanish national, was exempt from service and was all too happy not to go. (This irritated his friends. When Derain came home on leave, Picasso wrote to Apollinaire that "he went to see Matisse but did not come to see me.")

During the war, with most of their friends at the front, Matisse and Picasso saw a good deal of each other. When their friends did come home for more than brief leaves, it was usually because they were gravely wounded. Both Apollinaire and Braque suffered near-fatal head wounds and spent long periods in the hospital. In such circumstances, the very act of exhibiting was now open to mixed interpretations—especially for noncombatants like Matisse and Picasso. Since the Salons had been suspended, Matisse did not have his usual avenues open to him. And since Kahnweiler's stock had been sequestered as the property of an enemy alien, much of Picasso's work was unavailable.

Up until this time, Picasso had consciously avoided excessive exposure and commercialization of his art. But during the war, both he and Matisse were put in a very delicate position. In addition to not being in the army, both had strong prewar foreign connections. Matisse had long been associated with non-French collectors and students, a number of them German. Picasso was a foreign national associated with Cubism, a style that had been promoted by German dealers (notably Wilhelm Uhde and Kahnweiler) and that during the war had come to be labeled as *"Boche"* (Kraut). Both Matisse and Picasso therefore made an effort to participate in events that celebrated French culture or supported various aspects of the war effort. At the end of 1915, both artists donated works to an art raffle meant to benefit Polish artists who had become victims of the war; the following spring they donated works for a sale organized to benefit the Association for Blind Soldiers; and in May 1916 they cosponsored a "Granados-Satie" concert. They were also eager to participate in art exhibitions that were framed in a nationalist context. So when the couturier Paul Poiret decided to mount an exhibition called "L'Art Moderne en France" at his rue d'Antin salon in July 1916, both felt obliged to participate.

That this was a departure from Picasso's usual practice did not escape Juan Gris, who told Picasso that he was astonished to learn of his participation in such an event. According to Gris, Picasso replied "that during the war he had not turned down any French art shows lest people thought badly of him. For him, as for Matisse . . . to refuse to take part in shows here after having sold so many pictures abroad would

look odd." Matisse sent two paintings to this exhibition, one of a Moroccan woman, the other a still life. Picasso's contribution was more succinct but more significant. He had originally intended to send an ambitious recent picture, the large *Seated Man*, but he did not finish it in time for the exhibition. Instead he sent the even more ambitious *Les Demoiselles d'Avignon* (see Fig. 3.8), which was only now given its first public viewing. Showing this painting at the height of the war was an especially bold gesture. Not only was it sure to attract a certain amount of venom on purely artistic grounds, but its violence and fragmentation could be understood to incarnate the violence of the war itself.

Reactions were mixed. Some expressed astonishment that such an exhibition would even be mounted. "Would anyone ever have believed that we would see an art opening in wartime?" the critic for *L'Intransigeant* asked. But he then went on to praise Matisse's "seductive" color and to call Picasso's painting "overwhelming." Predictably, some of the press notices were openly xenophobic. In an apparent reference to Picasso, one reviewer proposed that the foreign artists "who wrongly didn't make any distinction between painting and the tango" ought to be sent back to their own countries: "The time for tests and experiments is over, we now have to decide to build. And when the new house is ready, the buffoons will have nothing more to do in our country, they will gather up their rags and return to the lands that they never should have left."

Les Demoiselles d'Avignon drew an especially strong reaction. One critic wrote that

> The Cubists are not waiting until the end of the war to reopen hostilities. At Poiret's gallery they are showing nude women who are spread in pieces over the four corners of the canvas: here an eye, there an ear, further on a hand, up above a foot, down below a mouth. Mr. Picasso, their leader, is perhaps the least disheveled of the whole lot. He paints, or rather daubs, five women who to tell the truth have craggy faces but whose limbs hold together. Moreover, they have pig-like snouts and their eyes wander carelessly above their ears. . . . Some Fauves, Matisse, Marquet, Flandrin, are shown nearby the Cubists. One shouldn't confound the Fauves with the Cubists. The Fauves are uncompromising about color but they don't chop up their forms the way the Cubists do and they don't scatter disconcerting parallelepipeds throughout their works.

This kind of negative criticism was of course not new. A few years earlier Apollinaire had noted that when one of Matisse's collectors was

going blind, the man's family blamed it on the Matisse paintings he owned; and Cubist paintings had frequently been described as incomprehensible signs of mental unbalance. But the wartime context gave such criticisms an especially ugly edge. The following year, when the absurdist ballet *Parade* (written and designed by Erik Satie, Jean Cocteau, and Picasso) was staged at the Théâtre du Châtelet in Paris, the audience became enraged and began to yell *"Sales Boches!"* (Dirty Krauts!) Picasso, fleeing his box as the audience also began to shout his name, was relieved to run into Matisse and cried out to him, "Ah! How happy I am to meet a real friend in such circumstances." The audience seemed ready to go on a rampage until Apollinaire stood up, dressed in his army uniform and with his head still wrapped in bandages, and managed to calm them.

IN THE MIDDLE OF THE WAR, both artists were especially interested in large-scale works. Matisse, responding in part to the austerity of the Picasso *Harlequin*, was inspired to do some of his largest and most abstract paintings, such as *The Piano Lesson*, *The Moroccans*, and *Bathers by a River* (Fig. 6.9), all of which to some degree utilize an implied grid.

Matisse originally had begun *Bathers by a River* in 1909 as a third panel for Shchukin's *Dance* and *Music* commission, and he had returned to it during the summer of 1913, when he began his serious engagement with Cubist painting. In 1916, heeding Picasso's *Harlequin*, Matisse took the painting even further toward abstraction, putting new emphasis on the collagelike disjunction of the forms and the dense black vertical bands. These vertical rhythmic elements both separate and unite the figures and become the determining syntactical element of the picture space, transforming the pastoral scene into an awesome vision that has a more extreme pictorial autonomy than anything Matisse had done before. The figures in this painting appear to hover in a severely abstracted space, and to exist virtually as ideas as well as things. In Picasso's Analytic Cubist paintings, this kind of effect had been achieved by avoiding the depiction of the full figure and of its surrounding space. In *Harlequin*, Picasso had devised an ingenious way of making the figure stand without seeming to take up space. In *Bathers by a River*, Matisse builds on what he had learned from Picasso's *Harlequin* and achieves a similar level of abstraction without sacrificing ei-

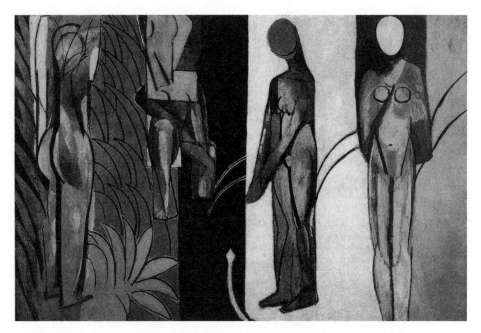

FIGURE 6.9 Matisse, *Bathers by a River*, 1916. 261.8 x 391.4 cm.

ther the fullness of the figures or their surrounding space, and he makes
the moments of illegibility especially telling by the way he plays them
against the general legibility of the picture as a whole. As a result, the
moments of difficult legibility induce a kind of metaphysical vertigo, in
which the continuous fabric of the world momentarily seems to falter
at the edge of an abyss.

Typically, Matisse arranges this and related pictures in terms of con-
trasts between the extreme rigidity of the vertical banding and the
sharp curves that play against it, inflecting the entire surface with a
counterpoint between straight and curving rhythmic beats. How differ-
ent a composition *Bathers by a River* is from the relentless angularity
of Picasso's contemporaneous *Seated Man*, which was one of Picasso's
most ambitious attempts to expand the scale of Cubist painting in com-
petition with Matisse's large paintings. In expanding his scale, Picasso
created forms that were quite literally meant to look architectural. The
stippled marks on the broad vertical planes suggest the walls of Amer-
ican skyscrapers, which Picasso had admired in photographs he had
seen in the American magazine *Architectural Record*. Picasso would in-
corporate a similar kind of double entendre into the costume of the
American manager in *Parade*. His work on that ballet, especially the
enormous curtain, would provide a further stimulus for him to work

on a large scale, and the zany variety of musical and literary styles in the ballet also pushed him toward a greater disparity of style—and toward a greater theatricality in the presentation of his subjects.

<center>—∞—</center>

TOWARD THE END OF 1916, Matisse was at the height of his engagement with Cubist pictorial language. But just when his work seemed to be moving toward pure abstraction, it suddenly turned in another direction—toward a surprising naturalism and a new sensuality. The stimulus for this shift in style seems to have been a model named Laurette, of whom virtually nothing is known, except that she probably had two sisters who sometimes posed with her. Matisse apparently became madly infatuated with this woman, and he painted her incessantly throughout the following year. Her presence so dominates his work at this time that—to borrow from the kind of categorizing applied to Picasso—it could be labeled his "Laurette Period."

With Laurette, Matisse begins to work in a serial manner unlike anything he had done before. In the forty or so pictures he did of her, he represents her in widely varied moods, wearing her hair in very different ways, dressed in many different kinds of clothing—and often even seeming to have very different personalities. Nowhere in his previous work is there such an obsessive fascination with a single person. It is with Laurette that he begins to develop the odalisque theme that would dominate his work in the 1920s, and she becomes a harbinger of the new sensuality that would reign in his work after the war.

Then quite abruptly, in the fall of 1917, Laurette suddenly disappears from Matisse's work, lingering only as a ghostly presence in the form of the Dream-of-Desire statue visible through the window of *The Music Lesson* (Fig. 6.10), which was the second, and last, painting Matisse did of his whole family together, and his last representation of the *Reclining Nude I* sculpture that he had begun to use in his paintings at the time of Olga Merson.

The Music Lesson is a pendant to the Cubist-inspired *Piano Lesson*, painted exactly a year earlier, and it confirms Matisse's return to a greater naturalism. Despite its loose rendering and the impression it gives of having been done in a single sitting, almost like a large watercolor, *The Music Lesson* bristles with tension. The sensuality of the voluptuous nude and of the teeming landscape around her contrast vividly with the banal interior. The disparity between the artist's family and the scene in

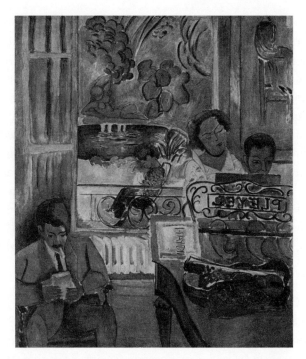

FIGURE 6.10 Matisse, *The Music Lesson*, 1917.
244.7 x 200.7 cm.

the garden is made all the more unsettling by the way the enormous nude
sculpture quite literally overwhelms Amélie Matisse, who sits just outside
the window, sewing. Only we, the viewers, share the artist's vision of the
lush world that beckons beyond his uncomprehending family—who are
as unaware of what is going on in the garden as they are of what is going
on inside of him. "One can't live in a house too well kept," Matisse later
observed. "One has to go off into the jungle to find simpler ways which
won't stifle the spirit." The view through the window here is like an
image of that "jungle"—which we see depicted as if we are looking over
the painter's shoulder, a perspective that allows us to share his vision of
himself in relation to his family and the world beyond it: his passionate
vision of nature, and his dream of desire.

ON JANUARY 23, 1918 the dealer Paul Guillaume opened a three-
week exhibition of works by Matisse and Picasso in his gallery on the
fashionable rue du Faubourg Saint-Honoré. This show was presented
as a collaborative effort meant to celebrate their preeminent position as

leaders of the avant-garde at a time when the end of the war was in sight and an especially prosperous art market was expected to emerge. It was the first exhibition in which the two artists were exclusively paired, and it has remained a landmark in the rivalry between them.

Guillaume, an ambitious, self-made man, knew both artists fairly well. He had unsuccessfully tried to become Picasso's main dealer in 1914 when Kahnweiler's gallery closed, and he was involved in selling or brokering the sale of works by Matisse on the secondary market. Guillaume was also a shrewd promoter of both African art and modern art, and he devised what was then an unusually high-powered publicity campaign for the show. In addition to a slim catalogue printed on fine paper, he had posters printed, and he sent out a press release that provided a ready-made historical context for anyone who might be interested in writing about it:

> M. Paul Guillaume, whose taste cannot be spoken of too highly, just had the most unusual and unexpected idea, that of bringing together in the same exhibition the two most famous representatives of the two grand opposing tendencies in great contemporary art. As one can guess, the artists in question are Henri Matisse and Pablo Picasso.
>
> The brilliant work of the former opens new routes from impressionism, and we are well aware that this vein of great French painting is far from being exhausted.
>
> The other, to the contrary, shows that this rich perspective is not the only one open to the artist or the collector, and that the concentrated art that produced the curiously contemporary aesthetic of cubism is connected via Degas, via Ingres to the highest traditions of Art.
>
> This will be a sensational exhibition and will be a milestone in the artistic history of our time.

For the catalogue, Guillaume turned to Apollinaire, who wrote two one-page essays, printed facing each other. (The poet also ghostwrote the press release, though that did not come to light until 1966.) As is the custom for such events, Apollinaire's essays are small praisesongs that emphasize what he sees as each artist's main virtues. But the contrasting ways he does so are revealing. In the essay on Matisse, Apollinaire praises the artist's extraordinary sensitivity to light and color and compares him to an orange: "Like the orange, Matisse's work is a fruit bursting with light." In the Picasso essay, Apollinaire compares the artist to a pearl, lustrous and mysterious: "He offers a

thousand opportunities for meditation, all animated by life and thought and illuminated by an internal light. Beyond that light, however, lies an abyss of mysterious darkness." Apollinaire's praise of Matisse is fairly warm, but he calls Picasso one of the greatest modern artists—indeed, one of the greatest artists ever: "Is his not the greatest aesthetic effort we have ever witnessed? He has greatly extended the frontiers of art, and in the most unexpected directions, where surprise awaits us like a stuffed rabbit beating a drum in the middle of the road." Simply on the basis of the catalogue, it is understandable that Matisse might feel the exhibition was a setup, in which he would be the fall guy.

Indeed, a few days before the exhibition opened, Matisse wrote to his wife that he had received an advance copy of the catalogue, and that it was "just what I thought. Apollinaire's preface well demonstrates it. In sum, I don't know what effect it will have, but I think that it was directed against me. . . . It's the peak of politics, to attract someone's works while he's away in order to try and demolish him. What must the cubists and cubifiers be saying."

In fact, although the exhibition was promoted as if it had been carefully planned and had benefited from the participation of both artists, it was very much a last-minute affair in which neither Matisse nor Picasso had an active role. Guillaume's ploy was the classic one of playing the two artists against each other by implying to each that the other had agreed to help get works for the show. Picasso was informed about it before Matisse, but as late as January 12, Guillaume was still fishing around for paintings and asking Picasso whether he knew anyone who would be "willing to lend us some of your good or important works." Matisse, who had left for Nice the month before, wasn't informed of the show until ten days before it opened, and since he stayed on in Nice, he never even saw it. It was only on January 14 that Guillaume, uneasy that he might be suspected of acting behind Matisse's back, and needing more Matisse paintings to balance the Picassos that were already committed, informed Matisse about the show and asked him for help with loans. "On the 23rd of this month an exhibition of works by you and Picasso is going to open at my gallery," Guillaume wrote. "I am anxious to present excellent things and have taken care to do so. However, I want to ask you whether you know of any of your works in private collections that you would like to see in the exhibition. What I really want above all are works that are *for sale*." As a prod, Guillaume added that Picasso was lending "one or two things in addition to what I was able to obtain from others."

When Matisse expressed his misgivings about such an undertaking, Guillaume promptly wrote to defend himself and to ask for Matisse's cooperation—or in any case, for a semblance of it, which would make paintings easier to procure: "You know that I have a number of your important works," Guillaume wrote rather unctuously on January 16.

> I thought that you would not be displeased to see them exhibited, not in a private exhibition that gave the impression of having been organized by you, which would consequently appear to be a personal statement of the sort that you would not want to occupy yourself with during the war, but on the contrary along with a certain number of works by Picasso. I did not think that this proximity would be something that would displease you.

Guillaume then backed Matisse into a corner by adding, "I have Picasso's consent. I lack only yours, for which I am now asking. Let me add that if you give your authorization I will be able to have some very beautiful things of yours, notably from Monsieur Hessel." To make refusal nearly impossible, Guillaume added that the revenues from the catalogue would be for the benefit of wounded war veterans. "We are counting on taking in a good deal of money with it," he added, "and we are certain that you will not want to have those funds be diminished by declining to give the simple authorization that I am asking for."

Although neither artist's very best works were exhibited, both men were fairly well represented. Sixteen paintings by Picasso are listed in the catalogue. The titles are often general and it is not always possible to know exactly which works were shown, but they range in time from his Blue and Rose Periods to some more recent Cubist works, including the 1914 *Portrait of a Young Woman* (Fig. 6.5). Only twelve Matisses are listed in the catalogue, but three large paintings were added at the last minute, for a total of fifteen. (In addition, each artist was represented by a number of watercolors and drawings.) Almost all the Matisses were figure paintings, and although there were some early works, such as the *Algerian Woman*, many were quite recent, including some works for which Laurette had modeled, most notably the large *Three Sisters* triptych, now owned by the Barnes Foundation.

Late in 1917, Matisse had renewed his contract with the Bernheim-Jeune gallery, which had then acquired several of his recent works—some of which were passed on to Guillaume to sell in the 1918 exhibition. This left Matisse feeling somewhat betrayed by his principal dealer as well; after all, while he was away in Nice, he relied on Bernheim-

Jeune to look after his best interests. Although it was not mentioned in any of the publicity, a third room in the gallery was filled with African art, highlighting it as an important source for the work of both artists.

As part of the publicity campaign he was devising, Guillaume arranged to have works from the exhibition filmed for a newsreel by Gaumont. Because there was neither sufficient space nor light in the cramped exhibition rooms, three works were chosen to be filmed on the street in front of the gallery in broad daylight. These were Matisse's *Studio, Quai St. Michel,* 1916 (now in the Phillips Collection), and two Picassos: the watercolor *Head of a Man,* 1907, and *Guitar and Clarinet on a Mantelpiece,* c. 1918 (both now in the Museum of Modern Art, New York). Images of these three paintings subsequently appeared in cinemas all over Paris, along with short clips showing various current events, such as the philosopher Henri Bergson being admitted into the French Academy and a car trying to break a speed record in the United States. The disconnected, collagelike sequences proved to be a great source of pleasure to the Cubists. Guillaume also had posters plastered all over the city, and Apollinaire's press release, along with a special printing of the catalogue on thinner paper, was freely distributed to magazines and newspapers all over France.

For the occasion, Guillaume also began to publish a magazine called *Les Arts à Paris,* timing the first issue to appear in tandem with the show. This in-house publication was the prototype for the now common gallery-sponsored publications that conflate criticism and commerce. It served as a publicity organ for the gallery, its artists, and its allies, and the first number included an overview of press reactions to the Matisse-Picasso exhibition. From these, it was clear that Matisse and Picasso were considered the principal leaders of the younger progressive artists. The texts of the reviews, however, were selectively edited. The painter Roger Bissière, for example, wrote two similar articles about the show, both of which were highly critical of the artists. Both articles were quoted in Guillaume's magazine, but the excerpts chosen concentrated only on the positive aspects of his reviews. In one excerpt, Bissière asserted that Matisse and Picasso not only were regarded as the leaders of the young, but also were the artists "who best represent the two faces of avant-garde painting." Despite their differences, he noted, both wanted "above all to react against the excessive place that had been given to *sensibility* in art, both wanted to restore intelligence and reason to the role that they had ceased to have." Not excerpted, however, were Bissière's comments that the work of both

artists was enclosed within a "necropolis" and would have little effect on the artists who emerged after the war. He wrote that Matisse's recent work was formulaic and lifeless and that Picasso's work was constructed like a theorem, "devoid of all human emotion."

———

WHAT PICASSO THOUGHT of this exhibition is unknown, but Matisse remained preoccupied with the fallout from it for months afterward. Even before the exhibition opened, he wrote to Guillaume from Nice to complain about the excessive publicity it was receiving, and he remained morbidly curious about people's reactions to it. He was concerned about its calling into question his retrieved position among the avant-garde, and it also made him aware that although he and Picasso were being singled out as the most important artists of their generation, the difference in their ages set them almost a generation apart. "Have you heard anything about this Matisse & Picasso exhibition," he asked his old friend André Rouveyre that March, "in which I have nothing to do with the ultra-modern publicity that fills me with disgust? Perhaps because I don't need it—in any case it's not of my generation." He continued to write to Guillaume, and as late as mid-March he was still absorbed by people's reactions to this first head-to-head exhibition with his main rival.

In the long run, the exhibition reinforced the preeminence of both artists. Louis Vauxcelles, who had played a role in the naming of both Fauvism and Cubism, characterized the variety of their styles as indicative of modern anxiety: "For twenty years, Picasso and Matisse have been feverishly searching, undergoing frequent metamorphoses, like all those tormented by anxiety." There was still some grumbling about the obscurity of Picasso's Cubism, which, according to one critic, required the viewer to read the "already abundant" literature on Picasso as a "catechism" in order to make sense of his works. But for all its shortcomings, the exhibition cemented the notion that together Matisse and Picasso more or less defined modern painting. The scene was set for the prominent English art critic Clive Bell to characterize them only a couple of years later as the preeminent heirs to Cézanne. "Even to people who seldom or never look seriously at a picture," Bell would write, "they have stood, these ten years, as symbols of modernity."

DREAMS OF DESIRE

For you must be caught up in the spirit of your time. . . .
the modern theme is the subterranean forces, those hidden
tides which govern everything and run humanity counter
to the apparent flood: those poisonous subtleties which
envelop the soul, the ascending fumes of sex.

—JAMES JOYCE

As the war drew to a close, the whole world seemed to have changed. The idea that modern art was moving toward the expression of transcendent new realities had been undermined by a growing sense of pessimism and disillusion. "Everybody was dissatisfied and every one was restless," Gertrude Stein recalled. "It was a restless and disturbed world." Matisse and Picasso were especially disturbed and restless, and each was at a turning point in life. In a curious way, they traded places. At the end of 1917, the bourgeois Matisse left his wife and family and went to live by himself in Nice, where he created a kind of harem with his models. The next year the bohemian Picasso, who had been drifting from woman to woman, settled down into marriage and a high bourgeois existence.

IN FEBRUARY 1917, Picasso, now thirty-five (roughly the same age Matisse had been when they first met), had gone to Rome with Jean Cocteau to work on the costumes and decor for the Ballets Russes production of *Parade*. There he fell in love with a twenty-five-year-old Russian ballerina named Olga Koklova, a lovely though rather sullen

and narrow-minded young woman who had pretensions to noble birth. That she spoke French with a thick Russian accent can only have appealed to Picasso; that she didn't particularly care for modern art probably piqued his amour-propre; that she resisted his sexual advances stirred his passion. In June, smitten with Olga, Picasso followed the Diaghilev troupe to Madrid and Barcelona, and when the dancers left for South America, Olga stayed behind with him. She was determined to marry him, and his willingness to comply was probably stoked by her refusing to have sex with him before they were married, remaining what Picasso called *"une vraie jeune fille."* Her virginity put her in a separate category from his previous women. In the division between doormats and goddesses, she was definitely—if only temporarily—in the latter category.

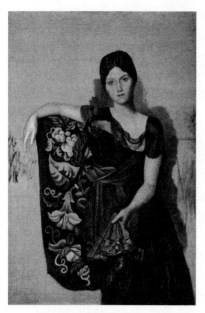

FIGURE 7.1
Picasso, *Olga in an Armchair*,
1918. 130 x 88 cm.

This was not a situation that Picasso bore easily, and some sense of his conflicting feelings can be seen in the lyrical drawings he did of her in Rome, and in the haunting portrait he painted of her in Montrouge in the spring of 1918, not long before they were married. In *Olga in an Armchair* (Fig. 7.1), her body is set against the floral patterning of the chair, her hair parted down the middle in a way that refers to Ingres's cool and tightly rendered portraits. But there is also an obvious reference to Matisse in the rich floral pattern on the chair and in the flowers on her dress, which serve as metaphors for her femininity. (The reference to her fertility is even clearer in a photograph Picasso used as the basis of the painting, in which a couple of Baga fertility sculptures are placed on the floor next to her.)

The painting is left unfinished, but in a very provocative way. Olga and the chair are rendered in meticulous detail, but they float in a background of blank canvas. On this "virgin" canvas, Picasso has set a number of disconnected brush marks: Some are simply abstract traces of his touch, as if to signal his presence. Others cluster around her body like an embrace, nominally to describe the cast shadow, although her body is so detached from the background that this area is not quite

convincing as shadow. Within this brushy area, just to the left of her head, is a clear open-mouthed profile of a man's face that is strikingly similar to the profile head on the palette in the 1915 *Harlequin*—as if Picasso has encrypted his own shadow into the picture as a watchful presence over his woman. In the Olga portrait, the sense of "unfinished business" as well as her extreme coolness (made all the more evident by the contrast between the icy way she is rendered and the warmer brush-strokes around her) suggest the troubled quality of Picasso's relation-ship to her, both physically and psychologically. If the painting does not quite convey the "hard look of profound dissatisfaction" that appears on Olga's face in the photograph, she is nonetheless almost inhumanly cool in this portrait—which a couple of years later Picasso would hang above their marriage bed.

PICASSO AND OLGA WERE MARRIED on July 12, 1918—first, as was legally required, in a civil ceremony, and then at the Russian Ortho-dox church in Paris, with Cocteau, Jacob, and Apollinaire as witnesses. That a fallen Catholic Spanish atheist would acquiesce to an elaborate church wedding gives a good indication of how many concessions Pi-casso thought he was ready to make. But doubts apparently set in almost immediately. While still on their honeymoon in Biarritz (where they stayed at the home of Eugenia Errazuriz, a wealthy Chilean patron of the arts and probably Picasso's former lover), they discovered they had very different tastes and expectations. As Picasso spent more time with Olga, he found her less interesting, and evidently less passionate, than he had expected. From Biarritz, he wrote a number of letters to Apollinaire that reflect his unsettled state. "I'm not really unhappy," he says in one. "I'm working, as I've told you, but write me some long letters."

Picasso's friendship with Apollinaire was a much needed anchor at this time. But on November 9, just two days before the armistice, Apol-linaire, severely weakened by his war wounds, died of influenza. Four days later, Picasso and Olga moved into a large and elegant new apart-ment on the rue La Boétie, in the center of the Right Bank gallery dis-trict. (The last entry in Apollinaire's diary reads: "Went to see the large new apartment that Picasso has rented on the rue de la Boétie.") For better or worse, Picasso was about to embark on the style of life Olga wanted him to lead.

In the early 1920s, Picasso became a fixture on the social and literary

circuit. He was written about by Marcel Proust, met James Joyce, and painted portraits of his elegant patrons and dealers. He made enormous amounts of money, and spent equally enormous sums. He dressed like "a well-to-do businessman, in a well-cut suit with a bow-tie, white pocket handkerchief and gold watch-chain," and people remarked on his volatile mannerisms. Maurice Sachs describes Picasso's behavior at a fashionable nightclub, noting his "hate-filled, rancorous voice, followed by his hail-fellow-well-met face, his pleasant laugh followed by a malevolent one, then the short witty quip cutting like the lash of a whip." Having quickly understood that his living habits were incompatible with Olga's, very soon after they moved into the rue La Boétie apartment he bought the one immediately above it to use as a studio, where he could spread out and work undisturbed, "turning its five rooms into a desolation of his own: not so much a studio . . . as an interconnecting series of little echoing deserts, their death as rooms made even more emphatic by the remaining marble fireplaces with their pier-glasses above." It was not a bad arrangement for "a semi-detached couple," and Picasso would continue to work there long after he had ceased to care about Olga.

<hr />

AS EARLY AS 1915 PICASSO had begun making meticulously rendered realistic drawings, and by the early 1920s he was alternating between a full-blown neoclassical style and more planar and abstract Synthetic Cubist imagery. Although his varied styles seemed to many people at the time merely to reflect his whims, they were largely determined by his sense of which kind of expressive language was most appropriate to render a given theme. These two very different painting vocabularies also coincided with two different sides of his personality. The classicizing paintings, such as *Three Women at the Spring* (Fig. 7.2), tend to have female subjects and to be calm, reassuring, and firmly rooted in history. They also served as an outlet for his deep sentimental streak, as in his maudlin pictures of doting mothers and of children dressed up in unbearably cute costumes. The Cubist paintings, such as *Three Musicians* (Fig. 7.3), tend to be full of tension and anxiety, and show his preoccupation with remaining "modern."

During the summer of 1921, while working at Fontainebleau, Picasso did a number of large paintings in these opposing styles. He did two versions of *Three Women at the Spring*, in which the large-scale, ponderous gestures and classical garb of the figures prepare us to see

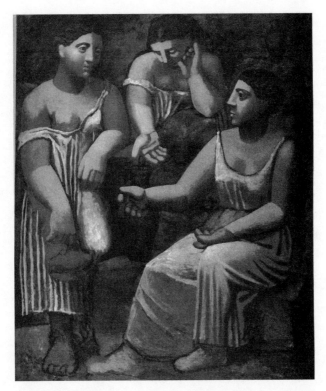

FIGURE 7.2 Picasso, *Three Women at the Spring*, 1921. 203.9 x 174 cm.

them in relation to such grand themes as the Three Graces or the Judgment of Paris. The precise subject of these paintings, however, is mysteriously indeterminate, and the composition resists a clear narrative reading, other than the one suggested by the filling of the jugs around the phallic spigot, with its clear overtones of fecundity and procreation. His son Paulo had recently been born, and the theme of fertile women in harmony with the earth, affirming both physical continuity and stable cultural values, would have had a particular resonance for him.

Picasso also did two versions of *Three Musicians* (Fig. 7.3), both of which bristle with tension and a macabre sense of menace. The different versions of *Three Musicians* and *Three Women at the Spring* were painted at the same time, and in photographs of Picasso's studio then, he is working simultaneously on both classical and Cubist images. In *Three Musicians*, the jazzlike stridency of the visual rhythms is aggressively modern. The subject, with its three male figures, among them the stock French comic character Pierrot, evokes the opposite of the assurance and affirmation seen in *Three Women at the Spring*. The painting

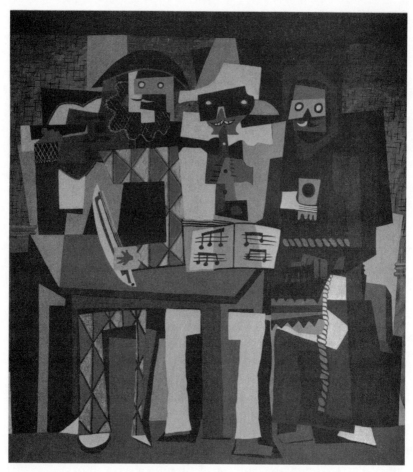

FIGURE 7.3 Picasso, *Three Musicians*, 1921. 203 x 188 cm.

is full of unexpected transformations, as in the way the body of Pierrot's instrument also contains a head in profile—perhaps Picasso's earliest clear use of a visual pun that would become common in his later work. The irregular juxtaposition of forms and the discrepancies in scale (such as the tiny left hand of the harlequin, which seems barely able to grasp the violin bow) give the picture a dissonant, syncopated rhythm that is heightened by the way the figures are crowded into the composition, suggesting a raucous, antic cacophony.

Although Picasso uses stock characters, they serve as masks for private references. The harlequin is a surrogate self-portrait of the artist, who since the turn of the century had represented himself in that guise. The pipe-playing Pierrot is an evocation of Guillaume Apollinaire, for whom the pipe is a double pun, referring not only to the poet's musical

pipes but also to the pipe that Apollinaire continuously smoked. The monk represents the ascetic Max Jacob, who had recently entered a monastery. During the summer of 1921, Picasso had good reason to think of these two once-dear, but now absent friends of his youth. That very May he had been commissioned to create a monument in memory of Apollinaire—a project he would wrestle with for decades. Shortly before Picasso painted *Three Musicians*, Jacob had taken up residence in a Benedictine monastery at St. Benoît-sur-Loire. Picasso had stood as godfather when Jacob converted from Judaism to Catholicism, but in recent years the artist had become alienated from his poet friend, whose poverty and lack of artistic success made Picasso uncomfortable. Jacob had been deeply hurt at not being named Paulo's godfather, and when the two men met for the last time that fall, Jacob broke down and wept, lamenting that Picasso was deader to him than Apollinaire. *Three Musicians* is the psychological as well as the stylistic opposite of *Three Women at the Spring*. In it, Picasso symbolically brings together the three old friends, as if meeting for the last time, joined in a jam session whose riffs and caterwauls stir up the presence of disconsolate ghosts.

Jacob was not the only friend Picasso alienated during those first years with Olga. He and Gertrude Stein also had a falling-out just after the war, and although they eventually reconciled and kept in touch until Stein's death, the old warmth between them was never rekindled. Things had changed, and Picasso had come to resent Stein's treating him as if he were still her young "discovery." (Matisse also fell out with Gertrude, definitively. He had long begrudged her abandoning him, and he refused to see her again after 1914 when she broke a promise to help support Juan Gris.)

Because of his extraordinary technical virtuosity, Picasso was able effectively and convincingly to employ conflicting styles at will, and he used these with great energy—another instance of his uncommon sensitivity to the arbitrariness of different languages. In fact, he was probably the first Western artist to insist willfully and persistently on the relative arbitrariness of the means of pictorial representation. Indeed, this ongoing engagement with the arbitrary is one of the most original and radical aspects of his entire career. Artists of the previous generation, such as Cézanne and van Gogh, had employed systematic "distortions" in their works, but each had done so as part of a supposedly direct way of communicating the "truth" of his own personal vision. Picasso's contemporaries, including Matisse, followed in that tradition. Matisse's varied styles between 1905 and 1918 had grown out of his direct visual

responses to what he was painting and were not calculated to be artificial or arbitrary.

Picasso, by contrast, insisted that there were many possible ways of arriving at the truth, and that all of them were equally artificial. To him, the artist could choose among many different visual languages, each of which could be made to have an equal claim to truth. Each of these different modes or styles, moreover, was conceived as being inherently expressive of attitudes that were implicitly contained within the style itself. For example, the different phases of his Cubist style address various ways of representing a fluctuant, uncertain world, full of discontinuities, in which the deep reality of things is often not what it seems. His neoclassical manner, by contrast, suggests a solid and stable world and places emphasis on cultural as well as physical continuity. (Even his realistic works, though, are full of exaggerations and distortions, such as the disproportionately large limbs and heads, which call attention to the way that they, too, are part of an artificial means of pictorial representation.) It was at this time, when he was so deeply involved with notions of different styles as emblematic of different and opposing views of reality, that Picasso made his famous statement that "Art is a lie that makes us realize truth, at least the truth that is given us to understand. The artist must know the manner whereby to convince others of the truthfulness of his lies."

MATISSE'S LIFE HAD TAKEN AN altogether different turn. In Nice, he initially set himself up in hotel rooms, in which he both lived and worked—a far cry from his spacious and well-equipped Paris studios. Some sense of his spiritual claustrophobia at the time is evident in the *Self-Portrait* (Fig. 7.4) he did shortly after he arrived in Nice. The picture shows him seated, palette and brush in hand, painting. A valise on the floor in front of him suggests his transience, and an umbrella leaning against the marble-topped hotel dresser intensifies the feeling of enclosure by evoking the out-of-doors and even the weather. Especially striking is the position of the paintbrush he holds in his palette hand (set next to his meaty thumb), which thrusts across his trousers like an erect phallus. The contrast between the sexual implication of the thumb and paintbrush and the image of the portly middle-aged man—neatly dressed in suit and tie and deeply engrossed in his work—is remarkable. For all its studied calm, this picture has an almost brutal quality.

It is a telling projection of his self-image at the beginning of 1918, in which the combination of the solid beefiness of his torso, the passivity of his pose, the intensity of his self-absorption, and the animal energy that seethes beneath the placid surface create an image of unsettling frankness.

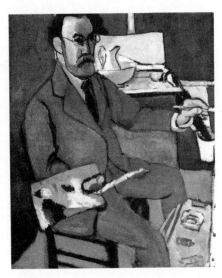

FIGURE 7.4 Matisse, *Self-Portrait*, 1918. 65 x 54 cm.

During those early years in Nice, Matisse came straight up against the existential problem that had started him painting to begin with, and that he now began to deal with more directly as a subject of his painting. Canvas after canvas is filled with images of boredom, claustrophobia, alienation, and sexual yearning. Although he was confident that during the past twenty years he had produced a body of work that was better than anything anybody else had done—with the possible exception of Picasso—now, in his forty-ninth year, he had reached an impasse. If he had previously sublimated his personal feelings into the intense pictorial rhetoric of his paintings, now he had to risk confronting his restlessness and unfocused desire more directly, and to do so he would return to a more literal description of the world around him. He had come to feel that the abstract rhythms and concentrated intensity of his more austere work had forced him to sacrifice other values, such as "corporeality and spatial depth, the richness of detail," as he said to an interviewer in 1919. "Now," he asserted, "I want to combine it all. . . . I want to depict the typical and the individual at the same time, a distillation of all I see and feel in a motif."

<hr />

ALTHOUGH MATISSE MADE REGULAR trips to Paris and continued to exhibit there, his life became increasingly centered on the small world he had created for himself in Nice. That world was highly feminized. During this period, Matisse became primarily a painter of women. Unlike in his earlier paintings, where the figures were often placed in a generalized or abstracted setting, now he set the women in a specific place—which itself is often highly feminized, after the fashion

of French hotel rooms, with their floral wallpaper, rich upholstery, and thin lace curtains that softly filter the Mediterranean light.

For these pictures, Matisse needed the presence of real women, and during his first months in Nice he worked with several models, reveling in their various sizes and shapes. Regardless of whether he in fact had sex with them, the parallel with a harem is inescapable. His public remarks about these women are usually quite general and high-minded, as in his later description of his fascination with the odalisque theme:

> Look at these Odalisques carefully: the sun's brightness reigns in a triumphal blaze, appropriating colors and forms. Now, the oriental decor of the interiors, all the hangings and rugs, the lavish costumes, the sensuality of heavy, slumbering flesh, the blissful torpor of faces awaiting pleasure, this whole ceremony of siesta brought to maximum intensity in the arabesque and the color should not deceive us: I have always rejected anecdote for its own sake. In this ambience of languid relaxation, beneath the sun-drenched torpor that bathes things and people, a great tension smolders, a specifically pictorial tension that arises from the interplay and mutual relations of the various elements. I eased those tensions so that an impression of felicitous calm could emerge from these paintings, a more or less amiable serenity in the harmony of intentionally amassed sumptuousness.

But occasionally he lets down his guard, and in a letter to a friend he expresses his delight in the sheer physical presence of the women themselves. "She's a big girl," he wrote of one new model, "a colossal woman with tits like 2 liter chianti bottles!"

This is the time when Matisse begins to work increasingly as he had from Laurette, in extended series of paintings done from the same model. His approach to the women he used as subjects was the opposite of the technique Picasso used for individual women as repeated subjects—and is related to the way Matisse worked directly from the model. Whereas Picasso, working from memory, transformed his models into types that remain similar throughout the series, Matisse emphasized the variability of his models—precisely the way they resist becoming types. So even though a given woman's face may be recognizable in a series of paintings, she often projects very different kinds of character and personality.

Late in 1918, for example, he developed a close relationship with a lovely dark-haired model named Antoinette Arnoux, whom he depicted in a variety of ways that recall his treatment of Laurette. He drew and painted Antoinette quite realistically, emphasizing the various aspects

of her personality and of her radiant sensuality. Like Laurette, she had abundant dark hair, which Matisse loved to rearrange in different ways for his paintings and drawings of her, and he also took to dressing her up in various costumes. It was she who posed for the celebrated *White Plumes* series of paintings and drawings, for which he improvised an elaborate hat out of ribbons and feathers, and in which her personality changes radically from picture to picture. He became so attached to her that in the summer of 1919 he took her to Paris, where he painted her in the garden at Issy alongside his daughter Marguerite, in an extraordinary picture called *Tea*, in which Marguerite bristles with tension while a dog beneath the table scratches itself. The dog, rendered with a disarmingly comic irony, is almost a stand-in for the artist, unable to quite keep himself under control.

THE SENSUALITY OF MATISSE'S PAINTINGS increased considerably when he began to work from a young model named Henriette Darricarrère in 1920. In the numerous paintings he did of her, her personality also changes a great deal. She becomes like an actress who plays a number of various roles, ranging from sensuous harem girl to young bourgeoise. In one picture, he even paints her with her two younger brothers, who are depicted playing checkers, much as Matisse had depicted his two sons in *The Painter's Family* of 1911. Matisse's early years in Nice were, in effect, his "Henriette Period." She became like a member of his family and remained his regular model and close companion for the next seven years.

Matisse's paintings of this period are part of an extended meditation on shifting perceptions, in which he explores Henriette's sundry moods with remarkable acuity. Frequently, she is nude or dressed as an odalisque. The odalisque paintings are part of an extended sexual fantasy, the creation of a harem in which the artist is able to revel in the sensual delight of the women he paints, while at the same time sublimating his desire sufficiently to produce good works of art. The Orientalist subject provides both an occasion and a psychological screen for the eroticism of the paintings, much as it did for nineteenth-century masters such as Ingres and Delacroix.

An excellent example of this kind of picture is *Seated Odalisque with Raised Knee* (Fig. 7.5), in which the flat, abstract background decoration is contrasted with the extreme physicality of the woman, and in which the

vividly palpable quality of her breasts and the filmy transparency of her culotte are depicted with breathtaking virtuosity. Like many of Matisse's

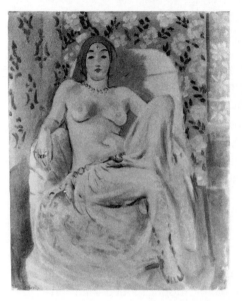

FIGURE 7.5

Matisse, *Seated Odalisque with Raised Knee*, 1922. 46.5 x 38.3 cm.

paintings from this period, this picture transposes a Moorish theme into a specifically French bourgeois setting, creating a curious mixture of the exotic and the familiar. In a room wallpapered with a French version of all-over Moorish decoration, and seated in a distinctly French armchair, the obviously French model is dressed in the provocative costume of a harem girl, complete with a small imitation tattoo mark on her forehead. In the hands of a lesser artist, such a picture might be ridiculous. But Matisse is able to unite these disparate elements in a vivid and engaging way.

Henriette was also the model for a series of reclining nudes that are variants of the Dream-of-Desire pose—frequently with some sort of floral backdrop that functions in a way similar to the plant forms in *Blue Nude*. (One of these paintings, *Reclining Nude with Raised Left Arm* of 1922, Matisse even had photographed while in progress, anticipating by more than a decade what would become a common practice during the 1930s.) Among the most remarkable and best-known of these paintings is the breathtakingly erotic *Odalisque with Magnolias* (Fig. 7.6). In this painting, the sensuous rendering of the woman's body is set above a bowl of fruit and in front of a violet floral pattern from which two splendid magnolias burst forth, acting as explosive symbols of her femininity. In the past, Matisse had used decorative elements as displacements of the energy of the central subjects in his paintings, but now he was doing so in an especially charged and direct way. Between 1908 and 1917, he had depicted the reclining nude with the raised arm through the intermediary of his *Reclining Nude* sculpture. Now he began to represent the pose directly from Henriette, who becomes a living incarnation of the Dream-of-Desire woman.

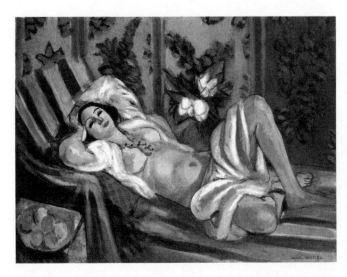

FIGURE 7.6
Matisse, *Odalisque
with Magnolias*, 1923.
65 x 81 cm.

MATISSE'S WORK DURING THIS period drew mixed reaction. He
had a core group of supporters, who justified his change in style, but he
had more detractors, who were disappointed by what they deemed a
decline in the quality and ambition of his work. As early as 1919, when
Matisse first showed his Nice paintings in Paris, Jean Cocteau chided
him for his new conservatism. "The sun-soaked *fauve* has become a
Bonnard kitten," he wrote, echoing Picasso's dislike for Bonnard. Al-
though Matisse had freed color and light from Impressionism, Cocteau
said, he was now falling backward into an Impressionist dependence on
"blinking in the sunlight." He attributed this regression into a new
kind of academicism to Matisse's "working without underlying disci-
pline, without the hidden geometrics of Cézanne and the old mas-
ters"—an obvious reference to Cubism. Pouring fat on the fire, Cocteau
noted that on his way out of the gallery, he found himself humming a
musical setting of Apollinaire's well-known poem "The Crayfish,"
whose last line captures the beast's uncertainty with "Backing up, back-
ing up." Matisse might have had reason to believe that Picasso prodded
Cocteau to make this attack. But even a more neutral observer such as
Fritz Vanderpyl wrote that Matisse, "with his superficial content and
skin-deep taste, seems, in a somewhat puerile way, to defy the future."

DURING THE EARLY 1920S, Matisse and Picasso had no direct con-
tact and probably gave little thought to each other's work. But in 1926,

when Matisse's daughter mentioned Picasso in a letter, Matisse wrote back with some heat: "I have not seen Picasso for years. . . . I don't care to see him again, . . . he is a bandit waiting in ambush." The bad feelings on Matisse's part seem to have been provoked by Picasso's recent appropriation of some of his motifs and subjects. This is especially evident in Picasso's odalisque-like *Woman with a Tambourine* (1925) and in a series of still lifes in which flat, brightly colored forms were set before windows. (Matisse was not alone in being aware of the connection. In 1920, Paul Rosenberg had urged Picasso to come to Nice before Matisse had "painted everything," noting that the season would be "the year of the window! Windows by Picasso, a window by Matisse.") Matisse would also have been justified in thinking that Picasso's *Three Dancers* (Fig. 7.7) appropriated a theme associated with him, and that it also recalled the composition of his

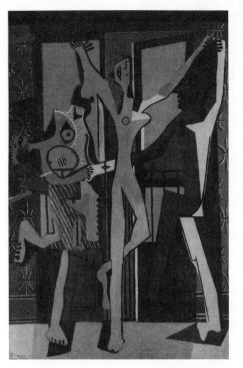

FIGURE 7.7
Picasso, *Three Dancers*, 1925.
215 x 142 cm.

Nasturtiums with "Dance" (II) of 1912 (see Fig. 5.10)—a painting that had been a favorite of Picasso's new friend André Breton, who a decade earlier had hung a reproduction of it on his wall.

Three Dancers introduces a new wave of violence into Picasso's work and marks a definite turning away from his neoclassical style toward an art that aspires to render complex layers of psychic states. This painting also played an important role in Picasso's relationship with Breton and the Surrealists. It was reproduced in the July 15, 1925, issue of *La Révolution Surréaliste*, which contained the first part of Breton's important essay "Surrealism and Painting" and reproduced five of Picasso's works, including *Les Demoiselles d'Avignon* and the recently finished *Three Dancers* (then titled *Young Girls Dancing Before a Window*). Appropriately, this anticlassical and antibourgeois picture was done under the star of *Les Demoiselles d'Avignon*, which had recently resurfaced in Picasso's life when Breton arranged for its purchase by the

couturier Jacques Doucet. Breton's enthusiasm for *Les Demoiselles* seems to have acted as a stimulus for Picasso to embark on a more radical course. Like *Les Demoiselles*, *Three Dancers* is a convulsive painting that Picasso threw himself into headlong. It is full of discordant forms and savage paint handling, especially in the figure on the left. And as *Les Demoiselles* had done, it would stimulate Picasso to embark on a more ambitiously revolutionary course.

Along with its mixture of different stylistic voices, *Three Dancers* also contains a complex layering of historical and symbolic references. One voice it speaks with is mockery: It satirizes a number of traditional themes, such as the Three Graces, and it parodies Jean Baptiste Carpeaux's famous dancers in front of the Paris Opéra. Another voice is high tragedy, referred to in the extended arms of the central dancer who, along with the flanking figures, connects the composition with that of a crucifixion; Picasso evidently had Matthias Grünewald's *Crucifixion* from the Isenheim altarpiece in mind when he painted it. It also speaks in a voice rough with rancor, and does so in a lethally personal way.

The composition is based on a 1916 photograph of Olga dancing in a production of *Les Sylphides*, which Picasso adapted in a 1919 drawing that shows Olga with two other dancers. In the drawing, Olga is on the left, so she is clearly the prototype for the most grotesque figure in *Three Dancers*. She and Picasso had become increasingly alienated over the past few years, during which their mutual exasperation had gradually given way to constant anger and then to an implacable mixture of love and hatred. In the dancer on the left, the paint is virtually slashed onto the canvas, with a violence reminiscent of the "African" faces in *Les Demoiselles d'Avignon*. This figure is especially macabre and monstrous, her grotesque, masklike face made all the more threatening by the jagged teeth in her open mouth. (She is also rendered with the greatest virtuosity—at once opaque and transparent, schematically abstract and full of optical detail.) Thus, this canvas, too, is one of "exorcism," in which the woman Picasso is living with plays an important role. The very dissonance of the picture, including its depiction of a violent "modern" dance, was calculated to be a frontal assault on Olga's conservative taste.

Each of the three dancers seems to embody different kinds of dance: on the left, modern dance mixed with a Dionysian frenzy; at the center, classical ballet mixed with flamenco; on the right, a kind of stately folk dance, perhaps a Catalan *Sardana*. The dancer at the right also clearly

suggests a double profile, here an obvious and fully developed trope on the doubled figure in the 1915 *Harlequin* (Fig. 6.8). The dichotomies between the different dancers make us especially aware of the powerful contrast between these disturbing women and the banal interior within which they are set, as if to suggest that the explosive emotionality of this dance is meant to tear apart the domestic setting. The painting is a series of destructions, of attacks: on classical dance; on the 1919 drawing of Olga; on representations of the Three Graces; on the tribulations of love; perhaps even on Matisse's own conception of life-affirming dance. (Picasso's statement to Christian Zervos a decade later comes to mind: "In my case, a picture is a sum of destructions.")

Picasso himself said that he associated this painting with his old friend Ramón Pichot, whom he had known since his Barcelona days, and whom he had spent time with during his first trip to Paris in 1900. Pichot had married Germaine Gargallo in 1902, only a year after Casagemas's suicide, and had exhibited in the Fauve room at the 1905 Salon d'Automne, where Matisse exhibited *The Woman with the Hat*. He had also attended the celebrated banquet Picasso gave for Le Douanier Rousseau in 1908—at which Pichot famously imitated the crucified Christ. Pichot may thus be suggested by the cruciform dancer at the center, where he is conflated with the presence of another old friend of Picasso's, Carles Casagemas, whom Picasso thought of as kind of a martyr. Picasso, who always held Germaine responsible for the suicide of Casagemas, saw her as a destructive femme fatale, and he believed that she had also destroyed Pichot. Many years later, in 1944, Picasso even took Françoise Gilot to see the aged Germaine Pichot, as a kind of object lesson, saying of her: "She's old and toothless and poor and unfortunate now. But when she was young she was very pretty and she made a painter friend of mine suffer so much that he committed suicide. . . . she turned a lot of heads. Now look at her."

Picasso heard of Pichot's death while he was working on *Three Dancers,* and he later said that the painting was connected to his misery on learning of Pichot's death, and that Pichot's profile appears in it "as a shadow against the window on the right of the canvas." Since the figure on the right is supposed to evoke Pichot, there is reason to believe that the grotesque woman on the left refers to Germaine Pichot as well as to Olga.

In fact, the painting is awash in shifting identities. Not only is the figure on the left associated with both Germaine and Olga, but the figure

on the right is also more than simply an evocation of Ramón Pichot. First, it is ostensibly a female figure, so Picasso's identification with Pichot must be understood as partial and symbolic rather than literal. And in any case, the profile of that dancer does not at all resemble Pichot, who had a distinctive, pointed beard—very much like the one worn by Picasso's father. Rather, the shadowy profile of this figure recalls the one Picasso used in depictions of himself—very like the one encrypted in the 1918 *Portrait of Olga* and that he would use in later paintings, such as the 1929 *Bust of a Woman with Self-Portrait*, in which his shadowlike profile is set next to an image of Olga screaming.

Picasso, Pichot, and Casagemas; Olga and Germaine. None of them is directly represented in *Three Dancers,* but all five seem to be brought together in this convulsive canvas, which makes us aware once again of just how complex Picasso's ambitions were at this time, when he was elaborating a pictorial language meant to suggest multiple and contradictory realities. By creating a style that could encompass the doubled identities of these dreaded women and suffering men—Germaine/Olga, Pichot/Casagemas, Pichot/Picasso—he seems to be questioning the very process by which identities are formed and maintained, and contemplating how people's roles and actions can intertwine over the course of a lifetime. In this painting, Picasso produces a multilayered image that responds to the complex and paradoxical nature of lived experience, creating graphic signs that stand for an intricate network of mental and emotional processes.

———

ONE OF THE MOST SIGNIFICANT episodes in Picasso's life began around the time he painted *Three Dancers,* when he met a statuesque young woman named Marie-Thérèse Walter, who was to play a major role in his art and in his relationship with Matisse. There has been much argument about exactly when Picasso met her. Although the date is often given as the beginning of 1927, there is good reason to believe they met in early 1925, when Marie-Thérèse was not quite sixteen years old. (If they met in early 1925, which is quite possible, then his new love for her may have generated the explosiveness of *Three Dancers.*) Because of her tender age and the adulterous nature of the liaison, he had urgent reason for keeping his relations with her a closely guarded secret. He was married to the madly jealous Olga, and his involvement with an underage girl could have landed him in prison. Although images associ-

ated with her appear in his art as early as 1925, for years her face is not clearly identifiable, and not until the early 1930s did he begin to represent her likeness in a direct, portraitlike way.

When Picasso told the critic Tériade in 1932 that his work was "a way of keeping a diary," he very likely had Marie-Thérèse in mind, for by then much of his recent work had been autobiographical—some aspects coded in an extremely private way, some easily decipherable, once the givens are known. In fact, even though she bore him a daughter in 1935, Marie-Thérèse's name was not made public until 1964, when Françoise Gilot published *Life with Picasso*. After that, the official story was that Picasso had met her in front of the Galeries Lafayette on January 8, 1927 (which for many people echoed Breton's celebrated meeting with Nadja on October 26, 1926, a paradigmatic example of the Surrealist *amour fou*). Eventually, Marie-Thérèse's account, which supported Picasso's, was published in a 1968 *Life* magazine article. "When I met Picasso I was 17," she averred. "I was an innocent young gamine. I knew nothing—life, Picasso, nothing. I had gone shopping at the Galeries Lafayette, and Picasso saw me coming out of the Métro. He simply grabbed me by the arm and said: 'I'm Picasso! You and I are going to do great things together.'" She soon became an important presence in Picasso's art—which she affected more directly and more powerfully than any other woman, in terms of its style, its subject matter, and its relationship to those around him, especially Matisse.

MARIE-THÉRÈSE WAS A TALL, well-built woman who projected a self-confident and nurturing femininity—somewhat reminiscent of Fernande Olivier in her commanding physical presence. By most accounts, she was disarmingly generous and good-natured, "young, fair-haired, fine-skinned, healthy, devoted to sport, good company, calm and gay." Although she was not especially intelligent, she was undemanding and deeply affectionate, had no particular ambition with regard to Picasso's wealth or fame, and "naturally and genuinely despised convention." Passionate, unworldly, and unpretentious, she was a natural or "primitive" version of the uninhibited and all-accepting woman the Surrealists were trying so hard to construct. When she and Picasso met, she lived with her mother in a suburb south of Paris, and she agreed to a rendezvous two days later, even though she knew he was married. "I was living with my family," she later said, "and I had to lie to them

more and more. I would say I was spending the afternoon with some girl friend, and I would come to Picasso. We would joke and laugh together all day, so happy with our secret, living a totally non-bourgeois love, a bohemian love away from those people Picasso knew."

Their relationship was rooted in a complex game of hiding and revealing, which soon spilled over into his art. Picasso's earliest representations of her were not paintings but geometric line drawings of musical instruments, done in pencil, in which he encodes cryptograms that use her initials: M-T. There is something charmingly adolescent about this gesture, almost like a schoolboy inscribing the initials of a girl he has a crush on into his notebook. The earliest clearly dated sheet, inscribed November 1925, is a collection of four such drawings. Typically, a good deal of attention is given to the sound-hole of the instrument, which is clearly meant as a double entendre for either a vagina or an anus—the latter suggested by the starlike forms that radiate out from it, a formula he would use again in drawings done toward the end of his life. Early in 1926, Picasso did a number of charcoal drawings of Marie-Thérèse's head and shoulders in which her features are (in retrospect) clearly recognizable. And in January 1926, he did *The Dress Designer's Workshop*, a large oil painting rendered in grisaille that uses repetitive, fragmentary curvilinear forms, and that is now generally acknowledged to be a representation of Marie-Thérèse sewing in the workshop of her mother, who was a milliner. This was soon followed by another large, mostly gray painting, *The Painter and His Model*, in which the forms are suggested by broad, looping curves that swing around rather than delineate the subject, making it difficult to read.

The linear style of these works is directly related to the notational systems Picasso was using in the studies for his illustrations for Balzac's *Unknown Masterpiece*—a story in which a seventeenth-century painter named Frenhofer spends years working on what is supposed to be his masterpiece, and overworks it to such a degree that he finally produces an incomprehensible muddle. The difficult legibility of the forms in *The Painter and His Model* seems to have been willful—as a way for Picasso both to reveal and to guard (or perhaps to guardedly reveal) his secret love. If the graphic rendition of the Marie-Thérèse figure at the right side of the painting recalls the small coded drawings with which Picasso first began to refer to her, the presence of the enormous footlike form at the center recalls the fictional Frenhofer's spectacularly failed painting, in which only a foot was clearly discernible.

With typical duality, while Picasso was doing these two large paintings

based on complex networks of curving forms, he was also creating a series of collages on the guitar theme, which are very close in vocabulary to the Marie-Thérèse cryptograms, and which have an alarming, almost fetishistic physical presence. Their combination of rope, nails, and applied cloth conjures a surprisingly potent mixture of sensuality and menace. Picasso even thought of adding razor blades to one of them, "so that anyone who picked it up would cut his fingers." Although such gestures have been taken as "an explosion of aggression in a language of evident sorrow," the matter seems more complex. These images are at once violent and tender, and oddly erotic—almost like sexual souvenirs taken from a woman's underwear. In these works, Picasso compounded the impulses of love and fury, of tenderness and sadism, that drove so much of his energy. He also seems to have felt a strong need somehow to communicate the force of his love and desire, though encoded so as to make them at the time undecipherable. And he also must have enjoyed outdoing the Surrealists at their own game of violent sexuality. One of these collages, *Guitar with a Knitting Needle*, was reproduced in the June 15, 1926, issue of *La Révolution Surréaliste* right after it was finished.

The mixture of love and violence was made all the more heady by the fact that when Picasso was beginning to celebrate Marie-Thérèse, he simultaneously was lashing out at Olga, with whom he was having a steady stream of violent confrontations. Olga, pathologically jealous by nature, was aware that something was amiss, and she was possessed by prolonged rages in which she would scream hysterically at her mute husband. (How different from the Matisses in *Conversation*.) A number of Picasso's paintings from the late 1920s depict a monstrous woman, her mouth open, the external forms of her head scrambled so as to evoke the hysteria that drives her from the inside. In the most celebrated of them, *Bust of a Woman with Self-Portrait* of 1929, the woman's frightful head—her hair flying stiffly, her teeth exposed, her sharp tongue thrusting from her mouth like a weapon—is played against the placid framed image of the man's head. In the ongoing theater of Picasso's life, Olga, once the model for the lovely ice princess, is now transformed into the monstrous harridan.

———

PICASSO COULD DEAL WITH OLGA in his art through the repertoire of imagery he had already been developing. Although Picasso had occasionally made forays into Matisse's territory, as in his paintings of

still lifes set in front of windows, or in his use of the wallpaper patterning and the window setting in *Three Dancers*, Matisse seems not to have loomed large in his consciousness. But as Picasso began to expand his imagery of Marie-Thérèse, this changed. As early as 1927, he began to heighten his color and to develop floral and wallpaper motifs that recalled Matisse's seated women. As he became more deeply absorbed by his love for Marie-Thérèse, he began to see things in Matisse's paintings that could help him sort out the expression of his own feelings.

At first, this borrowing seems to have made Picasso deeply uncomfortable, and his references to Matisse are initially ironic, rather biting, as if he felt impelled to parody the older painter as a way of gaining some distance from his feelings. The limp distortions of the body and superimposed profiles in *Woman in an Armchair* of 1927 transform this Matissian motif into a very different kind of image. Indeed, Picasso expresses both admiration and resentment of Matisse at this time. There was Matisse, off in Nice, painting pictures that cast him as a sultan with a make-believe harem, reveling in a kitschy version of the "filtered sensuality" that Picasso and his friends had always condemned as a form of hypocrisy. Worse, Matisse had fallen back on the exhausted nineteenth-century formula of mixing the erotic with the exotic and was painting odalisques as had Ingres and Delacroix. It was all too absurd. Yet at the same time, there was he, Picasso, bursting at the seams with real love and uncontrollable desire, but without the means to express his feelings adequately. Later, he could occasionally resort to a lyrical classicism in his representations of Marie-Thérèse, but that path was not yet open to him. He did not want to slip into the backward-looking conservatism Matisse seemed trapped in, and from which he himself had only recently escaped; and because his love was illicit, he could not risk making realistic depictions of Marie-Thérèse even if he wanted to.

A real shift in Picasso's imagery occurred in 1928, when he was pressed forward in two different directions: one, a new way of representing the female body; the other, the exploration of a more abstract space. That summer he created a number of images in which the woman's overall body is flattened out and splayed in a silhouette-like form over the surface of the picture, while the individual parts of the body are radically rearranged. The relative placement of the navel, eyes, nose, mouth, and vagina are sometimes so dislocated that it is at first difficult to tell which is which. These images are among the most startling in the history of the nude because of the emphasis they put on the woman's anus—a part of the anatomy that was almost never de-

picted in paintings of nudes, and that is given exaggerated prominence in Picasso's paintings, because it is frequently situated where one would expect to find the vagina. The allusion to anal sex in these images is so strong that only their highly stylized rendering prevents them from being obscene—or almost. When Picasso wanted to exhibit one of these paintings at Paul Rosenberg's gallery, the dealer refused, shouting at him, "I don't want any assholes in my gallery."

This incident is often cited as an example of Rosenberg's prurience or desire to control the marketability of Picasso's work. But in fact, Picasso was very consciously setting out to break social taboos in his paintings. In doing so, he made even the Surrealists seem tame. While they would talk endlessly about what their sexual preferences were, or ought to be, and would publish lengthy articles about love and sex, Picasso was flaunting his own sexual obsessions before the public—barely masked by the elliptical, abstracted qualities of the style in which they were rendered. As he himself noted, scandalous painting exists only to the degree that a painting is not a painting.

—∞—

As Picasso began to reengage with Matisse, Matisse was beginning to shift gears in his own painting. Early in 1926 he finished *Decorative Figure on an Ornamental Background* (Fig. 7.8), which he showed that May at the Salon des Tuileries. This picture was widely perceived as representing a significant development in Matisse's work, and it attracted a good deal of attention; even if Picasso did not attend the exhibition, he could scarcely have missed the noise the painting generated. The figure was strikingly geometric and sculptural, and the intensely decorated background and use of color were more abstract than anything Matisse had recently done. Some critics were scandalized by the painting's lack of charm; others rallied to the new rigor—and energy—that it seemed to suggest. "On seeing this painting," Tériade wrote, "you no longer fear old age because you see that the spirit can remain eternally young." What a contrast this was with Breton's recent description of Matisse as a "disheartened and disheartening" old lion who had been tamed and made to eat from the hands of the bourgeoisie. Later that year, as if to reaffirm his pedigree as a lion, Matisse showed two of his largest, most austere—and most Cubist-related—prewar canvases at Paul Guillaume's gallery. The exhibition of *The Piano Lesson* and of *Bathers by a River* (Fig. 6.9), along with only one

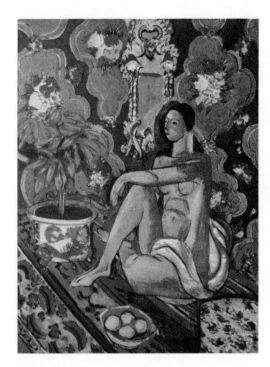

FIGURE 7.8
Matisse, *Decorative Figure on an Ornamental Background,* 1925–1926. 130 x 98 cm.

other painting, created a small sensation, especially among artists who had more or less dismissed Matisse. After having been distanced from the discourse of cutting-edge art for the past several years, Matisse was returning to the arena.

This renewal was not lost on Picasso, who responded to Matisse's paintings with increasing directness, in terms of his two rather different preoccupations: creating a more abstract space in his paintings, and giving free rein to the sensuality Marie-Thérèse had unleashed. An example of the first undertaking can be seen in Picasso's *Painter and Model* (Fig. 7.9), which responds to the vertical banding and expansive sense of space he had seen in Matisse's recently exhibited *Bathers by a River* of 1916. The rhythmic, bright yellow floral patterning on the chair in *Painter and Model* also recalls the decorative patterns in Matisse's recent paintings, and in making those patterns even flatter and more intense than Matisse's, Picasso uncannily anticipates Matisse's late cutouts. This picture challenges Matisse by alluding to him while remaining a quintessential Picasso, by taking elements from Matisse and making them into something very different—much as Matisse had done with Picasso's work back in 1913 and 1914. One of the most striking aspects of *Painter and Model* is the way forms migrate from one entity to another and are transformed as signs, depending on where

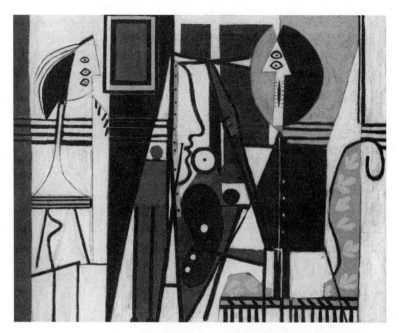

FIGURE 7.9 Picasso, *Painter and Model*, 1928. 129.8 x 163 cm.

in the picture they are placed. Especially stunning is the combination of male-phallic and female-vaginal elements in the artist's arm and face, which is looking in two directions at once: into the light and into the dark, toward the model and away from her. The displacement and interchange of various anatomical parts, especially the reference to sexual parts, is probably related to the Surrealists' similar concerns, along with the overt references to Oceanic art, especially Melanesian shields, which then were of particular interest to the Surrealists.

Painter and Model is also clearly related to the contemporaneous welded sculptures that Picasso was doing with Julio González, such as *Construction in Wire*, or *Head* of 1928, for which this painting served as a prototype. The reciprocal relationship between painting and sculpture was becoming increasingly important to Picasso (as it was to the Surrealists, who gave great emphasis to objects). But although the sculpture made by painters is traditionally regarded as a way of giving material presence to two-dimensional imagery, Picasso was much more concerned with *de*materialization, and the possibility of creating "nonspace," in both mediums. This issue was especially germane to Picasso's sculpture, and it also is a crucial element of his *Painter and Model*. For example, although Picasso had been impressed by Jacques Lipchitz's open sculptures, such as *Pierrot with Clarinet* of 1927, he must have

noticed that such sculptures were like costumes that had been cut open, without the bodies inside them: There is space where the body is supposed to be, but essentially it is based on a materialistic view of continuous space with empty intervals in it. Picasso, by contrast, aspired to a very different kind of spatial construction, literally creating a visual equivalent for an *idea* that doesn't exist in space. His aim was to sculpt "nothingness." Such ideas were no longer Cubist ideas per se, but rather were concentrated on finding ways of creating signs not simply for things but also for paradoxes—for contradictions as well as for assertions, for states of suspension and nonbeing as well as for being. The project for a monument to Apollinaire had been revived, and Picasso was again engaged in preparing a proposal for it (which was rejected by the committee). His desire to create a placeless and spaceless sculpture is appropriately similar to the conception Apollinaire had ascribed to the Picasso-like Oiseau du Benin in *Le Poète Assassiné:*

"A statue in what?" asked Tristouse. "In marble? In bronze?"
"No, that's too old-fashioned," replied the Oiseau du Benin. "I have to make him a profound statue made of nothingness, like poetry and fame."

Picasso's ambition to invent signs for space and for states of mind as well as for things—to create imagery that, like poetry, is everywhere and nowhere—led him to seek a radically abstract and disembodied space. This is perhaps why he makes oblique but clear references to Mondrian in his paintings at this time, evident in their geometry, their use of primary colors, and especially in their space, which—like the space in Mondrian's paintings, and in some earlier paintings of Matisse—aspires to the utterly immaterial.

BUT IT WAS IN THE REALM of blatant sexuality that Picasso's paintings turned most strongly toward Matisse. One of the most remarkable moments in Picasso's expression of Marie-Thérèse's sexuality came in summer 1928 when he was vacationing with Olga and Paulo at Dinard, on the Brittany coast. He installed Marie-Thérèse there as well, in a *pension de famille,* and the two of them evidently arranged trysts in a cabana on the beach. These events are recorded in a surprisingly direct way in a number of small paintings he executed that summer, of a large woman running on the beach or playing with a ball. In one of the most

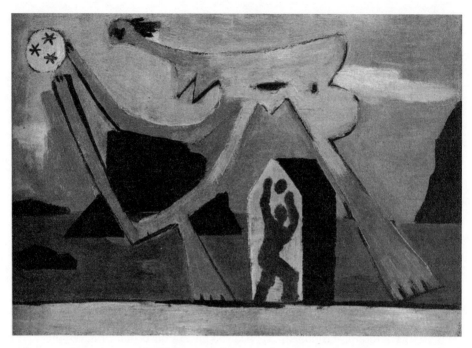

FIGURE 7.10 Picasso, *Ball-Players on the Beach*, 1928. 24 x 34.9 cm.

memorable of these, *Ball-Players on the Beach* (Fig. 7.10), the woman runs along the beach with a decorated ball, while the frenzied silhouette of a man can be seen juggling another ball in a nearby cabana. Of particular note is that both the vagina and anus of the woman are shown, with the anus quite prominent. This type of image is so insistent in Picasso's work at the time that it seems he has set out to break taboos by vaunting the delights of his sexual obsessions. The energy and directness of these small paintings are astonishing, and although they seem private and diarylike, Picasso did not keep them hidden. Some were published in the "Homage to Picasso" issue of the Surrealist magazine *Documents* in 1930.

That same issue of *Documents* also reproduced one of Picasso's most direct responses to Matisse, *Reclining Nude* of 1929 (Fig. 7.11), originally published under the title *The Painter's Studio*. In this painting, the woman reclines on a bed, positioned in a grotesque variation of a pose that "belonged" to Matisse—the Dream-of-Desire—that Matisse had used frequently during the 1920s in pictures such as *Odalisque with Magnolias* (Fig. 7.6). Picasso's conception of the figure is much starker than that in Matisse's paintings, but he cleverly employs his version of Matisse's displacement imagery—to ironic effect. In *Odalisque with*

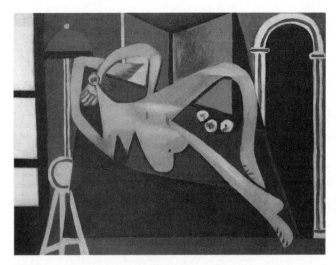

FIGURE 7.11
Picasso, *Reclining Nude,*
1929. 40 x 61 cm.

Magnolias, the fruit in the bowl and the flowers behind the woman are displaced signs of her femininity and sensuality. In Picasso's painting, three pieces of fruit are placed strategically between the woman's legs in a deadpan way, as a jibe at Matisse. Whereas in the Matisse paint-

ing, the woman's genitals are covered by the folds of her billowing trousers, here all her orifices are exposed. Her navel and vagina are painted in soft warm tones, and her anus is boldly set forth as a dark circle that commands attention as a primary focal point of the painting—as if to mock the relative discretion of Matisse's nudes.

Nude in an Armchair of 1929 (Fig. 7.12) makes a similar series of Matissian references—to the poses of paintings such as *Seated Odalisque with Raised Knee* (Fig. 7.5), *Decorative Figure on an Ornamental Background* (Fig. 7.8), and *Odalisque with a Tambourine* of 1926. But here Picasso seems to be referring to Olga rather than to Marie-Thérèse. The figure in this painting has the open mouth that Picasso associated with Olga

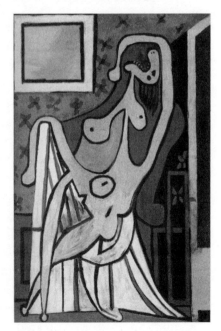

FIGURE 7.12 Picasso, *Nude in an Armchair,* 1929. 195 x 130 cm.

and is rendered with an odd combination of slackness and violence. Picasso, ever attentive to small details, also treats the woman's anatomy

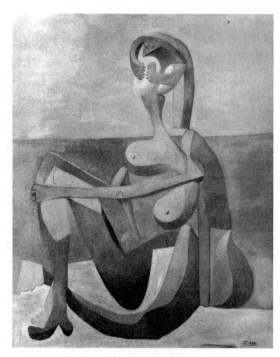

FIGURE 7.13
Picasso, *Seated Bather*, 1930.
163.2 x 129.5 cm.

somewhat differently from the renderings of Marie-Thérèse. The parts of her body seem droopy and disconnected and lack energy. Again, the woman's anus rather than her vagina receives primary focus—rendered here not as a clean round form set between two plump buttocks, but rather as a shit-smeared slash that reinforces the sense of physical disgust projected by the figure as a whole.

An even more aggressive reaction to Matisse is apparent in Picasso's appropriation of a Matisse pose for one of his most bitter and disturbing paintings of the period. *Seated Bather* (Fig. 7.13), painted early in 1930, translates the pose of Matisse's *Decorative Figure on an Ornamental Background* (Fig. 7.8), which had been praised for its renewed vigor and its sculptural qualities, into an image of remarkable ferocity. Part of the force of *Seated Bather* comes from the way it combines the ordinary pose and setting with an extraordinarily grotesque rendering. The duality between our normal expectations from such a pose and the ferocity of its embodiment reinforces the sense that it is a bitter attack on the monstrous woman depicted (and, by extension, on Olga). At the same time, it is an attack on the complacency Picasso associated with Matisse—even in what was considered Matisse's most vigorous recent image of a woman. Picasso's painting taunts Matisse by alluding to his recent work and stripping it of anything that could be considered in-

gratiating—the carpet, the potted plant, the tranquillity of the woman herself. *Decorative Figure on an Ornamental Background* had been related to a new toughness in Matisse's work; Picasso translates it into something that is much, much tougher—as if to suggest that the old lion had indeed forgotten how to roar.

During the next few years, Picasso would persistently alternate between violent and lyrical images, often associating them alternatively with the two women who had come to symbolize for him the opposing roles of horrific shrew and accommodatingly sensual lover. But soon it would be the image of the lover that he would come to associate most with Matisse.

———

AS MATISSE APPROACHED his sixtieth birthday, he was losing focus and found it increasingly difficult to paint. The change in his painting life seems to have been precipitated by radical changes in his domestic life. In 1927 he and Henriette Darricarrère parted ways. For the previous seven years, she had been his constant companion and principal model and a crucial source of inspiration for the rich sensuality of his imagery. Henriette was only nineteen years old when they first met; in 1927 she was approaching thirty and had reason to want another kind of commitment from Matisse. Little is known about the circumstances of their parting, but a sense of the grief he experienced at her loss can be seen in the last picture he painted of her, *Woman with a Veil* (Fig. 7.14).

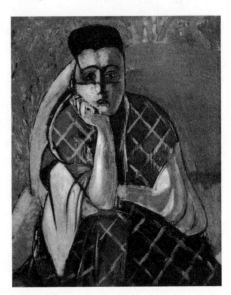

FIGURE 7.14 Matisse, *Woman with a Veil*, 1927. 61 x 50 cm.

In this painting, Henriette, who had so frequently posed nude for Matisse, is dressed from head to toe and pressed forward toward the picture plane with the kind of psychological directness usually associated with Picasso. Her pose is the traditional one of contemplation and melancholia—chin on hand, elbow on knee—and the planes of her face are fractured by the veil in a way that emphasizes both her inner sadness and her faraway gaze, and that recalls

Picasso's fractured treatment of faces at this time. The lines incised into the paint film palpably convey the raw emotion that is only partially masked by the woman's veil and by the impassively stable, Picasso-like way she is set within the canvas. The rendering of the red and green crisscross pattern on her dress is unusually rigid for Matisse, as is the way in which her body is so firmly anchored at the lower corners of the canvas. It is almost as if, for the expression of such intense sorrow, Matisse instinctively turned toward the vocabulary of Picasso, the better to express an emotion that was common to Picasso's art but so foreign to his own.

The following spring, Matisse's wife, with whom he had not lived together regularly for a decade, joined him in Nice, and the tenor of his life changed radically. Shortly after Amélie's arrival, the long series of odalisques came to an end, and he devoted most of his time to graphic works and sculpture. For the first time since the turn of the century, Matisse lacked a clear direction in his art. He had a great deal of trouble starting paintings and even more trouble finishing them. He was also receiving a lot of adverse criticism, so his inner doubts were compounded by public skepticism about the quality of his work. Even his staunchest supporters were equivocal about his recent paintings. When the first of four planned retrospective exhibitions opened at the Thannhauser gallery in Berlin, a reviewer noted that even the artist himself "recognized that he has reached a standstill in his art."

In one of the most thoughtful articles to appear at this time, André Levinson severely criticized Matisse's paintings of the 1920s, saying that the painter of the odalisques was a far cry from the man who had "been able to turn the art of his age upside down, and to so enrich and guide it." Levinson believed that Matisse's great contribution had been his application of the principles of decoration to easel painting and the way he emphasized the surface of the canvas by "inscribing all of the objects in the same plane, bringing them to the surface and reducing them to two dimensions." He praised the bold simplicity of Matisse's earlier paintings, most especially his use of pure colors "laid down in broad swaths with uniform intensity, their luminosity unaltered." If Matisse was a great painter, Levinson concluded, it was because of those early works and not because of his more recent ones.

Amélie's return did not help their marriage. She was chronically bedridden with a spinal disorder, and tension developed between her and a young model named Lisette, who had moved in with the Matisses to serve as her night nurse. It was therefore with some relief that Ma-

tisse escaped to Tahiti at the end of February 1930, stopping off in New York en route and crossing the United States by train before spending two and a half months in the South Seas. Typically, when Matisse was asked about his trip to Tahiti, he framed it as a way of seeking pictorial inspiration, claiming he was following in the footsteps of Gauguin in order "to see the night and dawn light of the Tropics, which doubtless have another density." He did not, however, do any serious painting in Tahiti, and Picasso, who hated traveling, could not refrain from deflating the whole undertaking. "From a professional point of view," Picasso told an interviewer, "it seems to me that it must be very galling to travel to the other side of the world, as Matisse did, following Gauguin's footsteps, only to discover that in the end the light over there and the essential elements of the landscape that attract the painter's eye are little different from those he could find on the banks of the Marne."

Only a few months later, Matisse took advantage of an opportunity to return to the United States, where, as a former first-prize winner at the Carnegie International Exhibition, he was invited to be a member of the 1930 jury. While he was in America, he was commissioned to do a mural for the Barnes Foundation in Merion, Pennsylvania, which had one of the world's largest collections of his paintings, including such early masterworks as Le Bonheur de vivre. The Barnes commission provided him with a long-awaited opportunity to work on a large-scale mural, and—along with a major challenge that Picasso would soon pose—played a decisive role in the formulation of his late style.

The first-prize award Matisse won at the Carnegie exhibit had been for a sumptuous but not especially distinguished 1924 still life. In 1930 he played a decisive role in persuading the conservative Carnegie jury to award first prize to Picasso, for a lyrical and quite naturalistic 1923 portrait of Olga—a painting that gave the impression that modern art had never really happened. The unlikely congruence of Matisse and Picasso at the Carnegie would turn out to be an ironic prelude to one of the most intense artistic exchanges ever to take place between them.

THE LANGUAGE
OF LOVE

Love must be reinvented, that is obvious.

— ARTHUR RIMBAUD

On June 16, 1931, the largest Matisse exhibition to date opened at the Galeries Georges Petit in Paris. Spanning the whole of Matisse's career, the exhibition included 141 paintings and about 100 drawings, but only a single piece of sculpture. (Curiously, although the models Laurette and Antoinette are named in the titles of some of the pictures, Henriette's name does not appear once, even though she was the woman most frequently depicted.) This widely anticipated event was the highlight of the season and drew a good deal of attention in the press. Magazines such as *Cahiers d'Art* published special Matisse issues, and there was an outpouring of articles and reproductions of Matisse's work.

The selection of paintings, however, gave a rather skewed version of Matisse's achievement. Although the exhibition included such important early works as *The Woman with the Hat, Blue Nude,* and *Goldfish and Sculpture,* the vast majority were his more realistic ones from the 1920s. While the exhibition was being planned, Matisse was in Nice working on the Barnes mural, and he had little direct input, aside from making an unsuccessful attempt to have some of his early paintings sent from the Soviet Union, which had appropriated the Shchukin and Morosov collections. The Bernheim brothers, who owned the Galeries Georges Petit, filled out the show with their substantial holdings of Nice-period works, which weighted the exhibition heavily in that direction. As a result, the exhibition only reinforced the idea that Matisse was somewhat out of step with

the times, and it got a lukewarm reception that did little to further his reputation. Typically, Matisse was characterized as being "vital though not profound" and criticized because he did not "search the soul."

One visitor who did find the exhibition of great interest was Picasso, whose presence at the elaborate preview was more visible than that of Matisse himself. According to one newspaper report, "Matisse refused to be lionized and slipped away early in the evening, preferring that his pictures speak for him. But Picasso, who, with Matisse, shares the distinction of being leader of twentieth-century painting, was much in evidence." The fuss over Matisse's exhibition awakened a keen sense of competition in Picasso, and as a countermove he arranged for two exhibitions of his work to open within the next few weeks: a mini-retrospective at the Galerie Percier, and a small, hastily organized exhibition of eight paintings (four recent) at Paul Rosenberg's gallery. To a degree, his strategy worked, for although most people liked Matisse's show better and it got more coverage, Picasso caught people's attention and was discussed in more serious, modern terms. Waldemar George called Matisse "the jewel in the crown of French painting," while associating Picasso with "a modern form of neurosis." Society portraitist Jacques-Emile Blanche, who preferred Matisse, characterized his painting as "sensual, aphrodisiac," and at its best as "all charm, joy and lightness." He nevertheless recognized Picasso's work for its "metaphysical disquietude," and characterized Picasso as "one of those who travel to the very edge of what lies beyond their capacities."

Picasso studied Matisse's exhibition very carefully, and the directness and sensuality of Matisse's work, so different from his own, struck a chord. A year earlier he had been especially intrigued by an exhibition of Matisse's sculpture at the Galerie Pierre, which distinctly affected his own sculpture. At the time, Picasso was working mostly with welded steel constructions, but in response to Matisse's sculpture, he began to model in clay, creating heads and figures that gave a similar emphasis to mass, sometimes responding directly to specific Matisse sculptures. The series of heads Picasso did of Marie-Thérèse, such as *Bust of a Woman* (Fig. 8.1), were inspired by Matisse's early *Jeannette* heads (Fig. 8.2). Similarly, Picasso's strikingly open *Reclining Bather* of 1931 (Fig. 8.3) contains a double reference to Matisse. The pose reflects Matisse's *Reclining Nude I* of 1907 (the Dream-of-Desire woman), while the open form and the twisting curves of the woman's body are clearly a response to Matisse's *La Serpentine* of 1909. But the result is very different. With his particular kind of dazzling inventiveness, Picasso opens up the forms of the

FIGURE 8.1
Picasso, *Bust of a Woman*,
1931. 86 x 32 x 48.5 cm.

FIGURE 8.2
Matisse, *Jeannette V*, 1916.
58 x 21.3 x 27.1 cm.

FIGURE 8.3 Picasso, *Reclining Bather,* 1931. 23 x 72 x 31 cm.

woman's body and recombines them in a violent and dissonant way that is far removed from the rhythmic harmonies of the Matisse sculptures.

The Georges Petit show now focused Picasso's attention on Matisse's painting, and Picasso signed on for his own retrospective exhibition at the same gallery, to open June 16, 1932, exactly one year after the Matisse show—timing that would make it impossible to miss the intended parallel. Learning from Matisse's mistakes, Picasso oversaw the choice of works in his exhibition and calculated carefully the effect they would have. He also decided to paint a substantial series of new works expressly for the show—paintings that would trump Matisse, and do so on his territory. Picasso began the project in December 1931, and most

FIGURE 8.4 Picasso, *Reclining Nude*, 1932. 130 x 161.7 cm.

of the works he painted during the next seven months were fairly direct responses to Matisse—at once an homage and a rebuff, almost as if he were saying to Matisse, "Look, here's how it should be done." Picasso had been referring to Matisse's works for the past several years, playfully and often with more than a hint of mockery, but now he raised the stakes and produced several paintings that are usually characterized as his most "Matissian," with bright colors, sweeping arabesques, intense decorative patterning, and an extravagantly lyrical sensuality. These Picasso paintings are in a sense more "Matissian" than anything Matisse himself had previously done; in a curious way, they anticipate Matisse's late style several years before Matisse had formulated it.

Picasso was enormously productive during this seven-month period of preparation. Several of his paintings, such as *Reclining Nude* (Fig. 8.4), are based directly on Matisse's *Blue Nude*—but twisted into spiraling arabesques, blazing with intense colors, and hyperbolically referring to the favorite Matisse devices of burgeoning plants, fruits, and rhythmic decorative patterns. Picasso kept painting right up to the opening of his exhibition; the paint was still not entirely dry on some of the canvases he sent to it.

The manic energy behind his escalating appropriation of Matisse's style and subject matter grew out of his desire to produce an ecstatic outpouring of painted love poetry to Marie-Thérèse. So powerful were his feelings for her that they demanded a mode of representation foreign to his working vocabulary. That Matisse possessed such a language rankled and provoked Picasso, and the work he produced in response to Matisse has an aggressive edge to it that mixes admiration with something nearing jealousy. In Picasso's responses to Matisse during the 1920s, he had been more inclined to mock than to imitate him. But in 1931, Picasso began to engage Matisse in a different, less malicious way.

The aggressive use of Matissian elements in the paintings Picasso did in preparation for his show at the Galerie Georges Petit are part of a hyperbolic language that he forged to celebrate an ecstatic voluptuousness. The allusions to specific Matisse paintings were a way of declaring his triumph over the older artist not only as a painter but specifically as a painter of sensuous images of women—as a lover. So strong are the Matissian elements in these paintings by Picasso that at times he almost seems to be trying to steal Matisse's artistic identity.

For example, The Dream (Fig. 8.5) is an extraordinarily lush and sensual painting that capitalizes on a number of works Matisse created during his Nice period. The subject of the languorous woman, the use of the rhythmic wallpaper pattern, and the rich, sensual colors of this painting clearly refer to Matisse's paintings of the late 1920s. But in this painting, Picasso is set on beating Matisse at his own game. The Dream is one of the most lyrical (almost sentimental) of his love poems to Marie-Thérèse. It shows her asleep in a red armchair, her hands folded over her lap, a string of pearls flung gracefully around her neck. Her face is divided down the middle so as to create a clear profile below the masklike full face—as if to suggest the descent from consciousness into sleep, or perhaps the alertness of the dream state within sleep itself. The whole painting is based on similarly strong contrasts, as between the curved forms of the woman and chair and the angular forms behind, or between the reds and greens in the background. In a striking metamorphosis, the upper part of her divided face is in the shape of an erect phallus, as if slyly to suggest the subject of her dreams. The chair she sits in seems quite literally aglow and appears to embrace her with its fiery reds and yellows—the traditional colors of Catalonia, which signal the artist's presence there too. In keeping with the theme of various states of consciousness, and

FIGURE 8.5
Picasso, *The Dream*, 1932.
130 x 97 cm.

of the exposed and the hidden, one breast is covered while the other is exposed; similarly, her converging hands cover yet call attention to her genital area. And the wavy lines across the front of her blouse not only represent folds in the cloth but also act as signs for "waves" of psychic energy, their gentle ripples signaling the inner tranquillity of her rhapsodic somnolence.

Although we can't know what Picasso was thinking at the time, this may well have been the moment he was ready to surrender himself to his love for Marie-Thérèse. It also signaled his recognition that he could speak most eloquently by using Matisse's language as a point of departure, transforming it into a language of ecstasy that went beyond anything Matisse had been able to create. The extraordinary poetry of that reinvented Matissian language was so compelling that it would eventually awaken Matisse to the unexplored possibilities of his own language—much as Picasso's Cubist paintings had allowed Matisse both to synthesize and to transcend his previous pictorial language in paintings like *Goldfish and Palette*.

PICASSO'S 1932 EXHIBITION WAS substantially larger than Matisse's had been. There are 225 works listed in the catalogue, including seven sculptures and six illustrated books. (One of those books, his recently published etchings for Ovid's *Metamorphoses*, was done in direct competition with Matisse's etchings for a collection of Mallarmé's poems, of which Matisse had shown a mock-up at his exhibition.) Picasso decided to play down his more conservative, neoclassical works, emphasizing instead his recent paintings and such major early ones as *La Vie, Two Nudes, Girl with a Mandolin (Fanny Tellier)*, "*Ma Jolie*," *Harlequin*, and *Three Musicians*.

Matisse was put on the defensive by the serious buzz that preceded the opening of Picasso's exhibition. In April 1932 he wrote to his son Pierre saying that Albert Barnes, who was now his main patron, had recently declined an offer to purchase Picasso's *La Vie*. According to Matisse, Barnes had said that Picasso could not see color and that his recent work had been "*a travesty of Matisse.*" It was not without pleasure that Matisse noted this (twice in the same letter), along with the information that Barnes was not interested in buying any more of Picasso's work. Picasso, for his part, both distanced himself from Matisse and attempted to minimize his mastery of color by extending a backhanded compliment. In an interview with the critic Tériade published the day before his exhibition opened, Picasso went out of his way to downplay the importance of color, in a way that clearly sets him apart from Matisse—just when Picasso was about to show some of his most richly coloristic paintings. "How often have I found that, wanting to use a blue, I didn't have it," he said, taking a position that would have been unimaginable to Matisse. "So I used a red instead of a blue. Vanity of things of the mind."

Having asserted the importance of inspiration over color, he then conceded that his main rival was also at least sometimes inspired. "In the end, the only thing that counts is what comes from yourself. It's a sun in the belly with a thousand rays. That's the only reason, for example, why Matisse is Matisse. Because he's got this sun in his belly. That's also why, from time to time, something is there."

MATISSE HAD GOOD REASON TO be startled by the work Picasso showed at the Georges Petit exhibition. Never in the twenty-six years they had known each other had either so aggressively incurred on the other's territory or so blatantly appropriated the other's imagery. The

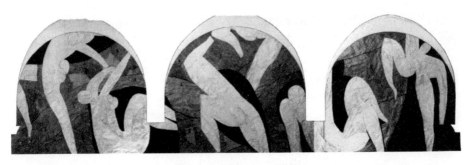

FIGURE 8.6 Matisse, Photograph of the Barnes Mural in progress, 1931

timing of Picasso's aggressiveness, moreover, directly upstaged Matisse, who had been planning to exhibit the completed Barnes mural—his most radically modern recent work—at the Galeries Georges Petit in the spring of 1932 before shipping it to the United States. For this special exhibition, the gallery was even planning to remain open until midnight. But because of a mistake in measuring the dimensions of the mural panels, Matisse had to cancel the exhibition and begin the enormous project all over again—which he did in July 1932, while Picasso's paintings were hanging at the Galeries Georges Petit.

In the first version of the Barnes mural, Matisse had started by painting Cézanne-like figures, but he turned instead to using pieces of cut paper so that he could make quick changes to the enormous panels (Fig. 8.6). In those early cut-paper compositions, he had treated the dancing figures with an unprecedented freedom, flattening and distorting their bodies in a way that owed more than a little to the imaginatively distorted figures in Picasso's 1928–1929 beach scenes (see Fig. 7.10) and large acrobats of 1929–1930 (Fig. 8.7). The way Picasso flattens and splays his figures in such works was previously foreign to Matisse, and in picking up on such ideas, Matisse gave them a new vitality. His dancing figures have an exhilarating sense of freedom, and a formal suppleness and linear energy that make the Picasso acrobats seem rather stiff and mannered. When the second version of the Barnes mural was finished the following spring, it was considerably more tumultuous and "Dionysian" (Matisse's word) than the first—which may well reflect Matisse's sense that the stakes had risen in his competition with Picasso.

PICASSO'S EXHIBITION HAD BEEN planned as a major historical statement; to emphasize this, Christian Zervos published the first

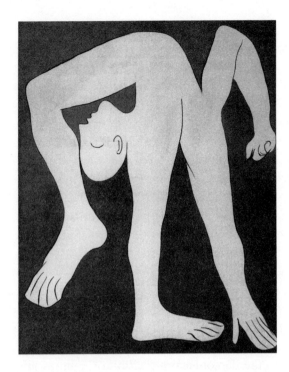

FIGURE 8.7
Picasso, *The Gray Acrobat*,
1930. 161.5 x 130 cm.

volume of his complete catalogue of Picasso's work the same month it opened. But if reactions to Matisse's show the previous year had been tepid, the critical reaction to Picasso's show was openly hostile, even among backers of modern art. Critics were annoyed with Picasso's variety of styles, his eclecticism, and what they saw as the vulgarity and grotesqueness of his recent figure paintings. And since the Picasso exhibition coincided with a large retrospective of Manet's work, there was ample opportunity to compare him unfavorably with an established master. Claude Roger-Marx, for example, noted that the relative sizes of the Manet and Picasso shows (150 and 225 works respectively) were in inverse proportion to their quality. He dismissed Picasso as "a man endowed with an extraordinary intelligence for drawing who would have deserved to have some genius, but has none."

Picasso's recent works came in for especially heavy criticism, in part because of their blatant sexuality and their connection to Matisse. "The master," one critic wrote, "would have given us a different opinion of himself, the man, by choosing at least to duck behind a bush before relieving himself of this style. It is a sort of very bad sub-Matisse, very bad, false . . . monumental vulgarity." For the prominent curator Germain Bazin, the failure of Picasso's recent work was self-evident: "His current downfall is one of the most troubling problems of our time." Another re-

viewer questioned whether Picasso was a painter at all, comparing him to the virtuoso violinist Niccolò Paganini: "a sort of fiddler for the devil. Any song can be demanded of him. He executes them faultlessly in a frenzy all his own. And it is this frenzy that makes him so grand but at the same time so undefinable." Picasso's various styles were called "the successive states of a man who attempts not to express himself sincerely but to discover a mode of expression that is different from everyone else."

When the exhibition traveled to Zurich, it fared no better. The critic Gotthard Jedlicka characterized Picasso's painting as "the most dangerous attack on French painting. . . . in every respect the invasion of a barbaric force into a secure world, with all the power and danger that entails." Matisse's painting, Jedlicka wrote, "is the dam that French painting has built, or tried to build, against this invasion." The psychologist Carl J. Jung saw the exhibition there and wrote a now-famous essay comparing Picasso's works with the pictures made by his patients, concluding that Picasso's art displayed the kind of fragmentation, contradiction, and "complete lack of feeling" characteristic of schizophrenics. Jung described Picasso as an "underworld" personality, drawn to darkness, who followed "the demoniacal attraction of ugliness and evil" rather than "the accepted ideals of goodness and beauty." For Jung, the "uncompromising, even brutal colors" of Picasso's recent paintings were "attempts to master his inner conflict by violence." Although Jung's analysis reflects a remarkable ignorance of modern painting, he nonetheless points to the way in which Picasso's personal pathology was able to reveal the social pathology of the world around him. The Cubist painter André Lhote was among the few writers who understood the artistic importance of how Picasso's painting reflected the "disquiet" of the age. Lhote characterized Matisse's contention that modern art should be like "a comfortable armchair" as a concept that "dates from the first thirty years of a century which has proved so fertile in extraordinary events," and presciently said, "I would be highly astonished if the worries of today—and tomorrow's revolutions—did not soon incite the public to clamor for works of art which administer more than just a 'little shock.'"

We can only imagine what Matisse thought of Picasso's exhibition. But a year later, when his son Pierre proposed a New York exhibition to follow Picasso's, Matisse coolly replied, "I do not have to respond to Picasso's exhibition, since it has been made in response to mine."

PICASSO'S WORKS FROM THE early 1930s constitute a crescendo in the erotic outpouring that he focused on Marie-Thérèse Walter. In June 1935 he learned she was pregnant, and on October 5 she gave birth to a daughter, Maria de la Concepcíon (called Maïa, or Maya), named after Picasso's dead sister. At this point, Picasso went through a time of high family drama. He decided his love for Marie-Thérèse was so strong that he wanted to divorce Olga and marry her. Olga responded with intransigent fury. By this time, as one biographer noted, "she had only one aim left in life—to make her husband's existence unbearable—and she even gave up her social activities to devote herself entirely to this exhilarating task." Lawyers were called in; property settlements were discussed. But since Picasso was still a Spanish citizen, his marriage was subject to the laws of Spain, where divorce did not exist.

Picasso was distraught. For a while he even stopped painting and focused his energy on writing highly inflamed, unpunctuated Surrealistic poetry. (Gertrude Stein, feeling that he was now invading her territory, told him in no uncertain terms that she thought his poetry was "more offensive than just bad poetry. . . . it is all right you are doing this to get rid of everything that has been too much for you. . . . but don't go on trying to make me tell you it is poetry." Picasso, amused by how Stein was protecting her turf, took a malicious pleasure in goading her. Since she had always said he was so extraordinary, he asked, then why wasn't she willing to admit that his writing was extraordinary, too?) In the end, the Spanish divorce law turned out to be a blessing in disguise. Within a year, Dora Maar would replace Marie-Thérèse as the center of his attention.

IF PICASSO'S AGGRESSIVE INCURSION into Matisse's domain had pointed to the weaknesses of Matisse's recent work, it had also indicated a possible way forward. Picasso not only had rudely awakened Matisse to just how far he had strayed from his earlier achievements, but also had put Matisse in the uncomfortable position of having to pass through territory recently occupied by Picasso before he could recapture his previous terrain. This Matisse did by using Picasso's language of love as the basis for the transformation of his own painting.

Since the late 1920s, Matisse's work had been suffering from what can only be called a lack of inspiration. "Several times I've settled down to paint," he had written his daughter in 1929, "but in front of the canvas I draw a blank." The sense of yearning that had been so strongly

stated in his paintings of the early 1920s had never been resolved. Picasso's recent work, literally bursting with passion, pointed not only to the formal laxity of Matisse's recent paintings but also to the uncertain quality of their underlying source of inspiration. If Matisse's painting lacked fervor, was it perhaps because fervor was lacking in his life? Although Matisse had always drawn inspiration from the women close to him, this influence was not something he readily acknowledged, perhaps even to himself. And at this moment in his career, it was precisely this inability to connect emotionally with the women around him that made it so difficult for him to work. His famous detachment from life risked detaching him from the vitality of his art. The shock of Picasso's exhibition at the Galeries Georges Petit led him to take stock of his situation as a man as well as a painter. And although his response would be delayed for a while, when it came it would be both a constructive and a shattering one, which involved his passion for a much younger woman.

Around the time of Picasso's 1932 exhibition, while Matisse was working on the second version of the Barnes mural, he had hired as a studio assistant a lovely young Russian émigré named Lydia Delectorskaya. After the mural was finished, she was engaged as a companion and nurse to his chronically bedridden wife. Although Lydia was remarkably intelligent as well as radiantly beautiful, Matisse supposedly did not take particular notice of her until one day, while he was talking to her, he suddenly said: "Don't move!" and began to draw her. Soon after, she began to model for him on a regular basis. And although she had no artistic training, and not even any particular interest in art, he began to train her as his secretary and studio manager. By then they were apparently deeply in love, and she began to appear as obsessively in his paintings and drawings as Marie-Thérèse had in Picasso's a few years earlier.

Again, a curious series of parallels emerges: At the same time that Picasso decides to ask Olga for a divorce, Matisse separates from his wife and begins to edge toward what would eventually turn out to be his own divorce proceedings. Both men are involved with beautiful young blondes—women who are not their usual "types." Marie-Thérèse was born in 1909. Lydia was born in 1910. The daily drama of Picasso's life at the time is familiar lore: Picasso moves Marie-Thérèse to an apartment right down the block from the apartment he and Olga and Paulo share on the rue La Boétie. Marie-Thérèse becomes pregnant. Picasso tells Olga he wants to leave her. Olga screams, threatens, throws things. The drama continues. Picasso has a bailiff come to assess their goods, and Olga

faints. Olga has a bailiff put seals on Picasso's studio doors. She moves out. She excoriates him in daily letters, which he perversely begins to look forward to receiving. This is more or less the expected Picasso style.

But Matisse's situation is uncannily similar, complicated by the fact that his grown daughter makes it clear that she is deeply disapproving of his behavior. Lydia is banished from the house, they meet secretly, she apparently acquires a revolver and threatens to kill herself. As Jane Bussy, who saw Matisse regularly at this time, points out, he "wanted his wife, he wanted his secretary, he wanted his daughter, above all he wanted—oh how he wanted!—not to be fussed and not to have to make up his mind." Eventually, "Mme Matisse, possessed with a demonic energy, her incurable disease of the spine completely cured, took up her bed and walked—or rather rushed about shrieking." Amélie takes to throwing furniture about the room and shouting at him. He is particularly stung one day when she cries out at him, "Monsieur Matisse, you may be a great artist, but you are a rotten scoundrel!" Would you believe it, Matisse exclaims to Bussy, "She said that to ME!" Ultimately, Matisse sets up his own household, with Lydia as his main model and his secretary, a post she would hold until the end of his life.

⸻

ONE OF THE FIRST PAINTINGS MATISSE did after he became involved with Lydia was *Nymph in the Forest* (*La Verdure*) (Fig. 8.8). This canvas is an exceptionally large depiction of a faun about to ravish a young woman, a theme that recalls the *Nymph and Satyr* (Fig. 5.4) Matisse had painted in 1908–1909 at the beginning of his affair with Olga Merson. But Matisse, unlike Picasso, was never comfortable with images of violent sexuality, and although he worked on this painting for years, he was never able to "solve" it. In its early stages, the painting depicted a faun bending closely over a recumbent nymph, excitedly playing pan pipes, and the border was decorated with a floral motif. Although Matisse exhibited the painting in that state in 1936, he would later rework it extensively but still not finish it. (He had encountered similar problems finishing *The Abduction of Europa*, another subject of violent desire, which he had worked on from 1927 to 1929, supposedly doing "three thousand sketches" for it.)

Picasso's tumultuous rape imagery, such as *Minotaur and Woman* (Marie-Thérèse) of 1933 (Fig. 8.9), may well have been a source of inspiration for Matisse, just as Matisse's exceptionally violent illustra-

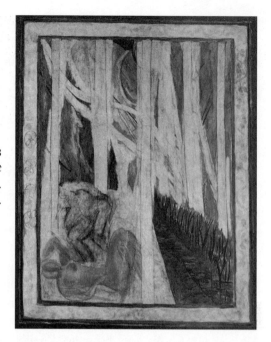

FIGURE 8.8
Matisse, *Nymph in the Forest*
(*La Verdure*), 1935–c. 1942.
242 x 195 cm.

tions for Joyce's *Ulysses* around this same time are directly related to some of the illustrations Picasso did for the Ovid volume. But the violence of Matisse's imagery may have had another source: Just as Matisse was becoming involved with Lydia, he learned that Olga Merson had died. Olga, who was Jewish, had been living in Germany. After she was deserted by her husband and thrown into despair by the rise of Nazism, she found life unbearable. The news of her suicide was a tremendous shock to Matisse.

———

IT IS CLEAR THAT THE SUPPOSED lack of connection between the events of Matisse's life and his art, one of the truisms in almost a century of writing about him, is something of a fiction, cultivated by a man who never resolved the contradiction inherent in his assertion that although his works are based on self-expression, they reveal nothing about him. And nowhere is this clearer than in the extraordinary outpouring of paintings and drawings for which Lydia Delectorskaya modeled in the mid-1930s. They are intensely exuberant, lyrical, tender, and explosively sensual. Like Picasso's slightly earlier paintings of Marie-Thérèse, they are the visual equivalent of fervent love poems.

This emotion is especially evident in the extraordinary drawings Ma-

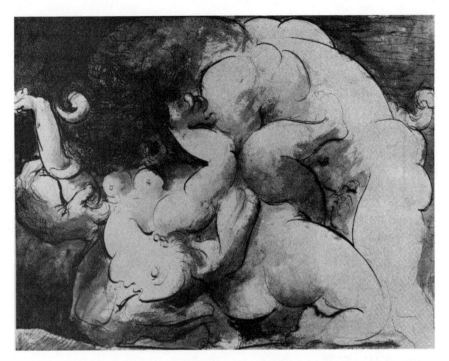

FIGURE 8.9 Picasso, *Minotaur and Woman* (Marie-Thérèse), 1933. 47 x 62 cm.

tisse did of Lydia in 1935 and 1936, which are to some degree a re-
sponse to Picasso's recent drawings, and especially to the exquisite etch-
ings of the artist-and-model theme that Picasso did for the so-called Vol-
lard Suite. Matisse's drawings of Lydia, such as *Artist and Model* of
1935 (Fig. 8.10), are remarkable for their virtuosity and intense sensu-
ality. Many of them were published as a portfolio by *Cahiers d'Art* in
1936, almost as if Matisse could not refrain from proclaiming his ob-
session with her to the world. In drawings such as *Artist and Model*, the
outpouring of emotion underlaying the image literally disorients it on
the page, making it difficult at first for us to locate ourselves in relation
to the space. We, like the artist, are what the French call *bouleversé*.

 The composition is organized around the contrasts between the undu-
lating curves of Lydia's body and the intense decorative patterning of the
cloth. As she reclines on the bed, we see Matisse's hand in the very act of
drawing, the pen probing its way into the image in a surprisingly sexual
way. (Lydia is also smiling with evident satisfaction, a rare expression in
Matisse's drawings.) Because of the way Lydia's image is repeated in the
mirror and in the drawing-within-the-drawing, her presence becomes es-
pecially intensified. This repetition allows Matisse to have Lydia be

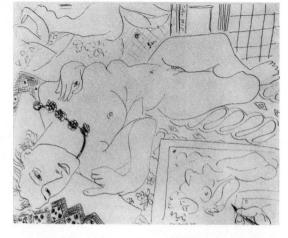

everywhere at once, filling every aspect of the drawing, as if he can't get enough of her—suggesting that she fills his being in the same obsessive way that she fills the drawing. The repetition of the subject is paralleled by the way the rhythmic pen marks are dispersed over the surface of the sheet, which emphasizes the paradoxes the image contains and becomes a metaphor for the omnipresence of the artist as well as the model.

The constant repositioning of both the artist's and the spectator's physical and mental relationships to the image is a crucial aspect of Matisse's drawings of the mid-1930s. It is accomplished in different ways and with varying effects. The frequent instances of multiple representations, multiple framings, and drawings within the drawings, for example, transform what at first appear to be straightforward, physical descriptions into enigmatic, elliptical images. Works such as *Artist and Model*, which clearly anticipate the extended set of "Themes and Variations" drawings that Matisse would do in 1941, are very different from Picasso's drawings at this time. Picasso's drawings of the 1930s have an elegantly attenuated linearity and treat their subjects with an almost classical austerity reminiscent of the exquisitely modulated drawings on Greek vases. Matisse's drawings are more fluid, more highly inflected, and remarkably abstract in the emphasis they give to the pen marks on the surface of the paper and to the all-over pictorial effect.

ONE WAY MATISSE NAVIGATED his way through Picasso's territory was by appropriating his image of Marie-Thérèse asleep, seen from close up. This is a theme that "belonged" to Picasso, who had painted it

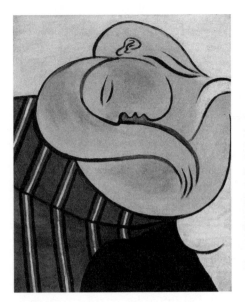

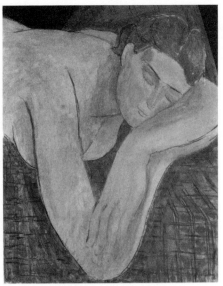

FIGURE 8.11
Picasso, *Woman with Yellow Hair*, 1931.
100 x 81 cm.

FIGURE 8.12
Matisse, *The Dream*, 1935.
81 x 65 cm.

numerous times, as in *The Dream* of 1932 (see Fig. 8.5) and in *Woman with Yellow Hair* of 1931 (Fig. 8.11). Matisse's earliest treatment of this motif is *The Dream* of 1935 (Fig. 8.12), which counters Picasso by employing the subtle painterly means that remained very much outside of Picasso's range. *The Dream* shows Lydia asleep, set against an indefinite blue background very different from the settings of Picasso's dreamers. Despite the stylization of paintings such as Picasso's *Woman with Yellow Hair*, for example, the figure in it is set in an actual physical space; and despite the sweeping curves of the woman's arms in the Picasso piece, it is a static image, grounded as it is by the thick outlining of Marie-Thérèse's figure and by the rigidly striped cloth set next to her. The space in Matisse's image of Lydia asleep, by contrast, is less clearly defined and draws us more closely into her private world; the transparent and somewhat insubstantial rendering in itself suggests the ethereal realm of sleep. We view the woman from such close physical proximity that we have an intimate—almost voyeuristic—relationship to her. As in Matisse's drawings, our physical orientation to the woman is somewhat indefinite; her image seems about to float before us, suggesting her withdrawal into another state of consciousness.

DURING THE MID-1930S, Matisse and Picasso responded to each other even more directly than they had during the years before World War I. But at the same time, their basic approaches to painting remained quite distinct. Matisse's paintings tend to diffuse the beholder's attention, and to create an all-over effect. When we look at them, our attention is forced to shift constantly and is often deflected away from things almost as much as it is focused on them. Matisse's paintings usually avoid anything like a "focal point," because they are organized in such a way that one thing always acts as a foil for something else. Wherever we look, we should also be looking somewhere else at the same time.

In contrast, Picasso's paintings tend to be more focused on their central themes, and the forms are usually set more rigidly within the picture space. To some degree, this difference is a matter of temperament, but it is also related to the artists' different ways of working. Matisse, working directly from nature, constantly wanted to infuse his pictures with more visual information than he could consciously focus on. As a result, we are constantly impelled to keep our gaze moving over the entire surface of the picture. Picasso, working largely from imagination, tends to begin with a visual idea that, no matter how elaborate it becomes, still makes itself felt as the central idea of the picture. Whereas Matisse's compositions often seem to oscillate and float out toward and even beyond the edges of the canvas, Picasso's compositions are more firmly structured and stable, and are often firmly anchored to the four corners of the canvas. As a result, whereas Matisse forced the objects he depicted to submit to the flow of the overall ensemble of the picture and to yield their identity to that totality, Picasso concentrated on the individual elements in a way that often suggests the process of naming. There is something pronouncement-like about the objects depicted in many of his paintings, as if the experience of the separate parts contains verbal identification. This is an effect that Picasso desired. Speaking of painting the nude, he remarked: "I want to say the nude. I don't want to do a nude as a nude. I want only to *say* breast, *say* foot, *say* hand or belly. To find the way to say it—that's enough. I don't want to *paint* the nude from head to foot, but succeed in *saying*. That's what I want. When one is talking about it, a single word is enough. For you, one look and the nude tells you what she is, without verbiage." For Matisse, on the other hand, the apparent indirection implied by this sort of "verbiage" was a crucial aspect of painting.

THEIR STRUGGLE TO CLAIM certain kinds of stylistic turf sometimes gave a testy edge to the interactions between Picasso and Matisse, especially with regard to the reclining woman in the Dream-of-Desire pose. Picasso's *Nude Asleep in a Garden* of 1934 (Fig. 8.13), for example, treats that motif in a way that comes about as close as he ever gets to Matisse's sensual painterliness. But Picasso adds an astonishing anatomical complexity to the motif that is very much his own, and very much beyond Matisse's range. As in Matisse's *Blue Nude*, the woman in the Picasso painting is set below plants that seem to sprout from her body, and she reclines against a red cushion imprinted with a Matissian pattern. Picasso clearly wants us to make the connection—and he does so in order that we may better appreciate

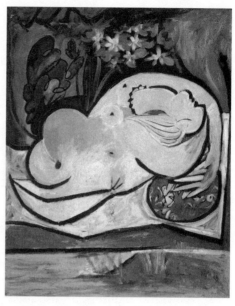

FIGURE 8.13
Picasso, *Nude Asleep in a Garden*, 1934. 162 x 130 cm.

the riff he is doing on Matisse. As in *Blue Nude*, the woman's body is contorted so that its various parts are presented as if from different viewpoints. But the contortion here is so extreme, so compressed, and so stunningly inventive, that we cannot say we *see* the various parts of her body in relation to each other; rather, we experience them with the kind of urgent, everything-at-once simultaneity that parallels desire itself. In this painting, the placement of the woman's various orifices is even more unexpected than in Picasso's other paintings of Marie-Thérèse. Her vagina is denoted simply by three short converging lines that can be rather easily overlooked, but her anus is grossly exaggerated and thrust forward in an unexpected and shocking way. And because the blatant sexual transgression of Picasso's image employs a pose and setting long associated with Matisse, the violation of Matisse's territory is made all the more acute.

Matisse's response to Picasso's inventive reorganization of the human figure was concentrated in one of his most sublimely sensuous pictures of Lydia, the so-called *Pink Nude* (Fig. 8.14), which was his variation on the pose of his 1907 *Blue Nude*. Matisse worked on *Pink Nude* for six

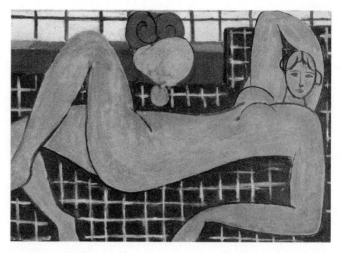

FIGURE 8.14
Matisse, *Large
Reclining Nude,* known
as *Pink Nude,* 1935.
66 x 92.7 cm.

months; he started it on May 3 and did not finish it until October 30, 1935. Returning to a practice he used with the Barnes murals, he photographed *Pink Nude* twenty-two times while it was in progress (and published some of the photos not long after the painting was finished). As with the murals, he also used pieces of cut paper to make quick modifications to the composition without having to wait for paint to dry.

The in-progress photographs show that the painting began as a relatively naturalistic rendering of a woman reclining on a couch, with a chair and a vase of flowers beside her. As the picture developed, Matisse radically altered not only the composition but its basic pictorial language as well, flattening the forms and striving for a musical balance between the organic curves of the figure and the regular geometric patterning in the background. He also tried to augment the forcefulness of the figure by contorting it in a manner similar to Picasso's. This is apparent in the May–August stages of the composition, in which Matisse takes unusual liberties with the woman's legs and torso in order to capture some of the sense of simultaneity that so intrigued him in Picasso's work. But in the end, such an approach was not true to his vision, and he reverted to an abstracted but more unified viewpoint. Toward the end of his work on the painting, he severely flattened and simplified the forms of the woman's body, and in the finished painting she is conceived in terms of stately arabesques played against the grid pattern of the cloth behind her, like the branches of a vine growing across a trellis. This classic dichotomy between arabesque and grid suggests a number of polarities: between stasis and dynamism, culture and nature, reason and passion.

The transformation of the woman's body and its surrounding space is accompanied by the transformation of the other objects in the painting, which in a sense become attributes of the figure. In the finished painting, the vase (which originally was red) has been painted pink, the same color as the woman's skin—as if to suggest a correspondence between the generative qualities of earth and flesh. The flowers also have been transformed, condensed into a curving flat yellow form that functions as a sign for them. The chair, which was quite clearly a piece of furniture in the earlier versions, has now become an abstract inverted double spiral—recalling an ancient symbol of procreation and fertility. The signs for vase, flowers, and fertility that are emblematically set above the woman's body suggest a symbolic exchange of attributes. The object of desire—the body of a single, beloved woman—is transformed into a universal symbol.

WHILE MATISSE WAS RECLAIMING a painting style based on pure, flat colors and sweeping curves in works such as *Pink Nude* and *Woman in Blue* (Fig. 8.15), Picasso's painting was becoming more angular and violent. This shift in Picasso's work coincided with the arrival of Dora Maar, a twenty-nine-year-old photographer whom Picasso met early in 1936. Their love affair started that fall, as the Spanish Civil war escalated. (Picasso was deeply committed to the Republican side, and in July 1936 he was even named director of the Prado Museum by the Republican government.) Dora's face begins to appear in Picasso's work during the fall of 1936, and it was she who the next spring photographed *Guernica* in progress—an interesting echo of Matisse's recent practice of creating a photographic record of his works.

FIGURE 8.15 Matisse, *Woman in Blue*, 1937. 92.7 x 73.6 cm.

The paintings of Dora mark a distinct move away from the Matissian imagery of much of Picasso's recent work. Whereas Marie-Thérèse had been painted with voluptuous

FIGURE 8.16
Picasso, *Dora Maar Seated*, 1937.
92 x 65 cm.

FIGURE 8.17
Picasso, *Weeping Woman*, 1937.
60 x 49 cm.

curves, Dora was painted in an angular way, an example of which appears in *Dora Maar Seated* (Fig. 8.16). In effect, Picasso began to return to the more angular, Cubist-inspired, and violent imagery that he had been engaged with before his Matissian phase. Dora is often depicted as overcome by grief and anxiety; a characteristic image of her is *Weeping Woman* (Fig. 8.17). Picasso imposed this role on her as an antidote to the softness and voluptuousness of Marie-Thérèse. He felt compelled to balance the submissive Marie-Thérèse with someone more intelligent, more worldly, more interesting, more emotionally difficult. And this change was directly related to the need he felt for something stronger, sharper, and more emotionally violent in his work. This shift points to an important aspect of how Picasso used the women in his life as subjects. He did not simply paint all the women who were his lovers; many of the women he was sexually involved with did not affect his work. Rather, relatively few of these women played roles in his art, but those who did were extremely important because he was able to use them as part of the dramatis personae that were so essential to the ongoing drama depicted in his work.

The appearance of the new woman in Picasso's life did not preclude the continued presence of the other. Although Dora Maar supplanted Marie-Thérèse as the center of his attention, he remained al-

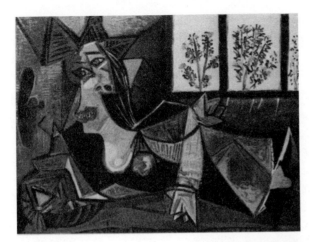

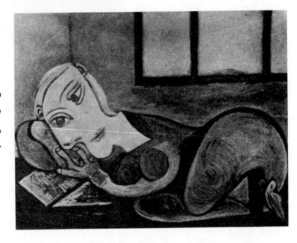

most equally involved with both of them for several years. They corresponded to his different needs, even to different parts of his personality, allowing him to give free rein to both his tenderness and his cruelty. Just as it is unimaginable to think of Marie-Thérèse as the subject of the vituperative or violent images Picasso created from Olga and Dora Maar, so it is equally impossible to think of Dora Maar being treated with the lyrical tenderness he brought to the images of Marie-Thérèse.

On January 20, 1939, Picasso painted two canvases that summed up his feelings toward the two women (Figs. 8.18, 8.19). These paintings are exactly the same size, and each depicts a woman reclining in front of a window. In these two paintings (which were done less than a week after the death of his mother), he seems to take stock of Marie-Thérèse and Dora, almost as if he had made love to both women on the same day and wanted

to capture what was distinct about each. (In fact, Picasso probably hadn't seen either woman that day.) Both paintings depict the women with his characteristic exaggerations. In *Reclining Woman with a Book*, Marie-Thérèse is rendered with a Matissian voluptuousness, in restful blues; the forms of her body are all curves and softness, and she seems to exist in a world completely removed from anything outside her own private space; even the opaque windows do not provide us with an outside view. In *Woman Reclining on a Couch*, Dora is rendered in a much more bristly and jagged way, and the colors in the painting are more complex and dissonant. She looks out at us, and is more active and alert to the possibilities of action in the world around her; on the wall next to her is a painter's palette, and through the windows we see trees. Marie-Thérèse is voluptuous, reassuring, and self-contained; Dora is prickly, complex, discomfiting, but stimulating and provocative.

The docile, sensuous persona of Marie-Thérèse could not serve to express the brutality and cruelty Picasso felt within himself and also saw being unleashed with an ever-increasing ferocity in the world around him. To some degree, Picasso's failure to sustain his love for Marie-Thérèse can be seen as a failure of love. But at the same time, it can also be seen as a transcendence of private love in order to act in a new public arena. It is no mere coincidence that Dora Maar entered Picasso's life when she did—not only because she came to stand for the worldly as opposed to the domestic woman, but also because she provided him with a visage and personality that allowed him to respond to the political events around him, enabling him to give a tangible face to the violence and terror provoked by the rise of fascism, the war in Spain, and the horrors that followed.

Even while Picasso was with Dora, he remained deeply involved with Marie-Thérèse, and they maintained an ardent correspondence. On one level, Picasso's ability to write passionate love letters to Marie-Thérèse while he was living in Antibes with Dora suggests the grossest hypocrisy. "My love," he wrote to her in 1939 while he was staying with Dora, "I love you more every day. You mean everything to me. And I will sacrifice everything for you, and for our love, which shall last forever. I Love you. I can never forget you, my love, and if I am sad, it is because I cannot be with you, as I would like to be. My Love, My Love, My Love: I want you to be happy. . . . I would give anything for that to be so. . . . My own tears would mean nothing to me if I could stop you from shedding even one." This letter is startling because he appears truly to mean what he says, at least in some abstract way. It is not only that he is not satisfied

with being with only one woman; he is not content with being simply one man. There is a division in him—Jung called it schizophrenia, though it might also be characterized as a Faustian hunger for experience—that is reflected in much of his work. His unsettled, restless nature does have something truly Faustian about it—a craving for experience, no matter what the risks, that sends him headlong into situations before he has any idea of how he might even begin to cope with their consequences. His letter to Marie-Thérèse carries all the sincere passion and all the utter falseness of Don Giovanni singing an aria to Donna Elvira.

PICASSO WAS NOTORIOUSLY unwilling to let people slide entirely from his grasp. Olga wrote him letters almost to her dying day, as did Marie-Thérèse. Dora and Marie-Thérèse would live the rest of their lives in homes that he gave them and that remained like shrines to him; he was even in touch with Fernande Olivier well into her old age. But there is nothing quite like the active overlap between Marie-Thérèse and Dora Maar between 1936 and around 1942. During that time, Picasso realized that although he was capable of great love, it existed almost as an emotional force beyond the object of his love—that is, it was a form of self-love that could sometimes be focused on someone else. His dialogues with these women were a kind of interior monologue, transformed into arias for which it was important to have an object. But once the aria is sung, its object becomes somewhat beside the point, almost an inconvenience—until the time comes to sing the next aria. Long after she had ceased to be of great interest to him, Marie-Thérèse lingered in his imagination, and presumably in his erotic fantasies, as the embodiment of a certain kind of emotional and sexual fulfillment. She remained the richest symbol of sensuality in his life, and his paintings of her are the most ecstatically sensual ones he did. She was, in effect, the Matissian woman, the shared Dream-of-Desire. It is not surprising that when she begins to disappear from his art, many of the most overtly Matissian elements in Picasso's painting go with her. Although the relationship between the two men at this time cannot be characterized simply as Picasso's desiring only what Matisse desired, and desiring only through Matisse's desire, which he thus tried to imitate, a strong element of this triangulation surely existed throughout the entire length of Picasso's relationship with—and depictions of—Marie-Thérèse.

The transition brought about by this failure of love was a shaping force in Picasso's oeuvre. A commitment to a single person to some degree implied a similar commitment to a single part of himself, as a core from which his feelings would proceed. And that was not possible for him. As he became less preoccupied with lyrical sensuality in his imagery, he became less directly preoccupied with the Matissian sensuality that had been the impetus for the transformation of his style in the 1930s. Just how far he had moved from Matisse can be seen by comparing his *Dora Maar Seated* of 1937 (Fig. 8.16) with Matisse's contemporaneous depiction of Lydia in *Woman in Blue* (Fig. 8.15), both of which allude in an explicit way to the pose in Ingres's celebrated *Portrait of Mme Moitessier*. The woman in *Dora Maar Seated* is prickly and angular, and the forms of her dress function almost like needles in a pincushion—the opposite of the Matisse woman. The perspective of the room compresses our focus on Dora herself and provides an almost cagelike structure, which we see as a metaphor for her psychological confinement. In Matisse's *Woman in Blue*, the sweeping curves of the elegantly unfurled arabesques both define and play against Lydia's body, like caresses, and the swelling forms of the chair and her body expand across the surface of the canvas in such a way that the woman and the background become part of a single entity. Even the crown of flowers behind her head and the drawings of her on the wall behind her serve to expand and enhance the image of the flowing ubiquitousness of her being.

—∞∞∞—

IN THE COURSE OF PICASSO'S WORK on *Guernica*, he produced a number of studies of weeping women, their grief-stricken eyes swimming crazily in various directions, their skin scarred with marks of their inner anguish, their mouths open in grimacing cries. This image became so deeply associated with Picasso's reaction to the Spanish Civil War that one of the weeping-woman drawings was used on the announcement of the exhibition of *Guernica* at the New Burlington Galleries in London in October 1938.

These images bear witness to Picasso's deepening bitterness and despair as the Spanish war raged on. He started a series of paintings of women with handkerchiefs almost immediately after *Guernica* was finished, and he treated the theme in a number of drawings and etched images in July 1937. In all of these, and in a number of paintings he did

that fall, the handkerchief serves as an essential prop for the expression of grief. In a painting of October 17, the woman bites on the handkerchief; in two paintings done the next day, the handkerchief is used to wipe the eyes. *Weeping Woman* is the most celebrated, and the most powerful, of these paintings. Although it is usually associated with Picasso's portraits of Dora Maar, this painting is not a portrait per se, and in fact some of its color harmonies—such as the violet, yellow, and red—are usually associated with Marie-Thérèse Walter instead. If we compare this painting with the contemporaneous *Dora Maar Seated* (see Fig. 8.16), for example, we are struck by the strong differences in the women's general bearing and even by such small details as the treatment of the fingernails: clawlike in *Dora Maar Seated* and bluntly rounded in *Weeping Woman*. At the same time, Dora Maar's anxious disposition no doubt served as a point of reference for the weeping-woman paintings. Some years later, when Picasso explained that "certain forms impose themselves on the painter," he noted that this was true of the portraits he did of Dora Maar. "I couldn't paint a portrait of her laughing," he said. "For me she's the weeping woman. For years I've painted her in tortured forms, not through sadism, and not with pleasure, either; just obeying a vision that forced itself on me. It was the deep reality, not the superficial one."

Weeping Woman is an image that transcends an individual personality to become a universal image of suffering. This is conveyed in an especially strong way by the sharp forms of the hands and face, which impart an almost unbearable feeling of grief. The way the white handkerchief both covers her face and reveals her skull underneath it suggests mortality as well as despair. In that part of the painting, there is also a breathtaking shift from visual to tactile impressions. We *see* the handkerchief but *feel* the skull, and in the process, we psychologically make the empathetic gesture of touching our own face. Hence we feel the figure from the inside out at the same time that we see her from the outside in. The image is given an added poignancy by being fixed within specific circumstances. The background suggests the inside of a room, made all the more confining by the barlike lines on the wainscoting, which emphasize the woman's emotional containment. Similarly, the presence of the hat with the tiny blue flower on it provides a touching contrast between the sedate way she is dressed and the wild emotion she expresses. (This recalls the similar contrast between conventional dress and extreme emotion in Matisse's 1913 *Portrait of Mme Matisse*.) The very ordinariness of her dress and hat suggests that

the horror she is experiencing can touch absolutely everyone, as indeed it would within the next few years. As Picasso later explained, he wanted especially to disturb people: "What interests me is to set up what you might call the *rapports de grand écart*—the most unexpected relationship possible between the things I want to speak about . . . I want to draw the mind in a direction it's not used to and wake it up. I want to help the viewer discover something he wouldn't have discovered without me." This is perhaps what Francis Bacon meant when he spoke of "Picasso's brutality of fact." By the late 1930s, Picasso had become the master of the unpleasant truth.

It suited his temperament. He loved to destroy almost as much as he loved to create: traditions, expectations, identities, the people close to him. He turned against all of them with a passion made all the more powerful by his extraordinary ability not to censor himself, either in his art or in his life. It was this capacity that also allowed him to make such potent use of clichés. He often built his imagery on elements that had fixed meanings, using what are often rather banal art-historical and cultural clichés to create works that contain powerful and complex meanings. (Matisse, by contrast, needed constantly to reinvent his iconography; clichés were anathema to him.) Among other things, this use of cliché was a powerful tool by which Picasso could make reference to "public" meanings in an intensely idiosyncratic or private way. There is no better example of this than in how he transformed the women in his life into stock characters: During the 1930s, for example, Olga had come to stand for the hysterical and devouring shrew; Marie-Thérèse Walter was the compliant and sensual earth goddess; Dora Maar became the dolorous sufferer. In his life they were real people, but in his art they are also characters in an ongoing drama. The personas they embody may be based on real people, as characters in novels sometimes are, but they are nonetheless fictional constructions. We can understand why Dora Maar later said that "all his portraits of me are lies. They're all Picassos, not one is Dora Maar." In his paintings of her, Picasso had taken possession of her persona and transformed it into a public image that was both more and less than the woman named Dora Maar.

DURING THE LATE 1930S, the dialogue between Matisse and Picasso continued not so much through direct responses in their work as

through a series of exhibitions they mounted in Paris, in which the tensions that had marked their relationship earlier in the decade now became more relaxed. They resumed a cordial if somewhat edgy friendship. To some degree, their relationship was built on their shared celebrity. The two of them were often enlisted to support similar causes and to act as figureheads for modern art. This led them to rush to each other's defense when either was being attacked. During the late 1930s, an entity that can be called "Matisse and Picasso" came into existence, in which the two artists stood for a very specific aspect of modern art. Their art was not completely abstract, and the subjects of their pictures dealt with many of the same themes; they stood for what we would now call "high modernism."

They even began to show at the same gallery. Paul Rosenberg, after years of courtship, finally persuaded Matisse to sign on with him in 1936. (In his first show at the gallery, Matisse was careful to be represented by his best recent work, including *The Dream*, *Pink Nude*, and *Nymph in the Forest*.) At this time, Matisse published a statement that implicitly renounced the way he had been working during the 1920s, praising instead the use of "beautiful blues, beautiful reds, beautiful yellows—matter to stir the sensual depths in men." This, he asserted, was "the starting point of Fauvism: the courage to return to the purity of the means. . . . In my last paintings I have united the acquisitions of the last twenty years to my essential core, to my very essence."

In 1936, Raymond Escholier proposed that Matisse have a compact retrospective as part of the major exhibition "Les Maîtres de l'Art Indépendant," in which Picasso was also well represented. Although Picasso showed only half as many works as Matisse, they included a number of his most powerful early paintings, such as *Portrait of Gertrude Stein*, *Woman in an Armchair*, *Harlequin*, and *Three Musicians*. To provide Picasso with a more international forum, Christian Zervos then organized an exhibition called "Origine et développement de l'art international indépendant," in which Picasso had almost twice as many paintings as Matisse. Both artists included some of their most abstract early works. And of course, the exhibition of *Guernica* at the Spanish Pavilion of the Exposition Internationale in Paris in July 1937 catapulted Picasso onto the world stage as never before, pushing him into a political arena that was totally foreign to Matisse. Picasso became a celebrity of the first magnitude, the political engagement of his art having brought him into the larger arena of

public consciousness to a degree that no other major artist of the century had achieved.

<center>⁂</center>

THE RIVALRY BETWEEN THEM, which persisted right to the end, was frequently expressed specifically in relation to the women in their lives. When Picasso fathered a child at age sixty-six, the seventy-seven-year-old Matisse could not refrain from noting the event—and from getting Picasso's age wrong—in a letter to André Rouveyre: "You know that Picasso at 70 just made a superb child who at four months resembles his father like two peas in a pod." (At the beginning of that same year, Picasso, constantly situating himself in relation to Matisse, had written in a notebook: "Matisse told me this afternoon first of January 1947: '*yesterday I became 77 years old.*'")

One revealing incident in this sexual competition involved Françoise Gilot, who was the mother of that child. Picasso became involved with Gilot, a young art student, in 1943, just as he was drawing away from Dora Maar. (Picasso would paint his own *Joy of Life* that fall, a large picture in celebration of Gilot's pregnancy. He, too, understood that she was restoring in him his feeling of youth. And how could he resist taunting his older rival exactly forty years after Matisse's "*Joy of Life*" had first been shown?) In March 1946, shortly before Gilot moved in with him, Picasso took her to meet Matisse in Vence. While they were discussing color in one of Matisse's paintings, Matisse turned to Gilot and said, "Well, in any case, if I made a portrait of Françoise, I would make her hair green." Picasso asked why Matisse would want to do a portrait of her in the first place, and the older painter replied, "Because she has a head that interests me, with her eyebrows sticking up like circumflex accents."

After the couple left, Picasso said he thought Matisse had gone a bit far. After all, he said, "Do I make portraits of Lydia?" When Gilot said she did not see the connection between the two, Picasso replied that in any case he now knew how he should paint her portrait.

Although Picasso didn't usually work from a model, shortly afterward he asked her to pose for him. He did three drawings of her head, then tore them up and said he wanted her to pose nude the next day. This time he did not draw; he simply stared at her fixedly for over an hour, then told her she could dress. That same day he began work on *Woman-Flower* (Fig. 8.20), a portrait of Françoise that clearly employs a Matissian metaphor. Even the working process was like Matisse's. Picasso began the

painting as a fairly realistic seated portrait, but eventually he simplified and abstracted the figure, until it was transformed into the symbolic form of a flower—with the hair painted a cool green. "Matisse isn't the only one who can paint you with green hair," he told Gilot when he had finished the portrait, observing that he had never wanted to paint anyone to look like a growing plant before.

Matisse had a very different impression of that first meeting with Gilot. "Three or four days ago," he wrote to his son Pierre, "Picasso came to see me with a very pretty young woman. He could not have been more friendly and he said he would come back and have a lot of things to tell me. He hasn't come back. He saw what he wanted to see—my works in cut paper, my new paintings, the painted door, etc. That's all he wanted. He will put it all to good use in time. Picasso is not straightforward. Everyone has known that for the last forty years."

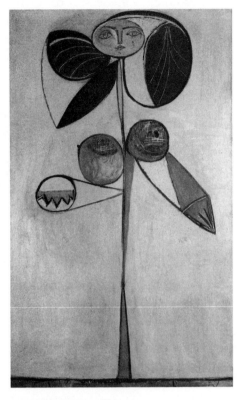

FIGURE 8.20 Picasso, *Woman-Flower*, 1946. 146 x 89 cm.

This incident had a curious sequel a couple of years later, when Picasso took Gilot to visit Matisse in Paris. When they arrived at Matisse's apartment, they found the door ajar, as if Lydia had stepped out for a moment to fetch something, so they walked in. As they made their way from the dark entrance hall into the bright light of the salon, they were startled to have Matisse jump out from behind a tapestry and shout, "Coo-coo, coo-coo!"

When Matisse realized it was not Lydia who had walked into the room, he flushed with embarrassment. Picasso could not contain himself. "Well," he said, "I didn't know you played hide-and-seek with Lydia. We're used to hearing Lydia call you *Monsieur* Matisse." Matisse laughed weakly and tried to change the subject, but now that Picasso had the upper hand, he was relentless. "The last time we saw you, in the Midi," he persisted, "you were so taken with the fact that Françoise's eyebrows reminded you of circumflex accents, you wanted

her to pose for you. It looks to me as though you were doing all right with Lydia's."

"It's unbelievable," Picasso exclaimed when he and Gilot left, "catching Matisse at a thing like that." Then he asked Gilot what she made of Matisse's relationship with Lydia, whether she believed that Lydia was really just his secretary. Gilot replied that she was content not to probe, that she felt it was best to let people say as much or as little as they wanted to about their private lives.

"But why is he always so formal with me," Picasso asked, "so composed? He could confide in me, trust me. Am I not his best friend?" His curiosity, he said, was legitimate; after all, if he didn't want to know such things about Matisse, then he also wouldn't be interested in "the emotions underlying a specific work by Matisse." And he did want to know, precisely because he felt that when Matisse depicted Lydia, his works had a different feeling from those with any of his other models.

"In any case," he concluded, "I can't understand how Matisse can manage not to lose his head in front of a model like that."

INTIMATIONS
OF MORTALITY

Do I believe in God? Yes, when I work.

—HENRI MATISSE

*How difficult it is to get something of
the absolute into the frog pond.*

—PABLO PICASSO

D uring the last phase of their interaction, Matisse and Picasso were
increasingly preoccupied with death. As with so much else in their
lives, they expressed this concern in very different ways. Picasso's work
had been haunted by a sense of mortality from his early days. Now it
became darker and more violent, and especially after the outbreak of
the Spanish Civil War, he often depicted subjects that evoked loss and
bereavement. The war in Spain and the impending menace in Europe
also directed his attention to political themes, as in *The Dream and Lie
of Franco* and the monumental *Guernica*, painted in the wake of the
first terror bombing of a civilian population. Increasingly, the pathol-
ogy and nihilism he had been accused of were understood to have had
a historical and political dimension—a response to precisely the sort of
"disquiet" André Lhote had written about at the time of the 1932
Georges Petit exhibition. Many agreed with Gertrude Stein's observa-
tion that Picasso was the only painter who saw the twentieth century
with the eyes of the twentieth century.

Matisse, who fell gravely ill shortly after the beginning of the war,
dealt very differently with his strong sense of impending mortality. Al-
though his close brush with death had a profound effect on his pictor-

ial language and his working practice, it had little effect on his imagery, and it made him all the more determined to transcend his fear. He began to work increasingly in cut paper, creating brilliantly colored and life-affirming works that seem to abide in a universe where death does not exist. He adopted a strategy of denying time and "lying against death." He and Picasso would have had a very different understanding of Dmitri Shostakovich's remark that "Fear of death may be the most intense emotion of all."

AT THE END OF THE 1930S, as Picasso approached sixty, he had good reason to reflect on his mortality. On January 13, 1939, his mother died in Barcelona, and two days later he painted a large still life with a bull's skull, as if to commemorate the event—a motif that would appear repeatedly in his subsequent work. Less than two weeks later, Barcelona fell to Franco's forces, and that spring Picasso painted several of his most disturbingly violent images, such as *Cat with a Bird*, a large painting in which a dead bird hangs from the teeth of a gleeful, ferocious, much larger-than-life cat. The general feeling of menace was given another tangible form when the Nazis auctioned 125 of the most valuable works of "degenerate art" that had been confiscated from German museums, including four paintings each by Matisse and Picasso. "Matisse and Picasso turned into cannon balls," one critic wrote, "that must be the oddest transformation of all time." As the world around him veered toward madness, Picasso sensed that a phase of his life was coming to an end. In June 1939 he thought seriously about collecting his complete writings, which were to be published by Vollard. But that August, Vollard was killed in a freak accident when a large Maillol sculpture in the back of his car broke loose, flew forward, and crushed his skull. (The superstitious Picasso, who had always detested Maillol's sculpture, would not have failed to note that both Vollard's chauffeur and his own were named Marcel.)

PICASSO'S PREOCCUPATIONS WITH love and death are brought together in a masterful way in *Night Fishing at Antibes* (Fig. 9.1), which he began just after he returned from Vollard's funeral in Paris and finished in the last days of August, just before Germany invaded

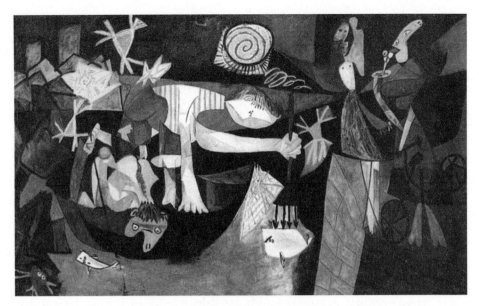

FIGURE 9.1 Picasso, *Night Fishing at Antibes*, 1939. 205.7 x 345.4 cm.

Poland. The painting is one of Picasso's most complex and paradoxical; it combines several different psychological points of view and treats death with a mixture of the comical and the tragic. The picture ostensibly represents two men fishing by the light of a *lamparo*, a bright acetylene lamp that is used as a decoy to attract fish and also provides the light by which to spear them. But the yellow circle with the spiral in it that denotes the *lamparo* looks instead like a bizarre combination of the sun and moon. (The exact nature of the light is complicated by the presence of a second lamp, which is attached to the side of the boat.) According to Roland Penrose, who saw the painting in Antibes just after it was finished, Picasso wanted to emphasize the way the decoy lamp is "to the fish a treacherous substitute for the sun, hung ambiguously on the horizon," and the red spiral was meant to denote a symbolic "source of nourishment." If there is some initial confusion about what we see in the painting, that is apparently the way Picasso wanted it, because the confusion forces us to see the *lamparo* somewhat as the fish do—as a trap that can be confused with the sun or the moon. This is an excellent example of what Picasso later described as the "subversive" element in his paintings, the element of surprise that helps "the viewer discover something he wouldn't have discovered without me" by provoking "contradictory tensions and opposing forces."

One of the fishermen, his head extended laterally like the body of a fish, is spearing a sole (a fish that, Picasso-like, has both eyes on the same side of its head). The other fisherman looks down at the water, and we notice that, ironically, his eyes and nostrils are also on the same side of his face—at least to the extent his face can be said to have sides. He stares into the water rather stupidly, watching the small fish swimming past him or searching for the end of the fishing line that is tied to his toe. At the lower left corner of the painting, a crab looks out at us with a rueful, frightened gaze, an expression that makes us empathize not only with the fishermen but also with the fish they are hunting.

The darkness of the night is punctuated by giant green and yellow moths, one of which flits away from the light in a dizzying spiral motion. Off in the background are the outlines of the Château Grimaldi (now, appropriately enough, the Musée Picasso) and a stone parapet on which two women stand. One spreads her arms in a gesture of greeting, while her buxom companion holds a bicycle and licks a provocatively phallic ice cream cone. For the fishermen, we sense, this is deadly serious work—as it is, of course, for the fish. We, however, see in the black and mauve Mediterranean night an odd mixture of sensuality and violence, in which the antic frivolity of the summer visitor is commingled with the serious life-and-death occupations of the local residents. The two young women, like us, seem to regard the fishermen's activity as a tragicomic sport, made all the more poignant by their antic clumsiness and ludicrous facial expressions.

Night Fishing at Antibes was inspired in part by Picasso's nocturnal strolls in Antibes with Dora Maar during the summer of 1939 (the woman with the ice cream cone is based on Maar, and her companion is Jacqueline Lamba, who was André Breton's wife). But it was also inspired by two paintings Picasso had recently seen at Matisse's studio in Paris, while he was there for Vollard's funeral. Both Matisse's *Daisies* and *Reader on a Black Background* employ deep blacks set against rich color harmonies and have a haunting sense of nocturnal light that find their echoes in *Night Fishing at Antibes*.

THE FOLLOWING MARCH, Picasso still had Matisse on his mind—and in his work—when he did several drawings of a woman with her arms raised above her head. The pose was one he had associated with Matisse since *Le Bonheur de vivre*, and the lyrical, pure line in Picasso's

drawings also evokes Matisse stylistically. But the painting these drawings eventually led to took a radical turn away from Matisse. For the purpose of major statements, Matisse's language no longer spoke to Picasso in the same useful way.

Woman Dressing Her Hair (Fig. 9.2) is one of Picasso's most awesome and disconcerting images of a woman. Although the model for the picture is usually said to be Dora Maar, the painting cannot be called a portrait; instead it is virtually a personification of anxiety, set within a confined, cell-like space. The woman's distorted body, dilated pupils, and flaring nostrils emphasize her anguish and alienation. The wrenching combination of the side and frontal views of her face gives her a monstrous quality, almost as if she could serve as an incarnation of the horror and anguish of war. Picasso himself said

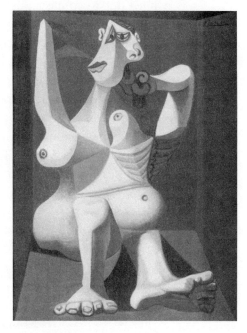

FIGURE 9.2
Picasso, *Woman Dressing Her Hair*, 1940. 130 x 97 cm.

he wanted the picture to "stink of war," and one writer has gone so far as to relate the position of the woman's arms to the swastika in the flag that flew in front of the city hall in Royan, where Picasso was staying when he painted it.

Although such reactions cannot be entirely gainsaid, they overlook the most essential aspect of the painting and the greatest source of its power: the way it plays two apparently opposite sets of emotions against each other. Indeed, the woman is in some ways monstrous, but she is also one of the most nurturing in all of Picasso's oeuvre. Atypically in Picasso's paintings, her nipples are clearly and simply delineated in a "functional" way, and we see the forms of her ample body as if we are a small person in relation to her, almost as a child would see its mother. Her feet, belly, and breasts are disproportionately large, and as our eyes move up her body, our hands seem to follow, for the depiction of her flesh is extremely tactile. The rendering of the ribs recalls the fleshy ribs in Picasso's *Woman in an Armchair* (see Fig. 6.3), which evoked the mortality of the dying Eva—a connection Picasso himself

later made, saying that in *Woman Dressing Her Hair* he had "started . . . over again" the ribs in the earlier painting.

It is hard not to connect this monstrous yet maternal woman with Picasso's mother, who had recently died, and to see her as an amazingly acute visualization of an infant's reaction to its mother—a being that is at once nurturing and terrifying. In any case, the painting is not simply about war, or about Dora Maar, or even about Picasso's reaction to the death of his mother. Rather, it conflates his feelings about women in a way that transcends notions of beauty and ugliness, and that brings together a number of opposing sentiments, including the "brutalization of what was made to be loved." If this painting was to some degree inspired by the death of Picasso's mother, it also draws us beyond any individual death or event and reminds us that the deaths of those close to us cannot help but make us ponder our own mortality—and in Picasso's case, given world events at the time, the impermanence of everything around him.

At the beginning of May 1940, Matisse came to Paris to sort through the artworks he had stored in his vault at the Bank of France. His plan was to make the division of property necessary for the legal separation from his wife and then to spend a month in Brazil with Lydia. One afternoon in the middle of the month, just after Matisse had left the Brazilian tourist office, he ran into Picasso on the rue La Boétie. Picasso inquired about him, and Matisse, who was on his way to his tailor's, described his travel plans.

"But don't you know what's happening?" Picasso asked. "The Germans are already at Reims." After a winter of the so-called phony war, the Germans had begun their spring offensive and had quickly raced past the supposedly impregnable Maginot Line.

"At Reims?" Matisse exclaimed. "But what about our army and our generals? What are they doing?"

At which Picasso threw up his hands and replied, "Well there you have it, my friend. It's the École des Beaux-Arts."

Picasso's acute connection between the rigidity, lack of imagination, and blindness of the French military and artistic establishments—the equation of the useless Maginot Line with the teaching at the national art school—struck a deep chord in Matisse. The two artists had been fighting against such institutional malaise all their lives, and here it had

come back at them with immense consequences. Picasso had little faith in any institution, no matter how well established, but Matisse still wanted to believe that (in everything but art) the established systems worked. So the incompetence, the uncertainty, and "the shame of suffering a catastrophe that we're not responsible for" greatly agitated him. "If everybody had looked after his own business as Picasso and I did ours," he wrote his son Pierre in New York, "this would not have happened."

A few days later, Picasso and Dora left to join Marie-Thérèse and Maya in Royan, and Matisse and Lydia left for Bordeaux. The countryside was already full of refugees, and the hotels were so full that schools and brothels were being used to lodge people. Matisse and Lydia could not get back to Nice until the end of August, around the time that Picasso and Dora returned to Paris. Both artists received offers to immigrate to the United States or Mexico, and both refused. "If everyone who has any value leaves France," Matisse wrote to Pierre, "then what remains of France?"

DURING THE WAR YEARS, the relationship between Matisse and Picasso changed. Though they still remained rivals, the trauma of the war forged a new solidarity between them. As the two most prominent artists in France, they came to stand for French culture, and even—in the face of a barbarous fascism—for the values of civilization itself. (This was an ironic turnabout; before the war they were frequently accused of having introduced barbarism into modern art.) The probity of their personal comportment also stood in clear contrast to the shoddy behavior of a number of their colleagues, such as Vlaminck and Derain, who accepted invitations to go on propaganda trips to Nazi Germany.

Matisse stayed in the south and Picasso remained in Paris, so they did not see each other at all during the war. But Matisse occasionally sent written messages, and they remained in touch through mutual friends, to whom they always posed questions about how the other was doing. Each was in his own way vulnerable during the German occupation. Both had numerous Jewish friends and dealers, and the art of both had been officially proclaimed "degenerate." As a foreigner, Picasso was in an especially delicate situation; he and Fernand Léger were the only two non-Jewish artists who were expressly for-

bidden to exhibit. Early in 1942 rumors circulated, and even reached New York, that Picasso had been committed to an insane asylum. That June, Vlaminck, embittered by his own artistic failure and hoping to ingratiate himself with the Germans, wrote a vicious article attacking Picasso for having dragged French painting "to the most deadly impasse, a state of indescribable confusion." For the first thirty years of the century, Vlaminck asserted, Picasso had "led painting to negation, impotence, death. . . . Picasso is impotence in human form." Under the Nazi occupation, the French reactionaries were coming out of the woodwork and blaming the ills of the world on modern art.

Matisse was horrified by these attacks and informed his son that Picasso was not in an asylum. "It's disgusting," he wrote. "It comes from the enemies of Picasso's painting. The same kind of noise was already being made twenty years ago when he began his extraordinary researches, cubism. . . . This poor man is paying very dearly for his exceptional quality. He is living quietly in Paris, has no wish to sell, asks for nothing. He has taken upon himself the dignity of colleagues who have abandoned theirs in an inconceivable way." Matisse added that he and Picasso had recently exchanged works and that Picasso was constantly telling people that the two of them were "the only two painters."

Picasso's staying on in Paris kept him at the center of things and eventually gave him some of the status of a "Resistant," while his celebrity standing created an aura of at least some protection. (Never a man of great physical courage, he exercised this prudently. When Max Jacob was arrested—with a portrait he had done of Picasso on his worktable when the Gestapo arrived—Picasso refrained from trying to intervene. Jacob died in the internment camp at Drancy.) Although German soldiers frequently came to inspect Picasso's studio for political reasons, they were more interested in his celebrity status than his politics. On one visit, a German officer looking at a postcard of *Guernica* is supposed to have asked Picasso: "Did you do this?"

"No, you did," Picasso replied.

PICASSO'S IMMEDIATE REACTION to the death of his mother had been to paint a still life with a skull. He returned to this imagery again in 1942 shortly after the death of his friend and collaborator Julio

González, when he painted *Still Life with a Steer's Skull* (Fig. 9.3). This is one of his most powerful and menacing still lifes. The starkly painted skull is set against the crosslike frame of the window behind it, which looks out into utter blackness—a striking transformation of a Matissian motif into a completely different vocabulary and mood. Although the sculptural rendering of the skull and the irregular scaffolding of the composition as a whole refer to González's sculpture, the painting transcends the topical and reflects the strong sense of menace and loss that everyone in Europe felt at the time. It is also Picasso's means for contemplating, and perhaps magically staving off, his deep-seated fears about his own inevitable disappearance—another kind of "exorcism."

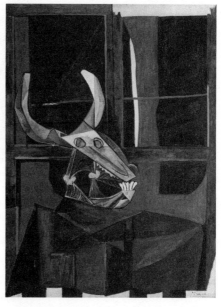

FIGURE 9.3

Picasso, *Still Life with a Steer's Skull*, 1942. 130 x 97 cm.

A similar sense of melancholy, even tragedy, suffuses *L'Aubade* (Fig. 9.4), painted just a month later. Picasso did numerous studies for this painting, which seems to have had a very charged meaning for him, combining as it does the images of Marie-Thérèse Walter (reclining on the bed) and Dora Maar (seated next to her with a lute). The composition refers to Ingres's famous *Odalisque and Slave*, but it also evokes the series of paintings of two odalisques Matisse did between 1926 and 1928, of which this is a macabre antithesis. *L'Aubade* (which means "morning song") was painted at one of the bleakest and most violent moments in the war. The crepuscular color and the unbearably tense silence of the bleak room create a morguelike atmosphere that evokes desolation and mourning rather than love or celebration. (The colors and overall effect of the painting are Goya-like in their dark intensity.) The stiff figure on the bed looks much more dead than asleep, and it has even been suggested that she seems to be turning, as if on an invisible spit, over the gridiron of the bed. The starkness of the room and the oddly moribund quality of the figures also remind us that at the time Picasso painted this, he was nearing the end of his close relationship with both of the women depicted.

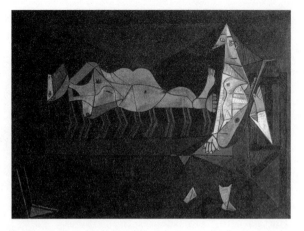

FIGURE 9.4
Picasso, *L'Aubade*, 1942.
195 x 265 cm.

IF MATISSE'S CONFRONTATION with death was artistically more oblique, it was physically more direct. He had been suffering from intestinal problems, and toward the end of 1940 a tumor was discovered. In January 1941 he went to Lyon to undergo surgery for duodenal cancer. Almost everyone, including Matisse himself, doubted that he would survive the operation. It is moving to see that even as Matisse was immersed in the complications of preparing for surgery, Picasso was on his mind. Just two days before the operation, he found time to write a brief message to him, as if he did not want to risk dying without leaving his longtime friend and rival some parting words—as if to say good-bye, but also simply to let him know that he was on his mind. "I'm slightly ill," he wrote. "Am at a clinic in Lyon for a small operation soon nothing dangerous."

In the hospital after his recovery, Matisse was known as *le ressuscité*, "the man who has risen from the dead." (In a letter to his friend Albert Marquet, he described himself as living "a second life.") He also came out of the experience with a new sense of psychological liberation and began to create some of his freest and boldest works. But from that moment on he was frequently bedridden and subject to all the complicated and humiliating procedures necessary to regulate the comings and goings of his digestive system. He knew his time was limited, and he felt a real sense of urgency to "finish" his life's work. He had just begun to open a new vista in his art with the technique of working in cut paper. Because of his illness, at this time he was probably more persistently conscious of the dross matter of his body than ever before in his life.

Yet instead of either exploring or succumbing to this, he began to seek an increasingly transcendent kind of art.

As if to better understand himself, the first painting Matisse began to work on after his convalescence was *Nymph in the Forest* (see Fig. 8.8), which he had struggled with for the past six years. This painting apparently presented a set of troubling, open questions about his relationship to women that he felt compelled to revisit after returning from the dead. It touched something in him that he had tried to deal with a number of times since 1908, but that he could never quite resolve. He had no better luck with it this time. He reworked the figures and rubbed out the decorative border to make the composition more direct and forceful, but he could not take the picture beyond a certain point. "There are so many things," Matisse had written just a few years before his operation, "I would like to understand, and most of all *myself*—after a half-century of hard work and reflection the wall is still there. Nature—or rather, *my nature*—remains mysterious. Meanwhile I believe I have put a little order in my chaos by keeping alive the tiny light that guides me and still energetically answers the frequent enough S.O.S."

The first new painting that he took up after his operation, as if to reaffirm his fresh engagement with life in the face of death, was *Still Life with a Magnolia* (Fig. 9.5), one of his most transcendent and disembodied works, and the antithesis of Picasso's still lifes at this time. The space in this painting is more abstract than in his earlier still lifes and seems clearly to anticipate the more abstracted imagery of his late cutouts. The tabletop is not shown, so that the objects seem to float in an indefinite and insubstantial ether. They are not so much depictions of things as signs for things that exist in a mental rather than a physical world. In 1908, when he had first formulated his thoughts about painting, he had written about probing beyond "the superficial existence of beings and things" and seeking "a truer, more essential character" that would "give to reality a more lasting interpretation." In the early 1940s, as he became increasingly involved with the abstracted pictorial space that would culminate in the cutouts, he wrote that he was aware that "above me, above any motif, above the studio, even above the house, there was a cosmic space in which I was as unconscious of the existence of any walls as is a fish in the sea." Despite the modesty of its subject matter, *Still Life with a Magnolia* has an enormous gravity and spiritual force. For years, it remained the standard by which Matisse judged his other paintings.

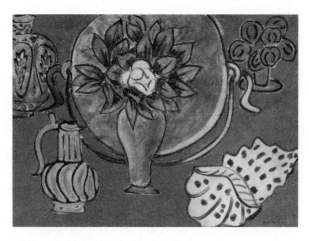

FIGURE 9.5
Matisse, *Still Life with
a Magnolia*, 1941.
74 x 101 cm.

The very notion of the "cosmic space" Matisse was exploring in this painting was antipathetic to Picasso, who said he did not like the piece because it was "too decorative." Françoise Gilot has recounted how "the open composition, with the copper cauldron partly out of the picture and the objects barely touching each other, not isolated or intersecting frankly, was anathema to the master of Cubism. It set his teeth on edge." Right to the end, the extreme fluidity and openness of Matisse's painting remained enigmatic to Picasso. Matisse perhaps sensed that this was not the aspect of his work Picasso liked best. When he wanted to thank Picasso for watching over his vault at the Bank of France, Matisse thought of sending him one of the studies for *Still Life with a Magnolia*, and even inscribed a dedication on the drawing: "to my friend Pablo Picasso." Then he thought the better of it and sent Picasso something else.

WHEN PICASSO MOVED TO the south of France after the war, it was easier for them to see each other, and the question of trading paintings came up more frequently. The exchange of works and the matter of mutual gifts remained prickly issues between them right to the end. Although both men were nourished and inspired by each other's work, exactly what they took from each other was a delicate affair. It is fair to say that none of the works they gave each other as gifts was of the very first rank—although in 1942 Picasso got a great Matisse, the 1912 *Basket of Oranges*, from a dealer in exchange for one of his own early paintings. It is said that Matisse had wanted to buy the painting back,

and that when he learned Picasso had acquired it, he was so moved that he wept. Picasso set great store by this painting, which was often displayed in his studio and which he showed along with his own work at his first postwar exhibition.

One of the most powerful paintings Picasso gave Matisse was an austere 1942 portrait of Dora Maar, which Matisse found deeply disturbing. "It's Dante confronting Hell," he wrote to a mutual friend. "I find the space in front of the face wholly expressive of something immense. What magic!" Later, when Matisse was working on the Stations of the Cross for the Vence chapel, he had it hung on his bedroom wall.

Each artist seems to have chosen for the other works that he felt captured some quintessential part of his own work but that was foreign to the other, or that gave familiar things a new twist or contained the seed of a new idea. At one point, for example, Picasso brought several of his recent paintings to Matisse to ask his opinion of them. Among them was an atypical painting called *Winter Landscape* (see Fig. 9.6), which Picasso propped up on the mantelpiece the better for the bedridden Matisse to see it. Matisse was so taken with it that he asked if he could keep it a while. Picasso was flattered, and when he came back a few months later, he was pleased to see his painting still prominently displayed on the mantelpiece, dominating Matisse's bedroom. Matisse announced to Picasso that he liked the landscape so much he wanted to exchange it for one of his own works. Picasso

FIGURE 9.6
Matisse's bedroom with Picasso's *Winter Landscape* (1950) on mantelpiece. c. 1951

was caught off guard. Precisely because *Winter Landscape* was such an unusual work, he felt it had sprung from a place in himself that he wanted to explore further. He was unable to say no to Matisse, however, so he agreed that an exchange of paintings would be a wonderful idea. But he added that *Winter Landscape* would be difficult to part with because it was pointing him toward a new vision. That, said Ma-

tisse, was exactly the reason he so much wanted to have it, and in return he was willing to offer Picasso an excellent work of his own.

Matisse's offer to trade one of his works shifted the terms of their negotiations over *Winter Landscape*, so Matisse suggested that he keep the picture while he looked for one of his paintings that would be an appropriate exchange. The next time the two artists met, Picasso told Matisse he would like to trade his painting for one of the paintings Matisse had done between 1907 and 1920. In that case, Matisse responded, Picasso should give him a Cubist painting. This led to a particularly awkward stalemate, since it implied that each man thought the other had produced his best work long ago. After the conversation took this uncomfortable turn, they changed the subject. When Picasso left, *Winter Landscape* still remained on Matisse's mantelpiece.

The next time Picasso came, he was amazed to see his landscape flanked by Matisse's maquettes for the chasubles he was designing for the Vence chapel—and that the decorated crosses in the chasubles bore an uncanny resemblance to the tree in his painting. He and Matisse agreed that the somber *Winter Landscape* created an astonishing contrast with the blazing colors of the chasubles, but Matisse never proposed a specific painting that he was willing to exchange for it. It had already served his purpose. Eventually Picasso took his painting back, under the pretense that he wanted to have it photographed.

Picasso owned seven paintings by Matisse and was known to say, "More and more, I feel the need to live with these." Although Picasso sometimes bought works by Matisse, the older painter apparently never bought a Picasso. In a curious way, right to the end of his life, Matisse thought of Picasso as the "kid," and although he had enormous regard and admiration for him—as well as a great envy of Picasso's amazing natural gifts—he was by then too self-absorbed to want to buy anyone else's work. As he blushingly told his old friend Simon Bussy, in explaining why he didn't go to see new work in the galleries, "I only take an interest in myself." For Picasso, the situation was very different. He not only acquired works by Matisse but displayed them prominently in his studio as well. Matisse's color was particularly puzzling to him. "Matisse has such good lungs," he said, speaking of how Matisse used color to make his canvases throb and expand. As Françoise Gilot remarked, Matisse "absent or present . . . was a part of our everyday life."

Sometimes Picasso acquired a painting by Matisse because he didn't understand it. Such was the case with *Tulips and Oysters* (1943), which

he became all the more attached to precisely because he could never figure out why he liked it so much. Although Matisse did not buy Picasso's paintings, he sometimes did studies of them to understand their structure. In 1948, after doing some drawings of Picasso's *Reclining Woman on Blue Bed* (1946) in Antibes, Matisse showed them to Picasso and made it clear that he especially appreciated the way Picasso handled a technique Matisse had never really mastered: the way the "curvilinear torsions led the eye to visualize together those planes that simultaneously showed a front and a back view of the same figure." He was also both impressed and put off by Picasso's uncanny ability to create double entendres—in this case between the form of the woman's body and what Matisse inescapably saw as the image of a detachable collar. After he had done his drawings, Matisse wrote Pierre about how puzzling he found Picasso's fascination with such paradoxes, remarking that Picasso was "a kind of superior clown . . . (this said without any mean-spiritedness)."

———

AFTER THE WAR, Matisse and Picasso emerged even more strongly entrenched as the two great figures in French painting, becoming in a curious way symbols for the liberation of France as well as of French art. But as soon as the occupation ended and they began to exhibit again, the old feelings of rivalry returned, especially on Matisse's part, for Picasso had become a world-class celebrity and was constantly at the center of attention, and controversy. At the 1944 Salon d'Automne, which was nicknamed the "Salon de la Libération," Picasso was given a special exhibition of almost eighty works—most of them done since 1939. And the day before the Salon opened, he scored a major publicity coup when the October 5 issue of *L'Humanité* (the daily newspaper of the French Communist Party) announced on its front page, complete with a photograph, that "The Greatest Painter Alive, Picasso, Has Joined the Party of the French Renaissance." (Matisse must have been piqued not only by that "greatest" but also by the fact that until now Picasso had been conspicuously absent from the autumn Salons.) The press coverage drew enormous crowds to the Salon, and a near-riot broke out. Several of Picasso's canvases were literally pulled from the walls, along with his 1942 sculpture *Bull's Head*, which he made by putting together the handlebars and seat of a bicycle.

Although Matisse did not see the exhibition, he was impressed by the effect it had on the public and wistfully wrote to Camoin that there had

been "demonstrations against it in the street. What a success!" The following year, when Matisse was given a similar special show within the Salon, he was disappointed by the reactions in the press, which found his works "soothing" in contrast to Picasso's "tormented violence."

Matisse's sense of renewed competition with Picasso led him to pay a good deal of attention to how his work was being shown. When Matisse was given the inaugural exhibition at the Galerie Maeght in December 1945, he carefully controlled the installation from Nice, not wanting to repeat the fiasco of his 1931 Georges Petit show. His exhibition at Maeght was decidedly didactic. His paintings were surrounded by framed black-and-white photographs taken of them while in progress, only slightly smaller than the paintings themselves, which demonstrated his process of progressive simplification. (Shortly after Picasso saw this show, he did a series of eleven lithographs that demonstrated the progressive simplification of the image of a bull.) When the Maeght exhibition traveled to Nice, it finally created a bit of a stir among the public, which delighted Matisse, who called it "a repetition of what happened in Paris for the Picasso exhibition."

But the main event at this time was the joint exhibition Matisse and Picasso were being given at the Victoria and Albert Museum in London, where their works would be exclusively paired for the first time since 1918. Matisse was anxious about the effect his works would have at this show, which was to open in December 1945. That May, Matisse wrote Picasso to ask if he would lend certain paintings he owned and to find out what kind of frames Picasso was planning to use. He knew Picasso had exhibited his paintings unframed at the Salon de la Libération, and he did not want his frames at the London show to look too elaborate by comparison. A few months later, on the eve of a meeting to work out more detailed plans for the exhibition, Matisse wrote in a notebook: "Tomorrow Sunday, at 4 o'clock, visit from Picasso. As I expect to see him tomorrow, my mind is at work. I'm doing this propaganda show with him in London. I can imagine the room with my pictures on one side, and his on the other. It's as if I were going to cohabit with an epileptic. How well-behaved I will look (even a bit silly to some) next to his pyrotechnics, as Rodin used to say of my works. I'm still moving ahead, I've never been put off by the proximity of someone weighty or even very embarrassing. Justice will prevail, I've always told myself. But then, what if he's right? People are so nutty!"

Matisse's fears were justified. Most of the attention went to Picasso, who was sometimes severely criticized but who was seen as better re-

flecting the extraordinary period the world had just gone through, in contrast to Matisse's "facile" and "decorative" work. Back in France, conservatives like Waldemar George took the xenophobic position that Picasso was not an appropriate representative of French culture, which only added to Matisse's distress. As Matisse told Brassaï, with "sadness and bitterness," Picasso was "the one who's getting most of the insults, not me. . . . They're courteous toward me. . . . Obviously, next to him, I always look like a little girl." (Brassaï notes that Matisse's comment reminded him of Picasso's calling Braque "my wife.") This exhibition made Matisse realize once again that the personality of Picasso had become larger than life. Like many super-celebrities, he had become a sacred monster—a grotesque mixture of repulsiveness and grace. In him people were able to recognize (and embrace) the stranger in themselves, which could help them seize on (and exorcize) their own demons.

After a while, this situation became one of the givens of Matisse's relationship with Picasso. In 1949, after Matisse showed his recent Vence interiors in an exhibition at the Musée National d'Art Moderne in Paris, he heard that Picasso was planning an exhibition in response. When he wrote to Father Couturier, who had initiated the Vence chapel project, he used a boxing metaphor: "We'll thus be inseparable in the ring, as we are in Paris and on the Côte d'Azur. I'm waiting for the attack, which is already being announced in various quarters. Some people fear for me, although not Mme Lydia. I'll keep you posted about the match."

As EARLY AS 1920, Clive Bell had said that the names of Matisse and Picasso went together like "those of Shelley and Keats or Fortnum and Mason." After the war, they were increasingly seen as constituting a somewhat Fortnum and Mason-like communal entity, as two halves of a single joint venture. For example, Matisse had a long-standing ambition to work in fresco. By 1943 he knew he would never be able to realize that ambition, and he told the poet Louis Aragon, "Perhaps after all I believe, without knowing it, in a future life . . . in some paradise where I shall paint frescoes." Some four years later, after a bout of insomnia, Matisse wrote to Picasso saying that during the night he had come up with the idea that Picasso should paint "a true fresco" for the new Picasso Museum in Antibes. "We'll find a mason to prepare the mortar for you," Matisse urged. "I am convinced that you would do

something splendid and very simply. I want you to undertake this work because it's impossible for me to do it, and I know you would do it better than I. Think about it. It's important for everyone. Forgive my insistence, it's my duty."

In a touching way, each man also saw the other's undertakings as bearing on a certain common interest. Matisse, for example, was disturbed when Picasso joined the Communist Party and allowed himself to be used shamelessly for party propaganda—especially since the party was so strongly against modern art. From the start, Picasso's statements about the party and why he joined it were full of wooden, bureaucratic language that belied everything his art stood for. "The Communist Party," he said right after he joined, "is the logical conclusion of my whole life, my whole work," because, he said, he had "never considered painting simply as an art of entertainment or escape." (Some may have seen his remarks as a reference to Matisse's style of painting.) Wasn't it the party, Picasso asked rhetorically, "that works hardest at understanding and molding the world, at helping the people of today and of tomorrow to become clear-minded, freer, happier? . . . I have never felt freer or more wholly myself! . . . I am once more among my brothers!" (Picasso's joining the party, it should be noted, dismayed progressive Soviet artists and intellectuals. Dmitri Shostakovich referred to Picasso, who lived in complete freedom, as "a bastard" for praising the Soviet system at a time when his followers in the Soviet Union were being "persecuted, hounded, and not allowed to work.")

Even though Picasso's art was open to Soviet charges of "decadent formalism," he was championed by the party, for which he served as a figurehead—and which in turn promoted him as a great humanitarian as well as a great artist. Until at least 1956, when he was disconcerted by the Soviet invasion of Hungary, Picasso took his commitment to the party very seriously. As much as he hated to travel, in 1948 he was persuaded to go to Wroclaw, Poland, for the Congress of Intellectuals for Peace. In October 1950 his famous poster image of "dove in flight" was adopted by the Second World Peace Conference, and that November he received the Lenin Peace Prize. But Picasso's personal and artistic independence and "abstract" style remained anathema to the party, and within its inner circles he was the subject of a good deal of debate and political struggle. At the ceremony for the Lenin Prize (which Picasso did not attend), a formula was invented that attempted to reconcile the party's mixed views about Picasso in relation to an artist like André Fougeron, who was being promoted by *L'Humanité* as the Communist

painter par excellence. Fougeron was said to fight "from his battlement as a Communist," Picasso "from his battlement as a partisan of peace."

When Stalin died, Picasso became embroiled in controversy over a rather bland drawing he did in memory of the late dictator, which was reproduced on the front page of *Les Lettres Françaises*. The party leadership considered it an affront to Stalin, and a considerable brouhaha ensued. Matisse's friend André Rouveyre characterized this event in a way that probably reflected Matisse's thoughts on the subject. "The Stalin-Picasso," he wrote Matisse, "is a real stupidity, an illustriously exemplary stupidity. That's what happens when you are willing to do anything at all on the condition that you don't understand anything and have nothing to say."

Similarly, Picasso found Matisse's work on the chapel at Vence extremely annoying. Since Matisse was not at all religious, Picasso believed he should not have taken on a commission for a religious project, and he constantly chided him about it. At one point, in 1949, he even told Lydia that he thought Matisse's accepting the chapel commission was a form of "whoring." Matisse's rejoinder came a few months later in a radio interview, during which he said, "All art worthy of the name is religious" and condemned the kind of anecdotal, "documentary art" promoted by the Communists.

Nevertheless, both artists also were willing to lend each other a helping hand, even in these problematical domains. In 1950 the Communist-run Maison de la Pensée Française asked Picasso to persuade Matisse to exhibit there, which Matisse agreed to, on condition that he be allowed to show a number of studies for the chapel, including the models for the building. When Picasso visited Matisse's studio, he was unhappy to find the entire space given over to work connected to the chapel. But at the same time he, too, was fascinated by the idea of doing such a project, in which the artist—like the Renaissance masters—would be able to conceive the whole ensemble: architecture, stained-glass windows, wall paintings, and even the chasubles the priests wore. When Matisse encountered difficulties with technical aspects of the wall paintings for the Stations of the Cross, Picasso arranged for him to work with ceramists at Vallouris so they could be rendered in tile; and when the first batch of tiles cracked during firing, Picasso rushed to Nice to comfort him. The raw, dissonant style and disjunctive narrative of the Stations of the Cross—some of Matisse's most disturbing images—definitely have a Picasso-like edge. While Matisse was working on them, he had Picasso's 1942 *Portrait of Dora Maar* ("Dante con-

fronting Hell") hanging next to his studies for the project, as if to provide additional grit for its violence.

When Picasso saw the finished chapel with its white tile interior, he is supposed to have said that it looked like a bathroom. During one visit there, Picasso was cornered by a nun who said she had something to tell him. All the people who came to see the chapel, she said, had their own opinions, and Matisse, she added, had said that he was fed up with all the criticisms and had told her, "There's only one person who has the right to criticize me, do you understand! That's Picasso."

To which the nun added, "Except, of course, for the good Lord."

At this Picasso gave her his wide-eyed look. In that case, he said, "Why doesn't the good Lord do it Himself?"

The year after Matisse's chapel was dedicated, Picasso began his own architectural murals, on subjects symbolizing "War" and "Peace," for the so-called Temple of Peace at Vallouris, where he was given a deconsecrated Cistercian chapel to decorate. The project occupied him for several months, and when it was finished, he had the notebooks of his numerous studies for it hastily published, as if to compete with the attention Matisse's chapel was getting.

IT WAS NOT UNTIL MATISSE began to work on his first extended series of cutouts, which would be published as illustrations in his book *Jazz* (1947), that he began to allude directly to themes of mortality. One of the *Jazz* plates, called "Destiny," is a dark and somber image, full of menace and rendered in funereal violets and blacks. Another, "Pierrot's Funeral," is as close as Matisse came to referring directly to his recent brush with death, but it is an antic, exuberant, almost joyous image. "Icarus" (Fig. 9.7) is one of the most memorable images from *Jazz*. Appropriately, it evokes the tragic death of a figure whose ambitions are very much like those of an artist, and whose death is both an exemplar and a warning. (Could Matisse be indirectly referring here to Picasso, who was flying so close to the sun with wings based on what Matisse himself had wrought? Impossible to know. In any case, we do know that the bursting stars around the figure are meant to refer to bursts of artillery and are one of Matisse's few references to the war.)

One remarkable aspect of images like "Icarus," and of the cutouts generally, is their extreme disembodiment—completely flat and virtually

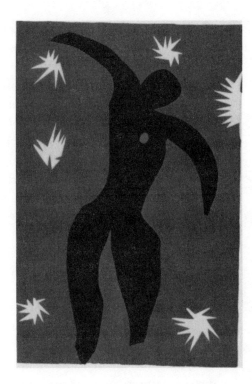

FIGURE 9.7
Matisse, "Icarus" (from *Jazz*),
1943–1947

without material substance. What Matisse referred to at the time as "signs" are often silhouettes, not at all the semiotic signs found in Picasso's works but rather flattened distillations of the shapes of things. The black figure in "Icarus," set against a deep blue ground and surrounded by exploding stars, suggests another world, not only in space but in time.

The immaterial and transcendent image of "Icarus" is very different in effect from Picasso's *The Shadow* (Fig. 9.8) of 1953, which also employs a silhouette but which instead of transcending the human condition is deeply immersed in it. Françoise Gilot left Picasso in September 1953, and that December, only a few days before *The Shadow* was painted, she had come to pick up their children, who had been visiting him for the Christmas holidays. The picture is set in a real place—their bedroom—and even such small details as the toy horse and carriage depict objects that Picasso owned. Yet it is a complex and enigmatic image, which combines two sources of light—a doorway and a window—that create a disorienting fragmentation of the forms. When David Douglas Duncan asked Picasso about this canvas, he replied, "That was our bedroom. Do you see my shadow? I had just come away from the window; so now do you see my shadow and the light of the sun falling on the bed and the floor?"

The sunlight coming through the open window frames the image of the woman on the bed and supposedly casts the shadow of the painter.

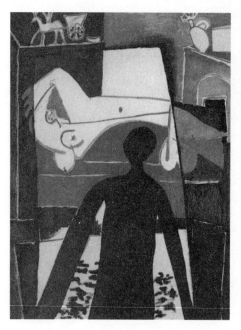

FIGURE 9.8
Picasso, *The Shadow*, 1953.
129.5 x 96.5 cm.

But the painter seems to be standing in the doorway, across the room from the woman, so that if it is his shadow that is cast, he would have to be in two places at once—which in a sense he is: standing in the painting and also standing behind himself watching his shadow-self standing in the doorway watching the specter of the lost woman on the bed. The answer, as in other of Picasso's works, is that he is "both here and elsewhere, as though he possessed double presence. . . . a *natura duplex*. . . . the man who sees sharply from where he is and from elsewhere at the same time . . . in whom contradictory natures concur." Because of the extreme contrasts in lighting effects, the woman also looks ghost-like. Is she any more or less real than he is, any less physically absent at the same time that she is psychologically so present? For a painting not done in a realistic style, it is amazing how vividly Picasso has caught both the visual effects of real light and shadow and their poetic effect. In visiting (or haunting) this room, the shadow of the painter seems to be revisiting a phase in his life that is now forever finished.

The pose and the rendering of the woman in *The Shadow*, with her small head and sweeping, upraised arm, clearly recall Matisse's *Pink Nude*. Compounding the reference to Matisse, the blue around the woman's body evokes not only the background of the *Pink Nude* but also a Matissian window. Once again, at a time of deep emotional crisis, Picasso refers to the Matissian language of transcendent sensuality, as if to acknowledge a level of tranquillity and resolution that existed in Matisse's art and life and that seemed forever unavailable to him.

This painting brings to mind lines from the poem "I Have Dreamt So Fiercely of You," by Picasso's friend Robert Desnos, who was killed during the war:

I have dreamt so fiercely of you,
So much loved your shadow,
That I am left with nothing of you.
I am left to be the shadow amid shadows
To be a hundred times more shadowy than the shadow
To be the shadow that will come and come again
Into your sun-drenched life.

The Shadow is one of Picasso's most moving images of the loneliness that haunted him all his life and from which he sought escape both through painting and through women. Shortly after he painted this picture, while dining with Douglas Cooper and John Richardson at the Château de Castille, Picasso was asked what he was working on.

"Caricatures of myself," he replied, referring to his recent drawings. "I'm a monkey, a dwarf, anything you please, a man with a mask. My existence is a shambles. Do you know that this is the first time I've ever been without a woman in my life? In the morning when I wake up I sometimes say to myself, 'You can't be Picasso.'"

—

AFTER 1948, MATISSE STOPPED painting altogether and worked in cut paper instead. Although his cutouts are sometimes related to collage, the relationship is only a remote one. Picasso's collages incorporated things from the real world that were purposely meant to be foreign to his handmade imagery. In Matisse's cutouts, the pieces of paper were always colored by Matisse or one of his assistants and always remained within the realm of art. Although the subject matter of many of the cutouts engages narrative and literature in a more direct way than did Matisse's earlier works, the very way Matisse used the technique does not allow for a mixture of the elements of art with pieces of real life. (Something similar can be said about Matisse's sculpture, which with one exception was always modeled in clay, unlike Picasso's sculpture, which often incorporated objects from the real world.) Some of the forms in Matisse's early cutouts do seem to be based on Picasso's earlier, cutout-like imagery, such as the acrobatic figures he did around 1930 (see Fig. 8.7). But even more important to Matisse was the idea of "freedom" that was so much part of Picasso's identity, and that Matisse found as stimulating (and problematic) at the end of his life as he had when the two first met. The freedom Matisse took in rearranging

the parts of the body in his cutouts, such as *Blue Nude (III)* (Fig. 9.9), certainly owes a good deal to Picasso, and the very idea of creating planes that had a double torsion was surely directly tied to Matisse's study of Picasso's figures.

Matisse retained his engagement with an affirmative sensuality long after his body was ravaged by illness and age. Right to the end of his life, he persisted in creating imagery that celebrated the gift of vitality Lydia had restored to him. This kind of celebratory sublimation is strikingly apparent in the cut-paper nudes, such as *Blue Nude (III)*, where Matisse condenses the vitality of the woman into a compact ensemble of signlike forms whose daring compression reveals how much he had learned from Picasso.

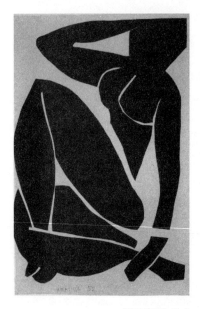

FIGURE 9.9
Matisse, *Blue Nude (III)*, 1952.
112 x 73.5 cm.

The more Matisse's body failed, the more he responded by inventing a mythic youthfulness that he could inhabit in his art. For Matisse, the first rule was to keep his art separated from the literal representation of the feelings behind it, to channel and redirect his emotions into imagery that transcended the raw stuff of life. In works such as *The Sheaf* of 1953 (Fig. 9.10), Matisse achieves a kind of spiritual vision that leaves the physical world behind. The subject of this large cutout refers to the concept of the sheaf *(la gerbe)* in Henri Bergson's *Creative Evolution*, which Matisse had read as a young man and had revisited in recent years. For Bergson, the sheaf is like the force of life itself. "For life is tendency," he wrote, "and the essence of the tendency is to develop in the form of a sheaf, creating by its very growth, divergent directions among which the impetus is divided."

In the late cutouts, Matisse cultivates an image of youthfulness and creates pictures that seem to exist in a world where there is no time and no death. In 1951, when Matisse was eighty-two, an American critic returned from France declaring, "Never before has Matisse seemed to me so young." Sublimating his physical decay in much the same way that he had sublimated his sexual desire in his work throughout most of his career, Matisse reminds one of the lines from Yeats's "Sailing to Byzantium":

FIGURE 9.10 Matisse, *The Sheaf*, 1953. 294 x 350 cm.

An aged man is but a paltry thing
A tattered coat upon a stick, unless
Soul clap its hands and sing, and louder sing
For every tatter in its mortal dress.

MATISSE DIED NOVEMBER 3, 1954, bringing an end to a conversation that had continued for nearly a half century. One of the first people his family called was Picasso. A servant answered the phone and after a long wait said that Picasso was having lunch and could not be disturbed. A few hours later, the Matisse family called back, thinking that Picasso had not been given the message. Picasso still could not come to the phone. When they called a third time, they were told, "Monsieur Picasso has nothing to say about Matisse since he is dead." According to Matisse's daughter, Picasso never sent a telegram or a note. Years later, she still remained vexed and puzzled by Picasso's lack of response and wondered whether he really could have uttered the words the servant relayed.

We can guess. Perhaps Picasso could not bear to think that Matisse

was dead. Perhaps it undermined the idea that almost all artists cherish, that somehow the very act of working is a way of putting off death. And here was Matisse working until the last minute, obviously unable to cheat death. Perhaps Picasso simply could not forgive Matisse for dying, as a child irrationally cannot forgive a dead parent for abandoning him. But we do know that Matisse's death deeply affected him. He stopped painting entirely for a fortnight after Matisse's death, and only a few weeks later when a visitor brought up the subject of Matisse, Picasso stared pensively out the window and muttered, "Matisse is dead, Matisse is dead."

WITHIN A FEW WEEKS OF Matisse's death, Picasso began to paint a kind of extended homage to him—mixed, as was his habit, with a good dose of competitive resistance. The intermediary was Delacroix, whom Picasso had long associated with Matisse, and for whom Picasso had the greatest admiration. In 1946, when Picasso was given the unprecedented opportunity to bring some of his paintings to the Louvre and compare them directly with those by the masters, he had first set his works (including *L'Aubade*) beside the great painters of Spain's Golden Age: Zurbarán, Velázquez, Murillo, and Goya. "You see, it's the same thing!" he said, with some relief, "it's the same thing!" He next went to the nineteenth-century French gallery, to see his works alongside those of Courbet and Delacroix, whose *Women of Algiers* he had a special regard for. While at the museum he said nothing about the French paintings, but later that day, when he was asked what he thought about Delacroix, his eyes narrowed and he said, "That bastard, he's really good."

Picasso's homage to Matisse took the form of a series of variations (see Fig. 9.11) on Delacroix's 1834 version of *Women of Algiers* (now in the Louvre), which was one of the sources for Matisse's odalisques. Although Picasso had previously done adaptations of master paintings, *Women of Algiers* was his first extended series of variations on a historical painting. And although his initial studies loosely followed the broad outlines of Delacroix's composition, Picasso soon began to mix in imagery from Delacroix's 1849 (Montpelier) version of the subject, and by the end of December he had introduced a reclining figure that does not appear in the Delacroix painting but that clearly refers to Matisse's *Pink Nude* (and recalls the reclining woman in *The Shadow*). "When Matisse died he left his odalisques to me as a legacy," Picasso

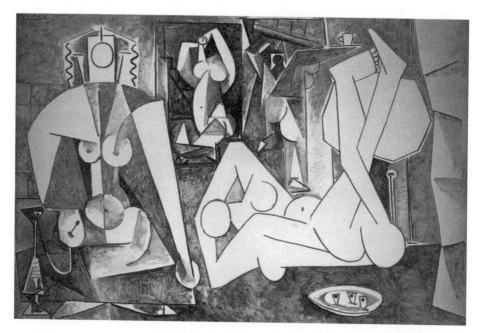

FIGURE 9.11 Picasso, *Variation on "Women of Algiers,"* 1955. 130 x 195 cm.

told Roland Penrose at the time, adding, "and this is my idea of the Orient though I have never been there." In a sense, Picasso was intruding into the "harems" (literally "forbidden spaces") of both Matisse and Delacroix, and perhaps taking special pleasure in gaining even deeper access to the forbidden space than Delacroix himself had attained when he managed to visit a harem in Algiers. In any case, Picasso's orgiastic renderings of the subject are frontal assaults on the comparative sexual discretion of both Delacroix's and Matisse's renderings of it.

Whereas the early variations are on medium-size canvases and are quite angular, from the eighth canvas on the compositions become more planar and more Matisse-like, and the size of the canvases is significantly increased. At various stages Picasso experiments with different degrees of detail in the faces of the figures, temporarily opting to leave them completely blank before returning to one quite detailed face in the final version. Years before, Picasso had criticized Matisse for precisely the same sort of faceless figures that he himself was now using, saying that when the face was omitted, the head remained "just an egg, not a head." Now, with Matisse gone, the terms had changed.

The thirteenth variation, commonly referred to as Canvas M (Fig. 9.11), is in many ways the best and the most Matisse-like, despite its

lack of color. Two of the three main figures are far removed from Delacroix and have been translated into common Matisse poses. The woman in the center with the raised arms is similar to the signature pose Matisse had been using since *Le Bonheur de vivre*, and which Picasso had employed several times in recent years. The reclining figure is a variation on the Dream-of-Desire woman that Picasso had also repeatedly been appropriating from Matisse since the 1920s—here conceived of as if the torso had two left sides. In the background (just above the reclining figure and to the right of the woman at the center), there is a standing figure, which is easier to read in earlier variations, whose head in this variation has been detached from the body and set framed as a silhouette that evokes the shadowy head and shoulders of the artist—in a way that is strongly reminiscent of the silhouetted figure standing in the doorway in Velázquez's *Las Meninas*. This shadowy head gives the painting another sense of double presence and adds an element of deep disquiet to it. Could that be because it was painted the very day Picasso heard that his estranged wife Olga had died?

THE MIXTURE OF HOMAGE and needling that is evident in Picasso's variations on Delacroix's *Women of Algiers* became something of an obsession with Picasso after Matisse's death. During the next few years he became fixated on the idea of doing variations on the masters, and these became a subgenre within his work. His variations seem to be animated by a desire both to possess a work of the master and to measure himself against it. In a curious way, Picasso is again asking the same question about the greatness of his gifts that he had posed back when he and Matisse first met. It is as if he were again struggling against doubts about whether his election as a great artist was really strong enough to defeat death. (This was something Matisse never visibly questioned, at least in his work.) In the end, especially in the variations on the masters, Picasso does seem to have been profoundly concerned about the possible death of his creative gift, and perhaps about its validity earlier on and the degree to which his work would survive him.

For a Spanish artist, the pinnacle of comparison would be with Diego Velázquez. And among Velázquez's works, none is more of a monument than *Las Meninas*, a great masterpiece of Spanish painting and an important icon of Spain's national identity. In repainting it, Picasso was not only reasserting his Spanishness but also assuming

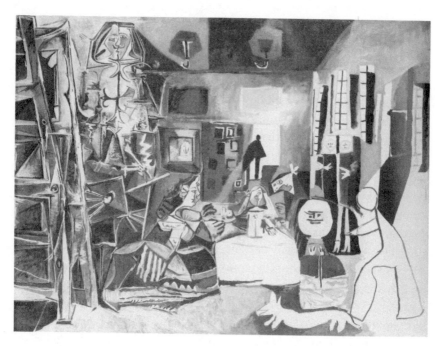

FIGURE 9.12 Picasso, *Variation on "Las Meninas,"* 1957. 194 x 260 cm.

Velázquez's position as the greatest of all Spanish painters. (For many years the brass plaque under *Las Meninas* had identified it as the "masterwork of world painting.")

In 1957, Picasso produced fifty-eight paintings based on Velázquez's masterpiece, starting on August 17 and ending December 30—the day before Matisse's birthday. He set aside a special studio for his work on the series, which he struggled with intensely, and which he did not let anyone see until the whole set had been completed. The first picture in this series of variations (Fig. 9.12) is the largest painting Picasso had done since *Guernica*, and its sheer size indicates its special importance for him. In 1957, Picasso was feeling increasingly alienated from his surroundings and increasingly out of touch with contemporary art. The official denunciations of Stalin and the subsequent Soviet invasion of Hungary left him also feeling politically isolated. He saw fewer and fewer people. More and more, his most stimulating company consisted of the dead masters he had been in dialogue with all his life. His variations on *Las Meninas* were an escape from the present, as well as an attempt to dominate the past and affirm his standing in the future.

Las Meninas is perhaps most famous for the way it combines a realistic view of a court scene with a mysterious and contradictory medita-

tion on the ambiguities of seeing and of being. In his large, contemplative painting about art and illusion, Velázquez shows himself in the act of painting a subject that appears to exist outside the canvas itself and that remains indefinite. The apparent realism of the picture is constantly challenged by ingenious sleights of hand that purposely call its narrative cohesion into question.

In Picasso's variation, the image of the artist dominates: He is rendered disproportionately larger than the other figures, and also as more complex. His dominance and possession of the painting are also asserted by the way in which, as our eye moves to the right, the figures become more thinly painted and more diagrammatically rendered. Picasso's substitution of an expansive horizontal format for Velázquez's squarer and more vertical one increases our awareness of progressive stylistic change as we move laterally across the picture. Whereas the left side of the painting has some of the fractured quality associated with Analytic Cubism, the extreme right side presents a simple, almost childlike rendering. The painting thus seems to have encoded within it a narrative about Picasso's early struggle to find his voice, which he described to Brassaï as a revolt against virtuosity and an attempt to retrieve the "genius" of the childlike (a quality his own childhood drawings never had). It also reflects his stated admiration for the childlike simplicity of Matisse's early work, which he considered "one of the keys to Matisse." In this Variation on "Las Meninas," everything is flattened: The social relationships are played down as much as the spatial relationships and the narrative ambiguities. The elimination of color in favor of a grisaille palette further drains the scene of its corporeality, and we cannot help but feel that the ambiguities in Velázquez's painting have been shifted to another field of inquiry, one with a certain edge of mockery.

Velázquez's painting located its greatest mystery just beyond the picture plane, where we ourselves stand. But in Picasso's painting, we are not directly implicated in the painting by the glances of the figures that inhabit it. In fact, the caricature-like faces of the Infanta and her entourage enact a parody of both Velázquez's vision and our own. Even the artist, who does look at us, does so in a baffling way. His face is split so that its opposing profiles confront each other at the same time that the full face looks out at us. The artist's activity is also difficult to fathom, since he seems to hold not one but two palettes, and the zigzag sign that denotes the folds on the cloth of his left sleeve connects them like a ferocious bolt of lightning. As if to emphasize the irreverence of his depiction, Picasso substitutes his dachshund, Lump, for the noble mastiff in the original. A

triumph over Velázquez? A draw? A defeat? Picasso must have asked himself the same questions. About Velázquez. And also about Matisse.

—⟨∞⟩—

DURING THE LAST YEARS of his life, Picasso became increasingly isolated from the world around him, encapsulated within the myth of his own fame. He was horrified by the crowds of people who gathered outside his house to photograph it or in the hope of catching a glimpse of him, and he became a prisoner there. His new wife, Jacqueline Roque, encouraged him to cut off his children and friends. Yet even as he shut out most of his family and his old friends, he felt compelled to entertain and be photographed by someone like David Douglas Duncan, as if having photographs of himself appear in millions of copies of magazines all over the world could help keep him from disappearing.

He was besieged by a series of physical and psychological woes. In 1964 he learned that Françoise Gilot was about to publish her memoirs, and he became involved in a bitter legal battle similar to the one with Fernande Olivier thirty years earlier, and with the same result. To make matters worse, Gilot's book was more probing than Fernande's had been and exposed his private life to a much greater degree. After a lifetime of miraculously good health, his body began to fail. That November he underwent prostate surgery, and for over a year he did not create a single painting. When the largest Picasso retrospective to date was shown in Paris in 1966, Pablo Picasso was not counted among the over 800,000 people who saw it. To add to his isolation, he was becoming deaf. He suffered the humiliation of having to tell a close friend to whom he spoke regularly on the telephone that he could no longer call her because he could not make out her words.

—⟨∞⟩—

MORE DISPARATE ATTITUDES toward death than Matisse's and Picasso's could hardly be imagined. In his art, Matisse had ignored the decline of his body and denied the finality of death with the same upward gaze as the poet in Yeats's "Sailing to Byzantium," who sings how "Once out of nature I shall never take /My bodily form from any natural thing." Picasso, on the other hand, was increasingly preoccupied by physical corruption and decay. His pictures become increasingly filled with expressions of nostalgia, sometimes even of disgust for the carnal-

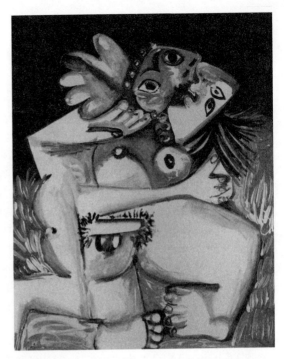

FIGURE 9.13
Picasso, *The Embrace*, 1969.
162 x 130 cm.

ity that had meant so much to him earlier in life. This is apparent in the hundreds of paintings and drawings that he did of sexual play during the last two decades of his life, such as *The Embrace* of 1969 (Fig. 9.13). "How difficult it is to get something of the absolute into the frog pond," he remarked when he was in his eighties, still struggling, still raging. Confronting the desolation of old age with unswerving focus, he saw death as an adversary he was impelled to remain locked in struggle with to the very end. Dylan Thomas's lines are pertinent:

Do not go gentle into that good night,
Old age should burn and rave at close of day;
Rage, rage against the dying of the light.

No other artist in the history of Western art has raged against the dying light so vividly and tenaciously. Picasso's late works are full of narratives of thwarted sexuality, physical decay, and even depictions of bodily functions that rarely appear in paintings: people pissing; puffy, wrinkled gaffers and hags trying to embrace and fondle each other. Few artists are granted sufficiently long life to bear witness to such a prolonged procession of death and deterioration, and none who have chosen to record this have done so with anything approaching the intensity

or directness of Picasso. If Matisse's triumph was, in effect, to transcend death by bravely ignoring it, Picasso's triumph was to look death and decay straight in the face and not flinch. Though it was not possible to report back from that "undiscover'd country from whose bourn no traveler returns," at least he would send back images from the most distant frontiers that adjoined it.

Picasso was enormously productive in his last years, during which he focused much of his terrible intensity on physical anguish, impotence, and frustrated desire, seeing sex now as a kind of cruel game, often stripped of sensuality or pleasure. As he worked, he kept Matisse sometimes in mind, occasionally including Matisse's face in drawings, sometimes referring to him indirectly, as in his 1971 series of etchings of brothel scenes, in which he pokes fun at the pudency of both Matisse and Degas.

FROM EARLY CHILDHOOD, Picasso had been obsessed with death, and he created some of the most compelling and powerful evocations of death that exist in any medium. But none is perhaps so moving as the extraordinary *Self-Portrait* (Fig. 9.14) he created the year before he died. Appropriately, it was not done in oil on canvas but in a medium often reserved for children's drawings: colored wax crayons on paper. This harrowing self-portrait seems to have been done directly from life, the artist examining himself in the mirror, noticing the "spidery age spot" on the left side of his face and the irregular stubble growing on his chin. Everything about this picture is disarming in the extreme, mustering as it does an arsenal of mixed signals and blatant contradictions in order to communicate a terrifyingly urgent and simple message. The subtle sophistication of the sculptural modeling is played against the childlike clumsiness of the design, with its oversized, mismatched eyes, clustered scribbles, and intensely simplified features. The fixity of the stare exaggerates the disparity between the large head and the narrow shoulders, emphasizing the puniness of the artist's shriveled body. The skull-like aura that bulges asymmetrically from the head seems both to expand out and to eat right into the flesh, as if to suggest the imminent decomposition of the head itself. Taken together, the enormous eyes, the fixed stare, and the severely compressed forehead suggest a mindlessness—but it is belied by the macabre, self-conscious intelligence that radiates from the picture. The mindlessness induced by that most powerful of emotions, raw fear?

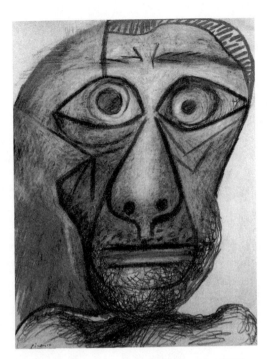

FIGURE 9.14 Picasso, *Self-Portrait*, 1972.
65.7 x 50.5 cm.

In this extraordinary picture, we sense that the artist has looked into the mirror and seen in his own face the fearsome image of death. Yet even as he recognizes this inevitable merging with that dreaded other, he retains his identity, and his integrity, staring back at death and at himself with a look that after more than ninety-one years remains at once stunned and defiant.

———⦿———

PICASSO DIED OF CONGESTIVE heart failure on April 8, 1973. Interspersed with his last gasping breaths, the name of Apollinaire could be made out, along with calls to his wife: "Where are you, Jacqueline?" His final coherent words were supposedly to his cardiologist, whom he told: "You are wrong not to be married. It's useful."

ate craving for life they exuded, and by their apparently helter-skelter mixture of subjects. The paintings were hastily done, mostly in monochromatic browns and grays but with occasional bursts of bright color, and they mixed together a quirky combination of subjects: seventeenth-century cavaliers set side by side with embracing and copulating couples, toreadors, painters and models, haggard old men, unappetizing nudes, biblical figures, voluptuous nudes. Some viewers shook their heads and said that Picasso had been desperately rummaging through the attic of his mind, pulling out whatever relic of the past he happened to come upon. Where, many asked, was the wisdom that was supposed to come with old age? They forgot that Picasso had been surprising people long before most of them had even been born. Nor did they want to consider that what one learned from old age wasn't necessarily what the young expected. The troubling message of those paintings put people off, and for the next several years they were generally ignored. It wasn't until ten years later, when the Guggenheim Museum organized an exhibition of them, that the tide turned and people began to give the late works serious consideration. As Gert Schiff remarked in the catalogue for the exhibition: "The truth is that all through his career Picasso was ahead of his audience by just one 'period.'"

Matisse's late works were better received in the years just after his death. They seemed to radiate a more serene wisdom and reflect a greater spirituality. Increasingly, they were understood to explore profound aspects of human experience and to express them with an inspired balance of sensuous presence and pure thought. Further, the disembodied space and abstract decorative motifs of his late cutouts spoke very persuasively to younger artists, especially in the United States. The Museum of Modern Art's 1961 exhibition, "The Last Works of Henri Matisse: Large Cut Gouaches," created a stir among artists and critics alike, who were impressed by the scale of Matisse's cutouts as well as by the way they maintained the fine line between figuration and complete abstraction.

The decades following the deaths of Matisse and Picasso brought enormous growth in blockbuster art exhibitions worldwide, and both artists have been the subject of a disproportionately large number of them. Hardly a year goes by without at least one major Matisse or Picasso show. These exhibitions have brought their work to an increasingly broad public, which lines up for hours to see them—making museums all the more eager to mount such shows. By bringing together large numbers of works by the artists and encouraging new research,

such shows have also deepened our understanding of Matisse and Picasso, both as artists and as men.

One of the landmarks in this exhibition history was the large Picasso retrospective that William Rubin organized for the Museum of Modern Art (MoMA) in 1980, which was timed to celebrate the centenary of the artist's birth in 1881. For the first time, the entire museum was emptied and filled with works of a single artist. No one doubted that the gesture was justified, since at the time virtually everyone acknowledged Picasso to be the greatest artist of the twentieth century. And since he was also the century's (and perhaps all of history's) most prolific artist, the show seemed endless as well as endlessly fascinating. On the evidence of that exhibition, Picasso seemed to have lived twenty different lives, all of them somehow packed into his art. More than any other exhibition I had ever seen, it gave the sense of a life lived—that is, a record of a person moving through and recording the various stages of his existence: from the awkward melancholy of adolescence, to the passionate embrace of abstract ideas that can virtually sustain a man during his twenties and thirties, to the trials of love, war, and old age. The works recorded with astounding energy and detail the growing complexity of friendships and love affairs, political engagements, and the disasters of what was already shaping up to be the bloodiest century in human history. Somehow Picasso seemed to get at the pulse of the century, almost to define it in terms of his own ruthless egotism. Viewers of the endless array of styles, the compulsive inventiveness, the very quantity of the work, couldn't help but think that Picasso's art was in some way emblematic of the violent and disjunctive sensibility of the century itself—a mirror to an especially disquieting period.

One curious phenomenon that emerged from that exhibition, however, was the feeling that Picasso's influence on younger artists was already on the wane. As recently as the early 1960s, Picasso still was deemed the most influential of all twentieth-century artists. But despite the power and complexity of his art, by the mid-1970s it seemed to be something of a dead end for young artists, offering little chance for subsequent development. The MoMA exhibition made people realize that his greatest contribution to the art of the twentieth century was undoubtedly the way he opened up the possibility that things in the world could be infinitely reinvented, recombined—taken apart and put back together in hundreds of unexpected ways. He showed how strange the world could be made to appear in painting, how radically the artist could reinvent the beings and things that inhabit it. And yet,

the very vocabulary he created for doing this had become so personal and idiosyncratic that no one else could use it. His schematic figures, and the heads with double profiles or with the eyes placed next to each other on the same side of the face, might be easily imitated by mediocre artists, but they resisted being taken further by good ones. And the way he conceived and constructed pictorial space was also becoming less helpful to younger artists than the more open kind of space created by Matisse.

The appreciation of Matisse's art had been given a great lift in 1970, when Pierre Schneider organized a large retrospective exhibition at the Grand Palais in Paris. At that time, Matisse was still being described as he had been during most of his career, as "so easy on the eye and in no way profound." But afterward, Matisse's reputation and influence steadily gained momentum and were given another great boost by the 1992 retrospective organized by John Elderfield, which marked only the second time that MoMA's permanent collections were removed so that the works of a single artist could fill most of the museum. At the time, many were surprised to see Matisse so honored, especially since the exhibition was not timed to commemorate either his birth or death. (Ironically, the show opened 100 years after Matisse failed the entrance examination to the École des Beaux-Arts.)

But by 1992, Matisse was at last beginning to escape from the cliché about being a lightweight, which he had to some degree invited with his remark about the good armchair. Since people often judge paintings with their ears instead of their eyes, that phrase had helped define his work, even though the evidence of his paintings indicated otherwise. But the spread of this cliché was of course only partly Matisse's fault. For the world to regard his vital and energetic works as soft required a point of comparison—which was provided by Picasso, who came to stand for the straight-backed wooden chair that was as hard as a torturer's rack. The clichés were nationalistic as well: bourgeois Frenchman, tough Spaniard. For most of their lives, the comparison hung in the air like a tangible aura, and it continues to linger even today.

By 1992, however, Matisse had already become the artist's artist par excellence. His work, and especially the way he created a transcendent and abstract space, was so suggestive and so open that artists working in many different manners could find inspiration in it. Although Matisse was less obviously inventive than Picasso, his particular kind of inventiveness was beginning to seem more useful, and even more universal. This is curious, because Matisse's works collectively give very little sense

of a life lived. Or more accurately, Matisse's works give a vivid sense of a life lived as an artist, but not nearly the same sense that Picasso gives of a life lived as a man. For example, Matisse gives almost no sense of the political or economic history of the twentieth century, or of the demonic energies it unleashed. He gives no sense that an artist might feel he ought to take revenge on the world. There is no equivalent to Picasso's *Guernica* in Matisse's art, or to the death-haunted still lifes or the harrowing political allegories, such as *The Charnel House*. Nonetheless, Matisse's painting does provide a profound engagement with the spiritual uncertainties of the century, and a very personal response to them, in his inspired balance between observation, analysis, and the pure poetry of painting.

IN A WAY, PICASSO TURNS OUT not to have been so much the painter of the future as the man of the future—and Matisse in many ways the man of the past but the painter of the future. Matisse, neatly attired in jacket and tie, discreet, private, somewhat inhibited in his actions, lived his life in what was increasingly regarded as an old-fashioned way. On the surface, at least, he embodied the discreet charm of the bourgeoisie. His attitudes seem curiously pre-Freudian, and he has come to stand for a sense of propriety that today is honored more in memory than in practice—when it is honored at all. That is partly why Matisse hated Surrealism so profoundly: The Surrealists wanted to bring out into the open everything that he believed should be kept private. Picasso, the Surrealists' hero, was very much a man we can recognize as a prototype for future behavior. He prided himself on his lack of inhibition, his lack of discretion, and gloried in what Francis Bacon characterized as "the brutality of fact." He dressed down. In his early days he affected workman's blues; later he was seen bare-chested or in polo shirts. He was often photographed barefoot or wearing sandals, a curious echo of his first patrons, those peculiarly gauche Americans, Leo and Gertrude Stein, who amazed the French by strolling around the center of Paris wearing sandals.

Picasso was also the first celebrity artist—important not only as a great artist but also as a public figure in the early days of the invention of international celebrities. To his contemporaries and rivals, this was a source of both resentment and amusement. The story is told, for example, of Matisse arriving at La Coupole one day during the mid-1930s and being greeted by a wave of recognition. As he came through the

door, a thrill went through the vast restaurant and the waiters began to rush toward him, at which Matisse turned to his companion and murmured, ironically, with humor but not without an edge of annoyance: "They think I'm Picasso!"

Not only did Picasso set the standard for fame among artists, but until Andy Warhol no modern artist did quite so much to encourage it. During his later years Picasso did so shamelessly, playing the clown for magazine photographers such as David Douglas Duncan and delighting in having photos of himself reproduced by the millions in publications all over the world. Only the faces of certain politicians or of the most famous movie stars were as well known as his. To an unprecedented degree, his life was lived in public—in direct contrast to the discretion and decorum of Matisse. It is not surprising that after Picasso's death, automobiles, telephones, and restaurants were named for him, and owning "a Picasso" came to be considered an unfailing mark of prestige for the nouveaux-riches.

———

IN 1999 THE KIMBELL ART MUSEUM in Fort Worth, Texas, became the unlikely venue for the first Matisse and Picasso exhibition in which their works were hung side by side. (At the 1918 and 1945 shows, the two artists had been given separate galleries.) Although the Kimbell is known primarily for its collections of ancient and old-master art, it too made the grand gesture of emptying its handsome stone-walled galleries to make way for this exhibition, which was centered around works from the 1930s when the exchange between the two artists was especially intense. The curator of the exhibition, Yve-Alain Bois, framed the dialogue between them as a kind of extended game of chess, with each man anticipating the specific moves of the other while at the same time keeping the strategy of the whole board and the history of past moves in his head.

The exhibit was an eye-opening experience. Seeing the two artists' works together inevitably made the viewer consider their art in terms of both their struggle with form and their lives as men. In such a context of close scrutiny, it became clear how focused Picasso's imagery is, and how unconditional and dispersed Matisse's seems by comparison. In what is probably the best characterization of Picasso's spatial construction, Leo Steinberg has written of the "deep space funneled by complementary perspectives" in Picasso's art as becoming collapsible and as

being capable of undergoing "instant inversion," as in a cat's cradle: "A brace of vanishing points receding, but 'receding' from both near and far vantages simultaneously; the space defined as a scaffolding of visual rays, wavetrains of imagined eyereach projected towards foci whence sight always turns home again."

The metaphor of the cat's cradle is a brilliant and true one, and it points to one of the greatest divergences between Picasso and Matisse. Picasso plays a masterful game with an incredibly complex network of lines of sight, and with the multiple foci and multiple levels of consciousness that emerge from these varying points of focus. Matisse's space is organized in another, more open way. It is an unrestricted terrain where there are no roads, no fixed pathways, often no real points of focus. Within his paintings, we are always traveling overland and usually without a map; space is evoked in such a complex way that the energy of looking is constantly dispersed and absorbed into an intangible domain in which things and not-things coexist as equals.

Picasso also usually fills the center of his paintings, whereas even when Matisse marks the center, he frequently pivots his forms away from it or hinges them to the very edges of the canvas. As a corollary to this, Picasso tends to anchor his forms to the corners rather than to the sides of his pictures, which gives them an architectural solidity and directness of statement, as if the picture itself is striking a pose for us. Matisse's paintings, by contrast, seem disarmingly informal, almost casual at first regard; only after extended study do we begin to perceive their unusual kind of complexity. Picasso's paintings tend to say one thing, very richly and very complexly, but in a more focused, somewhat circumscribed way. The forms in Matisse's paintings, by contrast, are much harder to pin down. They seem to keep opening up. The transcendent space evoked by his paintings and cutouts is so suggestive and so open that they suggest infinite possibilities.

MATISSE AND PICASSO HAVE in many ways redefined how the world looks to us. Both were pioneers in the art of representing multiple, shifting realities. After them, nothing looks quite the same as before to anyone who is paying attention, and nothing can be represented in quite the same way. But as close as they came to abstraction in the years just before World War I and just after World War II, both men retreated from it. Around 1912, when Kandinsky and Mondrian began

to develop their abstract styles, they initially relied on pictorial ideas that had come from Matisse and Picasso, but neither Matisse nor Picasso followed suit. Neither was willing to let go entirely of making reference to the real world. And both later spoke out firmly against non-representational painting.

However abstract their work might appear, both artists remained rooted in direct references to the real world, and both emphasized a variety of imagery over the severely focused and pared-down imagery of an artist like Mondrian, who not only worked toward a single style but also distilled his forms to create a single type of image. Both Matisse and Picasso wanted to retain their contact with the real world, and both wanted their paintings to reflect the variety of human experience that such contact made possible, even necessary. In many ways, both artists were firmly grounded in the traditions of the nineteenth century. If in their lifetimes they were important as the initiators of something truly new, we can now also see them as standing at the end of a painting tradition that started in the High Renaissance.

Both artists thought a great deal about Delacroix and Courbet, and that nexus is an especially informative one, for it directs our attention to the exact moment in the history of modern painting when the weight of meaning shifted from the public to the private—from the historically sanctioned pictorial rhetoric and conventional literary and biblical subjects of Delacroix, to the oblique and unorthodox compositional modes, and the curiously privatized subjects, of Courbet. Picasso, as we have seen, was never fully resolved on this issue. Although he recognized that Courbet's path was more appropriate to the experience of modern life, Delacroix's rhetoric seemed to embody a grander artistic ambition. (Matisse had similar concerns and was keenly aware of the differences between linear "grand style" and the half-tones in more realistic painting, which were "closer to the truth but less grand.") Throughout his life, Picasso alternated between these extremes, which are perhaps most overtly reflected in the constant tension in his work between public and private subjects and straightforward and rhetorical styles; between portraits and still lifes on the one hand, and the large public statements such as *Guernica* on the other.

———

BOTH MATISSE AND PICASSO affirmed the primacy of painting, and in a sense they anticipated the crisis that would overtake painting

during the second half of the twentieth century. When they arrived on the scene in 1905, it seemed to many in the art world that Cézanne and the Post-Impressionists had blocked the way; it was as if everything had already been done. Matisse and Picasso reopened the dialogue with the past and changed its terms. Matisse has emerged as the painter's painter, the artist best able to plumb those aspects of human experience that only the particular poetics of painting can capture. Picasso's ideas were less profoundly painterly but in many respects more far-reaching. He has been a strong paradigm for various art forms that go beyond traditional definitions of painting and sculpture. Duchamp's ready-mades, various forms of mixed media, even certain kinds of performance art, can ultimately be traced back to him.

The historical positions of Matisse and Picasso, like their art, are extremely complex and are still in the process of being sorted out. Although the question inevitably arises as to which of them was the greater artist, the answer will certainly remain open. They were very different sorts of men, and their art speaks to us in very different ways. Their achievements stand so far above most of their contemporaries that they lead us to another question: If we were to add the name of a third great twentieth-century artist to theirs, whose would it be?

NOTES

PREFACE

viii "'the emanation, the . . .'" André Verdet, "Entretiens avec Henri Matisse," in *Prestiges de Matisse* (Paris, 1952); trans. Jack Flam, *Matisse on Art,* rev. ed. (Berkeley and Los Angeles: University of California Press, 1995), p. 212.

x "'confronting death, or . . .'" See Harold Bloom, *Wallace Stevens: The Poems of Our Climate* (Ithaca and London: Cornell University Press, 1977), pp. 375–406. Bloom calls the first of these crossings the Crossing of Election, in which the artist confronts the question of whether he is truly an artist. The second, called the Crossing of Solipsism, "struggles with the death of love and tries to answer the fearful query Am I capable of loving another besides myself?" The third and final crossing is called the Crossing of Identification, the dilemma here being "the confrontation with mortality, with total death." Bloom notes that these three crossings seem to have "three characteristic marks in nearly every poem in which they occur": (1) a "dialectical movement of the senses . . . sometimes between different degrees of clarity and sight"; (2) an "oscillation between mimetic and expressive theories of poetic representation"; and (3) a "movement toward an even greater degree of internalization of the self, no matter how inward the starting point was."

xi "'All things considered . . .'" Pierre Daix, *La Vie de peintre de Pablo Picasso* (Paris: Le Seuil, 1977), p. 177.

xi "'Only one person . . .'" André Malraux, *Picasso's Mask* (New York: Holt, Rinehart, and Winston, 1976), pp. 7–8; translation modified.

CHAPTER 1

1 "'You are at . . .'" Vicente Huidobro, poem to Picasso; as cited by Jean Leymarie in Brigitte Léal, Christine Piot, and Marie-Laure Bernadac, *The Ultimate Picasso* (New York: Harry N. Abrams, 2000), p. 11.

4 "His later contempt . . ." John Richardson, *A Life of Picasso. Volume I: 1881–1906* (New York: Random House, 1991), p. 277.

4 "fraudulent financial scheme . . ." For details of the financial scandal, see Hilary Spurling, *The Unknown Matisse: A Life of Henri Matisse: The Early Years, 1869–1908* (New York: Alfred A. Knopf, 1998), pp. 234–242.

5 "'a sort of god . . .'" Jacques Guenne, "Entretien avec Henri Matisse," *L'Art vivant* 18 (September 15, 1925); trans. Flam 1995, p. 80.

5 "'It has been said . . .'" Guillaume Apollinaire, *La Revue immoraliste*, April 1905; as translated in Leroy C. Breunig, ed., *Apollinaire on Art: Essays and Reviews, 1902–1918* (New York: Da Capo Press, 1987), p. 13.

7 "'because what he . . .'" Louis Vauxcelles, "Le Salon d'Automne," *Gil Blas*, October 17, 1905.

CHAPTER 2

9 "Matisse was far . . ." Fernande Olivier, *Picasso et ses amis* (Paris: Stock, 1933); trans. Jane Miller, *Picasso and His Friends* (New York: Appleton Century, 1965), p. 84; hereafter cited as Olivier 1933.

9 "'It was . . . a thing . . .'" Leo Stein, *Appreciation: Painting, Poetry, and Prose* (New York: Crown, 1947), p. 158.

9 "'very strange in . . .'" Gertrude Stein, *The Autobiography of Alice B. Toklas* (New York: Vintage Books, 1955), p. 34. First published 1933; hereafter cited as Stein 1933.

11 "'painted with chrome . . .'" Cited in Alfred H. Barr, Jr., *Matisse, His Art and His Public* (New York: The Museum of Modern Art, 1951), p. 56.

11 "It was through . . ." The offer was made on November 18, after the picture had been on view for a month. (Matisse archives, Paris.) Gertrude gives the impression that she instigated the purchase of *The Woman with the Hat*, but in fact Leo apparently did. In any case, although the painting was held by Leo and Gertrude, it was apparently a joint purchase by all four Steins, and it eventually passed into the possession of Michael and Sarah. (See Barr 1951, pp. 57–58.)

13 "But a good deal . . ." Leo met Picasso before Gertrude did, and it is likely that he visited the Bateau-Lavoir alone before going there with Gertrude. Recently, Anne Baldassari has discovered a letter, in the Picasso archives, from Roché to Picasso that casts serious doubt on the sequence of events described by the Steins. In the letter to Picasso, dated May 8, 1905, Roché wrote: "On Wednesday morning at 10 am I will bring to your place the American whom I've spoken to you about. If you have something else to do let me know right away via express letter. But try to be there, because he is leaving." (*Je vous amènerai chez vous Mercredi matin à 10 heures cet Américain dont je vous ai parlé. Si vous avez autre chose à faire prévenez moi de suite par un pneumatique. Mais tachez d'être là, car il va partir.*) Since May 8 was a Monday, the timing of the meeting two days later makes perfect sense. (The letter is reproduced correctly in Elizabeth Cowling, John Golding, Anne Baldassari, Isabelle Monod-Fontaine, John Elderfield, and Kirk Varnedoe, *Matisse Picasso* [Paris: Réunion des musées nationaux/ Centre National d'Art et de Culture Georges Pompidou/ Musée National d'Art Moderne, 2002], p. 368; hereafter cited as Paris 2002. In the English edition of the same catalogue [Elizabeth Cowling,

John Golding, Anne Baldassari, Isabelle Monod-Fontaine, John Elderfield, and Kirk Varnedoe, *Matisse Picasso* (London: Tate Publishing, 2002), p. 363; hereafter cited as London 2002], there is an inexplicable translation error in which "tomorrow" is added before "Wednesday," but that word does not appear in Roché's letter.) Since the Steins would soon be going away for the summer, it was natural for Roché to press Picasso, and it seems that this letter was indeed the one that set up the first meeting between Leo Stein and Picasso, and that it most likely happened in May rather than in the fall of 1905. Of course, it is possible that Picasso was not free and that the meeting did not take place; but Leo Stein's own account suggests that it did, since he says he went to see Picasso's show (his only one that year, which took place in February–March) on the advice of gallery owner Clovis Sagot, and that he left an offer for some drawings for which he got no response. "When, a few days later, I dropped in at Sagot's to talk about Picasso," Stein recounted, "he had a picture by him, which I bought. It was the picture of a mountebank with wife and child and an ape. . . . Soon after, I learned that a friend, Pierre Roché, knew Picasso." (Stein 1947, p. 169.) Leo Stein says he arranged to meet Picasso via Roché, with whom he discussed Picasso, and that it was Roché who "a few days later led me to the Rue Ravignon [*sic*]." (Stein 1947, p. 170.) Gertrude apparently did not meet Picasso until after the Steins returned to Paris in the fall (see Stein 1947, p. 173). My thanks to Anne Baldassari for sharing her documentation with me.

14 "'The ape looked . . .'" Stein 1947, p. 169.

15 "The studio was . . ." See Jeanine Warnod, *Le Bateau-Lavoir: 1892–1914* (Paris: Presses de la Connaissance, 1975), pp. 4–6; Patrick O'Brian, *Pablo Ruiz Picasso: A Biography* (New York: Norton, 1994), pp. 124–125; André Salmon, *Souvenirs sans fin* (Paris: Gallimard, 1955), vol. 1, p. 170; Roland Penrose, *Picasso: His Life and Work*, rev. ed. (New York: Harper and Row, 1973), pp. 96–97.

15 "There, 'every chair, . . .'" Hans Purrmann, "Über Henri Matisse," *Werk*, June 1946; English translation, Museum of Modern Art archives, New York.

15 "In Matisse's immaculate . . ." Stein 1947, p. 170.

16 "'When Picasso had looked . . .'" Stein 1947, p. 170.

16 "In Andalusia, where . . ." David Gilmore, *Aggression and Community: Paradoxes of Andalusian Culture* (New Haven: Yale University Press, 1987), p. 161; cited in Richardson 1991, p. 10.

16 "'a large, placid . . .'" O'Brian 1994, p. 129.

17 "She wanted to . . ." Fernande Olivier, *Loving Picasso: The Private Journal of Fernande Olivier*, foreword and notes by Marilyn McCully, trans. Christine Baker and Michael Raeburn (New York: Harry N. Abrams, 2001), pp. 137–169.

18 "'had an astonishing . . .'" Olivier 1933, p. 88.

18 "'Of course I agreed . . .'" Stein 1947, p. 171.

18 "'*Elbirre, écoute-moi . . .*'" Guillaume Apollinaire, *La Femme assise*, in Michel Décaudin, ed., *Oeuvres en prose* (Paris: Gallimard, 1977), vol. 1, chaps. 5, 2, pp. 478, 423; hereafter cited as Apollinaire 1977.

19 "'vertical invader . . .'" The phrase is used by John Berger to characterize Picasso's appearance in Paris (*The Success and Failure of Picasso,* New York: Pantheon, 1965, p. 40). Berger appropriates the term from Ortega y Gasset, who in his *Revolt of the Masses* (1932) characterizes the newly rising man of the people as "a primitive man, a barbarian appearing on the stage through the trap-door, a vertical invader."

20 "'if you do not . . .'" Stein 1933, p. 119.

21 "Picasso had seen . . ." This drawing (Musée Picasso 462), dated to ca. 1904, is reproduced in Jean Clair, ed., *Picasso Erotique* (Munich-London–New York: Prestel, 2001), p. 40. The Cézanne painting, now in the Musée d'Orsay, is reproduced in Lawrence Gowing, *Cézanne: The Early Years, 1859–1872* (New York: Abrams, 1988), p. 63, fig. 42.

22 "'All his pictures, . . .'" Stein 1947, pp. 160–161.

CHAPTER 3

23 "Matisse and Picasso . . ." Stein 1933, p. 64.

23 "'Picasso sat very . . .'" Stein 1933, pp. 46–47.

24 "At the time . . ." Stein 1933, p. 49. *Three Lives* was published in 1909. Stein also began *The Making of Americans* while Picasso was working on her portrait; that book was finished in 1908 but not published until 1925.

24 "Accounts differ as . . ." The date is generally given as March 1906 (see Richardson 1991, p. 411: "the Steins brought them together in March 1906"), around the time of the Salon des Indépendants, but the two may have met earlier. Fernande Olivier (Olivier 2001, pp. 197–198) says they met at one of the Steins' Saturday dinners. Matisse's daughter Marguerite situates the encounter at the Bateau-Lavoir, where she accompanied her father and the Steins (Brassaï, *Conversations with Picasso*, Chicago and London: University of Chicago Press, 1999, p. 332), but she is almost certainly mistaken in conflating Matisse's first visit to Picasso's studio with their first encounter. Gertrude Stein says the meeting took place shortly before she and her brother left for Italy for the summer, and Leo situates it around the time of the Redon and Manet show at the Durand-Ruel gallery, which opened in February 1906. Since both artists were invited to the Steins' parties at the rue de Fleurus during the winter of 1905–1906, and each could see the other's most recent work there, if they did meet as late as March, the delay would suggest that the Steins orchestrated their meeting rather carefully. See Anne Baldassari's interesting discussion of their opportunities to meet in Paris 2002, pp. 367–368.

24 "'sort of kimono . . .'" Mabel Dodge Luhan, *European Experiences*; as cited in Renate Stendhal, ed., *Gertrude Stein in Words and Pictures* (London: Thames & Hudson, 1995), p. 40.

25 "'On the Avenue . . .'" Brassaï 1999, p. 332; translation modified. In a 1907 article about Félix Vallotton's portrait of Stein, Apollinaire wrote some amusing remarks about how the French perceived the Steins' way of dressing. See Breunig 1987, p. 29.

25 "'leader of a school'" Matisse had been characterized in those words by Louis Vauxcelles the year before (Louis Vauxcelles, *Gil Blas*, March 23, 1905). To establish a connection between the two exhibitions, the Druet show included an oil sketch for *Le Bonheur de vivre*, entitled *"Etude du tableau exposé aux 'Indépendants'"* (Study for the picture at the 'Indépendants'); Galerie Druet, *Exposition Henri-Matisse* [March 19–April 7, 1906] (Paris, 1906), cat. no. 13.

26 "The ring of dancers . . ." For discussions of the sources, see especially Barr 1951, pp. 88–92; Jack Flam, *Matisse: The Man and His Art, 1869–1918* (Ithaca: Cornell University Press, 1986), pp. 157–162.

26 "Stéphane Mallarmé's erotic . . ." See Flam 1986, pp. 156–157; and John Elderfield, *Henri Matisse: A Retrospective* (New York: Museum of Modern Art, 1992), pp. 54–55.

27 "'question' of the . . ." Charles Morice, *Mercure de France*, April 15, 1906, pp. 535–537.

27 "'the most important . . .'" Barr 1951, p. 82.

27 "Shortly after the . . ." Because of their uncertainty about their financial position in the aftermath of the San Francisco earthquake, the Steins could not immediately buy *Le Bonheur de vivre*. Gertrude assured Matisse that "if our situation does not change, we will take the painting" (Judi Freeman, *The Fauve Landscape*, New York: Abbeville, 1990, p. 92). In early May, Michael Stein was still en route to San Francisco to assess the damage to the family fortunes, and Leo wrote to Matisse that as soon as Michael got to San Francisco, he would be able to let him know how things stood. Leo Stein to Matisse, May 6, 1906 (written from 27 rue de Fleurus); Matisse archives, Paris. At the Steins' residence, the painting was hung at the imposing height of twelve to fifteen feet.

27 "'I can't see you . . .'" Penrose 1973, p. 122.

28 "That May, when . . ." Leo Stein to Matisse, May 6, 1906 (written from 27 rue de Fleurus); Matisse archives, Paris.

29 "(A sheet of studies . . ." This sheet, on which the same pose is rendered in four different moods, is reproduced in *Quelque chose de plus que la couleur: Le dessin fauve 1900–1908* (Marseilles: Musée Cantini, 2002), no. 231, p. 235.

30 "'Never mind,' Picasso . . ." Penrose 1973, p. 122.

31 "Our sense of . . ." See John Elderfield's interesting discussion of the Stein portrait in London 2002, p. 113, where he notes, "Painting the mask didn't solve a problem; it explained a problem."

31 "'the linguistic mask . . .'" Michael North, "Modernism's African Mask: The Stein-Picasso Collaboration," in Elazar Barkan and Ronald Bush, eds., *Prehistories of the Future: The Primitivist Project and the Culture of Modernism* (Stanford: Stanford University Press, 1995), p. 271.

31 "'between impersonality and . . .'" North 1995, pp. 283–284.

32 "When he returned . . ." See Stein 1947, p. 192.

32 "Since the previous . . ." He passed there on his way home from the new studio he had rented to work on *Le Bonheur de vivre*. Matisse's interest in

African sculpture clearly dates to the beginning of 1906, rather than to the end as is usually believed. He did one of his earliest African-influenced sculptures, *Standing Nude*, during the summer of 1906, and in March 1906 when Derain was in London looking at Primitive art in the British Museum, he sent Matisse letters containing large schematic drawings of African and Oceanic sculptures. Derain to Matisse, letters of March 6 and 8, 1906, from 65 Blenheim Crescent, Holland Park, London; Matisse archives, Paris.

32 "'Compared to European...'" Matisse, interviews with Pierre Courthion, 1941, typescript, pp. 53–54; hereafter cited as Courthion 1941.

33 "number of erotic drawings..." See Clair 2001, pp. 169–170, 188.

33–34 "'For us it was...'" Malraux 1976, pp. 10–11; translation modified. This conversation took place in 1937.

34 "*Tableau No. III*, ..." It is listed in the Salon catalogue as *Tableau No. III*, an allusion to its being the third of Matisse's paintings of imagined subjects, following *Luxe, calme et volupté*, which had been shown at the 1905 Indépendants, and *Le Bonheur de vivre*, which had been shown there in 1906. The title *Blue Nude* was not given until later, and the subtitle *Souvenir de Biskra* (Memory of Biskra), now in common use, was not used in public until the painting was shown at the 1931 Matisse retrospective at the Georges Petit gallery. See Galeries Georges Petit, *Henri Matisse, 16 juin–25 juillet 1931* (Paris, 1931), p. 15, no. 17.

36 "'cried out in...'" Stein 1933, pp. 17–18.

37 "'Their harmonies no...'" Michel Puy, "Les Fauves," *La Phalange*, November 15, 1907; reprinted in Puy, *L'Effort des peintres modernes* (Paris: Albert Messein, 1933), p. 62.

37 "'The Philosophical Brothel'..." On the origin of the title, see William Rubin, "The Genesis of *Les Demoiselles d'Avignon*," in William Rubin, Hélène Seckel, and Judith Cousins, *Les Demoiselles d'Avignon*, Studies in Modern Art 3 (New York: Museum of Modern Art, 1994), pp. 17–19.

38 "In a crayon drawing..." Another compositional study for *Les Demoiselles* (Carnet, Musée Picasso 1861: 29R) also includes a *porrón*, similar to the one in *The Harem*, as do studies for the still life (Carnet, Musée Picasso 1861: 40R, 41R). These are published in Paris, Musée Picasso, *Les Demoiselles d'Avignon* (Paris, 1988), vol. 1, pp. 157, 161; hereafter cited as Paris 1988. The crayon study, now in Basel, Switzerland, is reproduced in ibid., p. 25.

38 "This skull, which..." Drawings of a skull appear in studies for the painting. See Carnet, Musée Picasso, 1861: 15V, 16V, 17V, 18R; reproduced in Paris 1988, vol. 1, p. 153. See also the drawing *Love and Death* of 1903, reproduced in ibid., vol. 2, p. 416 (where the drawing is dated to 1901; the more convincing date of 1903 is given in Rubin, Seckel, and Cousins 1994, p. 57).

39 "'insatiable need for...'" Richardson 1991, pp. 26–27.

39 "'goddesses and doormats'" See the interesting discussion in Yve-Alain Bois, "Painting as Trauma," in Christopher Green, ed., *Picasso's* Les Demoiselles d'Avignon (Cambridge: Cambridge University Press, 2001), pp. 31–54.

40 "taken for a bidet . . ." John Richardson, *A Life of Picasso, Volume II: 1907–1917* (New York: Random House, 1996), pp. 18–19, discusses the image of the bidet. One Picasso scholar has objected to this reading on the grounds that people don't put food next to a bidet; but of course doing so increases the transgressive nature of the painting, another instance of how Picasso loves to break rules.

41 "But Africa also . . ." See Patricia Leighten, "The White Peril and *L'art Nègre*: Picasso, Primitivism, and Anticolonialism," *Art Bulletin* 72, 4 (December 1990), pp. 609–630.

42 "Picasso's even larger . . ." See, for example, the exemplary discussion of *Les Demoiselles* in Leo Steinberg, "The Philosophical Brothel," *October* 44 (Spring 1988): pp. 7–74. This is a revised version of Steinberg's groundbreaking essay originally published in *Art News*, September and October 1972.

42 "'Does that interest . . .'" Walter Pach, *Queer Thing, Painting* (New York and London: Harper, 1938), p. 125. Hilary Spurling has placed this conversation in spring 1907 and assumed that the two men were standing in front of the recently acquired *Blue Nude* (Spurling 1998, p. 376); this has unfortunately become accepted as fact (see London 2002, p. 364). The picture Pach is referring to, however, is not actually named; it is described simply as "a large painting by Matisse," which hardly fits *Blue Nude*. Moreover, Pach met the Steins in Italy during the summer of 1907 and did not visit the rue de Fleurus apartment until the fall of 1907; Picasso's critique would no longer make sense in relation to *Blue Nude* in the fall of 1907, after he had painted *Les Demoiselles d'Avignon*. (My thanks to Laurette E. McCarthy for providing me with the following information about Pach's relationship with the Steins: "Pach arrived in Italy sometime in late May/early June 1907 to make arrangements for the Chase European Summer School in Florence. . . . He stayed in Italy throughout the summer and early fall. . . . Leo Stein invited Pach . . . to lunch and took them to Berenson's villa—Berenson wasn't home. The Steins also introduced Pach to Matisse at this time. He [Pach] arrived in Paris in the fall of 1907." Matisse and Pach evidently first met at Michael and Sarah Stein's villa.)

43 "It remained in . . ." Moreover, Picasso frequently repainted his pictures at this time (he worked on *Three Women* for almost a year), and he may have intended to repaint part of *Les Demoiselles*. In fact, according to Anne Baldassari, Picasso may well have repainted parts of *Les Demoiselles* sometime in 1908. (Verbal communication, June 2002.)

43 "'*mon nu couché*' . . ." Pierre Daix, *Picasso: Life and Art* (New York: Harper Collins, 1993), p. 78.

CHAPTER 4

45 "You've got to . . ." Daix 1993, p. 64.

45 "Kahnweiler, who saw . . ." Daniel-Henry Kahnweiler, "Picasso et le cubisme," 1953; as cited in Richardson 1996, p. 34.

45 "'now giving him . . .'" André Salmon, "Histoire Anecdotique du Cubisme," in *La Jeune Peinture Française* (Paris: Albert Messein, 1912), p. 51.

46 "'wonderful language that . . .'" February 27, 1907; Guillaume Apollinaire, *Journal Intime 1898–1918*, ed. Michel Décaudin (Paris: Editions du Limon, 1991), p. 142; hereafter cited as Apollinaire 1991a. The passage is worth quoting at length: "In the evening, I dined with Picasso, saw his new painting: even colors, pinks of flesh, of flowers, etc., women's heads similar and simple, heads of men too. Wonderful language that no literature can express, for our words are made in advance. Alas!"

46 "'With your painting, . . .'" "*Ta peinture, c'est comme si tu voulais nous faire manger de l'étoupe, ou boire du petrole.*" See Richardson 1996, p. 83.

46 "'an enormous picture, . . .'" Stein 1933, p. 22; this description of Picasso's painting coincides with Alice Toklas's first visit to the Bateau-Lavoir in October 1907.

46 "'but that's the fourth . . .'" Kahnweiler archives, as cited in London 2002, p. 364.

46 "*Matisse induces madness! . . .*" Salmon 1955, pp. 187–188; Spurling 1998, pp. 379–380.

47 "'is forced to . . .'" Gertrude Stein, *Picasso*, 1938; reprinted in Gertrude Stein, *Picasso: The Complete Writings* (Boston: Beacon, 1985), p. 35.

47 "As Baudelaire had . . ." Baudelaire; as cited in Richardson 1996, p. 14.

48 "'If we are to . . .'" Arthur Power, *Conversations with James Joyce* (New York: Lilliput Press, 1999), pp. 86–87.

48 "'habit of shutting . . .'" Josep Palau i Fabre, *Picasso: The Early Years, 1881–1907* (Barcelona: Poligrafa, 1985), pp. 430–432.

49 "photographs at this . . ." See Anne Baldassari, *Picasso and Photography: The Dark Mirror* (Paris: Flammarion, 1997); also her stimulating text on Matisse and Picasso and photography in *Beaux-Arts: Matisse Picasso,* special number, September 2002, pp. 7–22.

49 "'In order to show . . .'" André Salmon, *L'Air de la Butte* (Paris: Editions de la Nouvelle France, 1945), p. 21.

49 "'heavy somber lights, . . .'" Guillaume Apollinaire, "Les Jeunes: Picasso, Peintre," *La Plume*, May 15, 1905; trans. in Breunig 1987, p. 14, translation modified.

49 "'There's not much light . . .'" Claude Roy, *La Guerre et la Paix* (Paris, 1954), p. 21; trans. in London 2002, p. 390.

50 "Max Jacob said . . ." Brassaï 1999, p. 135.

50 "'profaner of love, . . .'" Micheline Sauvage, *Le Cas Don Juan* (Paris: Seuil, 1953); as cited in Clair 2001, p. 15.

50 "his gargantuan appetites . . ." See Geneviève Dormann, *La gourmandise de Guillaume Apollinaire* (Paris: Albin Michel, 1994).

51 "'incontestable talent appears . . .'" Breunig 1987, pp. 13–14; translation modified.

51 "his first visit . . ." The date of their meeting is usually given as 1904, but Peter Read (*Picasso et Apollinaire: Les métamorphoses de la mémoire, 1905/1973*, Paris: Jean Michel Place, 1995, pp. 18–22) makes a convincing case for January 1905.

52 "'I am Croniamantal, . . .'" In Apollinaire 1977, p. 298; see also Read 1995, p. 83. Apollinaire's book was apparently first written in 1907, rewritten in 1911, and published as part of an eponymous collection in 1916.

52 "In 1907, Golberg . . ." See Spurling 1998, pp. 398–401.

52 ". . . in another journal." Guillaume Apollinaire, "Henri Matisse," *La Phalange* 11, 18 (December 1907), p. 481; trans. Flam 1995, pp. 27–30.

52 "'I have never . . .'" Flam 1995, p. 29.

52 "incorrectly attributing the . . ." "The Cubists, who are so unjustly mocked, are painters who try to give their works the greatest degree of plasticity. . . . The name Cubism was coined by the painter Henri Matisse, who used it to describe a picture by Picasso." Apollinaire, *Le Mercure de France*, October 16, 1911; in London 2002, p. 366.

53 "'The erudite Henri . . .'" Apollinaire, *Le Mercure de France*, April 16, 1911; in London 2002, pp. 365–366.

53 "'I have only . . .'" Matisse to Jean Biette, October 16, 1910; Matisse archives, Paris.

53 "The poem summarizes . . ." See Pierre Caizergues and Hélène Seckel, eds., *Picasso/Apollinaire Correspondance* (Paris: Gallimard, 1992), p. 199, for a reproduction of the dedication.

53 "some of its themes . . ." Jean-Jacques Lebel, "Picasso's (Erotic) Gaze," in Clair 2001, pp. 56–58. Here again the French title, *Le Désire attrapé par la queue*, contains an obvious pun: The word *queue* is slang for penis, creating a parallel title that might be translated as *Desire Caught by the Cock*.

53 "Apollinaire's other erotic . . ." This book was planned and possibly written in 1907, though it may not have been published until 1911. The book was announced and described in a 1906–1907 catalogue of erotic books, with the author described as "G.A."; but no trace of the supposed 1907 edition—in which the narrator's name is given as "Willie"—has been found. It should be noted, however, that Picasso's copy of the 1907 edition of *Onze Mille Verges* is the only one that has survived; even Apollinaire did not have a copy of it in his library. Given the clandestine nature of such publications at the time, precise bibliographical information is difficult to ascertain. For details on the publication, see Guillaume Apollinaire, *Oeuvres en prose complètes*, ed. Pierre Caizergues and Michel Décaudin (Paris: Gallimard, 1993), vol. 3, pp. 1325–1327; hereafter cited as Apollinaire 1993.

54 "'I saw the place . . .'" Guillaume Apollinaire, *Les exploits d'un jeune don juan* (Paris: Lor du Temps, 1979), pp. 25–27.

55 "'susceptible only to . . .'" Salmon 1955, pp. 187–188.

55 ". . . a 'key picture.'" Picasso said this in 1962; see Varnedoe in London 2002, p. 29.

56 "'A hit! One . . .'" Salmon 1955, pp. 187–188; see also London 2002, p. 364.

56 "Picasso later even . . ." Françoise Gilot, *Matisse and Picasso: A Friendship in Art* (New York: Doubleday, 1990), p. 62.

56 "'there is nothing . . .'" Stein 1933, p. 65.

56 "his 'brutal egotism,' . . ." See Leon Katz, "Matisse, Picasso, and Gertrude Stein," in *Four Americans in Paris: The Collections of Gertrude Stein and Her Family* (New York: Museum of Modern Art, 1970), p. 55.

59 "A number of . . ." These include the birth of Aphrodite; the story of Dryope, in which Apollo disguises himself as a tortoise and lets Dryope and the tree nymphs (Hadryads) play with him until Dryope takes him into her lap and he turns into a serpent and is able to couple with her; and the myth of Chelone, who is turned into a turtle by Hermes for refusing to attend the wedding of Zeus and Hera. See especially John Elderfield, "Moving Aphrodite: On the Genesis of *Bathers with a Turtle* by Henri Matisse," in Yve-Alain Bois, John Elderfield, and Laurie A. Stein, *Henri Matisse: "Bathers with a Turtle"* (Saint Louis Art Museum Bulletin, 1998), pp. 20–49. Elderfield also gives fair summaries of the interpretations by Claudia Rousseau and Sarah Whitfield.

60 "The final version . . ." For an extended discussion, see Leo Steinberg's masterful essay "Resisting Cézanne: Picasso's 'Three Women,'" *Art in America* 66, 6 (November-December 1978), pp. 115–133.

60 "'completely influenced by . . .'" Stein 1933, p. 65. Apollinaire had made a similar remark some twenty years earlier, when the so-called Salon Cubists showed at the 1911 Salon des Indépendants.

60 "Besides, Karl Osthaus . . ." See Yve-Alain Bois, "Matisse's *Bathers with a Turtle*"; in Saint Louis Art Museum 1998, pp. 16–17.

61 "'the force, the . . .'" See Gaston Diehl, *Henri Matisse* (Paris: Tisné, 1954), p. 17.

61 "The artists involved . . ." See the excellent discussion of this by Anne Baldassari in Paris 2002, pp. 45–49.

61 "'a new world, . . .'" Gelett Burgess, "The Wild Men of Paris," *Architectural Record*, May 1910, p. 401.

62 "'Always the cubes, . . .'" Wide discussion has centered on exactly what was said by whom, and in what context. See, for example, Judith Cousins, "Chronology," in William Rubin, *Picasso and Braque: Pioneering Cubism* (New York: The Museum of Modern Art, 1989), especially pp. 435–436, note 62.

62 "Apollinaire rallied to . . ." Guillaume Apollinaire, Preface to *Catalogue de L'Exposition Braque*, November 9–28, 1908, at the Galerie Kahnweiler; as trans. in Breunig 1987, pp. 51–52; translation modified.

63 "Given Matisse's sympathy . . ." Braque later said of Cézanne's effect on him at L'Estaque: "It was more than an influence, it was an initiation." Jacques Lassaigne, "Entretien avec Georges Braque," in *XXe Siècle* 41, 1973, p. 3.

65 "'What I dream of . . .'" Matisse, "Notes of a Painter," *La Grande Revue*, December 25, 1908; in Flam 1995, p. 42.

CHAPTER 5

67 "Matisse—color. Picasso—form" Wassily Kandinsky, *On the Spiritual in Art and Painting in Particular*, 1912; trans. Kenneth C. Lindsay and

Peter Vergo, eds., *Kandinsky: Complete Writings on Art* (Boston: G. K. Hall, 1982), vol. 1, p. 152.

68 "But Picasso chafed . . ." See Richardson 1996, pp. 146–147.

68 "By 1910, Leo . . ." In the catalogue for Matisse's 1910 retrospective exhibition at the Bernheim-Jeune gallery, all the pictures that were at Gertrude and Leo's are listed as belonging to Mr. "L.D.S." By 1912, Leo had begun to sell his Matisses through the Durand-Ruel gallery.

68 "'There are lovers . . .'" André Salmon, *Paris-Journal*, December 22, 1910; as cited in Rubin 1989, p. 371.

69 "'To paint not . . .'" Stéphane Mallarmé, letter to Henri Cazalis, from Tournon, autumn 1864(?). See Rosemary Lloyd, ed., *Selected Letters of Stéphane Mallarmé* (Chicago and London: University of Chicago Press, 1988), p. 39.

69 "When the word . . ." Charles Morice, "La Vingt cinquième Exposition des Indépendants," *Mercure de France*, April 16, 1909, p. 729. In Vauxcelles's review of Braque's 1908 exhibition at Kahnweiler's (*Gil Blas*, November 14, 1908), which is often credited with the invention of the term "Cubism," Vauxcelles, picking up on Matisse's critique of Braque at the Salon jury, had written: "He constructs metallic, deformed men that are terribly simplified. He disdains form and reduces everything, places and figures and houses into geometric designs, into cubes." Vauxcelles's use of the word "cubes" is merely descriptive of the forms in those particular paintings and does not imply an "ism."

70 "'a kind of laboratory . . .'" See Françoise Gilot and Carlton Lake, *Life with Picasso* (New York, Toronto, London: McGraw-Hill, 1964), pp. 75–77.

70 "In *Woman with a* . . ." These paintings are reproduced in Pierre Daix and Joan Rosselet, *Picasso: The Cubist Years 1907–1916: A Catalogue Raisonné of the Paintings and Related Works* (Boston: New York Graphic Society, 1979), p. 239, no. 263; p. 246, no. 299.

71 "(Years later, it . . ." André Salmon, "Les Fauves," in Salmon 1912, p. 19.

71 "Although in 1909 . . ." Matisse spoke of using *"une écriture"* (a form of writing) in an interview with Charles Estienne, but he described it as being *"celle des lignes"* (that of lines). Charles Estienne, "Des tendances de la peinture moderne: Entretien avec M. Henri-Matisse," *Les Nouvelles*, April 12, 1909, p. 4; in Flam 1995, p. 54.

72 "'Henri Matisse contradicts . . .'" André Salmon, "Henri Matisse," *Paris Journal*, February 15, 1910; as cited in Paris, Centre Georges Pompidou, *Henri Matisse: 1904–1917* (Paris, 1993), p. 457. See also Jacques Rivière's letter to André Lhote of February 20, 1910; cited in ibid., p. 457.

74 "Some of the boldness . . ." Given the potentially disastrous situation that could develop if his wife found out about the affair, Matisse made every effort to keep it hidden. This he generally succeeded in doing, even though Gertrude Stein and Alice Toklas knew of it, and so Matisse must have been relieved to see it omitted from Gertrude Stein's account of him when she published *The Autobiography of Alice B. Toklas* in 1933. It was only much later, after Matisse had become involved with Lydia Delectorskaya, another Russian

woman, that Toklas mentioned the connection: "You remember that he started his Russian friendships with Olga Merson." Alice Toklas to Annette Rosenshine, August 5, 1950; published in *Staying on Alone: Letters of Alice B. Toklas* (New York: Liveright, 1973), p. 200.

74 "This is one . . ." For background on Fanny Tellier, see Richardson 1996, pp. 150–151.

75 "'A woman in an . . .'" Picasso's description is given in a list of paintings drawn up for Kahnweiler on June 5, 1912. See Centre Georges Pompidou, Musée National d'Art Moderne, *Donation Louise et Michel Leiris: Collection Kahnweiler-Leiris* (Paris, 1985), p. 167. An inscription on the back of the stretcher also states that the painting represents a "Femme à la cithare" (Daix and Rosselet 1979, p. 272, no. 430). But on the basis of what we actually see, such an identification would be very difficult indeed.

75 "what he called 'attributes' . . ." Gilot and Lake 1964, pp. 72–73.

76 ". . . a popular song." "Dernière Chanson," which became popular in Paris during October 1911. For a detailed discussion of the background, see Jack Flam, "Picasso et 'Ma Jolie': Vers une nouvelle poétique de la peinture," *Revue de l'Art* 113 (1996), pp. 32–39; also Jeffrey S. Weiss, "Picasso, Collage, and the Music Hall," in Kirk Varnedoe and Adam Gopnik, *Modern Art and Popular Culture: Readings in High and Low* (New York: The Museum of Modern Art, 1990), pp. 83–84.

76 "'new measures of space . . .'" Apollinaire gave a lecture on the subject at the Bernheim-Jeune gallery in 1911, which formed the basis for his article, "La peinture nouvelle: Notes d'art," *Les Soirées de Paris* 3 (April 1912), pp. 89–92. See also Linda Dalrymple Henderson, *The Fourth Dimension and Non-Euclidean Geometry in Modern Art* (Princeton: Princeton University Press, 1983), pp. 44–102.

76 "These ideas were . . ." Gino Severini, "La peinture d'avant-garde," *Mercure de France* 121 (June 1, 1917), p. 459.

76 "'the consciousness of . . .'" Max Weber, "The Fourth Dimension from a Plastic Point of View," *Camera Work* 36 (October 1910), p. 25. Apollinaire did a translation of this article, which affected his own ideas about the fourth dimension, thus reintegrating an American version of Matisse's thinking about the subject into French Cubist thought.

77 "'a greater plasticity.' . . ." Gilot and Lake 1964, p. 77.

77 "'That's Cubism . . .'" Sylvain Bonmariage, "Henri Matisse et la peinture pure," *Cahiers d'Art* 1, 9 (November 1926), p. 239. Bonmariage places the incident, which took place at the boulevard de Clichy, around 1909; but since Jean Metzinger, who was also present, is mentioned as a theorist of Cubism, it very likely happened later.

78 "'went to fetch . . .'" Christian Zervos, "Notes sur la formation et développement de l'oeuvre de Henri Matisse, *Cahiers d'Art* 6, nos. 5–6 (1931), pp. 246–248. Picasso was at the boulevard de Clichy from September 1909 until the fall of 1912.

79 "Around the same time . . ." The picture was shown along with works by other artists associated with Matisse. Apollinaire wrote: "A very good like-

ness of *Henri Matisse* by Mme Meerson [*sic*] makes this group serve as an homage to the master of powerful and pleasant colors." Apollinaire, "Le Salon d'Automne," 1911, in Breunig 1987, p. 186.

80 "'a real step...'" Sarah Stein to Matisse, October 1911; Matisse archives, Paris.

81 "Gleizes and Metzinger's book..." Albert Gleizes and Jean Metzinger, *Du "Cubisme,"* 1912; trans. Robert L. Herbert, *Modern Artists on Art: Ten Unabridged Essays* (Englewood Cliffs, N.J.: Prentice-Hall, 1964), pp. 4–5.

81 "'In the final analysis...'" *Zhivoe Slovo*, "Henri Matisse," 35, October 31, 1911; as cited in Albert Kostenevich and Natalya Semyonova, *Collecting Matisse* (Paris: Flammarion, 1993), p. 51.

81 "This reminder of Cubism..." Apollinaire, "Le 'KUB,'" *La Vie Anecdotique*, December 1, 1911; in Apollinaire 1993, p. 96.

81 "'I was entrenched...'" André Verdet, *Entretiens notes et écrits sur la peinture* (Paris: Editions Galilée, 1978), p. 127; trans. Jack Flam, ed., *Matisse: A Retrospective* (New York: Levin, 1988), p. 152; translation modified.

82 "'So P. confronted...'" Michael Stein to Gertrude Stein, June 19, 1912; cited in Richardson 1996, p. 229.

82 "'Fernande has run...'" Picasso to Braque, May 18, 1912; in Caizergues and Seckel 1992, p. 93, n. 2.

82 "This was especially..." See Richardson 1991, pp. 463–464. Also Fernande Olivier, *Souvenirs intimes écrits pour Picasso* (Paris: Calmann-Lévy, 1988), p. 197: "Picasso, whose jealousy was the sole cause of our fallings-out." Writing of the period around 1911, Pierre Cabanne claims that before Picasso's affair with Eva, "Fernande also made attempts to forget Pablo's difficult character in the arms of Mario Meunier and Roger Karl (in what exact order is now forgotten)." Pierre Cabanne, *Pablo Picasso: His Life and Times* (New York: William Morrow, 1977), p. 147.

83 "To make the break..." Matisse to an unknown woman close to Olga Merson, January 11, 1912, Getty Center for the History of Art and the Humanities. The letter is dated "Jeudi- 11 Jan."

83 "When Gilot asked..." Gilot 1990, p. 28.

83 "Confined within the..." The painter Jean Puy likened Matisse to "a goldfish who intensely exults in the iridescence of colors and forms through the dematerializing globe of his bowl and who... would show the world... made into agreeable ghosts for his enchanted eye." Jean Puy, "Souvenirs," *Le Point* 21 (Special Matisse Number), 1939, p. 24.

85 "a bombastic manifesto..." The Bernheim-Jeune Futurist exhibition ran February 5–12; for the English version of the catalogue, see Umbro Apollonio, *Futurist Manifestos* (New York: Viking, 1973), pp. 45–50.

85 "'symbolism of loss,'..." For a discussion of "the symbolism of loss" in this painting, see Elizabeth Cowling, *Interpreting Matisse Picasso* (London: Tate Publishing, 2002), pp. 47–50.

86 "'there is no dramatic...'" Roger Fry, "The Grafton Gallery: An Apologia," *The Nation* (London), November 9, 1912, pp. 250–251.

87 "'No sharper contrast...'" Fry 1912, pp. 249–251.

89　"One day, having . . ." Courthion 1941, p. 55.

89　"'We ride on horseback . . .'" Picasso to Gertrude Stein, August 29, 1913; Matisse to Gertrude Stein, late August 1913; Beinecke Library, Yale University. The French texts are given in Paris 2002, p. 374.

89　"'Well, Matisse paints . . .'" Riichiro Kawashima, "Henri Matisse," January 1933; trans. Flam 1988, p. 294.

90　"Although Picasso struggled . . ." For the history of the commission, see William Rubin 1989, pp. 63–69. See also the excellent discussion of the issue of scale by John Elderfield in London 2002, pp. 141–143.

91　"Collage resonated with . . ." This work can be dated to late autumn by the newspaper clipping, which is from the November 18, 1912, issue of *Le Journal*.

93　"After more than . . ." Richardson 1996, p. 276.

93　"'in waterless containers . . .'" John Golding, in London 2002, p. 80.

93　"'Look at Matisse's . . .'" See Richardson 1996, p. 281; Pierre Schneider, *Matisse* (New York: Rizzoli, 1984), p. 269.

94　"Years later, when . . ." See Chapter 9.

94　"'that can satisfy . . .'" André Salmon, "Le Salon," *Montjoie* 1, 11–12 (November-December 1913), p. 4.

94　"More significant was . . ." Apollinaire, *L'Instransigeant*, November 14, 1913, and *Les Soirées de Paris*, November 15, 1913; Breunig 1987, pp. 324, 330–331, translation modified.

96　"They would not . . ." See John Elderfield's illuminating discussion of this in London 2002, p. 144.

96　"'I think that . . .'" Verdet 1978, p. 127; trans. Flam 1988, p. 152.

97　"He later recalled . . ." This was in a conversation with Pierre Daix. See Daix 1993, p. 135; translation slightly modified.

98　"'shock people by . . .'" Richardson 1996, p. 299.

98　"It has been suggested . . ." Richardson 1996, p. 299.

99　"'a forum for . . .'" Michael C. FitzGerald, *Making Modernism: Picasso and the Creation of the Market for Twentieth-Century Art* (New York: Farrar Strauss Giroux, 1995), p. 38. My account is based primarily on FitzGerald, pp. 15–46.

99　"(This was equivalent . . ." One thousand francs in 1914 would be the equivalent of about $3,530 in 2001 dollars. According to Gerald Reitlinger, *The Economics of Taste* (London: Barrie and Jenkins, 1970), vol. 3, p. 18, a 1914 franc was worth $.20; therefore 1,000 francs would have been worth $200 in 1914. A 1914 dollar was roughly the equivalent of $17.65 in 2001 dollars; see John J. McCusker, "Comparing the Purchasing Power of Money in the United States (or Colonies) from 1665 to Any Other Year Including the Present," Economic History Services, 2001, URL: http://www.eh.net/hmit/ppowerusd/.

99　"Picasso carefully recorded . . ." FitzGerald 1995, pp. 40–44.

100　"The association of . . ." For details about the commission, see Flam 1986, pp. 386–394.

102 "(Matisse included a sketch . . ." Matisse to Camoin, October 1914; see Flam 1986, p. 399.

104 "'I believe Matisse's . . .'" André Breton to Jacques Doucet, November 6, 1923; cited in Paris 1993, pp. 501–502.

105 "'My life is hell . . .'" Picasso to Gertrude Stein, December 9, 1915; cited in Daix 1993, p. 147, and Paris 2002, p. 375; translation modified.

107 "'I've done a picture . . .'" Picasso to Gertrude Stein, December 9, 1915; cited in Daix 1993, p. 147, and Paris 2002, p. 375; translation modified.

107 "The master of . . ." Léonce Rosenberg to Picasso, November 25, 1915; cited in Paris 2002, p. 375. A partial translation is given in Daix 1993, p. 146.

108 "When Derain came . . ." Picasso to Apollinaire, April 24, 1915; in Caizergues and Seckel 1992, p. 133.

108 "According to Gris . . ." Juan Gris to Léonce Rosenberg, June 15, 1916; cited in London 2002, p. 369, and Paris 2002, p. 376.

109 "'Would anyone ever . . .'" L'Intransigeant, July 16, 1916; cited in Paris 2002, p. 376.

109 "foreign artists 'who . . .'" Roger Bissière, L'Opinion, June 24, 1916.

109 "The Cubists are not . . ." Anonymous review, Cri de Paris, July 30, 1916; cited in Paris 2002, p. 376.

109 "A few years earlier . . ." Apollinaire 1991a, p. 148.

110 "'Ah! How happy . . .'" Schneider 1984, p. 735.

111 "The stippled marks . . ." Richardson 1996, p. 414.

113 "'One can't live . . .'" Matisse interviewed by Tériade, 1929; trans. Flam 1995, p. 84. For a discussion of Matisse's family in relation to his art, see Schneider 1984, pp. 330–331.

114 "M. Paul Guillaume, whose . . ." Guillaume Apollinaire, Oeuvres en prose complètes, vol. 2, ed. Pierre Cauzergues and Michel Décaudin (Paris: Gallimard, 1991), p. 1650; hereafter cited as Apollinaire 1991b. The press release was written by Apollinaire after he received a letter from Paul Guillaume asking him to write a text for an exhibition of his collection; it was first published in Les Nouvelles littéraires, January 20, 1966.

114 "Apollinaire's essays are . . ." Guillaume Apollinaire, Catalogue des oeuvres de Matisse et de Picasso, January 23–February 15, 1918 (Paris: Galerie Paul Guillaume, 1918).

115 "'just what I thought . . .'" Henri Matisse to Amélie Matisse, January 19, 1918; Matisse archives, Paris.

115 "'willing to lend us . . .'" Paul Guillaume to Picasso, January 12, 1918; Musée Picasso archives, Paris; cited in Paris 2002, p. 377.

115 "'On the 23rd of . . .'" Paul Guillaume to Henri Matisse, January 14, 1918; Matisse archives, Paris.

116 "'I have Picasso's consent . . .'" Paul Guillaume to Henri Matisse (January 16, 1918); Matisse archives, Paris. The letter is dated simply "Mercredi 16" (Wednesday 16); my thanks to Wanda de Guébriant for helping me set in order the sequence of letters between Guillaume and Matisse. Guillaume shrewdly ends his letter by mentioning both his and Apollinaire's interest in the paintings of Matisse's daughter Marguerite, who was still pursuing a career as a painter.

116 "Only twelve Matisses . . ." Paul Guillaume in a letter to Amélie Matisse, January 24, 1918, informs her that she should not be upset because there were fewer Matisses than Picassos listed in the catalogue, since three large works had been added, obtained from the dealer Hessel. Matisse archives, Paris.

116 "Almost all the Matisses . . ." My profound thanks to Anne Baldassari for sharing her extensive documentation of the exhibition with me. For an excellent attempt to reconstruct the list of works exhibited, see Baldassari's essay on the exhibition in Paris 2002, pp. 361–364.

117 "with African art . . ." This was noted in the diary of the worldly Abbé Mugnier, who saw the exhibition after a luncheon with the Baroness de Brimont, Edith Wharton, André Gide, and Bernard Berenson (who evidently had a fairly low opinion of both artists' work). Abbé Mugnier, *Journal de l'Abbé Mugnier (1879–1939)* (Paris: Mercure de France, 1995), p. 329, entry for February 7, 1918.

117 "These were Matisse's . . ." Ary Leblond in a letter dated March 11, 1918, told Matisse that the rooms in Guillaume's gallery were too narrow for his paintings and that the whole gallery space was smaller than his studio; Matisse archives, Paris.

117 "Roger Bissière, for example . . ." Roger Bissière, *L'Opinion;* as reprinted in "La Presse à propos de l'Exposition Matisse et Picasso," *Les Arts à Paris*, no. 1, March 15, 1918, p. 10.

118 "'devoid of all human . . .'" Bissière, *L'Opinion*. Bissière expressed similar views in an article that appeared in *Paris-Midi*. For a discussion of the opinions in the press, see Baldassari in Paris 2002, pp. 361–364. My thanks to Anne Baldassari for making this and other material available to me before it was published.

118 "Even before the exhibition . . ." The letter to Guillaume is mentioned in a letter from Matisse to his wife, in which he says, "I just wrote to Guillaume to tell him that I'm not too happy with the publicity that he is creating around this little exhibition." Henri Matisse to Amélie Matisse, January 20, 1918; Matisse archives, Paris.

118 "'Have you heard anything . . .'" Henri Matisse to André Rouveyre, March 2, 1918; cited in Hanne Finsen, ed., *Matisse-Rouveyre Correspondance* (Paris: Flammarion, 2001), p. 30.

118 "He continued to write . . ." In a letter to his wife, Matisse confided his suspicions that people who came to Nice from Paris seemed to be avoiding talk about the exhibition. Henri Matisse to Amélie Matisse, March 18, 1918; Matisse archives, Paris.

118 "'For twenty years . . .'" Louis Vauxcelles reviews, *Le Pays;* as reprinted in *Les Arts à Paris* 1, March 15, 1918, pp. 9–10.

118 "There was still . . ." Doms, *La Revue*; as reprinted in *Les Arts à Paris* 1, March 15, 1918, p. 9.

118 "'Even to people who . . .'" Clive Bell, "Matisse and Picasso: The Two Immediate Heirs to Cézanne," *Arts and Decoration* 14 (November 1920), pp. 42–44.

119 "For you must be . . ." Power 1999, p. 64.

119 "'Everybody was dissatisfied . . .'" Stein 1933, p. 190.

120 "She was determined . . ." Daix 1993, p. 163.

120 "(The reference to her . . ." This connection is made by Anne Baldassari, who convincingly argues that Picasso would have been fully aware of the fertility function of the Baga sculptures, and who gives documentation that fixes the date of the painting in the spring of 1918 (it is frequently dated to 1917); see Baldassari in *Beaux-Arts: Matisse-Picasso* (Special Number), September 2002, pp. 22–24. The photograph is also reproduced in William Rubin, ed., *Picasso and Portraiture: Representation and Transformation* (New York: Museum of Modern Art, 1996), p. 306, along with a photograph of the painting hanging in the Picassos' bedroom.

121 "Within this brushy area . . ." The profile head is discussed by Kirk Varnedoe in "Picasso's Self-Portraits," in Rubin 1996, pp. 145–149.

121 "'hard look of . . .'" O'Brian 1994, p. 227.

121 "'I'm not really unhappy . . .'" Daix 1993, p. 163.

121 "'Went to see the . . .'" Apollinaire 1991a, p. 161.

122 "He dressed like . . ." On Picasso's manner of dressing, see Jean-Paul Crespelle, *Picasso and His Women* (New York: Coward-McCann, 1969), pp. 127–128. For Sachs's comments, see Pierre Cabanne, *Le siècle de Picasso 2: L'epoque des metamorphoses (1912–1937)* (Paris: Gallimard/Folio, 1992), p. 621; also Cabanne 1977, p. 236; translation modified.

122 "'turning its five rooms . . .'" O'Brian 1994, p. 233.

123 "The precise subject . . ." In many of his neoclassical paintings, Picasso consciously refers to ancient sources, especially figures in the Roman frescoes that he had seen at Pompeii and Herculaneum. *Three Bathers* and *The Rape* of 1920 were clearly based on such frescoes (see Daix 1993, pp. 174–175). *Three Women at the Spring*, which was painted at Fontainebleau, was inspired partly by paintings and relief sculptures that Picasso saw at the Château de Fontainebleau, and the theme may have been suggested by the name of the town; it also refers to Poussin's *Eleazar et Rebecca* (Louvre, Paris), with its lyrical but austere rendering of a scene around a well.

124 "Although Picasso uses . . ." The autobiographical connections in this painting were made by Theodore Reff, "Picasso's *Three Musicians*: Maskers, Artists, and Friends," *Art in America*, December 1980, pp. 124–142.

125 "Jacob had been . . ." Cabanne 1977, pp. 220–221.

126 "'Art is a lie . . .'" Picasso to Marius De Zayas, 1923; cited in Dore Ashton, ed., *Picasso on Art: A Selection of Views* (New York: Viking, 1972), p. 21.

127 "He had come to . . ." Ragnar Hoppe, "På visit hos Matiss," 1919; trans. Flam 1995, p. 76.

128 "Look at these Odalisques . . ." Verdet 1978, p. 126.

128 "'She's a big girl . . .'" Matisse to Charles Camoin, May 2, 1918; Claudine Grammont, ed., *Correspondance entre Charles Camoin et Henri Matisse* (Paris: Bibliothèque des Arts, 1997), p. 121.

129 "She became like . . ." Born in 1901, Henriette was not yet twenty when she first posed for him. When she began to model for him in 1920, she lived with her family in Matisse's neighborhood; she modeled for him regularly until 1927. See Jack Cowart and Dominique Fourcade, *Henri Matisse: The Early Years in Nice, 1916–1930* (Washington, D.C.: National Gallery of Art, 1986), pp. 26–27.

130 "(One of these paintings . . ." This painting is reproduced in Guy-Patrice and Michel Dauberville, *Matisse: Henri Matisse chez Bernheim-Jeune* (Paris: Bernheim-Jeune, 1995), vol. 2, p. 1011. See also ibid., pp. 1009–1025 for other early Nice period variants on the pose. For the in-progress photographs of *Reclining Nude with Raised Left Arm*, see Anne Baldassari, "Effacement progressif du tableau," in *Beaux-Arts: Matisse-Picasso*, September 2002, pp. 38–39.

131 "'The sun-soaked *fauve* . . .'" Jean Cocteau, "Déformation Professionelle," May 12, 1919; reprinted in *Le Rappel à l'ordre* (Paris: Stock, 1926), pp. 98–99; trans. Flam 1988, pp. 174–175.

131 "But even a more . . ." Fritz Vanderpyl, "Salons et Expositions," *Le Petit Parisien*, November 14, 1920.

132 "Matisse wrote back . . ." Matisse to Marguerite Matisse Duthuit, June 13, 1926; in Yve-Alain Bois, *Matisse and Picasso: A Gentle Rivalry* (Paris: Flammarion, 1998), p. 33; partial versions in London 2002, p. 19, and Paris 2002, p. 381.

132 "In 1920, Paul Rosenberg . . ." Paul Rosenberg to Picasso, from Nice, January 27, 1920; cited in London 2002, p. 371, and Paris 2002, p. 378.

132 "had been a favorite . . ." Paris, Musée National d'Art Moderne, *André Breton: La beauté convulsive* (Paris, 1991), p. 87.

133 "Grünewald's *Crucifixion* from . . ." See Susan Galassi, *Picasso's Variations on the Masters: Confrontations with the Past* (New York: Harry N. Abrams, 1996), p. 76 and p. 211, n. 58.

134 "(Picasso's statement to . . ." Christian Zervos, 1935; in Ashton 1972, p. 38.

134 "presence of Casagemas . . ." This is suggested by Ronald Alley, *Picasso: The "Three Dancers"* (London: Tate Gallery, 1986), p. 21.

134 "Many years later . . ." Gilot and Lake 1964, p. 82.

134 "Picasso heard of Pichot's . . ." In 1964, when the Tate acquired the painting, Picasso told Roland Penrose that he didn't like the title *Three Dancers*, and that "it was above all connected with his misery on hearing of the death of his old friend the painter Ramón Pichot, whose profile appears as a shadow against the window on the right of the canvas." (Penrose 1973, p. 258.) According to Daix, "This is a 'burial' of Pichot, his silhouette as long as day without bread." Daix 1993, p. 190.

136 "Eventually, Marie-Thérèse's account . . ." Barry Farrell, "His Women: The Wonder Is That He Found Time to Paint," *Life*, special Picasso issue 65, 26 (December 27, 1968), p. 74. Subsequently, many other writers on the subject opted for the 1927 date in order to protect Picasso from the scandal entailed in his being sexually involved with such a young girl. But strong evidence suggests that Picasso met Marie-Thérèse Walter in 1925, probably

early in the year and not later than November, probably near the Gare Saint-Lazare, and they became intimately involved not long after. In a letter from Picasso to Marie-Thérèse Walter, released by their daughter Maya in 1981, he writes: "Today, 13th July, 1944, is the seventeenth anniversary of your birth in me, and twice that of your birth in this world, where, having met you, I began to live." This is interpreted as meaning that the sexual relationship began on her eighteenth birthday (she was born July 13, 1909). For details of the evidence and a stimulating discussion of Picasso's portraits of Marie-Thérèse, see Robert Rosenblum, "Picasso's Blonde Muse: The Reign of Marie-Thérèse Walter," in Rubin 1996, pp. 336–384.

136 "'young, fair-haired . . .'" O'Brian 1976, pp. 284–285.

136 "'I was living . . .'" Farrell 1968, p. 74. Apparently she resisted having sex with him for a while. (Daix 1993, p. 202.)

137 "The earliest clearly . . ." These drawings are reproduced in Christian Zervos, *Pablo Picasso* (Paris: Editions Cahiers d'Art), V, 406.

137 "Typically, a good deal . . ." This motif appears in drawings done in February 1925, which have clear sexual overtones; see Zervos V, 383–390.

138 "Picasso even thought . . ." Penrose; as cited in Daix 1993, p. 193.

138 "*Bust of a Woman* . . ." Reproduced in Zervos, VII, 248.

139 "*Woman in an Armchair* . . ." Zervos, VII, 78.

140 "When Picasso wanted . . ." Daix 1993, p. 236. FitzGerald 1995, p. 301, n. 93, says the painting in question may be *Nude Asleep in a Garden* (Fig. 8.13), but that remains uncertain.

140 "As he himself noted . . ." "Only when painting isn't really painting can there be an affront to modesty." Hélène Parmelin, *Picasso: The Artist and His Model, and Other Recent Works* (New York: Abrams, 1965), p. 160; cited in Ashton 1972, p. 15.

140 "'On seeing this painting . . .'" See the reviews of the exhibition in Isabelle Monod-Fontaine, Anne Baldassari, and Claude Laugier, *Matisse: Oeuvres de Henri Matisse* (Paris: Centre Georges Pompidou, Collections du Musée National d'Art Moderne, 1989), pp. 79–82.

140 "'disheartened and disheartening' . . ." André Breton, *Le Surréalisme et la peinture*, rev. ed. (Paris, 1965); trans. Simon Watson Taylor, *Surrealism and Painting* (New York, 1972), p. 9.

142 "Especially stunning is . . ." The vaginal form of the artist's mouth may be meant as a witty pun, showing us what is on the artist's mind as he works. Picasso had directly illustrated such a theme in an early drawing, *Le sexe dans la tête*, c. 1901, which shows a man with a vagina at the top of his head (reproduced in Paris 1988, p. 485, ill. 210). Also of interest in this context is the letter Picasso wrote December 9, 1911, to Braque at Céret: "For those who look with their ears, behold a naked woman. You are prudish, but let me say that the sexual organs are just as amusing as brains, and if one's sex was on one's face, in the nose's place (which might well have happened), where would modesty be then?" Judith Cousins with Pierre Daix, "Documentary Chronology," in Rubin 1989, p. 386.

142 "*Painter and Model* . . ." Both the painting and the sculpture were re-

produced in the January 1929 issue of *Cahiers d'Art*. This began a long line of innovative metal sculptures, notably *Head of a Woman* and *Woman in the Garden* of 1929.

143 "A statue in . . ." Apollinaire 1977, p. 301.

144 "Some were published . . ." *See Documents*, no. 3 (1930), pp. 170, 171, 181.

148 "'recognized that he . . .'" Fritz Neugass, "Henri Matisse: Pour son soixantième anniversaire," *Cahier de Belgique* 3 (March 1930), p. 100; trans. Flam 1988, p. 244. The exhibition at the Berlin gallery ran from February 15 to March 19, 1930.

148 "'been able to turn . . .'" André Levinson, "Les Soixante ans de Henri Matisse," *L'Art Vivant* 6, 121 (January 1930), p. 27.

148 "Levinson believed that . . ." Levinson 1930, p. 27.

149 "'to see the night . . .'" Florent Fels, *Henri-Matisse* (Paris: Editions des Chroniques du Jour, 1929), p. 50.

149 "'From a professional . . .'" Albert Junyent, "Une vista a Picasso, senyor feudal," *Mirador* (Barcelona), August 16, 1934, 6, 289, p. 7; cited in Marie-Laure Bernadac and Androula Michael, eds., *Picasso: Propos sur l'art* (Paris: Gallimard, 1998), p. 29.

CHAPTER 8

151 "Love must be . . ." "*L'amour est à réinventer, on le sait.*" Arthur Rimbaud, "Delires," *Une saison en enfer*. Arthur Rimbaud, *Oeuvres complètes*, ed. Antoine Adam (Paris: Gallimard, 1972), p. 103.

152 "'vital though not . . .'" Henry McBride, "The Palette Knife," *Creative Art* 9, 4 (October 1931), p. 270.

152 "'Matisse refused to be . . .'" Helen Appleton Read, "Matisse, Accepted at Last,"*Brooklyn Eagle Magazine,* July 26–31, 1931; as cited in London 2002, p. 376.

152 "Waldemar George called . . ." Waldemar George, "Les cinquante ans de Picasso et la mort de la nature-morte," *Formes*, no. 14 (April 1931), p. 56; Waldemar George, "Dualité de Matisse," *Formes*, no. 16 (June 1931), p. 94; Jacques-Émile Blanche, "La peinture et la canicule," *Le Figaro*, July 17, 1931; as cited in London 2002, p. 376.

155 "In a striking metamorphosis . . ." The colors here are similar to those that refer to Marie-Thérèse in poetry Picasso wrote a few years later, where he writes of her "blond hair" and "lilac colored arms." See, for example, Marie-Laure Bernadac and Christine Piot, eds., *Picasso: Collected Writings* (New York: Abbeville, 1989), pp. XXI, 17, 136.

157 "According to Matisse . . ." Matisse to Pierre Matisse, April 7, 1932; in Paris 2002, p. 385.

157 "In an interview with . . ." Tériade, "En causant avec Picasso," *L'Intransigeant*, June 15, 1932; in Bernadac and Michael 1998, p. 27.

159 "He dismissed Picasso . . ." Claude Roger-Marx, *L'Europe Nouvelle*, July 9, 1932; cited in Bois 1998, p. 74.

159 "'The master,' one critic . . ." Louis Mouilleseaux, "Expositions: Manet-Picasso," *Le Cahier* June–July 1932, pp. 44–46.

159 "'His current downfall . . .'" Germain Bazin, "Un bilan: L'Exposition Picasso," *L'Amour de l'Art* 13, 7 (July–August 1932), p. 247.

160 "'a sort of fiddler . . .'" Fritz Vanderpyl, "Ménétier du diable," *Le Mois,* July 1, 1932, p. 225.

160 "'the successive states . . .'" Raymond Galoyer, "Peinture négative," *L'Aube,* July 11, 1932.

160 "'the most dangerous attack . . .'" Gotthard Jedlicka, *Picasso* (Zurich, 1934), as cited in London 2002, p. 377. First given as a lecture in 1932.

160 "The psychologist Carl J" Carl J. Jung, "Picasso," *Neue Zürcher Zeitung,* November 13, 1932; trans. Marilyn McCully, ed., *A Picasso Anthology: Documents, Criticism, Reminiscences* (Princeton: Princeton University Press, 1982), pp. 182–186.

160 "André Lhote was among . . ." André Lhote, "Chronique des Arts," *Nouvelle Revue Francaise,* August 1, 1932, p. 288.

160 "'I do not have . . .'" Matisse to Pierre Matisse, August 10, 1933; in Bois 1998, p. 248, n. 166.

161 "'she had only one . . .'" Crespelle 1969, p. 135.

161 "'more offensive than . . .'" Gertrude Stein, *Everybody's Autobiography* (New York: Random House, 1937), p. 37; as cited in Arianna Stassinopoulos Huffington, *Picasso: Creator and Destroyer* (New York: Simon and Schuster, 1988), p. 224.

161 "'Several times I've settled . . .'" Matisse to Marguerite Matisse Duthuit, November 21, 1929; in Bois 1998, p. 57.

162 "Although Lydia was . . ." See Lydia Delectorskaya, *Henri Matisse, Peintures de 1935–1939 . . . l'apparente facilité . . .* (Paris: Adrien Maeght, 1986), pp. 14–16. (English trans., *With Apparent Ease . . . Henri Matisse,* Paris, 1988.)

163 "'wanted his wife . . .'" Jane Simone Bussy, "A Great Man," *The Burlington Magazine* 128, 995 (February 1986), p. 83. Bussy was the daughter of the painter Simon Bussy, an old school friend of Matisse's.

163 "'Mme Matisse, possessed . . .'" Bussy 1986, p. 83: "*Monsieur Matisse, vous êtes peut-être un grand artiste mais vous êtes un sale coco!*"

163 "'three thousand sketches' . . ." See Bois 1998, p. 46. As Bois notes, Michel Georges-Michel, who is the source for this statement, probably exaggerated; but in any case, Matisse apparently did a great number of studies. Moreover, lack of finish plagued virtually all Matisse's treatments of such themes. The 1909 *Nymph and Satyr* was one of a pair of paintings, and the other one (now lost) was apparently never finished. In 1935, Matisse also started two other large paintings treating the nymph and faun theme—both now at the Musée National d'Art Moderne in Paris—which barely got beyond the stage of very powerful preliminary drawing on the canvas.

164 "The news of her . . ." Olga Merson committed suicide in Berlin in 1929. Matisse, however, did not learn of her death until the early 1930s (which is perhaps why the date of her death is given as "1934 or later" in Kostenevich and Semyonova 1993, p. 12). My thanks to Hilary Spurling for providing in-

formation about the date of Merson's death and about when Matisse learned of it (oral communication, September 2002).

166 "This is a theme . . ." Picasso painted the motif numerous times in the mid-1930s, in paintings such as *The Muse* (1935) and related *Sleeping Woman* images.

168 "'I want to say . . .'" Parmelin 1965, pp. 15–16; as cited in Ashton 1972, p. 101.

174 "(In fact, Picasso . . ." See Rubin, "Reflections on Picasso and Portraiture," in Rubin 1996, pp. 88–89.

174 "'My love,' he wrote . . ." Picasso to Marie-Thérèse, July 19, 1939; cited in Daix 1993, p. 259.

175 "Although the relationship . . ." See the interesting discussion of this aspect of their rivalry in Bois 1998, especially pp. 20–22.

176 "in a number of . . ." See Judi Freeman, *Picasso and the Weeping Women: The Years of Marie-Thérèse Walter and Dora Maar* (New York: Rizzoli, 1994), pp. 112, 113, 115.

177 "'certain forms impose . . .'" Gilot and Lake 1964, p. 122.

178 "'What interests me . . .'" Gilot and Lake 1964, pp. 59–60.

178 "'Picasso's brutality of . . .'" Bacon told David Sylvester that Matisse was "too lyrical and decorative He doesn't have Picasso's brutality of fact." David Sylvester, *The Brutality of Fact: Interviews with Francis Bacon* (London: Thames and Hudson, 1987) p. 182.

178 "'all his portraits . . .'" James Lord, *Picasso and Dora: A Personal Memoir* (New York: Farrar Straus Giroux, 1993), p. 123.

179 "'beautiful blues, beautiful reds . . .'" E. Tériade, "Constance du fauvisme," *Minotaure* 2, 9 (October 15, 1936), p. 3; trans. Flam 1995, p. 122.

180 "When Picasso fathered . . ." Matisse to Rouveyre, August 19, 1947; in Finsen 2001, p. 464.

180 "'Matisse told me . . .'" Bernadac and Piot 1989, p. 371.

180 "And how could he . . ." For a color reproduction of *Joy of Life*, see London 2002, p. 23. It must be said that for all its animated drawing and somewhat Matisse-like figures, Picasso's *Joy of Life* is a bit of a dud, in which the frolicking figures look like characters who have wandered away from some sort of street fair.

180 "In March 1946 . . ." Gilot and Lake 1964, pp. 99–100.

181 "'Matisse isn't the only . . ." Gilot and Lake 1964, pp. 115–120.

181 "'Three or four days . . .'" Matisse to Pierre Matisse, March 19, 1946; in Paris 2002, p. 396.

182 "'It's unbelievable,' Picasso . . ." Gilot and Lake 1964, p. 192; Gilot 1990, pp. 82–83.

182 "'But why is he . . .'" Gilot 1990, pp. 82–84.

CHAPTER 9

183 "*Do I believe* . . ." *Jazz* (Paris: Tériade, 1947), n.p.; trans. Flam 1995, p. 173.

183 "How difficult it is . . ." Picasso, speaking in 1966; cited in Jean Leymarie, *Picasso: The Artist of the Century,* p. ix; as cited in Huffington 1988, p. 474.

183 "Gertrude Stein's observation . . ." Gertude Stein, *Picasso,* 1938; reprinted in Stein 1985, p. 52.

184 "'Fear of death . . .'" Solomon Volkov, ed., *Testimony: The Memoirs of Dmitri Shostakovich* (New York: Harper and Row, 1979), p. 180. Shostakovich continues: "I sometimes think that there is no deeper feeling. The irony lies in the fact that under the influence of that fear people create poetry, prose, and music; that is, they try to strengthen their ties with the living and increase their influence on them."

184 "still life with a bull's . . ." Zervos, IX, 237.

184 "*Cat with a* . . ." Zervos, IX, 297.

184 "'Matisse and Picasso turned . . .'" Raymond Escholier, *Le Journal,* June 19, 1939; as cited in London 2002, p. 381.

184 "In June 1939 . . ." Brassaï 1999, p. 48.

185 "According to Roland Penrose . . ." Penrose 1973, p. 333. William Rubin (*Picasso in the Museum of Modern Art,* New York, 1972, p. 232, n. 5) accepts Penrose's reading and cites a 1971 letter from Roland Penrose affirming that the upper light is meant to represent the *lamparo* and not the moon.

185 "the 'subversive' element . . ." Gilot and Lake 1964, pp. 59–60.

186 "One spreads her arms . . ." In a witty visual pun, the handlebar of the bicycle echoes the provocation of the ice cream cone in the way it seems to penetrate her groin.

186 "Both Matisse's *Daisies* . . ." See the discussion of this relationship in Bois 1998, p. 116. The tragicomic mood and the composition of Picasso's painting also appear to refer to the work of Paul Klee, whom both Picasso and Matisse greatly admired. In 1936, Picasso had even gone to Switzerland to visit Klee, who was terminally ill.

187 "Picasso himself said . . ." Pierre Daix, in Daix 1993, pp. 261–262; see Daix 1993, p. 135, regarding Picasso's wanting the painting to "stink of war."

188 "'started . . . over again . . .'" Daix 1993, p. 135.

188 "'brutalization of what . . .'" Leo Steinberg, "The Algerian Women and Picasso at Large," in *Other Criteria: Confrontations with Twentieth-Century Art* (New York: Oxford University Press, 1972), pp. 224–226. Although Steinberg centers his discussion on the woman's ugliness, he nonetheless rightly feels impelled to compose a veritable list of the opposing meanings that the image seems to carry.

188 "'But don't you know . . .'" The exact words of this conversation have been given variously. My account is based on Courthion 1941, as given in Paris 2002, p. 389; letters from Matisse to Pierre Matisse, mid-June 1940, as given in Paris 2002, p. 389, and London 2002, p. 381; Penrose 1973, p. 336, citing André Verdet, "Picasso et ses environs," *Les Lettres nouvelles,* Paris, July–August 1955.

189 "'the shame of suffering . . .'" Matisse to Pierre Matisse, September 1, 1940; cited in London 2002, p. 381; Paris 2002, p. 390.

189 "'If everyone who . . .'" Matisse to Pierre Matisse, September 1, 1940; cited in London 2002, p. 381; Paris 2002, p. 390.

189 "Both had numerous . . ." As far back as 1937, Louis Gillet, of the French Academy, had written that Picasso's mother was Italian and "of Jewish descent." "Trente ans de peinture au Petit Palais," *Revue des Deux Mondes*, August 1, 1937; as cited in London 2002, p. 380.

190 "'to the most deadly . . .'" Maurice de Vlaminck, *Comoedia*, June 6, 1942; in Daix 1993, p. 266; translation modified.

190 "'It's disgusting,' he wrote . . ." Matisse to Pierre Matisse, June 6, 1942; in Paris 2002, p. 391.

190 "Jacob died in . . ." Jacob died on March 5, 1944. For details about his death and the contentious debate about precisely what Jacob's various friends did or did not do, see Hélène Seckel and André Cariou, *Max Jacob et Picasso* (Paris: Réunion des Musées Nationaux, 1994), pp. 273–277.

190 "On one visit . . ." Penrose 1973, p. 342. The image is variously described as a photograph or a postcard. According to Cabanne 1977, p. 347, Picasso sometimes gave German soldiers postcards of *Guernica*.

191 "even been suggested . . ." John Elderfield in London 2002, p. 285.

192 "'I'm slightly ill . . .'" Matisse to Picasso, Interzone Postcard from Lyon, January 14, 1941:"*Je suis légerement malade. . . . Suis clinique Lyon pour petite intervention prochaine sans danger.*" In Paris 2002, p. 390.

192 "(In a letter . . ." Matisse to Albert Marquet, January 16, 1942; cited in Dominique Fourcade, ed., *Matisse: Écrits et propos sur l'art* (Paris: Hermann, 1972), p. 288.

193 "'There are so many . . .'" Matisse to George Besson, December 1938; in Cowart and Fourcade 1986, p. 57.

193 "'the superficial existence . . .'" Matisse, "Notes d'un peintre"; trans. Flam 1995, p. 39.

193 "'above me, above any . . .'" Louis Aragon, *Henri Matisse, Roman* (Paris: Flammarion, 1972), vol. 1, p. 208.

193 "For years, it remained . . ." See Bois 1998, p. 142, for an interesting discussion of the painting, which was completed October 21, 1941, and Matisse's notion of "painting with bricks."

194 "'it was 'too decorative' . . ." Gilot 1990, pp. 12–13.

194 "It is said that . . ." See John Golding, in London 2002, p. 82.

195 "'It's Dante confronting . . .'" Matisse to Max Pellequer, undated letter in response to a letter of June 24, 1943; cited in Bois 1998, p. 133.

195 "That, said Matisse . . ." Some years before, Matisse had made notes about a tree that had reminded him of a somewhat similar Picasso landscape: "a robust olive tree—old, with its main branches cut down—has young branches that dance and express the promise of a new life. I pass by it every day and often I think of a painting by Picasso, representing a Provençal town or the outskirts of such a town. In the foreground a large tree, an olive tree it seems to me, also quite heavily pruned. The gap between the young shoots and

the thick trunk had struck me and had always seemed unlikely to me. Now I see what enticed him to represent such a thing." Notes in Matisse's diary, February 7, 1944; quoted in Bois 1998, p. 130.

196 "'More and more . . .'" Rosamond Bernier, *Matisse, Picasso, Miró as I Knew Them* (New York: Knopf, 1991), p. 27.

196 "'I only take . . .'" Bussy 1986, p. 81.

196 "'Matisse has such good . . .'" Gilot and Lake 1964, p. 271.

196 "'absent or present . . .'" Gilot 1990, p. 28.

196 "Such was the case . . ." Gilot 1990, pp. 29–30.

197 "'curvilinear torsions led . . .'" Gilot 1990, p. 107.

197 "'a kind of superior . . .'" Matisse to Pierre Matisse, April 29, 1948; cited in Bois 1998, p. 192.

197 "'The Greatest Painter . . .'" For a reproduction of the page, see Gertje R. Utley, *Picasso: The Communist Years* (New Haven and London: Yale University Press, 2000), p. 4.

197 "Although Matisse did not . . ." Matisse to Camoin, November 16, 1944; Grammont 1997, p. 211.

198 "'soothing' in contrast . . .'" Gaston Diehl, *Le XXé Siècle*, October 11, 1945; as cited in London 2002, p. 384.

198 "'a repetition of . . .'" Matisse to Pierre Matisse, March 10, 1946; cited in Bois 1998, p. 184.

198 "'Tomorrow Sunday, at 4 . . .'" Matisse notebook entry, August 3, 1945; in London 2002, p. 384, translation modified; Paris 2002, p. 395.

198 "Most of the attention . . ." See the reviews cited in London 2002, p. 384.

199 "Back in France . . ." For a discussion of the works shown, see Bois 1998, pp. 180–189; also London 2002, p. 384.

199 "As Matisse told Brassaï . . ." Brassaï 1999, p. 293.

199 "'We'll thus be inseparable . . .'" Matisse to Father Couturier, June 23, 1949; in M. A Couturier and L. B. Rayssiguier, *La Chapelle de Vence: Journal d'une création* (Paris: Editions du Cerf, 1993), pp. 209–210.

199 "'Perhaps after all . . .'" Louis Aragon, "Matisse en France," in Henri Matisse, *Dessins: Thèmes et variations* (Paris, 1943), pp. 25–28; trans. Flam 1995, p. 150.

199 "'We'll find a mason . . .'" Matisse to Picasso, September 8, 1947; in London 2002, p. 386; Paris 2002, p. 399.

200 "'The Communist Party . . .'" "Pourquoi j'ai adhéré au Parti Communiste," *L'Humanité*, October 29–30, 1944, p. 1.

200 "Dmitri Shostakovich referred . . ." Elizabeth Wilson, *Shostakovich: A Life Remembered* (Princeton: Princeton University Press, 1994), p. 271.

201 "Fougeron was said . . ." Daix 1993, p. 305; translation modified.

201 "'The Stalin-Picasso . . .'" Rouveyre to Matisse, April 2, 1953; in Finsen 2001, p. 639.

201 "Similarly, Picasso found . . ." Sometime around 1950–1951, Picasso wrote on a piece of paper: *grande chapellerie moderne/ A l'odalisque repeinte)/ Henri Matisse chapelier modiste*, with its pun on *chapellerie*, which means

"hat shop," and which translates roughly as "great modern hat shop/ (At the repainted odalisque)/ Henri Matisse hatter milliner." Bernadac and Piot 1989, p. 372.

201 "At one point . . ." Cabanne 1977, p. 429.

201 "'All art worthy . . .'" Matisse, interview with Charbonnier, August 1950; trans. Flam 1995, p. 192.

202 "During one visit there . . ." Malraux 1976, pp. 7–8.

203 "'That was our bedroom . . .'" Léal, Piot, and Bernadac 2000, p. 401.

204 "'both here and elsewhere . . .'" Steinberg 1972, p. 222.

204 "I Have Dreamt So . . ." Robert Desnos, "I Have Dreamt So Fiercely of You," as translated in Brassaï 1999, pp. 372–373.

205 "'Caricatures of myself . . .'" Lord 1993, p. 195. Picasso was quite literally working on drawings of dwarfs, monkeys, and men with masks at the time.

206 "'For life is tendency . . .'" Henri Bergson, *Creative Evolution* (New York: Modern Library, 1944), p. 110.

206 "'Never before has Matisse . . .'" Barr 1951, p. 12.

207 "Years later, she still . . ." Brassaï 1999, p. 333; translation slightly modified.

208 "'Matisse is dead . . .'" Joseph Kissel Foster, *Art Digest*, December 1, 1954; cited in London 2002, p. 390.

208 "'You see, it's . . .'" Penrose 1973, p. 405.

208 "'That bastard . . .'" Gilot and Lake 1964, p. 203.

208 "'When Matisse died . . .'" Penrose 1973, p. 406. Picasso began drawings for the series on November 27, 1954, and did the first canvas on December 13; he finished the series of fifteen canvases on February 14, 1955. In addition to the paintings, Picasso also did a large number of prints and drawings on the theme.

209 "In a sense . . ." The point is made by Galassi 1996, pp. 132–133.

209 "Years before, Picasso . . ." In 1946 he had told Gilot: "As long as you paint just a head, it's all right . . . but when you paint the whole human figure, it's often the head that spoils everything. If you don't put in any details, it remains just an egg, not a head. You've got a mannequin and not a human figure." Gilot and Lake 1964, p. 119.

210 ". . . had two left sides." See Steinberg 1972, pp. 141–143, for a brilliant discussion of the spatial construction of the painting and for Picasso's use of such conceits, which Steinberg refers to as perhaps the last time "that the power of painting sought to define itself not in paring down to an essence, but in the enormity of its reach."

210 ". . . Olga had died?" This is pointed out by Galassi 1996, p. 144.

211 "'masterwork of world . . .'" In Spanish, *"obra culminante de la pintura universal."* Galassi 1996, p. 148; translation modified.

211 "He set aside . . ." See especially, Hélène Parmelin, "Picasso and *Las Meninas,*" *Yale Review* 47 (June 1958), pp. 581–582.

212 "'genius' of the childlike . . ." For Picasso's thoughts about Matisse and children's art, see John Richardson, "Understanding the Paintings of Pablo

Picasso," *The Age* (London), December 22, 1962; as cited in Ashton 1972, p. 164. For his discussion of the implications of having never drawn like a child, see Brassaï 1999, pp. 114–115.

213 "was becoming deaf . . ." See O'Brian 1994, pp. 467–469.

214 "'How difficult it is . . .'" Picasso in 1966, in Leymarie, *Picasso: The Artist of the Century*, p. ix; as in Huffington 1988, p. 474.

215 "This harrowing self-portrait . . ." See Rubin 1996, p. 172. Rubin also points out, following Adam Gopnik, that the structure of the head refers back to the caricature-like images of the aged Josep Fontdevila that Picasso had done in Gosol in 1906.

216 "Interspersed with his . . ." Huffington 1988, p. 468, based on an account in *Paris-Match*, April 21, 1973, p. 76.

CHAPTER 10

217 "Tate Modern is . . ." *The Times*, London, May 8, 2002, p. 14. The headline refers to the Matisse-Picasso exhibition that had just opened at the Tate Modern. The byline for the author of the review was given as "Rachel Campbell-Johnston referees."

218 "'The truth is . . .'" Gert Schiff, *Picasso: The Last Years, 1963–1973* (New York: Braziller, 1983), p. 11.

220 "'so easy on the . . .'" Denys Sutton, "Matisse Magic Again," *Financial Times*, London, June 3, 1970.

222 "'They think I'm . . .'" Bussy 1986, p. 81.

222 "Leo Steinberg has . . ." Steinberg 1972, p. 219.

224 "And both later . . ." See, for example, their conversation about this in Gilot and Lake 1964, pp. 268–270. In 1952, Matisse told André Verdet that an artist could not "start from a void. Nothing is gratuitous. As for the so-called abstract painters of today, it seems to me that too many of them depart from a void. They are gratuitous, they have no power, no inspiration, no feeling, they defend a *non-existent* point of view: they imitate abstraction." See Flam 1995, pp. 216–217.

224 "(Matisse had similar . . ." See Matisse to Charles Camoin, May 2, 1918; in Grammont 1997, p. 120.

LIST OF ILLUSTRATIONS

Collection, formed by Dr. Claribel Cone and Miss Etta Cone of Baltimore, Maryland.

1/2 in (116.8 x 100.6 cm). The Museum of Modern Art, New York. Gift of Mr. and Mrs. John Hay Whitney.

5.10: Matisse, *Nasturtiums with "Dance" (II)*, 1912. Oil on canvas, 6 ft 3 in x 44 7/8 in (190.5 x 114 cm). The Pushkin State Museum of Fine Arts, Moscow.

5.11: Matisse, *Conversation*, 1912. Oil on canvas, 69 5/8 x 7 ft 1 3/8 in (177 x 217 cm). The State Hermitage Museum, St. Petersburg.

6.1: Picasso, *Guitar, Sheet Music, and Glass*, 1912. Charcoal, gouache, and pasted paper, 18 7/8 x 14 3/4 in (47.9 x 36.5 cm). The McNay Art Institute, San Antonio. Marion Koogler McNay Bequest.

6.2: Matisse, *Portrait of Mme Matisse*, 1913. Oil on canvas, 57 x 38 1/8 in (145 x 97 cm). The State Hermitage Museum, St. Petersburg.

6.3: Picasso, *Woman in an Armchair* (Eva), 1913. Oil on canvas, 58 1/4 x 39 in (148 x 99 cm). Private Collection.

6.4: Matisse, *Portrait of Mlle Yvonne Landsberg*, 1914. Oil on canvas, 58 x 38 3/8 in (147.3 x 97.5 cm). Philadelphia Museum of Art. The Louise and Walter Arensberg Collection.

6.5: Picasso, *Portrait of a Young Woman*, 1914. Oil on canvas, 51 1/4 x 38 1/8 in (130 x 97 cm). Musée National d'Art Moderne, Centre National d'Art et de Culture Georges Pompidou, Paris.

6.6: Picasso, *Card Player*, 1913. Oil on canvas, 42 1/2 x 35 1/4 in (108 x 89.5 cm). The Museum of Modern Art, New York. Acquired through the Lillie P. Bliss Bequest.

6.7: Matisse, *Goldfish and Palette*, 1914. Oil on canvas, 57 3/4 x 44 1/4 in (146.5 x 112.4 cm). The Museum of Modern Art, New York. Gift and Bequest of Florence M. Shoenborn and Samuel A. Marx.

6.8: Picasso, *Harlequin*, 1915. Oil on canvas, 72 1/4 x 41 3/8 in (183.5 x 105.1 cm). The Museum of Modern Art, New York. Acquired through the Lillie P. Bliss Bequest.

6.9: Matisse, *Bathers by a River*, 1916. Oil on canvas, 8 ft 7 in x 12 ft 10 in (261.8 x 391.4 cm). The Art Institute of Chicago. Charles H. and Mary F. S. Worcester Collection.

6.10: Matisse, *The Music Lesson*, 1917. Oil on canvas, 96 1/3 x 79 in (244.7 x 200.7 cm). The Barnes Foundation, Merion, Pennsylvania.

7.1: Picasso, *Olga in an Armchair*, 1918. Oil on canvas, 51 1/4 x 34 5/8 in (130 x 88 cm). Musée Picasso, Paris.

7.2: Picasso, *Three Women at the Spring*, 1921. Oil on canvas, 80 1/4 x 68 1/2 in (203.9 x 174 cm). The Museum of Modern Art, New York. Gift of Mr. and Mrs. Allan D. Emil.

7.3: Picasso, *Three Musicians*, 1921. Oil on canvas, 80 x 74 in (203

x 188 cm). The Philadelphia Museum of Art. A. E. Gallatin Collection.

7.4: Matisse, *Self-Portrait*, 1918. Oil on canvas, 25 1/2 x 21 1/4 in (65 x 54 cm). Musée Matisse, Le Cateau.

7.5: Matisse, *Seated Odalisque with Raised Knee*, 1922. Oil on canvas, 18 1/4 x 15 in (46.5 x 38.3 cm). The Barnes Foundation, Merion, Pennsylvania.

7.6: Matisse, *Odalisque with Magnolias*, 1923. Oil on canvas, 25 5/8 x 31 7/8 in (65 x 81 cm). Private collection.

7.7: Picasso, *Three Dancers*, 1925. Oil on canvas, 84 5/8 x 55 7/8 in (215 x 142 cm). Tate, London.

7.8: Matisse, *Decorative Figure on an Ornamental Background*, 1925–6. Oil on canvas, 51 1/8 x 38 5/8 in (130 x 98 cm). Musée National d'Art Moderne, Centre National d'Art et de Culture Georges Pompidou, Paris.

7.9: Picasso, *Painter and Model*, 1928. Oil on canvas, 51 1/8 x 64 1/4 in (129.8 x 163 cm). The Museum of Modern Art, New York. The Sidney and Harriet Janis Collection.

7.10: Picasso, *Ball-Players on the Beach*, 1928. Oil on canvas, 9 1/2 x 13 3/4 in (24 x 34.9 cm). Musée Picasso, Paris.

7.11: Picasso, *Reclining Nude*, 1929. Oil on canvas, 15 3/4 x 24 in (40 x 61 cm). Musée National d'Art Moderne, Centre National d'Art et de Culture Georges Pompidou, Paris.

7.12: Picasso, *Nude in an Armchair*, 1929. Oil on canvas, 76 3/4 x 51 1/4 in (195 x 130 cm). Musée Picasso, Paris.

7.13: Picasso, *Seated Bather*, 1930. Oil on canvas, 64 1/4 x 51 in (163.2 x 129.5 cm). The Museum of Modern Art, New York. Mrs. Simon Guggenheim Fund.

7.14: Matisse, *Woman with a Veil*, 1927. Oil on canvas, 24 x 19 5/8 in (61 x 50 cm). The Museum of Modern Art, New York. The William S. Paley Collection.

8.1: Picasso, *Bust of a Woman*, 1931. Bronze, 33 7/8 x 12 1/2 x 19 in (86 x 32 x 48.5 cm). Musée Picasso, Paris.

8.2: Matisse, *Jeannette V*, 1916. Bronze, 22 3/4 x 8 1/3 x 10 3/4 in (58 x 21.3 x 27.1 cm). The Museum of Modern Art, New York. Acquired through the Lillie P. Bliss Bequest.

8.3: Picasso, *Reclining Bather*, 1931. Bronze, 9 x 28 1/3 x 12 1/4 in (23 x 72 x 31 cm). Musée Picasso, Paris.

8.4: Picasso, *Reclining Nude*, 1932. Oil on canvas, 51 1/4 x 63 2/3 in (130 x 161.7 cm). Musée Picasso, Paris.

8.5: Picasso, *The Dream*, 1932. Oil on canvas, 51 1/4 x 38 1/8 in (130 x 97 cm). Private collection.

8.6: Matisse, Photograph of the Barnes Mural in progress, 1931. The Barnes Foundation, Merion, Pennsylvania.

8.7: Picasso, *The Gray Acrobat*, 1930. Oil on canvas, 63 5/8 x 51 3/4 in (161.5 x 130 cm). Musée Picasso, Paris.

8.8: Matisse, *Nymph in the Forest (La Verdure)*, 1935–c. 1942. Oil on canvas, 7 ft 8 1/4 in x 6 ft 4 3/4 in (242 x 195 cm). Musée Matisse, Nice-Cimiez.

8.9: Picasso, *Minotaur and Woman*, 1933. India Ink on blue paper, 18 1/2 x 24 1/2 in (47 x 62 cm). The Art Institue of Chicago. Gift of Marguerite Blake.

8.10: Matisse, *Artist and Model*. Pen on paper, 1935. 17 3/4 x 22 1/3 in (45.1 x 56.8 cm). Private Collection.

8.11: Picasso, *Woman with Yellow Hair*, 1931. Oil on canvas, 39 3/8 x 31 7/8 in (100 x 81 cm). The Solomon R. Guggenheim Museum, New York. Thannhauser Collection, Gift, Justin K. Thannhauser, 1978.

8.12: Matisse, *The Dream*, 1935. Oil on canvas, 31 7/8 x 25 5/8 in (81 x 65 cm). Musée National d'Art Moderne, Centre National d'Art et de Culture Georges Pompidou, Paris.

8.13: Picasso, *Nude Asleep in a Garden*, 1934. Oil on canvas, 63 3/4 x 51 1/4 in (162 x 130 cm). Musée Picasso, Paris.

8.14: Matisse, *Large Reclining Nude*, known as *Pink Nude*, 1935. Oil on canvas, 26 x 36 1/2 in (66 x 92.7 cm). The Baltimore Museum of Art. The Cone Collection, formed by Dr. Claribel Cone and Miss Etta Cone of Baltimore, Maryland.

8.15: Matisse, *Woman in Blue*, 1937. Oil on canvas, 36 1/2 x 29 in (92.7 x 73.6 cm). Philadelphia Museum of Art. Gift of Mrs. John Wintersteen.

8.16: Picasso, *Dora Maar Seated*, 1937. Oil on canvas, 36 1/4 x 25 5/8 in (92 x 65 cm). Musée Picasso, Paris.

8.17: Picasso, *Weeping Woman*, 1937. Oil on canvas, 23 5/8 x 19 1/4 in (60 x 49 cm). Tate, London.

8.18: Picasso, *Woman Reclining on a Couch* (Dora Maar), 1939. Oil on canvas, 38 1/4 x 51 1/4 in (97 x 130 cm). Private collection.

8.19: Picasso, *Reclining Woman with a Book* (Marie-Thérèse Walter), 1939. Oil on canvas, 38 x 51 3/8 in (96.5 x 130.5 cm). Musée Picasso, Paris.

8.20: Picasso, *Woman-Flower*, 1946. Oil on canvas, 57 1/2 x 34 1/2 in (146 x 89 cm). Private collection.

9.1: Picasso, *Night Fishing at Antibes*, 1939. Oil on canvas, 81 x 136 in (205.7 x 345.4 cm). The Museum of Modern Art, New York. Mrs. Simon Guggenheim Fund.

9.2: Picasso, *Woman Dressing Her Hair*, 1940. Oil on canvas, 51 1/4 x 38 1/4 in (130 x 97 cm). The Museum of Modern Art, New York. Lousie Reinhardt Smith Bequest.

9.3: Picasso, *Still Life with a Steer's Skull*, 1942. Oil on canvas, 51 1/4 x 38 1/4 in (130 x 97 cm). Kunstsammlung Nordrhein-Westfalen, Dusseldorf.

9.4: Picasso, *L'Aubade*, 1942. Oil on canvas, 76 3/4 x 104 3/8 in (195 x 265 cm). Musée National d'Art Moderne, Centre National d'Art et de Culture Georges Pompidou, Paris.

9.5: Matisse, *Still Life with a Magnolia*, 1941. Oil on canvas, 29 1/8 x 39 3/4 in (74 x 101 cm). Musée National d'Art Moderne, Centre National d'Art et de Culture Georges Pompidou, Paris.

9.6: Matisse's bedroom with Picasso's *Winter Landscape* (1950) on mantelpiece, circa 1951.

9.7: Matisse, "Icarus" (from *Jazz*), 1943–47.

9.8: Picasso, *The Shadow*, 1953. Oil and charcoal on canvas, 60 x 38 in (129.5 x 96.5 cm). Musée Picasso, Paris.

9.9: Matisse, *Blue Nude III*, 1952. Gouache on paper, cut and pasted, on white paper, 44 x 29 in (112 x 73.5 cm). Musée National d'Art Moderne, Centre National d'Art et de Culture Georges Pompidou, Paris.

9.10: Matisse, *The Sheaf*, 1953. Gouache on paper, cut and pasted, on white paper, 115 3/4 x 137 3/4 in (294 x 350 cm). University of California Los Angeles Art Museum.

9.11: Picasso, *Variation on "Women of Algiers,"* 1955. Oil on canvas, 51 1/4 x 76 3/4 in (130 x 195 cm). Private collection.

9.12: Picasso, *Variation on "Las Meninas,"* 1957. Oil on canvas, 76 3/8 x 102 3/8 in (194 x 260 cm). Museo Picasso, Barcelona.

9.13: Picasso, *The Embrace*, 1969. Oil on canvas, 63 3/4 x 51 1/4 in (162 x 130 cm). Private collection.

9.14: Picasso, *Self-Portrait*, 1972. Pencil and crayon on paper, 25 3/4 x 20 in (65.7 x 50.5 cm). Private collection.

ACKNOWLEDGMENTS

While researching and writing this book, I was helped by many people. In particular I want to thank the following friends and colleagues for sharing their resources and insights with me, and for helping me with various kinds of information: Anne Baldassari, John Cauman, Eric de Chassey, Delphine Daniels, Miriam Deutch, John Elderfield, Wanda de Guébriant, George Matisse, Laurette McCarthy, Isabelle Monod-Fontaine, Marie-Thérèse Pulvénis de Séligny, John Richardson, and Hilary Spurling.

In addition, my special thanks go to Thérèse Delpech, Dominique Fourcade, and Fronia Simpson for reading substantial parts of the typescript, and for their valuable suggestions; and to Ida May B. Norton for her skillful editing.

I also want to thank Cass Canfield, Jr., who initiated the project, and most especially my editor at Westview Press, Sarah Warner, for her constant support and enthusiasm.

Finally, special thanks go to Denyse Montegut for her crucial help with all phases of the writing of the book and the preparation of the manuscript.

BIBLIOGRAPHY

Alley, Ronald. *Picasso: The Three Dancers*. London: Tate Gallery, 1986.

Apollinaire, Guillaume. Preface to *Catalogue de l'Exposition Matisse-Picasso*, January 23–February 14, 1918 (Paris: Galerie Paul Guillaume, 1918).

Apollinaire, Guillaume. *Oeuvres en prose*, ed. Michel Décaudin (Paris: Gallimard, 1977), vol. 1, chaps. V, II, pp. 478, 423; cited as Apollinaire 1977.

Apollinaire, Guillaume. *Journal Intime: 1898–1918*, ed. Michel Décaudin (Paris: Editions du Limon, 1991); cited as Apollinaire 1991a.

Apollinaire, Guillaume. *Oeuvres en prose complètes*, vol. 2. Ed. Pierre Cauzergues and Michel Décaudin. Paris: Gallimard, 1991; cited as Apollinaire 1991b.

Apollinaire, Guillaume. *Oeuvres en prose complètes*, vol. 3. Ed. Pierre Caizergues and Michel Décaudin. Paris: Gallimard, 1993; cited as Apollinaire 1993.

Apollonio, Umbro. *Futurist Manifestos*. New York: Viking, 1973.

Aragon, Louis. "Matisse en France." In Henri Matisse, *Dessins: Thèmes et variations* (Paris, 1943), pp. 25–28.

Aragon, Louis. *Henri Matisse, Roman*. Paris: Flammarion, 1972.

Les Arts à Paris, no. 1, March 15, 1918.

Ashton, Dore, ed. *Picasso on Art: A Selection of Views*. New York: Viking, 1972.

Baldassari, Anne. *Picasso and Photography: The Dark Mirror*. Paris: Flammarion, 1997.

Baldassari, Anne. In *Beaux-Arts: Matisse-Picasso* (Special Number). September 2002.

Barr, Alfred H., Jr. *Matisse, His Art and His Public*. New York: The Museum of Modern Art, 1951.

Bell, Clive. "Matisse and Picasso: The Two Immediate Heirs to Cézanne." *Arts and Decoration* 14 (November 1920), pp. 42–44.

Bernadac, Marie-Laure, and Michael, Androula, eds. *Picasso: Propos sur l'art*. Paris: Gallimard, 1998.

Bernadac, Marie-Laure, and Piot, Christine, eds. *Picasso: Collected Writings*. New York: Abbeville, 1989.

Bernier, Rosamond. *Matisse, Picasso, Miró as I Knew Them*. New York: Knopf, 1991.

Bois, Yve-Alain. *Matisse and Picasso: A Gentle Rivalry*. Paris: Flammarion, 1998.

Bois, Yve-Alain, Elderfield, John, and Stein, Laurie A. *Henri Matisse: "Bathers with a Turtle."* Saint Louis Art Museum Bulletin, 1998.

Brassaç. *Conversations with Picasso*. Chicago and London: University of Chicago Press, 1999.

Breton, André. *Le Surréalisme et la peinture*. Rev. ed., Paris, 1965; translated by Simon Watson Taylor, *Surrealism and Painting* (New York, 1972).

Breunig, Leroy C., ed. *Apollinaire on Art: Essays and Reviews, 1902–1918*. New York: Da Capo Press, 1987.

Burgess, Gelett. "The Wild Men of Paris." *Architectural Record*, May 1910, pp. 401–414.

Bussy, Jane Simone. "A Great Man." *The Burlington Magazine* 128, 995 (February 1986), pp. 80–85.

Cabanne, Pierre. *Pablo Picasso: His Life and Times*. New York: William Morrow, 1977.

Cabanane, Pierre. *Le siècle de Picasso 2: L'epoque des metamorphoses (1912–1937)*. Paris: Gallimard/Folio, 1992.

Caizergues, Pierre, and Seckel, Hélène, eds. *Picasso/Apollinaire Correspondance*. Paris: Gallimard, 1992.

Clair, Jean, ed. *Picasso Érotique*. Munich-London-New York: Prestel, 2001.

Cocteau, Jean. "Déformation Professionelle," May 12, 1919; reprinted in *Le Rappel l'ordre* (Paris: Stock, 1926).

Couturier, M.-A., and Rayssiguier, L.-B. *La Chapelle de Vence: Journal d'une création*. Paris: Editions du Cerf, 1993.

Cowart, Jack, and Fourcade, Dominique. *Henri Matisse: The Early Years in Nice, 1916–1930*. Washington, D.C.: National Gallery of Art, 1986.

Cowling, Elizabeth. *Interpreting Matisse Picasso*. London: Tate Publishing, 2002.

Crespelle, Jean-Paul. *Picasso and his Women*. New York: Coward-McCann, 1969.

Daix, Pierre. *La Vie de peintre de Pablo Picasso*. Paris: Le Seuil, 1977.

Daix, Pierre. *Picasso: Life and Art*. New York: Harper Collins, 1993.

Daix, Pierre, and Boudaille, Georges, with Joan Rosselet. *Picasso, 1900–1906*. Neuchâtel, 1966; trans. as *Picasso, The Blue and Rose Periods, A Catalogue Raisonné, 1900–1906*. Greenwich, 1967 (Rev. ed., Neuchâtel, 1989).

Daix, Pierre, and Rosselet, Joan. *Picasso: The Cubist Years 1907–1916: A Catalogue Raisonné of the Paintings and Related Works*. Boston: New York Graphic Society, 1979. Originally published as *Le Cubisme de Picasso*, Neuchatel: Ides et Calendes, 1979.

Dauberville, Guy-Patrice, and Dauberville, Michel. *Matisse: Henri Matisse chez Bernheim-Jeune*. 2 vols. Paris: Bernheim-Jeune, 1995.

Delectorskaya, Lydia. *Henri Matisse, Peintures de 1935–1939 . . . l'apparente facilité . . .* Paris: Adrien Maeght, 1986. English trans., *With Apparent Ease . . . Henri Matisse*, Adrien Maeght, Paris, 1988.

Diehl, Gaston. *Henri Matisse*. Paris: Tisné, 1954.

Elderfield, John. *Henri Matisse: A Retrospective*. New York: Museum of Modern Art, 1992.

Elderfield, John. "Moving Aphrodite: On the Genesis of *Bathers with a Turtle* by Henri Matisse," in Yve-Alain Bois, John Elderfield, and Laurie A. Stein, *Henri Matisse: "Bathers with a Turtle"* (Saint Louis Art Museum Bulletin, 1998).

Farrell, Barry. "His Women: The Wonder Is That He Found Time to Paint." *Life*, special Picasso issue 65, 26 (December 27, 1968), pp. 64–85.

Fels, Florent. *Henri-Matisse*. Paris: Editions des Chroniques du Jour, 1929.

Finsen, Hanne, ed. *Matisse-Rouveyre Correspondance*. Paris: Flammarion, 2001.

FitzGerald, Michael C. *Making Modernism: Picasso and the Creation of the Market for Twentieth-Century Art*. New York: Farrar Strauss Giroux, 1995.

Flam, Jack. *Matisse on Art*. Revised ed. Berkeley and Los Angeles: University of California Press, 1995.

Flam, Jack. *Matisse: The Man and His Art, 1869–1918*. Ithaca: Cornell University Press, 1986.

Flam, Jack, ed. *Matisse: A Retrospective*. New York: Levin, 1988.

Fourcade, Dominique, ed. *Matisse: Écrits et propos sur l'art*. Paris: Hermann, 1972.

Freeman, Judi. *The Fauve Landscape*. New York: Abbeville, 1990.

Freeman, Judi. *Picasso and the Weeping Women: The Years of Marie-Thérèse Walter and Dora Maar*. New York: Rizzoli, 1994.

Galassi, Susan. *Picasso's Variations on the Masters: Confrontations with the Past*. New York: Harry N. Abrams, 1996.

George, Waldermar. "Dualité de Matisse." *Formes*, no. 16 (June 1931), pp. 94–95.

Gilot, Françoise, and Lake, Carlton. *Life with Picasso*. New York, Toronto, London: McGraw-Hill, 1964.

Gilot, Françoise. *Matisse and Picasso: A Friendship in Art*. New York: Doubleday, 1990.

Gleizes, Albert, and Metzinger, Jean. *Du "Cubisme,"* 1912; trans. Robert L. Herbert, *Modern Artists on Art: Ten Unabridged Essays* (Englewood Cliffs: Prentice-Hall, 1964), pp. 1–18.

Gowing, Lawrence. *Cézanne: The Early Years, 1859–1872*. New York: Abrams, 1988.

Grammont, Claudine, ed. *Correspondance entre Charles Camoin et Henri Matisse*. Paris: Bibliothèque des Arts, 1997.

Green, Christopher, ed. *Picasso's Les Demoiselles d'Avignon*. Cambridge: Cambridge University Press, 2001.

Henderson, Linda Dalrymple. *The Fourth Dimension and Non-Euclidean Geometry in Modern Art*. Princeton: Princeton University Press, 1983.

Huffington, Arianna Stassinopoulos. *Picasso: Creator and Destroyer*. New York: Simon and Schuster, 1988.

Jung, Carl J. "Picasso," *Neue Zürcher Zeitung*, November 13, 1932; trans. Marilyn McCully, ed., *A Picasso Anthology: Documents, Criticism, Reminiscences* (Princeton: Princeton University Press, 1982), pp. 182–186.

Katz, Leon. "Matisse, Picasso, and Gertrude Stein." In *Four Americans in Paris: The Collections of Gertrude Stein and Her Family*. New York: Museum of Modern Art, 1970.

Kandinsky, Wassily. *On the Spiritual in Art and Painting in Particular*, 1912; trans. Kenneth C. Lindsay and Peter Vergo, eds. *Kandinsky: Complete Writings on Art* (Boston: G.K. Hall, 1982), vol. 1, pp. 114–219.

Kostenevich, Albert, and Semyonova, Natalya. *Collecting Matisse.* Paris: Flammarion, 1993.

Lassaigne, Jacques. "Entretien avec Georges Braque." *XXe Siècle,* 41, 1973.

Léal, Brigitte, Piot, Christine, and Bernadac, Marie-Laure. *The Ultimate Picasso.* New York: Harry N. Abrams, 2000.

Leighten, Patricia. "The White Peril and *L'art Nègre*: Picasso, Primitivism, and Anticolonialism." *Art Bulletin* 72, 4 (December 1990), pp. 609–630.

Levinson, André. "Les Soixante ans de Henri Matisse," *L'Art Vivant* 6, 121 (January 1930), pp. 22–28.

Leymarie, Jean. *Picasso: The Artist of the Century.* New York: Viking, 1972.

London. Tate Gallery. *Matisse Picasso.* London: Tate Publishing, 2002; cited as London 2002. Co-authored by Elizabeth Cowling, John Golding, Anne Baldassari, Isabelle Monod-Fontaine, John Elderfield, and Kirk Varnedoe. (Also co-published by the Museum of Modern Art, New York in 2003.)

Lord, James. *Picasso and Dora: A Personal Memoir.* New York: Farrar Straus Giroux, 1993.

Malraux, André. *Picasso's Mask.* New York: Holt, Rinehart and Winston, 1976.

Matisse, Henri. Interviews with Pierre Courthion, 1941, Typescript, Getty Research Institute Library. Getty Center, Los Angeles, CA.

Matisse, Henri. *Dessins: Thèmes et variations.* Paris, 1943.

Matisse, Henri. *Jazz.* Paris: Tériade, 1947.

Monod-Fontaine, Isabelle, Baldassari, Anne, and Laugier, Claude. *Matisse: Oeuvres de Henri Matisse.* Paris: Centre Georges Pompidou, Collections du Musée national d'art moderne, 1989.

Mugnier, Abbé. *Journal de l'Abbé Mugnier (1879–1939).* Paris: Mercure de France, 1995.

O'Brian, Patrick. *Pablo Ruiz Picasso: A Biography.* New York: Norton, 1994.

Olivier, Fernande. *Picasso et ses amis.* Paris: Stock, 1933; trans. Jane Miller, *Picasso and His Friends* (New York: Appleton Century, 1965); cited as Olivier 1933.

Olivier, Fernande, *Souvenirs intimes écrits pour Picasso* (Paris: Calmann-Lévy, 1988).

Olivier, Fernande. *Loving Picasso: The Private Journal of Fernande Olivier*, Foreword and notes by Marilyn McCully, trans. Christine Baker and Michael Raeburn (New York: Harry N. Abrams, 2001).

Pach, Walter. *Queer Thing, Painting*. New York and London: Harper, 1938.

Palau i Fabre, Josep. *Picasso: The Early Years, 1881–1907*. Barcelona: Poligrafa, 1985.

Paris. Centre Georges Pompidou, Musée National d'Art Moderne, *Donation Louise et Michel Leiris: Collection Kahnweiler-Leiris*. Paris, 1985.

Paris. Centre Georges Pompidou. *Henri Matisse: 1904–1917*. Paris, 1993.

Paris. Galeries Georges Petit. *Henri Matisse, 16 juin–25 juillet 1931*. Paris, 1931.

Paris. Musée National d'Art Moderne. *André Breton: La beauté convulsive*. Paris, 1991.

Paris, Musée Picasso. *Les Demoiselles d'Avignon*. Paris, 1988.

Paris. Réunion des musées nationaux/Centre national d'Art et de Culture Georges Pompidou/Musée national d'art moderne. *Matisse Picasso*. Paris: Réunion des musées nationaux/Centre national d'Art et de Culture Georges Pompidou/Musée national d'art moderne, 2002. Co-authored by Elizabeth Cowling, John Golding, Anne Baldassari, Isabelle Monod-Fontaine, John Elderfield, and Kirk Varnedoe; cited as Paris 2002.

Parmelin, Hélène. "Picasso and *Las Meninas*." *The Yale Review*, 47 (June 1958), pp. 581–582.

Parmelin, Hélène. *Picasso: The Artist and His Model, and Other Recent Works*. New York: Abrams, 1965.

Penrose, Roland. *Picasso: His Life and Work*. Rev. ed. New York: Harper and Row, 1973.

Power, Arthur. *Conversations with James Joyce*. New York: Lilliput Press, 1999.

Read, Peter. *Picasso et Apollinaire: Les métamorphoses de la mémoire, 1905/1973*. Paris: Jean Michel Place, 1995.

Reff, Theodore. "Picasso's Three Musicians: Maskers, Artists, and Friends." *Art in America*, December 1980, pp. 124–142.

Richardson, John. "Understanding the Paintings of Pablo Picasso." *The Age* (London), December 22, 1962.

Richardson, John. *A Life of Picasso. Volume I: 1881–1906*. New York: Random House, 1991.

Richardson, John. *A Life of Picasso, Volume II: 1907–1917*. New York: Random House, 1996.

Roy, Claude. *La Guerre et la Paix*. Paris, 1954.

Rubin, William. *Picasso in the Museum of Modern Art*. New York, 1972.

Rubin, William. *Picasso and Braque: Pioneering Cubism*. New York: The Museum of Modern Art, 1989.

Rubin, William, ed. *Picasso and Portraiture: Representation and Transformation*. New York: Museum of Modern Art, 1996.

Rubin, William, Seckel, Hélène, and Cousins, Judith. *Les Demoiselles d'Avignon*. Studies in Modern Art 3. New York: Museum of Modern Art, 1994.

Salmon, André. "Histoire Anecdotique du Cubisme." In *La Jeune Peinture Française*. Paris: Albert Messein, 1912.

Salmon, André. *L'Air de la Butte*. Paris: Editions de la Nouvelle France, 1945.

Salmon, André. *Souvenirs sans fin*. Volume 1. Paris: Gallimard, 1955.

Schiff, Gert. *Picasso: The Last Years, 1963–1973*. New York: Braziller, 1983.

Seckel, Hélène and Cariou, André. *Max Jacob and Picasso*. Paris: Réunion des Musées Nationaux, 1994.

Spurling, Hilary. *The Unknown Matisse: A Life of Henri Matisse: The Early Years, 1869–1908*. New York: Alfred A. Knopf, 1998.

Stein, Gertrude. *The Autobiography of Alice B. Toklas*. New York: Vintage Books, 1955. (First published 1933; cited as Stein 1933.)

Stein, Gertrude. *Everybody's Autobiography*. New York: Random House, 1937.

Stein, Gertrude. *Picasso*, 1938; reprinted in Gertrude Stein, *Picasso: The Complete Writings* (Boston: Beacon, 1985).

Stein, Leo. *Appreciation: Painting, Poetry and Prose*. New York: Crown, 1947.

Steinberg, Leo. "The Algerian Women and Picasso at Large." In *Other Criteria: Confrontations with Twentieth-Century Art*. New York: Oxford University Press, 1972, pp. 125–234.

Steinberg, Leo. "Resisting Cézanne: Picasso's 'Three Women'." *Art in America* 66, 6 (November–December 1978), pp. 115–133.

Steinberg, Leo. "The Philosophical Brothel." *October* 44 (Spring 1988), pp. 7–74. (First published *Art News*, vol. 71, September and October 1972.)

Sutton, Denys. "Matisse Magic Again." *Financial Times*, London, June 3, 1970.

Sylvester, David. *The Brutality of Fact: Interviews with Francis Bacon.* London: Thames and Hudson, 1987.

Utley, Gertje R. *Picasso: The Communist Years.* New Haven and London: Yale University Press, 2000.

Verdet, André. "Entretiens avec Henri Matisse." In *Prestiges de Matisse.* Paris, 1952.

Verdet, André. *Entretiens notes et écrits sur la peinture.* Paris: Editions Galilée, 1978.

Volkov, Solomon, ed. *Testimony: The Memoirs of Dmitri Shostakovich.* New York: Harper and Row, 1979.

Warnod, Jeanine. *Le Bateau-Lavoir: 1892–1914.* Paris: Presses de la Connaissance, 1975.

Wilson, Elizabeth. *Shostakovich: A Life Remembered.* Princeton: Princeton University Press, 1994.

Zervos, Christian. "Notes sur la formation et le développement de l'oeuvre de Henri-Matisse." *Cahiers d'Art* 6, nos. 5–6 (1931), pp. 246–248.

Zervos, Christian. *Pablo Picasso.* 33 volumes. Paris: Editions Cahiers d'Art, 1932–1966.

INDEX

wealth of, 99

working habits, 15, 22, 48–49, 128, 168, 205

works. *See headings beginning with* Matisse's works

and World War I, 102–103, 107–118

and World War II, 188–190

Matisse, Jean, 2

Matisse, Marguerite, 2, 230, 241

and Antoinette Arnoux, 129

and Lydia Delectorskaya, 163

portrait of, 55–56

on the Steins, 24–25

Matisse–Picasso relationship

and African art, 32–34

and Apollinaire, 52–53

artists disengaged from each other in the early 1920s, 131–132

artists out to "get" each other, 46

artists viewed as aesthetically incompatible, 68–69

artists viewed as twin leaders of the avant-garde, 87, 89, 117–118, 179, 197, 199–200

Basket of Oranges acquired by Picasso, 83, 93, 194–195

contrasts between the artists, ix, 15–18, 22, 48–49, 69, 77, 87. *See also* Aesthetic judgment

exchange of works, 54–56, 194–197

first meetings, vii, 18, 24–25, 230

and frescoes, 199–200

graffiti campaign by Picasso's friends, 46, 56

horseback rides, 89, 93

joint auction, 98–99

joint showings, 113–118, 198–199, 241–242

Matisse re-integrated in the avant-garde by Picasso's interest, 94

Matisse's 1931 exhibit and Picasso's 1932 exhibit of Matissian responses, 151–161

Matisse's death, 207–208

Matisse's reserve about his private life, viii, 93–94

Matisse's views on Picasso, xi, 28, 46–47, 52, 77, 89–90, 107

parallel love lives, 82–83, 162–163

perception of common interests, 200–202

perception of shared understanding, 69, 89–90

Picasso's first exposure to Matisse's work, 20–21

and Picasso's illness (1913), 93

and Picasso's love for Marie-Thérèse, 138–140

and Picasso's portrait of Gertrude Stein, 19, 21–22

Picasso's views on Matisse, xi, 27, 89, 139, 157, 194, 212

post–World War II rivalry, 197–199

and relations with women, viii–ix, 180–182

renewed friendship and interest in each other's work (1913–1918), 89–118

and the Steins, 19, 21, 22, 28, 43

stylistic turf wars, 57, 96, 132, 151–171

tensions relaxed (late 1930s), 178–180

Winter Landscape borrowed by Matisse, 195–196

and World War I, 108

and World War II, 189–190

Matisse, Pierre, 2, 157, 160, 181, 189, 197

Matisse's works

aesthetic judgments of. *See* Aesthetic judgment

content of. *See* Matisse's works: content

cutouts, 202–203, 205–206, 218

owned by Picasso, 83, 93, 194–197

style and technique. *See* Matisse's works: style and technique

Vence chapel, 49, 195, 196, 201–202

wood-carving, 32

See also Sculpture